VIDA AMERICANA: MEXICAN MURALISTS REMAKE AMERICAN ART, 1925–1945

EDITED BY
BARBARA HASKELL

WITH ADDITIONAL ESSAYS BY
MARK A. CASTRO, DAFNE CRUZ PORCHINI,
RENATO GONZÁLEZ MELLO, MARCELA GUERRERO,
ANDREW HEMINGWAY, ANNA INDYCH-LÓPEZ,
MICHAEL K. SCHUESSLER, GWENDOLYN DUBOIS SHAW,
SHIPU WANG, AND JAMES WECHSLER

WHITNEY MUSEUM OF AMERICAN ART, NEW YORK
YALE UNIVERSITY PRESS, NEW HAVEN AND LONDON

VIDA
AMER

MEXICAN MURALISTS
REMAKE AMERICAN ART, 1925–1945

ICANA

CONTENTS

This catalogue was published on the occasion of the exhibition *Vida Americana: Mexican Muralists Remake American Art, 1925–1945*, organized by Barbara Haskell, curator, with Marcela Guerrero, assistant curator; Sarah Humphreville, senior curatorial assistant; and Alana Hernandez, former curatorial project assistant, Whitney Museum of American Art, New York.

Whitney Museum of American Art, New York
February 17–May 17, 2020

McNay Art Museum, San Antonio
June 25–October 4, 2020

Vida Americana: Mexican Muralists Remake American Art, 1925–1945 reveals what can be achieved by the exchange of ideas and aspirations, styles and techniques between artists from different countries. The profound and lasting influence of the Mexican muralists on American artists is on full view in this groundbreaking exhibition and its accompanying catalogue. Together, these artists and their works create a conversation for today's artists and the public that is new and innovative, in spite of being firmly planted in the cultural history of the last century. At the Jerome L. Greene Foundation, we believe art can enrich lives, and it is an honor to partner with the Whitney Museum of American Art on this ambitious endeavor.

Christina McInerney
President and CEO
Jerome L. Greene Foundation

Vida Americana: Mexican Muralists Remake American Art, 1925–1945—both the exhibition and this accompanying catalogue—are about the relationships and connections of a period that coincides with the Museum's inception and resonates with its mission, as well as those of its precursors. Although the Whitney was founded in 1930, the Museum's roots began with the Whitney Studio Club, an organization originated by the artist and philanthropist Gertrude Vanderbilt Whitney in her own studio in 1918 as a home for artists—a place that provided community space for a few hundred member artists to work, socialize, read, and exhibit. Mrs. Whitney, along with Juliana Force, her executive assistant who would become the first director of the Museum, presented the work of Club members as well as exhibitions by artists of diverse backgrounds and standings who were working both in the United States and abroad. As Force declared, "the ideal exhibition . . . is an integral part of an artistic plan." And her plan was to elevate artists in the United States by exposing them to what she and Mrs. Whitney perceived to be some of the most vital works of the time. They also supported artists by acquiring work for Mrs. Whitney's collection and encouraging other American art collectors to pay attention to the work of U.S. artists.

In 1924 the Studio Club presented an exhibition of three Mexican artists, José Clemente Orozco, Luis Hidalgo, and Miguel Covarrubias, that was organized by artist Alexander Brook, who served as the assistant director of the Club. It was Orozco's first exhibition in the United States. A few years later, in 1926, Orozco also showed watercolors from his House of Tears series at the Club; the following year Force provided critical support for Orozco at a time when he desperately needed it by acquiring ten of his drawings. My purpose here is not to assert the Whitney's profound and enduring support of Mexican artists of this time, or to imply that its interest in these artists was unique—in fact, the Museum of Modern Art, founded in 1929, gave Diego Rivera its second monographic exhibition, in 1931—but rather to offer context. *Los tres grandes*—as the leading Mexican muralists, Orozco, Rivera, and David Alfaro Siqueiros, were known—all arrived in the United States in the late 1920s or early 1930s to execute mural commissions and were warmly received in artistic circles. As one learns in this volume, they had significant influence on artists in this country, many of whom were mainstays of the Club and eventually the Whitney Museum, among them Thomas Hart Benton, the Regionalist painter who began exhibiting at the Whitney in the mid-1920s. Indeed, Benton, who once proclaimed that the Mexican muralists produced "the only great art of our time," along with Orozco, was commissioned in 1930 to create murals for

ADAM D. WEINBERG

FOREWORD

the New School for Social Research in New York. And in 1932 Benton produced murals for the library of the newly opened Whitney Museum, which, like the New School, was located in Greenwich Village. Many other artists featured in this catalogue and exhibition were members of the Club with long-term connections to the Whitney, ranging from Ben Shahn to George Biddle, William Gropper to Philip Guston, Jackson Pollock to Isamu Noguchi.

These historical Whitney connections are important and compelling, yet alone they do not provide a convincing case for the relevance of this exhibition. Although the idea for this exhibition, originated by longtime Whitney curator Barbara Haskell, was hatched almost a decade ago, a broad renewed interest in twentieth-century Mexican art has been evident in recent years. In 2011–12 the Museum of Modern Art celebrated its own historical support of Mexican artists with the exhibition *Diego Rivera: Murals for The Museum of Modern Art*; in 2016–17 the Philadelphia Museum of Art presented *Paint the Revolution: Mexican Modernism, 1910–1950* organized with the Museo del Palacio de Bellas Artes, Mexico City; and in 2017 the Dallas Museum of Art organized the traveling exhibition *México 1900–1950: Diego Rivera, Frida Kahlo, José Clemente Orozco, and the Avant-Garde*; and these are but three of a number of other recent exhibitions about this moment in Mexican art history. I believe these exhibitions have come about for varying reasons: a desire on the part of U.S. museums to exhibit work by a wide range of artists, to broaden our understanding of the global trajectory of modern art, to recognize and engage with public art, to revisit neglected traditions like figurative painting, and to explore their own history and mine their own collections.

For the Whitney Museum, all of the above are true. As a museum devoted to American art, it is incumbent upon the Whitney to present the breadth and diversity of twentieth- and twenty-first-century art and its multitudinous traditions, sources, influences, and directions. During the years in which we were preparing for the opening of the new Whitney building, we recognized the clear urgency to exhibit works by underrepresented American artists. We embarked on an extensive collection-cataloging project to enable our curators to explore our holdings and discover works that may have been overlooked for years. And we revisited our acquisition and exhibition priorities to ensure that both new works entering our collection and the exhibitions we presented moving forward, starting with the inaugural exhibition *America Is Hard to See* (2015), demonstrated our renewed commitment to and continually evolving understanding of American art. In recent years, the Whitney has examined the connections between the art of this country and Latin America, for example, with our recent exhibitions *Pacha, Llacta, Wasichay: Indigenous Space, Modern Architecture, New Art* (2018); *Hélio Oiticica: To Organize Delirium* (2017); and *Carmen Herrera: Lines of Sight* (2016).

Like most contemporary U.S. museums, the Whitney has been working largely within established tropes; over the years we have to some degree neglected many significant artists and movements that give a richness, texture, and counterpoint to a more one-dimensional, Eurocentric, modernist approach. In this we may have, for too long, ignored the influence and impact of artists like the Mexican muralists celebrated in this volume, and favored abstraction at the expense of the rich tradition of figurative art in this country. As a museum with deep institutional holdings and limited, though recently much expanded, exhibition space, we continually search for meaningful ways to bring

works long in storage into public view. The Whitney has a rich collection of prints from the 1920s and 1930s by artists connected to the Mexican muralists on themes related to the subject of this exhibition: from support for workers' struggles to anti-lynching statements. As Barbara Haskell notes in her essay in this volume, Siqueiros was known for "using art to denounce exploitative labor practices, economic imperialism, and what he called the 'anti-democratic politics of racial discrimination'"; on Rivera, she writes: "his empathy with the working class and disenfranchised commingled with awe at the marvels of industry and the modern metropolis"; and about Orozco: "[his work] enthralled the art world with its marriage of figurative imagery, fraught content, and expressive brushwork." In these ways, this exhibition enables the Whitney to present a new understanding of art history, one that acknowledges the wide-ranging and profound influence the Mexican muralists had on the style, subject matter, and ideology of art in the United States between 1925 and 1945—a history reflected in our own history and collection. And it reminds us of the power of art in revolutionary times.

But what makes this exhibition more timely and urgent than one could have imagined is the political context of the last two years at a time when people living south of the U.S. border, in Mexico and Central American countries, are being disparaged and vilified by our current government. *Vida Americana* reaffirms our connection to Mexico and its rich cultural traditions; it reasserts that U.S. artists have learned and borrowed from Mexican traditions and, above all, that people of goodwill in both countries share in the belief that art unites, it doesn't divide; it can be utilized to attack inequity and exploitation of the past and present but it also expresses hope and yearning for a better existence that can be realized in the present. As Haskell cogently states at the close of her essay, "It thus seems more imperative than ever to acknowledge the profound and enduring influence Mexican muralism has had on artmaking in the United States and to highlight the beauty and power that can emerge from the free and vibrant cultural exchange between the two countries."

—

First and foremost I thank Barbara Haskell for conceiving this project long ago and letting it marinate, knowing that its time, the right time, would come. The exhibition is another example of her painstaking research into under-acknowledged areas of American art history, and I congratulate her on this historic project. I am delighted that the reach of this important exhibition will extend to San Antonio, where the McNay Art Museum will host it. I offer my warmest thanks to Richard Aste, director, and his staff for their enthusiastic partnership.

An exhibition such as this requires significant support and I salute the foundations, corporations, and individual donors who have made its realization possible. The Jerome L. Greene Foundation has long been a steadfast supporter of programming that broadens the impact and reach of the arts and I am delighted that it is lead sponsor of *Vida Americana*. I am deeply grateful to Citi, Citibanamex, and Delta for their sponsorship of the exhibition as well. Major support was provided by three longtime supporters of the Whitney's programming and I thank each of them: the Barbara Haskell American Fellows

Legacy Fund, the Henry Luce Foundation, and the Terra Foundation for American Art. The generosity of the Mr. and Mrs. Raymond J. Horowitz Foundation for the Arts Inc. and the National Endowment for the Arts must also be acknowledged along with the significant support provided by the Arthur F. and Alice E. Adams Charitable Foundation and the additional support from the Garcia Family Foundation and the Robert Lehman Foundation Inc. Curatorial research and travel were funded by the Steven and Alexandra Cohen Foundation, for which I am most thankful. And I offer my gratitude to the Wyeth Foundation for American Art for its support of this beautiful catalogue. Finally, my deepest appreciation goes to the individual and institutional lenders in the United States, Mexico, and as far away as Japan, who graciously agreed to temporarily part with works of art, many of which are quite fragile, so that they might be seen and enjoyed by audiences in New York and San Antonio. And I extend my heartfelt thanks to the Mexican government, in particular the Secretariat of Culture and the National Institute of Fine Arts and Letters (INBAL), for their support of this exhibition and their assistance with the loans of artworks housed in Mexican collections, public and private.

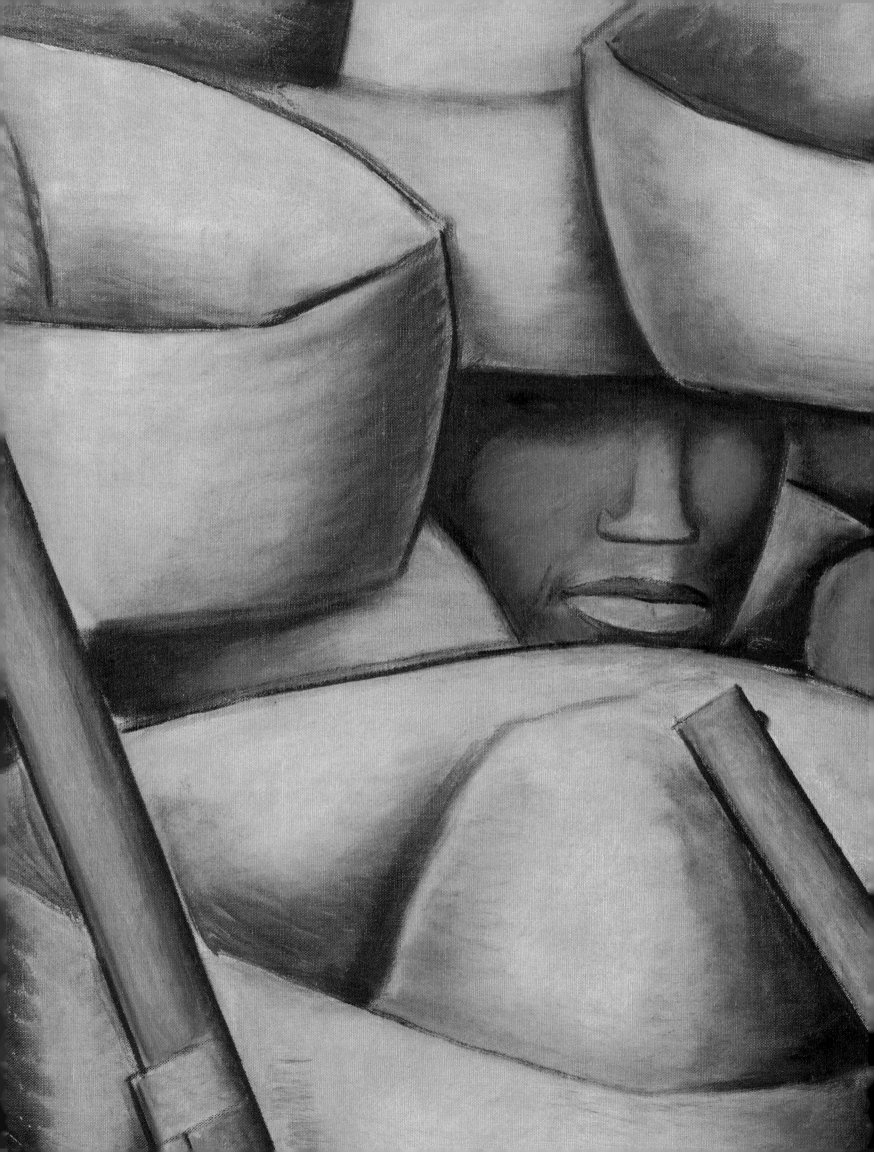

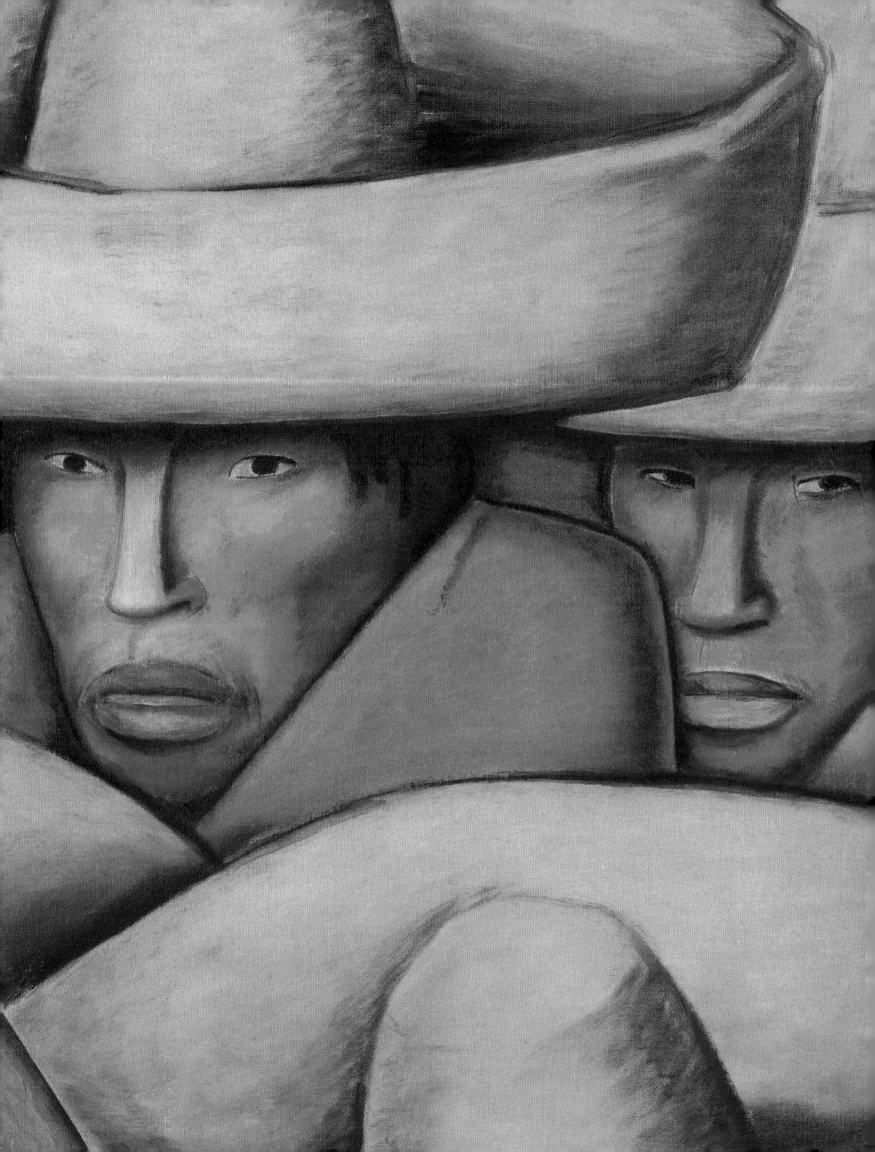

Out of the fragile peace that emerged in 1920 at the end of the Mexican Revolution came a cultural transformation that was hailed as the "greatest Renaissance in the contemporary world."[1] At the center of Mexico's "new efflorescence" were the monumental public murals commissioned by the newly installed government of President Álvaro Obregón that depicted the history and everyday life of the nation's people.[2] By portraying social and political subject matter with a pictorial vocabulary that celebrated the country's pre-Hispanic traditions, the murals invested the age-old technique of fresco painting with a bold new vitality that rivaled the avant-garde trends sweeping through Europe, while at the same time establishing a new relationship between art and the public by telling stories that were relevant to ordinary women and men. Nothing in the United States compared. Enthralled, American visitors to Mexico flooded journals such as *The Nation*, *New Masses*, and *Creative Art* with effusive reports about the murals. "Mexico is on everyone's lips," photographer Edward Weston reported. "Mexico and her artists."[3] Waves of American artists flocked to Mexico to see the murals for themselves and to work with the muralists. But as political tensions flared following the end of Obregón's term in 1924 and mural commissions declined, the muralists turned to the United States for patronage. Between 1927 and 1940, Mexico's three leading muralists—José Clemente Orozco, Diego Rivera, and David Alfaro Siqueiros—came to the United States to execute lithographs and easel paintings, exhibit their art, and create large-scale murals on both the East and West coasts and in Detroit. Their influence would prove decisive for American artists searching for alternatives to European modernism and seeking to connect with a public deeply shaken by the onset of the Great Depression and the economic and social injustices exposed by the collapse of the U.S. stock market. As artist and critic Charmion von Wiegand declared in 1934, Mexican artists were "a more creative influence in American painting than the modernist French masters. . . . They have brought painting back to its vital function in society."[4]

The Mexican Renaissance followed the devastation of the country's ten-year civil war, in which an estimated one in ten Mexicans died and tens of thousands fled, many to the U.S. The series of assassinations, coups, and armed conflicts that had erupted after the 1910 ouster of Porfirio Díaz, the dictator who had ruled the country for thirty-one years, would ultimately yield a new constitution that ratified a sweeping spate of reforms, among them Marxist-oriented policies that sought to reduce the influence of the Catholic Church, empower labor unions, and redistribute the holdings of wealthy

BARBARA HASKELL

AMÉRICA: MEXICAN MURALISM AND ART IN THE UNITED STATES, 1925–1945

landowners. The uneven implementation of these reforms and the conservative backlash they inspired led to an unstable political situation. To achieve unity in a country made up of hundreds of ethnic groups with no common culture and many different languages, officials in the incoming Obregón administration and their allies realized the government needed to construct a shared understanding of Mexican identity and national history, one in which the country's Indigenous peasant population was recast into a bedrock role. "Let the native be the basic unit of the economic and cultural ideal," exhorted anthropologist Manuel Gamio. "Every inhabitant must identify himself in spirit with the peasant if he would call himself a legitimate son of the land."[5] Native crafts were the peasants' art. More importantly, they were the art form seen as least contaminated by foreign modes. To celebrate this "most Mexican aspect of Mexico," the Obregón administration levied a one-time tax on the wealthy to sponsor a 5,000-object *Exhibition of Popular Arts* in connection with the 1921 centennial of Mexico's independence from Spain.[6] To ensure that their selections expressed the essential spirit of the Mexican people, the show's organizers excluded objects that exhibited overt signs of modern or foreign influence. Sensing an opportunity to boost Mexico's image in the U.S., Obregón funded the exhibition's travel to Los Angeles, selecting as the catalogue's author the American writer and occasional Mexican resident Katherine Anne Porter, who described vernacular art as representing the "unbroken record of [the Mexican peasant's] racial soul."[7] The exhibition's two-week run in L.A. was a sensation, fueling the commercial vogue for Mexican curios in the U.S. and codifying the equation between the "real" Mexico and its native population, who seemed from afar to possess a purity, divine gentleness, and innate sense of harmony and beauty that connected with a deeper past rooted in ancient traditions.

This vision of Mexico captured the American imagination as an antidote to the rootlessness and isolation of modern urban and industrial life. Since the turn of the twentieth century, American intellectuals had voiced concern that the country's materialism and its obsession with individual achievement had deprived the average citizen of the sense of "wholeness" that comes from being part of an organic society. The accelerated growth of consumerism and mass-media culture in the 1920s led to extensive public debates about the drawbacks of modern life, as exemplified in Robert and Helen Lynd's widely read 1929 book *Middletown*, the couple's sociological study of the small American city of Muncie, Indiana, whose inhabitants they described as isolated within a community of fraying social ties. American intellectuals in Mexico such as Anita Brenner, Frances Toor, Stuart Chase, and Carleton Beals contrasted this isolation with life in Mexico's rural villages, which they saw through a romantic lens as an Eden populated by people intimately connected to the land who were guided by an uncorrupted innocence and authenticity. Toor did so in *Mexican Folkways*, the bilingual journal she published in Mexico City from 1925 to 1937; Brenner in articles and in her highly influential 1929 book, *Idols behind Altars*; and Chase and Beals in their 1931 bestselling books, *Mexico: A Study of Two Americas* and *Mexican Maze*, respectively. Writing as if "enchanted and convinced by a miracle," as one critic put it, these authors valorized Mexico's small-scale agrarian communities as spiritually superior to the regimentation and alienation of modern urban life.[8] Unlike Americans who live in "compartments of uncorrelated action," the life of the Mexican peasant "is one texture,"

Beals wrote. "The day, for him, is woven into a unity, satisfying in its completeness."[9] The sentiment was echoed by Chase, whose *Study of Two Americas* compared the Lynds' Middletown with the Southern Mexican village of Tepoztlán. Values in Tepoztlán, Chase wrote, are grounded "in innately valuable things. . . . To the village Mexican, life lies clear and sharp beneath his eyes. . . . The future hangs like a great black raven over Middletown. In Tepoztlán the sky is clear. . . . We are cluttered up with things essentially meaningless, and, being human, we flounder, puzzled and perplexed, trying to find the values which will give meaning back to life. Tepoztlán . . . never bothers its head about the meaning of life. It lives."[10] Even as a number of left-wing critics dismissed the work of these authors as a primitivizing, "Mexico-as-noble-savage" school that ignored the brutal realities of peasant life, the popularity of such books spoke to a widespread longing in America for a simpler, more spiritually authentic and connected way of living.[11] Yet whatever veneration for Mexican culture these authors' glowing appraisals inspired, too often it failed to extend to people of Mexican descent living in the United States. Subject to racist hostilities and exploitative labor practices, their situation grew dire during the early years of the Great Depression, when state and local governments across the country, acting upon President Herbert Hoover's call for "American jobs for real Americans," initiated campaigns to send Mexican Americans to Mexico, either through voluntary means or forced deportation. It is estimated that as many as two million people were subject to "repatriation," as the purges were euphemistically called, even though it is thought that well over half were birthright citizens of the U.S.

Meanwhile in Mexico, the idealized image of peasant life was being reinforced by native-born Mexican artists, such as Rivera, Miguel Covarrubias, Frida Kahlo, and Alfredo Ramos Martínez (fig. 1), as well as by foreigners such as Edward Weston, Tina Modotti, Sergei Eisenstein, and Paul Strand (fig. 2). Cognizant of the centrality of the revolution to the myth of the new Mexico, these artists balanced their romanticized portrayals of peasants with visual narratives of the suffering and oppression the population had endured under Spanish rule and the dictatorship of Díaz, and the people's heroic struggle for emancipation. Nowhere was this more true than in the public murals commissioned by the government's Department of Public Education under the leadership of renowned philosopher and writer José Vasconcelos. Many of the artists Vasconcelos hired were Communists who had fought in the revolution and whom Siqueiros, Rivera, and Xavier Guerrero organized in 1922 into a trade union, the Syndicate of Technical Workers, Painters, and Sculptors. The organization's manifesto, authored by Siqueiros, explicitly repudiated "so-called easel painting and every kind of art favored by ultra-intellectual circles, because it is aristocratic, and we praise monumental art in all its forms, because it is public property."[12] It further proclaimed that "at this time of social change from a decrepit order to a new one, the creators of beauty must use their best efforts to produce ideological works of art for the people; art must no longer be the expression of individual satisfaction which it is today, but should aim to become a fighting, educative art for all." Artists from across Mexico and around the world rallied to this cause, but it would be Rivera, Orozco, and Siqueiros who would become the most important figures, and in particular Rivera, whose virtual dominance of commissions by the late 1920s led some contemporary observers to misdiagnose Mexican muralism as a homogenous movement possessed of "one idea, one aesthetics and one objective."[13]

FIG. 1
Alfredo Ramos Martínez, *Women with Fruit*, c. 1930.
Oil on canvas, 36 × 34 in. (91.4 × 86.3 cm).
Private collection

FIG. 2
Paul Strand, *Man, Tenancingo de Degollado*, 1933
(printed later). Platinum print, 6 ½ × 5 ⅛ in.
(16.5 × 13 cm). Center for Creative Photography,
University of Arizona, Tuscon; gift of Ansel and
Virginia Adams

That was not the case, although Rivera's remarkable output between 1923 and 1928 and its dissemination in the press garnered him a reputation in the United States as "Mexico's greatest painter" whose work conveyed "the spirit of Mexico."[14] The artist's epic narratives of Mexican history mythologized the country's peasantry and the revolution. Using high-key color, stylized, volumetric figures, and a modern "montage" aesthetic to depict the trials and heroic triumphs of Mexico's Indigenous people and to celebrate their popular culture, he provided the nation with a vision of itself as a unified country with a shared past, present, and future. Orozco, in contrast, depicted the struggle for liberation as one of tragedy and stifled promise, the monumental, eerie stillness of his revolutionary scenes exuding not hope but resignation and despair. Siqueiros, the youngest of *los tres grandes* (The Three Greats), as the three leading muralists were called, focused primarily on labor organizing during the 1920s rather than on artmaking. Nevertheless, as secretary general of the Syndicate and executive director of its journal, *El Machete*, he played a seminal role during this period in articulating the artistic and political goals of Mexican muralism through his texts and speeches. Once he returned to painting in 1930, he harnessed rough textures, resonant dark tonalities, and sculpturally modeled figures rooted in pre-Hispanic forms to forge a politically and aesthetically revolutionary art.

In 1924, Plutarco Elías Calles succeeded Obregón as Mexico's president. Primarily focused on the country's economy, he eliminated mural commissions for all but Rivera. Orozco was the first of *los tres grandes* to come to the United States in search of patronage. "There was little to hold me in Mexico in 1927 and I resolved to go to New York," he later recalled. "I knew nobody, and I proposed to begin all over."[15] After having first relied on Anita Brenner as his agent, with disappointing results, Orozco turned to Alma Reed, an American journalist who had been engaged to Felipe Carrillo Puerto, the socialist governor of Yucatán, before his murder. When Orozco met her, she was

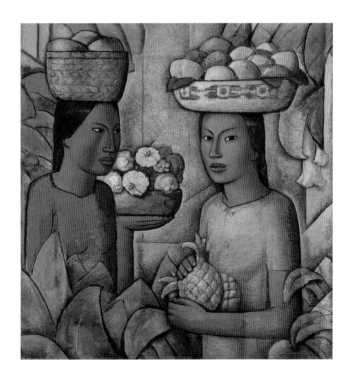

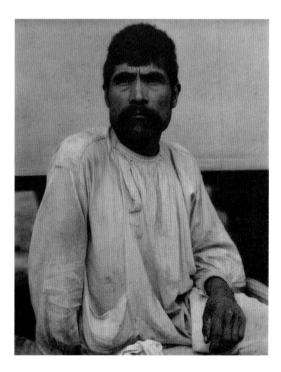

FIG. 3
José Clemente Orozco, *Struggle in the Occident*,
west wall of *A Call for Revolution and Universal
Brotherhood*, 1930–31. Fresco, 6 ft. 6 in. ×
30 ft. 8 ¹¹⁄₁₆ in. (2 × 9.4 m). The New School for
Social Research, New York

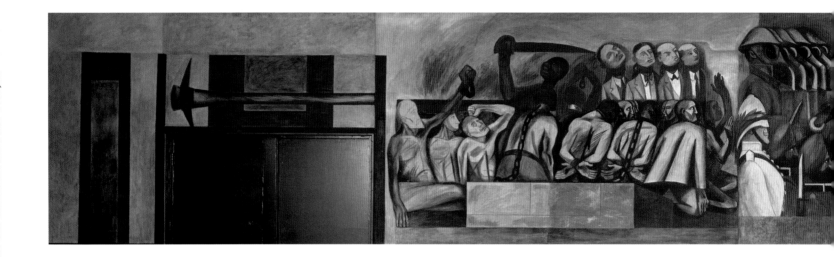

assisting heiress Eva Palmer-Sikelianos to run the Delphic Circle, an "ashram"
Palmer-Sikelianos had established in New York with her husband, the Greek poet Angelos
Sikelianos, to promote peace, harmony, and spiritual regeneration, in part through a
revival of Classical Greek culture. Through Reed, Orozco became an intimate of the
circle, actively engaged in its esoteric discussions on topics spanning Greek mythology,
William Blake, Eastern religion, Friedrich Nietzsche, and Dynamic Symmetry, the
compositional system formulated by Jay Hambidge based on the diagonals of squares.
These discussions would impact the subject matter and structure of Orozco's art, but
of more immediate importance was Reed's impassioned promotion of his career through
gallery exhibitions and mural commissions. The first such commission she arranged was
in 1930 for the newly constructed dining hall at Pomona College in Claremont, California.
Orozco's decision to base the mural's central image on Prometheus, the mythological
Greek Titan who infuriated the gods by giving fire to man, owed to multiple factors,
including the similarity between the myth of Prometheus and that of the ancient
Mesoamerican deity Quetzalcoatl, and the enthusiasm for the Prometheus subject of
Pomona art-history professor Joseph Pijoan, who played a major role in the commission.
No less influential were Palmer-Sikelianos's rehearsals at the ashram of Aeschylus's
Prometheus Bound in preparation for her 1930 staging of the play in Greece. Orozco's
Prometheus (pl. 28), completed in mid-June, enthralled the art world with its marriage of
figurative imagery, fraught content, and expressive brushwork. *Los Angeles Times* critic
Arthur Millier ranked it among "the most significant art outburst[s] of our time," one
that made "the esthetic experiments of modern Paris" seem like "trifling matters" in
comparison.[16] By October, Orozco was a household name, "almost as essential to smart
dinner table conversation as backgammon," as *Time* magazine put it.[17]

 The painter Charles Pollock had come to similar conclusions about Orozco's talent
the year before. Writing in spring 1929 to his seventeen-year-old brother Jackson, he
had declared the work of Orozco and Rivera to be "the finest painting that has been
done . . . since the sixteenth century" and suggested several articles for Jackson to
read, including the January 1929 issue of *Creative Art* devoted entirely to the Mexican
muralists.[18] Jackson had encountered Rivera's work the previous year at Communist
Party meetings he had attended, but he found the *Creative Art* issue so inspiring that

he told his brother he would like to go to Mexico "if there is any means of making a livelihood there."[19] He stayed in Los Angeles, but when Charles returned home to visit in the summer of 1930, the brothers traveled to Pomona College to see *Prometheus*, a reproduction of which Jackson would keep tacked to the wall of his New York studio throughout the 1930s, calling it "the greatest painting done in modern times."[20]

That fall, Pollock moved to New York to enroll in Thomas Hart Benton's class at the Art Students League and soon became an intimate of his teacher's family, who lived a few floors above the apartment Jackson shared with his brother and sister-in-law. Benton himself had developed a deep admiration for Orozco's work after seeing it exhibited at New York's Architectural League in April 1929, and he had arranged for an expanded presentation at the Art Students League a few weeks later that included easel paintings, lithographs, and photographs of Orozco's murals in Mexico City. Benton's respect for the Mexican artist led him to join Delphic Studios, the gallery Alma Reed opened in October 1929 with a two-person show of Benton's and Orozco's art. Reed would maintain a permanent, rotating exhibition of Orozco's work that Pollock would likely have seen, and he undoubtedly witnessed the production of the murals that Orozco and Benton would each paint in the fall of 1930 at the New School for Social Research, since he posed for a number of the figures in Benton's.

Alvin Johnson, the pioneering president of the New School, under whom the institution would become a university-in-exile for intellectuals fleeing Nazi Germany, had hired Joseph Urban to design new quarters for the school on West 12th Street in 1930. Assured by Reed the school need pay only for materials, Johnson commissioned Orozco and Benton to paint what each separately considered "the most powerful living movement of our time."[21] Benton chose industry, labor, and popular culture; Orozco chose revolution and universal fraternity. If the utopian theme seemed at odds with the Mexican artist's otherwise pessimistic nature, the choice paid tribute to his patron and the ideology of the Delphic Circle, as Orozco acknowledged to Reed, telling her, "You are always going to feel very much at home here, Almita. . . . You will be among your friends; it is just another Ashram."[22] *A Call for Revolution and Universal Brotherhood*, as Orozco titled his mural, filled the four walls of the school's dining room and the wall of an exterior lounge with

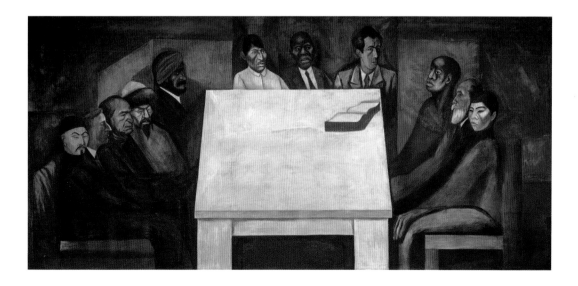

FIG. 5
Diego Rivera, *The Making of a Fresco Showing the Building of a City*, 1931. Fresco, 18 ft. 8 ¾ in. × 32 ft. 6 in. (5.7 × 9.9 m). San Francisco Art Institute (formerly California School of Fine Arts)

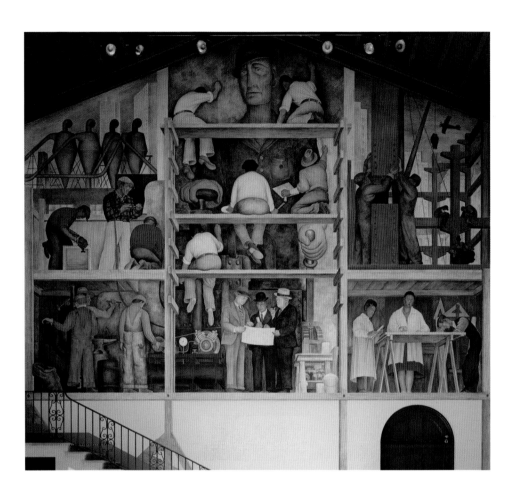

a before-and-after scenario. Two facing walls depicted the revolutionary struggles in Russia, India, and Mexico, as symbolized by Vladimir Lenin, Felipe Carrillo Puerto, and Mahatma Gandhi (fig. 3); the two other walls portrayed an idealized postrevolutionary world of interracial harmony, productive labor, and domestic tranquility (fig. 4). Due perhaps to what Orozco later admitted was an "overrigorous" reliance on Dynamic Symmetry, his mural disappointed most observers, including *New York Times* critic Edward Alden Jewell, who wrote with "genuine regret" at having to negatively appraise it.[23] Nevertheless, large crowds came to see it along with Benton's more successful mural *America Today* (pl. 63). Together, they fueled the nation's growing excitement about public art depicting contemporary issues in a modern vocabulary.

In November 1930, at exactly the moment Orozco was starting work on his New School mural, Rivera arrived in San Francisco. Yet unlike his fellow muralist, Rivera's reputation as "the hero of the entire western world" preceded him.[24] His dominance in press coverage of the Mexican Renaissance had led to solo shows of his work up and down the California coast, including one at San Francisco's Beaux Arts Gallery in 1926 and a 180-work exhibition that opened at the city's Legion of Honor five days after his arrival. Moreover, he had a devoted group of artists—Maxine Albro, Victor Arnautoff, Ray Boynton, Ralph Stackpole, Clifford Wight, and Bernard Zakheim—who had studied with him in Mexico and were ready to assist him on the mural commissions in San Francisco he had already secured. Indeed, Boynton and Stackpole had been instrumental in obtaining two of those commissions by repeatedly assuring patrons of

FIG. 6
Bernard Zakheim, *Library*, 1934. Fresco, 10 × 10 ft.
(3 × 3 m). Coit Tower, San Francisco

the quality of Rivera's art, gifting them examples of it, and in Boynton's case, writing an article in *Mexican Folkways* in which he compared Rivera to Giotto and hailed him as the "prophet of the Mexican renaissance."[25] Their promotion worked. Between November 1930 and August 1931, Rivera made three murals in San Francisco: *Allegory of California* for the staircase leading to the Luncheon Club of the Pacific Stock Exchange (p. 181, fig. 1); *Still Life and Blossoming Almond Trees* for the dining terrace of the Stern family estate in nearby Atherton (p. 182, fig. 2); and *The Making of a Fresco Showing the Building of a City* for the California School of Fine Arts (fig. 5).

In Mexico, Rivera's reputation had been that of a political radical whose murals embodied "the living principle" of the "mighty word . . . REVOLUTION."[26] His scathing denunciations of the brutality of hacienda owners toward the Mexican peasantry and his caricatures of debauched American capitalists were seen as the epitome of revolutionary public art. As Arnautoff later recalled, "Everything that I had learned and achieved in painting before somehow fell into place and took shape under Rivera's guidance. Being with Rivera [in Mexico] confirmed me in the belief that the making of art is not a matter of idle contemplation, it cannot leave the viewer indifferent. Its goal is to move people."[27] Three years after Rivera left San Francisco, each of his assistants would be hired by the Public Works of Art Project, the precursor to the Works Progress Administration under the New Deal, to paint murals in the stairways and lobbies of Coit Tower, the city's memorial to its volunteer firemen. Following Rivera's lead, three of them—Arnautoff, Zakheim, and Wight—would include details in their murals that authorities interpreted as communist propaganda: a figure reaching for Marx's *Das Capital* in Zakheim's *Library* (fig. 6); the left-wing *Masses* and *Daily Worker* on the newsstand in Arnautoff's *City Life*; and a hammer, sickle, and "United Workers of the World" legend in Wight's *Surveyor and Steelworker*. The controversy delayed the tower's opening for four months but ultimately resulted only in the whitewashing of Wight's

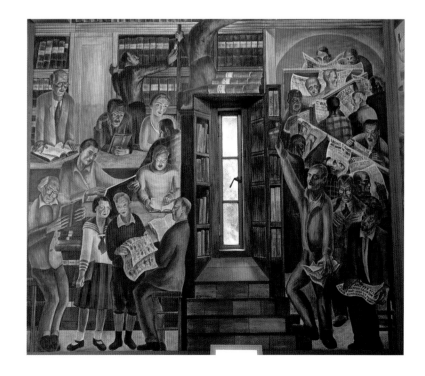

contentious imagery. Paradoxically, Rivera largely avoided overt political commentary in his own San Francisco murals, electing instead to focus on "the immense possibilities" of America's engineering and industrial achievements, which he called "the greatest expressions of the plastic genius of this New World."[28] As if heeding his own admonition to "become aware of the splendid beauty of your factories, admit the charm of your native houses, the lustre of your metals, the clarity of your glass," he harnessed glowing, warm colors and rounded, monumental shapes to celebrate the abundance of California's natural resources and the state's industrial and technological accomplishments.[29]

After San Francisco, Rivera ventured to New York where the Museum of Modern Art was organizing a mid-career retrospective of his work with Frances Flynn Paine as curator. Paine was director of the Rockefeller-funded Mexican Arts Association, an organization dedicated to fostering goodwill between Mexico and the United States through cultural exchange. Abby Rockefeller's involvement in the association owed to her genuine interest in Mexican art, but her support of the organization aligned with the family's efforts to fend off nationalization of their Mexican oil fields through art-diplomacy. Honoring Rivera with a solo exhibition at MoMA, a museum she had helped found, extended this strategy. The artist's 1929 expulsion from the Mexican Communist Party and his work for American capitalists in both Mexico and the U.S. heartened the family. Writing to Rockefeller, Paine assured her that Rivera "still is, sincerely and intensely, for 'the people' but one can now reason with him and from that viewpoint much can be hoped."[30] MoMA's Rivera exhibition—only the second one-person show in the museum's short history (after Henri Matisse's)—opened on December 23, 1931. It broke all attendance records and thrust Rivera into the spotlight as "the most talked-about artist on this side of the Atlantic."[31] In keeping with Paine's predilection for Mexican crafts, her selection of easel paintings privileged Rivera's folkloric images of Mexican peasants (pl. 1). To augment these, Rivera made five portable frescoes in advance of the exhibition that depicted Mexican history and the revolution. As he would do in the lithographs he subsequently made for the Weyhe Gallery, he based them on Tina Modotti's photographs of details of his Mexican murals. Extracting images from their larger narrative context monumentalized them, allowing Rivera to further mythologize the Mexican struggle against oppression and celebrate the heroism of the revolution. After the show opened, the artist went on to paint three additional fresco panels on New York themes, in which his empathy with the working class and disenfranchised commingled with awe at the marvels of industry and the modern metropolis (pl. 62; p. 183, fig. 3).

Rivera's cozy relationship with American capitalists complicated his already fraught affiliation with the Communist Party, whose members saw his American commissions and continuing alliance with the Calles government as a betrayal of the revolution. Perhaps thinking his charm would prevail, on January 1, 1932, he spoke at the John Reed Club in New York, which had been formed two years prior by eight staff members from the Communist-affiliated journal *New Masses* to encourage the creation of art that would be a "weapon in the battle for a new and superior world."[32] The club had taken its name from the founder of the American Communist Party and author of *Ten Days that Shook the World*; by 1931, there were thirty John Reed Clubs in major cities across the country, each organizing exhibitions and hosting lectures. Rivera intended his appearance

before the group to vindicate his San Francisco commissions. But his assertions that he was a "propagandist of communism" who had acted as a "guerilla fighter" in taking commissions from the "enemy" were interrupted by hecklers who denounced him as a "renegade" and "counter-revolutionist" whose work had deteriorated after he abandoned the revolutionary struggle in favor of painting for the moneyed elite.[33] The month following his lecture, a four-page indictment of him appeared in *New Masses* penned by the magazine's editor, Joseph Freeman, under the pseudonym Robert Evans, which closed with the caution that Rivera "must realize that cut off from the revolutionary workers and peasants, he faces corruption as a man and bankruptcy as an artist."[34] Undaunted, Rivera left for Detroit in April to begin a mural commission for the Detroit Institute of Arts funded by Edsel Ford, the son of the founder of the Ford Motor Company.

In mid-April 1932, Siqueiros arrived in Los Angeles.[35] The younger artist's fervent commitment to the Communist Party, which had been outlawed in Mexico in 1925, had landed him in prison followed by a year of internal exile in the town of Taxco, where he met Russian filmmaker Sergei Eisenstein, who was then working on his film *Que Viva México!*. Siqueiros's role in the revolution and his friendship with Eisenstein made him a lionized figure in Los Angeles. As artist Reuben Kadish would later say, "Siqueiros coming to L.A. meant as much then as did the Surrealists coming to New York in the forties."[36] Following well-received shows of Siqueiros's work at Jake Zeitlin's bookshop/art gallery and at Earl Stendahl's gallery at the Ambassador Hotel, he began teaching a course in the history of European and Mexican mural painting at the Chouinard Art Institute; a month later, he received permission to complete the course by having his students assist him in painting a 24-by-19-foot mural on a wall of the school's outdoor sculpture courtyard. By the time he started to paint in mid-June, his class had expanded beyond the initial ten professional artists to include art students who would form the core of what he called the "Bloc of Mural Painters," among them three of Jackson Pollock's high-school friends—Kadish, Harold Lehman, and Philip Guston (then Goldstein)—and Pollock's half-brother, Sande McCoy, as well as Dean Cromwell, Paul Sample, Myer Schaffer, and Luis Arenal, a politically radical Mexican art student living in Los Angeles whose sister Siqueiros would later marry. The challenge of painting outdoors on a wall whose upper portion was visible from fast-moving cars compelled Siqueiros to experiment with new materials and technologies: waterproof cement, airbrushes, spray guns, blowtorches, and photographic projections. The result, *Street Meeting* (p. 189, fig. 1), depicted the twice-life-size figure of an impassioned union organizer in a red shirt haranguing an audience that included an African American man and a white woman, each holding a child, and a racially integrated row of construction workers perched on a scaffold looking down from above. *L.A. Times* critic Arthur Millier proclaimed it "the first wave in the long anticipated fresco movement" in Los Angeles, and eight hundred people attended its unveiling on July 7, where Siqueiros exhorted artists to express the "revolutionary ideology of the proletariat."[37] By the mid-1930s, however, the mural had disappeared, covered with plaster and other building materials after being ravaged by the elements.[38]

F. K. Ferenz, director of the Plaza Art Center on Olvera Street in downtown Los Angeles, had met Siqueiros through the John Reed Club.[39] Sympathetic to Siqueiros's politics, he conceived the idea of having the artist paint an outdoor mural

FIG. 7
David Alfaro Siqueiros, *Portrait of Mexico Today*, 1932.
Fresco on cement, 8 ft. 3 in. × 32 ft. (2.5 × 9.8 m).
Santa Barbara Museum of Art; anonymous gift 2001.50

at the Italian Hall where the center was located. Encompassing the original site where the Pueblo de Los Ángeles was established in 1781, Olvera Street had recently been renovated into a folkloric "Mexican marketplace" through a civic campaign spearheaded by Anglo socialite Christine Sterling, who envisioned life in Los Angeles when California was still part of Mexico as an "almost ideal existence" full of "romance and real happiness."[40] In mid-August, Ferenz convinced Sterling to commission Siqueiros to paint a mural on the theme of "tropical America" on the 82-foot-long wall on the Italian Hall's roof overlooking Olvera Street. Having read about Rivera's Pacific Stock Exchange mural, Sterling apparently expected Siqueiros to paint a picture of a "continent of happy men surrounded by palm trees."[41] Instead, working at night with an amplified "Bloc" of more than thirty artists, Siqueiros fashioned a strident visual condemnation of the exploitation of Mexico's Indigenous people by the country's ruling class and American imperialists: a lone Mexican man crucified on a double cross in front of a crumbling Mayan temple enveloped by a lush, overgrown tropical jungle, the mural's message reinforced by the armed revolutionaries depicted nearby who appear to take aim at the bald eagle perched above the victim's head (pl. 99). As Lorser Feitelson, the prominent Post-Surrealist painter in Los Angeles and early mentor to Guston, Kadish, and Pollock, reported, the "reaction in the art world was wonderful . . . [the mural] had guts in it! It made everything else of the time look like candybox illustrations. Many of the artists said, 'My God! This is a wonderful vocabulary.'"[42] But the contradiction between Siqueiros's indictment in *Tropical America* and the mythic vision of California's Mexican past that Sterling wished to memorialize forced Ferenz to whitewash the portion of the mural that was visible from the street soon after its unveiling on October 9, and to paint over the entire image two years later.

The precariousness of Siqueiros's finances led vanguard film director Dudley Murphy, best known for his 1924 collaboration with Fernand Léger on the film *Ballet Mécanique*, to arrange a private, three-day showing of Siqueiros's art at his Pacific Palisades home. As a thank-you for the ten paintings that sold, Siqueiros painted

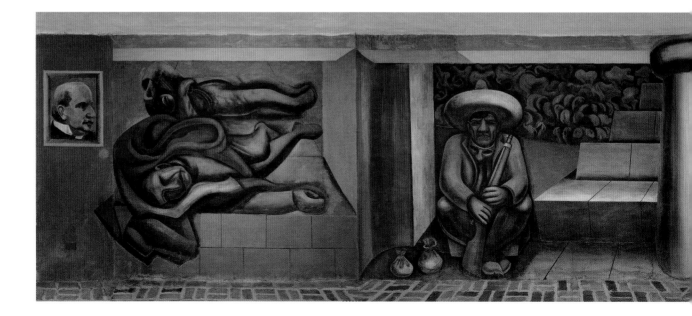

a three-sided mural in the director's outdoor covered patio, assisted by Kadish, Arenal, Guston, and Fletcher Martin, a new recruit to the Bloc of Mural Painters.[43] Entitled *Portrait of Mexico Today* (fig. 7), the mural depicts the period in Mexico after Calles had left office but when he still wielded control through the puppet presidents who succeeded him. Under the so-called *Maximoto*, Calles outlawed the Communist Party, forbade strikes, and curtailed land redistribution. In his mural, Siqueiros took direct aim at the former president's corruption and his alliance with American business interests by presenting him as an unmasked armed bandit with bags of money at his feet and surrounded on one side by impoverished women and a child, and on the other by corpses and a portrait of American financier J. P. Morgan. Only the image of an armed revolutionary soldier on an adjacent wall offered hope of a sort, symbolizing for the artist the "life-restoring battle for a new social order."[44]

Siqueiros was deported in late November after his visa expired, but the example he set of using art to denounce exploitative labor practices, economic imperialism, and what he called the "anti-democratic politics of racial discrimination" continued to resonate in Los Angeles.[45] In February 1933, Hollywood's John Reed Club announced an exhibition in support of the "Scottsboro Boys," the nine African American teenagers falsely accused of raping two white women on a train in Alabama in 1931 and sentenced to death. Using techniques Siqueiros had taught them, Lehman, Kadish, Guston, and Arenal created portable cement murals depicting lynching and other atrocities against African Americans. The night before the show's opening, the Los Angeles police raided the exhibition and destroyed the murals with bullets, lead pipes, and rifle butts. Undeterred, Guston and Kadish continued making politically charged murals. They mailed a photograph of one they had painted for the Workers' Alliance Center containing images of Lenin, Marx, and the *Communist Manifesto*'s opening lines to Siqueiros, who promised to help them obtain a mural commission in Mexico. By July, the two artists, along with their friend Jules Langsner, were in the central Mexican city of Morelia, painting a mural in the two-story patio of the local university's Museo Michoacano,

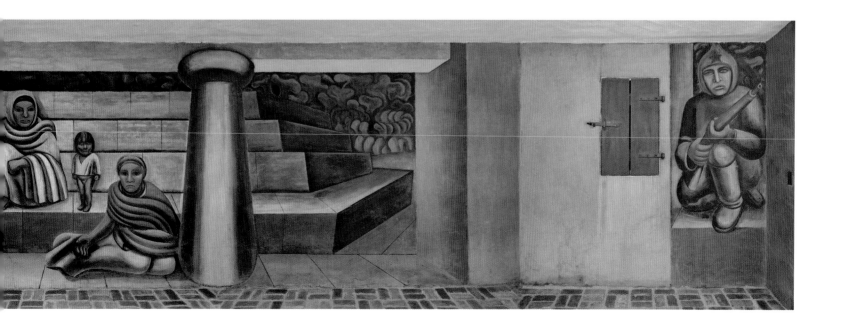

which also contained murals by American painters Marion and Grace Greenwood and Ryah Ludins. Siqueiros remained in touch with Guston and Kadish during their stay, sending them a photograph of the mural he had just completed in Buenos Aires. The Americans paid tribute to their mentor by incorporating that mural's dramatic foreshortening of swirling, monumental figures, evocative juxtapositions, and multiangular perspectives in their own Morelia mural, *The Struggle against Terrorism (The Struggle against War and Fascism)* (pl. 106).

While Siqueiros was in Los Angeles—from April to November 1932—Rivera was busy in Detroit working on a mural cycle in the courtyard of the city's Institute of Arts that would present a largely celebratory vision of modern American industry, one that was unscarred by the Depression, even as the economic crisis had precipitated a hunger strike by more than three thousand Detroiters against the Ford Motor Company the month before the artist's arrival. In his mural, Rivera paid homage to Detroit's pharmaceutical, medical, and chemical industries, but it was the city's ties to Ford that took center stage, particularly the company's production of its new model V8 at its vast River Rouge Plant (pls. 53, 54). Thematically, Rivera designed the mural to highlight the relationship between modern industry and nature, with an additional emphasis on racial integration. Four huge allegorical nudes symbolizing the world's four major races adorned the mural's top sections, below which Rivera depicted the raw minerals used to make automobiles. The artist devoted the courtyard's two main walls to the production of the Ford V8, casting the factory's undulating pipes and rounded machinery forms as counterparts to the fluid rhythms of nature. Dominating the south wall was the factory's huge stamping press, whose image Rivera fused with that of Coatlicue, the Aztec mother-earth goddess of creation and destruction. In the upper corners of the north and west walls, the artist addressed the potential of modern science to either benefit or harm humanity by contrasting images of vaccination, passenger planes, and a dove with those of bombs, poison gas, and a hawk. But in referencing Coatlicue he went further, visually encapsulating in one image technology's power for good and evil. The message was lost on most viewers, who interpreted the mural as a paean to technology's positive role in society. The most significant criticism of *Detroit Industry* arose over Rivera's vaccination scene, whose resemblance to the Holy Family elicited attacks from the local Reverend Ralph Higgins and Catholic priest Charles Coughlin, one of the first religious leaders to use radio to reach a mass audience. The controversy brought hundreds of thousands of people to see the mural in person and encouraged even more to search it out in reproduction. Artists working on government-sponsored murals during the Depression would be profoundly influenced by its subject matter and figure-filled style (fig. 8). For Marvin Beerbohm and William Gropper, working in Detroit on mural commissions for the Works Progress Administration (WPA), the proximity to Rivera's mural would be crucial (pls. 52, 59).

In January 1932, before Rivera had arrived in Detroit, protests erupted after word got out that both he and Spanish artist José Maria Sert had been awarded commissions to paint murals for Rockefeller Center, whose first buildings were scheduled to open the following year. Whereas the opposition Rivera had faced over his San Francisco commissions owed to his Marxist politics, in New York the furor centered on the awarding of such sizeable commissions to two foreigners while American artists struggled

FIG. 8
Philip Evergood, *Steelworkers*, n.d. Gouache and casein
on board, 15¾ × 47½ in. (40 × 120.7 cm). Detroit
Institute of Arts; gift of Mrs. Robert Boram F.63.40

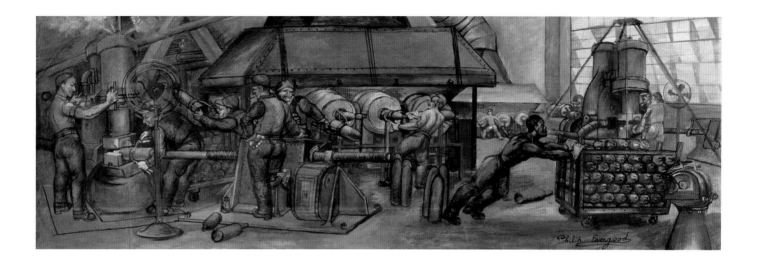

through the Depression. Artist John Sloan, president of the Art Students League, led the charge, publishing a formal letter of protest in the *Brooklyn Eagle*.[46] To ameliorate the hostility, the Junior Advisory Committee of the Museum of Modern Art, chaired by Nelson Rockefeller, announced its sponsorship of an exhibition of mural designs by American artists on the theme "postwar world." Although the show was never billed as an audition for Rockefeller Center, that was how it was perceived—and it was a disaster. Curator Lincoln Kirstein asked each of the sixty-five selected artists to submit one large-scale painting and three small-scale studies and gave only ten weeks to prepare them; the submissions were largely disappointing. When the show opened on May 8, critics excoriated the designs as "incoherent," "inept," and worse, and MoMA President Conger Goodyear demanded that the murals by Gropper, Ben Shahn, and Hugo Gellert be removed because of their alleged communist content (pls. 72, 73). The show's artists, led by Reginald Marsh, rebelled and threatened to withdraw from the exhibition. Faced with a public relations nightmare, the museum allowed the paintings to remain on view. The lesson was not lost on Shahn, who would play a leading role in the controversy the following year over Rivera's Rockefeller Center mural. Mutual professional respect and a shared fluency in French characterized the two artists' relationship. Rivera would write glowingly of Shahn's Sacco and Vanzetti series in 1932 and would author the foreword to Shahn's 1933 Downtown Gallery exhibition devoted to Tom Mooney, the San Francisco labor organizer wrongfully convicted of a bombing attack.[47] For his part, Shahn would be deeply influenced by Rivera's densely packed compositions, detailed rendering of figures, and use of black underpainting (pl. 61).

Despite the MoMA fiasco, the Rockefeller Corporation would ultimately commission more than twenty American artists to create paintings and sculptures to be scattered throughout the center's fourteen-building complex, while reserving its most prestigious commissions—those for the ground floor of the fifty-story RCA building—for Rivera, Sert, and British muralist Frank Brangwyn. Rivera's assignment was to portray "man at the crossroads, uncertain but hopeful for a better future," a theme that accorded with John D. Rockefeller Jr.'s conception of technology as a tool for mankind's material and spiritual emancipation. Rivera's sketch, which the building's architect Raymond Hood approved in January 1933, contained no controversial political imagery (fig. 9). But when

FIG. 9
Diego Rivera, *Study for Man at the Crossroads*, 1932.
Oil on canvas, 5 ft. 9 ⅛ in. × 15 ft. 7 ⅜ in. (1.8 × 4.8 m).
Frida Kahlo and Diego Rivera Archives, Anahuacalli
Museum, Mexico City

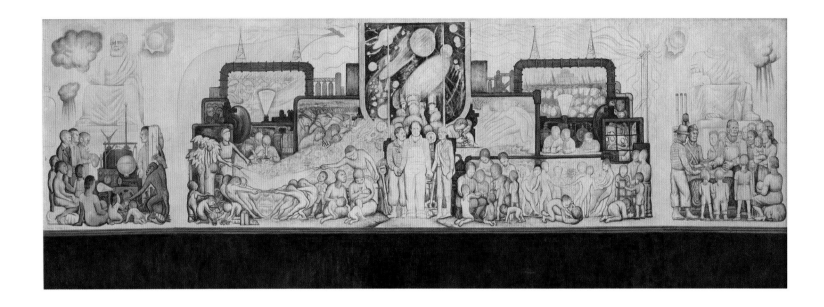

Rivera began to paint two months later, his composition hardened into a dichotomy between a sybaritic, violent capitalist society and a utopic communist one. For the first month, no one objected, including Nelson Rockefeller, who observed the mural's progress almost daily. By late April, however, Rivera was facing backlash on two opposing fronts: a headline on the front page of the conservative *World-Telegram* blared, "Rivera Perpetuates Scenes of Communist Activity for RCA Walls—and Rockefeller Jr. Foots the Bill," which was followed three days later by a vitriolic denunciation in the communist press of the artist's alliances with American capitalists.[48] Stung by the latter, Rivera asked his assistants for a photograph of Vladimir Lenin, whose portrait he painted into his RCA mural joining hands with a soldier, an industrial worker, and a farmer. Attempting to harness the diplomatic skills that would later serve him as four-term governor of New York, Nelson Rockefeller politely asked Rivera to remove the portrait; the artist refused, most likely out of desire for communist approval and fear of Shahn's threat to organize a strike of his assistants if Rivera altered or removed the image. On May 9, the mural was covered. News of its censorship was carried on the front pages of newspapers across the country, and at first it seemed like a replay of the MoMA controversy, as the art groups scheduled to participate in the upcoming Municipal Art Gallery show to be held in the RCA building threatened to withdraw in protest.[49] But less than two weeks later, the artist resistance collapsed. To compound the failure of Rivera's brinksmanship with the Rockefellers, General Motors cancelled its contract for the artist to paint a fresco for the company's pavilion at the 1933 Chicago World's Fair.

Bertram Wolfe had followed the Rivera–Rockefeller controversy closely. A noted writer and future biographer of both Rivera and Leon Trotsky, Wolfe had met the artist in Mexico where he had gone in the early 1920s at the behest of the American Communist Party to bring order to the party's Mexican branch. In 1929, he established what became known as the New Workers School near Union Square as a training center for workers affiliated with the communist splinter group he had formed with Jay Lovestone that year. By 1933 the school had relocated to the third floor of a dilapidated building on East 12th Street. Wolfe offered the low-ceilinged space to Rivera, who used his Rockefeller fee to

FIG. 10
Diego Rivera, *Portrait of America* (detail), 1933.
New Workers School, New York. Photograph by
Lucienne Bloch

paint an epic of American history from the colonial era to the present in twenty-one portable fresco panels (fig. 10). Rivera's assistants on the Rockefeller project—Shahn, Lucienne Bloch, Clifford Wight, Stephen Dimitroff, Seymour Fogel, and Hideo Benjamin Noda—joined him. In keeping with Wolfe's Marxist reading of American history, Rivera emphasized class struggle and the country's violence against African Americans (pls. 95–97). Rather than sketch from life, he worked from books Wolfe brought him that he kept on the scaffold as source material for the mural's mass of portrait heads. While some critics applauded Rivera's *Portrait of America*, others unfavorably likened its congested composition to propaganda posters that viewers needed a guidebook to understand.[50] Rivera finished the project in mid-December 1933 and returned to Mexico.[51] On February 9, 1934, news reached him that his Rockefeller Center mural had been destroyed. In retaliation, he painted a modified version of it, entitled *Man, Controller of the Universe* (pl. 91), in the newly renovated Palace of Fine Arts in Mexico City.

On May 9, 1933—the very day that Rivera's RCA mural was covered—artist George Biddle, a patrician friend of Franklin Delano Roosevelt who had spent time with Rivera in Mexico, wrote to the newly inaugurated thirty-second president of the United States: "The Mexican artists have produced the greatest national school of mural painting since the Italian Renaissance. Diego Rivera tells me that it was only possible because Obregón allowed Mexican artists to work on plumbers' wages in order to express on the walls of the government buildings the social ideals of the Mexican Revolution. The younger artists of America are conscious as they never have been of the social revolution that our country and civilization are going through, and they would be very eager to express these [ideals] in permanent art form if they were given the government's cooperation."[52]

The idea that the government could employ artists in the service of rallying a fractured society around a set of social ideals appealed to Roosevelt, who had come into office promising to steady a nation whose faith in America's foundational ideals had

FIG. 11
Marion Greenwood, *Water and Soil*, 1937. Oil on wood,
18 × 35 in. (45.7 × 88.9 cm). Collection of Susan
Stockton and Chris Walther

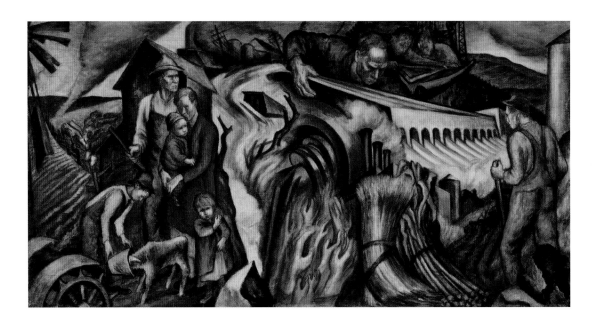

been shattered by the Depression. Roosevelt passed along Biddle's letter to the Treasury Department, which oversaw the construction of public buildings and the purchase of art to decorate them. That December, following Obregón's example, the department launched the short-lived Public Works of Art Project (PWAP) under the directorship of Edward Bruce, an artist then working as a Treasury lawyer. A year later, the Roosevelt administration established the WPA's Federal Art Project (FAP), administered by art historian and museum curator Holger Cahill, and the Treasury's Section of Painting and Sculpture, again under Bruce's leadership. The two men's shared belief in art's social role and their desire to integrate the arts into everyday public life echoed the ideology of the Mexican muralists. Just as Siqueiros had renounced easel painting for private patrons in favor of monumental public art and Orozco had exalted the mural because it could not be "made a matter of private gain" nor "hidden away for the benefit of a certain privileged few," so too did Cahill and Bruce want "to take the snobbery out of art and make it part of the daily food of the average citizen," as Bruce put it.[53] Although the FAP was more pluralistic and permissive than the Section and its scope extended well beyond mural commissions, Cahill concurred with Bruce in rejecting art whose "self-communicated mysteries" were understood only by an elite in favor of an accessible, democratic art that belonged to the masses.[54]

Before the launch of the New Deal art programs, the most vocal proponents of the populist effort to embed art within the fabric of everyday social life were the American Regionalists. Paradoxically, given their aesthetically conservative styles and penchant for a nostalgic national past rooted in Anglo-Saxon heritage, the movement's leading spokesmen championed Mexican muralism. Critic Thomas Craven applauded the muralists as "forerunners of a new art in the modern world [that] will not be devoted to the whims of rich collectors nor to the scholastic attention of specialists, but to the needs of large groups of people who, for a long time, have taken no interest in art because art has taken no interest in them."[55] Likewise Thomas Hart Benton, Regionalism's most famous practitioner, hailed the art of the Mexican muralists as "correspond[ing]

FIG. 12
Eitarō Ishigaki, *American Independence*, 1938,
temporarily tacked up in the Harlem Courthouse,
New York, awaiting approval from the Municipal
Art Commission

perfectly with what I had in mind for art in the United States."[56] To him, their art "was the only great art of our time. . . . The Mexican movement and our Americanist one were the only two in this century which made a genuine effort to wrest art from its privatism and return it to a meaningful place in Western society."[57] Ultimately, the Mexican artists' embrace of Marxism would alienate both men, who would argue that it was "as hopeless to try to make North American art by imitating Mexicans as it was by imitating Frenchmen."[58] But in the early 1930s, they saw Mexican muralism as allied with Regionalism in bringing art back into contact with the public and "put[ting] to shame the combined efforts of the modern Europeans."[59]

With one-third of the American workforce unemployed and droughts devastating Midwest farms, FAP and Section murals needed to assure Americans of their ability to endure and triumph. More than ever before, as novelist John Dos Passos asserted, the country needed to know "what kind of firm ground other men, belonging to generations before us, have found to stand on."[60] Earlier in the century, literary critic Van Wyck Brooks had called upon writers to *invent* a past that would be "usable" for the present.[61] FAP and Section administrators asked their muralists to do precisely that: visualize an equitable and prosperous past—and present—that could provide the nation with a sense of optimism about its future. Not surprisingly, the majority of government-funded murals were uplifting, especially Section murals, which Bruce hoped would make Americans "feel comfortable about America."[62] American artists from across the country and across the political spectrum responded by recasting scenes of everyday life, past and present, as the source of national strength, often rooted in values associated with strong family and community ties. With the Neoclassical styles and allegorical Hellenistic subject-matter of earlier murals considered arcane, American artists turned to the example set by the Mexican muralists (figs. 11, 12). "Through the lessons of our Mexican teachers, we have been made aware of the scope and fullness of the 'soul' of

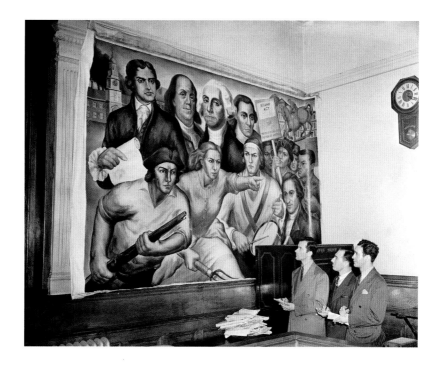

our own environment," Chicago painter Mitchell Siporin declared. "We have been made aware of the application of modernism toward a socially moving epic art of our time and place."[63]

Yet for politically left-leaning artists in the U.S., the federally funded mural commissions offered little opportunity to engage with socialist subject matter as overtly and passionately as had their Mexican counterparts, given the U.S. government approval process, which reflected a suspicion of communism on the part of a large swath of American society. In marked contrast, the Mexican government welcomed Marxist content as a way of bolstering its legitimacy in the face of what many felt was its betrayal of the revolution. For American artists under contract to the Mexican government, the freedom was exhilarating. Paul Strand, for example, made a film under the auspices of the Mexican Department of Education about the struggles of an impoverished fishing community in Veracruz that successfully unionized to combat economic and social injustice. *Redes*, as it was titled in Spanish, aired to great acclaim in Mexico in 1936, followed by a successful showing in the United States under the title *The Wave*. A similar tolerance for socialist subject matter characterized the murals commissioned for Mexico City's vast, newly constructed Abelardo L. Rodríguez market. Rivera was the project's technical director, tasked with advising the artists and approving their final sketches, but the team was assembled and overseen by American-born artist Paul Stevenson, who had settled permanently in Mexico in 1924, joined the Syndicate, and changed his name to Pablo O'Higgins. Of the ten artists who participated in the project, four were American: O'Higgins, Marion and Grace Greenwood, and Isamu Noguchi. Except for the Greenwoods and Noguchi, all were former Rivera assistants. "Emphasize *local* conditions, *actual struggle*, and present-day reality of exploitation, misery, and social retrogression," O'Higgins exhorted. "Get immediate *demands* up on the wall, with as little allegory as possible."[64] The Greenwood sisters obliged, adopting Rivera's montage aesthetic and multiple vanishing points to portray the social and economic injustices suffered by agricultural workers and miners (figs. 13, 14), the artists' Marxist message underscored by the rallying cry Marion painted at the junction of their two murals: "*Trabajadores del mundo, unanse*" ("Workers of the world, unite"). Noguchi's 72-foot-long, carved-brick-and-cement relief *History as Seen from Mexico in 1936* (pl. 77) was equally socialist in intent, contrasting the dark forces of war, fascism, and capitalism on the right with the benefits of science, agriculture, and proletarian cooperation on the left. As Noguchi described it: "There were war, crimes of the church, and 'labor' triumphant. Yet the future looked out brightly in the figure of an Indian boy, observing Einstein's equation for energy."[65] The decidedly political content in these murals was completely absent in FAP and Section murals, which underwent extensive scrutiny to eliminate all suggestion of "un-American," communist, or other controversial imagery. Shahn, for example, saved his Bronx post office mural from being obliterated by swapping out a Walt Whitman poem that local clergymen considered antireligious for an innocuous one, but he was unable to prevent his and Lou Bloch's mural design for New York's Rikers Island from being rejected by the authorities as insufficiently inspirational. A similar fate befell Fletcher Martin's *Mine Rescue*, intended for the post office of the mining community of Kellogg, Idaho. Other murals, like Edward Millman's ten-panel

FIG. 13
Marion Greenwood, *Industrialization of the Countryside* (detail), 1935–36. Fresco. Abelardo L. Rodríguez Market, Mexico City

FIG. 14
Grace Greenwood, *Mining* (detail), 1935–36. Fresco. Abelardo L. Rodríguez Market, Mexico City

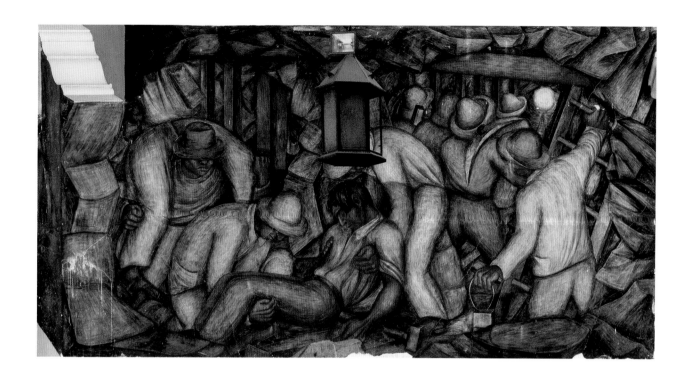

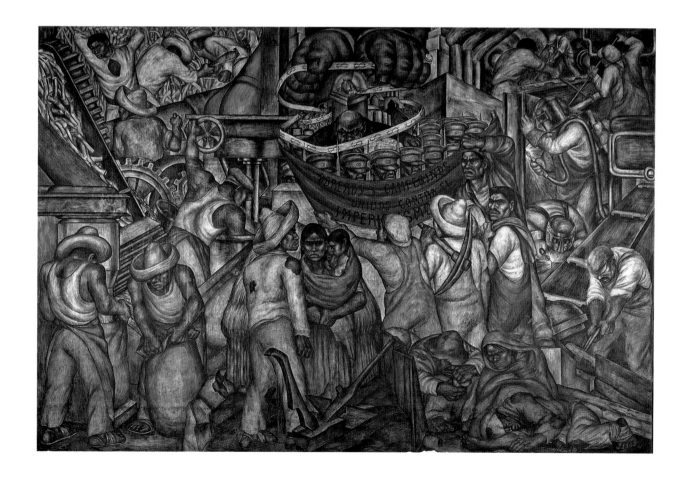

FIG. 15
Charles White, *The Contribution of the Negro to Democracy in America*, 1943. Egg tempera, 11 ft. 9 in. × 17 ft. 3 in. (3.6 × 5.3 m). Hampton University Museum and Archives, Virginia

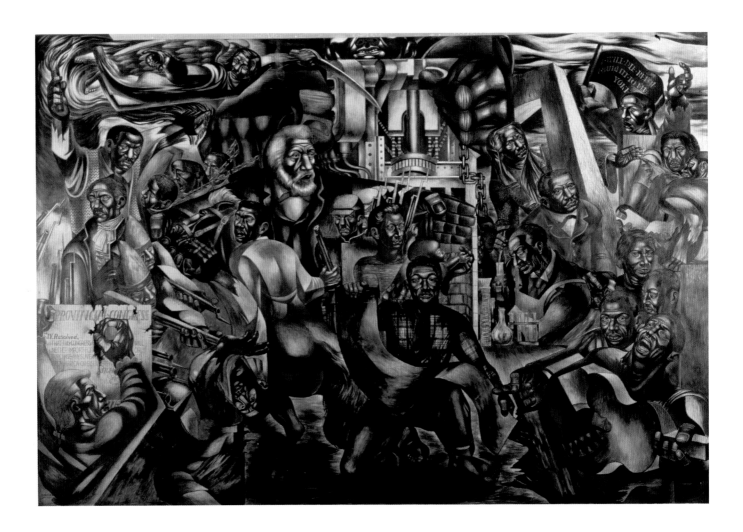

depiction of the struggles of celebrated American women for a Chicago high school, were whitewashed after being completed because of their content.

Outside the sphere of federal sponsorship, however, countless American artists seized upon the Mexican muralists' strategy of infusing their art with social and political content to catalyze change, with *New Masses* and the John Reed Clubs serving as the epicenter of their activities. Following Lenin's admonition that art should be "imbued with the spirit of the class struggle being waged by the proletariat," members of the John Reed Clubs pledged to abandon "the treacherous illusion that art can exist for art's sake, or that the artist can remain remote from the historic conflicts in which all men must take sides."[66] Although the Mexican muralists were not official members of the Reed Clubs, they participated in club-sponsored exhibits, and their work and ideas were extensively covered in *New Masses*. As a result, artists affiliated with these organizations such as William Gropper, Seymour Fogel, Philip Evergood, Jacob Burck, Joe Jones, Anton Refregier, Harry Gottlieb, Eitarō Ishigaki, and Hugo Gellert created lithographs, easel paintings, and murals "under the influence of Orozco, Rivera, and Siqueiros" as Reed Club member Raphael Soyer put it.[67] Even the mainstream press acknowledged the influence. As *Art Digest* noted, "Social protest is one thing American artists did not 'crib' from the French (to a Frenchman art is an escape not a reminder of the defects in his national life). It came up from the south below the Rio Grande."[68]

FIG. 16
Aaron Douglas, *Into Bondage*, 1936. Oil on canvas,
60⅜ × 60½ in. (153.4 × 153.7 cm). National Gallery of
Art, Washington, DC; Corcoran Collection (museum
purchase and partial gift from Thurlow Evans Tibbs, Jr.,
The Evans-Tibbs Collection) 2014.79.17

Capitalist exploitation of labor, police brutality, and racial injustice were among the
issues taken up by American artists during this time, the latter being of particular
importance in the wake of the Scottsboro case and given the persistence of lynching.
In early 1935, New York's John Reed Club and the NAACP each mounted separate
exhibitions aimed at increasing public awareness of lynching in order to generate
support for anti-lynching bills in Congress. When those bills failed to pass, the urgency
of the issue redoubled.

The impact of the Mexican muralists on the work of African American artists
extended far beyond issues surrounding racist violence. Just as Mexican artists had
crafted a redemptive national narrative by using Mexican subjects and themes, so
too did African American artists forge a unique art out of their own racial history of
oppression and resistance and their contributions to national life. "Art must be an
integral part of the struggle," Charles White said, voicing the sentiment of many
likeminded artists. "It can't simply mirror what's taking place. . . . It must ally itself with
the forces of liberation."[69] White's formative introduction to the work of the muralists
occurred in the early 1930s in Chicago through Millman and Siporin, both of whom had
worked with Rivera in Mexico. Although White later claimed that it was not until 1946
and his own encounter in Mexico with artists who were "working to create an art about
and for the people" that he "clarified the direction in which [he] wanted to move," it is
clear that his engagement with Mexican muralism a decade earlier had informed his
goals and techniques, as attested by his *Progress of the American Negro: Five Great
American Negroes* (pl. 51) and *The Contribution of the Negro to Democracy in America*
(fig. 15).[70] White was not alone among African American artists in directly engaging with
the muralists. Hale Woodruff, for example, studied in Mexico with Rivera in 1934, while

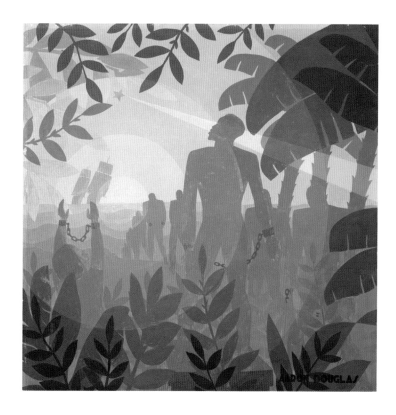

FIG. 17
José Clemente Orozco, *The Epic of American Civilization*
(panels 11–15), 1932–34. Fresco, 10 ft. × 36 ft. 1 in.
(3 × 11 m). Hood Museum of Art, Dartmouth College,
Hanover, New Hampshire; commissioned by the
Trustees of Dartmouth College P.934.13.13–17

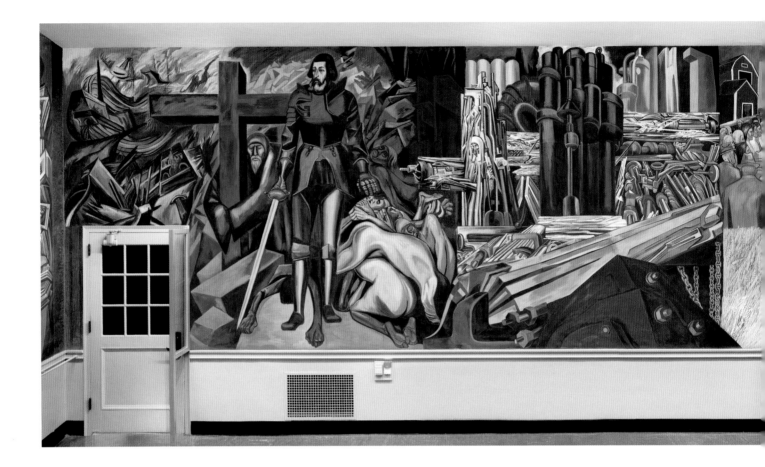

others such as Charles Alston and Aaron Douglas were made aware of the muralists'
art through their work on U.S. mural projects (fig. 16). "Orozco and Rivera were
tremendous influences on all artists, black and white, in this country," Alston later
recalled. "I happened to be on the mural project so I was particularly aware of [them]."[71]
Jacob Lawrence, too young to be on the mural project, encountered the muralists,
particularly Orozco, through Alston and through Thomas Craven's *Men of Art* (1931).
Looking back on his career, he credited Orozco with inspiring his own ambitions and
style, particularly his use of diagonals and architectonic structure.[72]

Of the three Mexican muralists, Orozco was the most resistant to depicting
contemporary events in his art, preferring instead to evoke the timelessness of humanity's
oscillation between ignorance and progress and the pathos of the human condition
as embodied in myth. In his third and most ambitious mural in the U.S., *The Epic of
American Civilization*, created for the reserve reading room of the Baker Library at
Dartmouth College between May 1932 and February 1934, he returned to the theme
of the archetypal hero-martyr who sacrifices himself for the sake of humankind's
enlightenment and liberation. Orozco divided the mural into two chronological sequences:
the first depicts the pre-Columbian world from the ancient migration of Indigenous
people through the Aztec ritual of human sacrifice to the arrival of the enlightenment-
giving deity Quetzalcoatl and his subsequent rejection by humanity; the second
shows the arrival of Cortés and a nightmarish vision of the post-Hispanic culture of
mechanization, social conformity, capitalist greed, militarism, and sterile academic

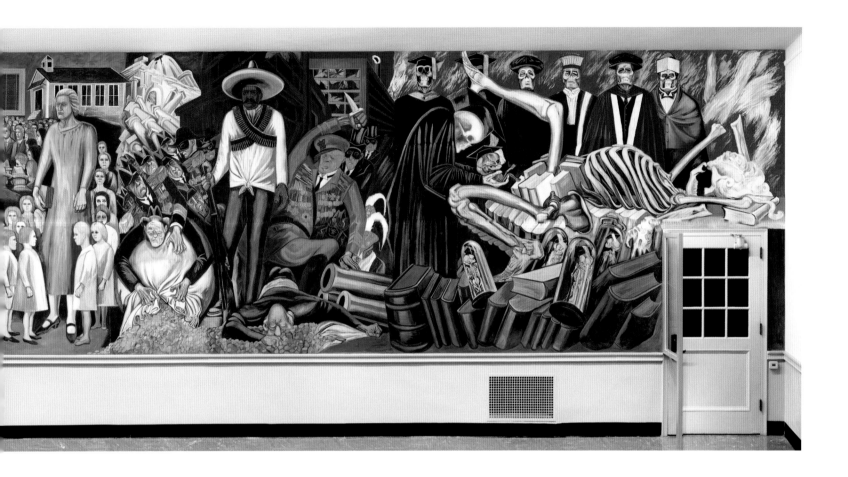

learning (fig. 17). What should have been Orozco's triumph when the mural was unveiled on February 13, 1934, was eclipsed by the destruction of Rivera's Rockefeller Center mural just a few days prior. But as word of Orozco's mural spread, countless artists trekked to Dartmouth to witness firsthand its volcanic energy and iconography of anguish and upheaval. Pollock made the trip in the summer of 1936 with his half-brother Sande McCoy and Guston and Kadish, who had relocated to New York late the year before. What Guatemalan art critic Luis Cardoza y Aragón called "the desolate bitterness of Orozco, absent of hope, born from the collision between longing and reality" struck a chord with Pollock.[73] Shortly after seeing the mural, he began to channel Orozco's expressionist, visceral brushstrokes, intense earth tones, and tormented, dismembered figures into a personal vocabulary of "carnal excess" and psychic trauma (fig. 18).[74]

Orozco's work influenced Pollock at the same time the American artist began his most personal engagement with Siqueiros, who had come to New York in mid-February 1936 with Orozco and other fellow Mexican artists as part of the country's delegation to the three-day American Artists' Congress, formed the previous year to fight war and fascism and to lobby for artists' rights and economic security. Four years earlier, Pollock had seen Siqueiros's *Street Meeting* mural on a summer visit to Los Angeles and had been unimpressed. "Orozco is the *real* artist and his Prometheus is really the thing to look at," he had told Kadish.[75] But when Siqueiros opened his Experimental Workshop on West 14th Street soon after the congress ended, Pollock was among the initial group

FIG. 18
Jackson Pollock, *Untitled (Figure Composition)*,
1938–41. Gouache on paper, 22 ¾ × 17 ¾ in.
(57.8 × 45.1 cm). The Metropolitan Museum of Art,
New York; gift of Lee Krasner Pollock, 1982

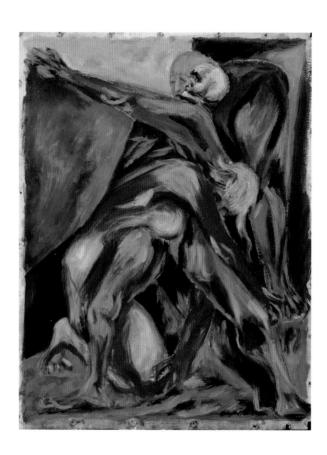

of artists who joined, along with McCoy and Harold Lehman (fig. 19). In keeping with Siqueiros's belief that the "fundamental problem of revolutionary art is a technical problem," the workshop's purpose was twofold: to create temporary artworks for political events and to serve as a laboratory for experimentation with modern industrial materials and techniques (fig. 20).[76] Pollock worked on the workshop's first collective project: a monumental polychromed float for the 1936 May Day parade that featured a prone figure symbolizing Wall Street being smashed by an enormous mechanical hammer decorated with the communist hammer and sickle. But what most engaged his attention were the experimental easel paintings Siqueiros made at the workshop. Alex Horn, a fellow workshop member, described the exhilaration that the Mexican artist's presence inspired: "Spurred on by Siqueiros, whose energy and torrential flow of ideas and new projects stimulated us all to a high pitch of activity, everything became material for our investigation. . . . We sprayed through stencils and friskets, embedded wood, metal, sand and paper. We used [lacquer] in thin glazes or built it up into thick globs. We poured it, dripped it, splattered it, hurled it at the picture surface."[77] Perhaps out of what Harold Bloom called the "anxiety of influence," Pollock would later fail to mention his time at the workshop. But he was a sufficiently valuable member that when Siqueiros left New York in December to join the Republican Army in the Spanish Civil War, it was only Pollock and two others—Lehman and McCoy—to whom he wrote to say goodbye. Not until 1947, when Pollock began to drip and pour paint from sticks and hardened brushes onto canvas tacked to the floor of his studio would he begin to process his experiences at the Experimental Workshop. Even then, he treated the flinging of

FIG. 19
George Cox, David Alfaro Siqueiros, and Jackson
Pollock in New York, 1936. Jackson Pollock and Lee
Krasner papers, circa 1905–1984. Archives of American
Art, Smithsonian Institution, Washington, DC

paint as a means to create an allover network of lines rather than as the genesis of a
figurative image as Siqueiros had done. But as Charles Pollock noted, his brother's
participation in the workshop was "a key experience in Jackson's development . . . the
violation of accepted craft procedures, certain felicities of accidental effect, scale,
must have stuck in his mind to be recalled later, if even unconsciously, in evolving his
mature painting style."[78]

Meanwhile, the disenchantment with Rivera that had erupted in 1932 grew. In May
1934, Siqueiros had published a scathing critique in *New Masses*, "Rivera's Counter-
Revolutionary Road," in which he vilified his compatriot as a "demagogue," "mental
tourist," "opportunist," and "saboteur."[79] Other critics such as Stephen Alexander and
Mary Randolph piled on, accusing Rivera of being a "cheaply opportunistic business
man," a "prostitute," and the "Morgan of the Mexican art market" who had exploited his
popularity for personal aggrandizement and remuneration.[80] Appraisals of Siqueiros's
and Orozco's work, meanwhile, were glowing. By the time the Museum of Modern Art
opened its *20 Centuries of Mexican Art* exhibition in May 1940, the primacy of Siqueiros
and Orozco over Rivera had extended well beyond the far-left press. Rivera, once
considered the "high priest of Mexican muralism," was widely considered the show's
biggest disappointment.[81] Critics bashed his inclusions as "astonishingly bad," "sugary,"
and among "the most ghastly surrealist conceptions ever shown in New York."[82] Orozco
and Siqueiros, in contrast, received high praise, and when the museum decided to
represent muralism in the exhibition more fully than documentary photographs would
allow, it commissioned Orozco rather than Rivera to create a mural on site. Owing to
logistical issues at the museum, Orozco did not begin painting until the middle of June,
almost two months after the show opened. Working in a cordoned-off section of the
museum's lobby, he created a six-part portable mural, which MoMA Director Alfred Barr
titled *Dive Bomber and Tank* (pl. 37). With British and other Allied forces having been
evacuated from Dunkirk only a few days before Orozco started painting, the mural's
subject matter seemed particularly timely, especially for Orozco. Through an almost

FIG. 20
Siqueiros and members of his Experimental Workshop in front of portraits of Earl Browder and James Ford, Communist Party candidates for president and vice president, in New York, 1936. Archivo El Centro Nacional de Investigación, Documentación e Información de Artes Plásticas (CENIDIAP), INBA, Mexico City

abstracted depiction of tank treads, chains, an airplane section, and bomb-like projectile, Orozco addressed what he called the "subjugation of man by the machines of modern warfare."[83] Many people including numerous artists, among them Guston, Lawrence, Pollock, Refregier, and Zakheim, came to the museum to watch Orozco paint (fig. 21). The mural's convulsive vocabulary and generalized evocation of existential crisis mesmerized them. "Form, color, and still it had a narrative," Lawrence later said.[84] Even Shahn, Rivera's former assistant, admitted that his mentor's work seemed utopic and simplistic in comparison. "The great one [is] Orozco," he confided to his wife.[85]

Orozco completed *Dive Bomber and Tank* in July 1940, just as Rivera arrived in San Francisco to paint his last American mural. The occasion was the Art in Action program, created in the second year of the Golden Gate International Exposition on Treasure Island to attract visitors by having artists paint works in the Fine Arts Palace while the public watched. Rivera, who had become alarmed by what he felt was the penetration into Mexico and the U.S. by Nazi and Stalinist agents, choose as his theme "pan-American unity," which he saw as a bulwark against the takeover of the continent by totalitarian forces. His talk of "Nazi bombings in Detroit to stop airplane motor production" and of the need to "hunt and liquidate" Nazis and Stalinists alike might have been hyperbolic and paranoid, but his disillusionment with communism was shared by an increasing number of American artists following the Moscow show trials of 1936–38 and the Soviet Union's signing of a nonaggression pact with Germany in August 1939.[86] A few months before Rivera arrived in San Francisco, more than thirty members of the American Artists' Congress had resigned from the organization over its refusal to condemn the Soviet Union's invasion of Finland. It was in this context that Rivera depicted the cultures of Mexico and the United States as constituting a common America. In the center of his 74-foot-long mural, he portrayed the god Quetzalcoatl as a towering machine, surrounded by scenes of Indigenous Mexico and

FIG. 21
José Clemente Orozco (far right) and onlookers
observing progress on his *Dive Bomber and Tank* at the
Museum of Modern Art, New York, 1940

industrial America (fig. 22). Although the mural received a lukewarm response from critics when it was unveiled on December 1, one of whom judged its accumulation of details a "formless jumble of episode and gadget" lacking the drama of a cohesive whole, it was enthusiastically embraced by the public, attracting more than a hundred thousand visitors.[87]

—

Overriding conflict dominated the subsequent decades: the Allied versus the Axis powers during World War II, followed by the Cold War standoff between the United States and Soviet Union. An either-or dichotomy crystallized across the geopolitical map, pitting Soviet totalitarianism against Western ideas of freedom and democracy— ideas that became increasingly entwined with a veneration of capitalism and individual self-determination. By the 1950s, exhausted after nearly two decades of privation and war, mainstream American society was embracing bland normalcy and unabashed materialism. No wonder, then, that the Mexican muralists fell out of favor in the U.S., considering their works' complex engagement with the American capitalist system— at once celebrating its ingenuity and industry while critiquing its social and economic injustices. The postwar equation between heroic nationalist subject matter and Socialist Realism, endorsed by both the Nazi and the Soviet regimes, further eroded recognition of the muralists' art, whose monumental figurative imagery seemed too reminiscent of fascist and Soviet models. With abstraction and nonobjective art

FIG. 22
Diego Rivera, *Pan American Unity*, 1940.
Fresco, 22 × 74 ft. (6.7 × 22.6 m). City College of
San Francisco

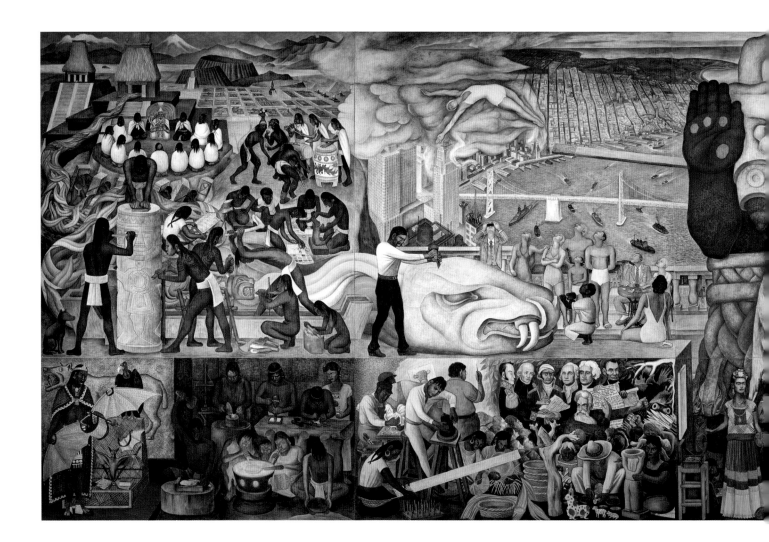

heralded as the pictorial counterpart to internationalism and seen as synonymous
with the commitment to individual freedom at the heart of American identity, the
influence of the Mexican muralists was all but written out of American art history.

By the time the Soviet Union collapsed and the Cold War came to an end, the
hegemony of abstract art was already being contested, as artists began to reintroduce
figurative imagery and narrative back into their work. Politically, the discrediting of
communism ushered in an era of triumphant capitalism that has left the U.S. and
much of the rest of the world grappling with the cultural destabilizations wrought by
rising inequality and the effects of racial and economic injustice—issues that bear
an uncanny resemblance to those taken up by *los tres grandes* and the American
artists who looked to them for inspiration. Faced with the disparities between lived
reality and America's professed ideals of inclusion and equity, countless artists
have begun embracing the social role of art and using aesthetic means to speak out
against all manner of injustice. In such a climate, the Mexican muralists have once
again emerged as models of how to marry aesthetic rigor and vitality to socially
conscious subject matter that addresses the most fundamental questions concerning
our collective pursuit of a more just and equitable society. Notwithstanding the
rich cultural ties and decades of migration that have long existed between the

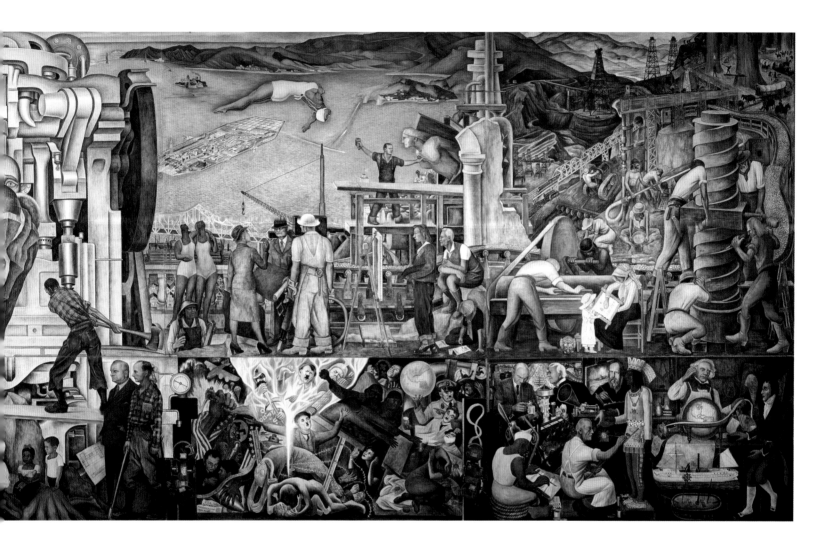

United States and Mexico, the relationship between the two countries has always been fraught, marked as much by mutual wariness and bouts of hostility as by a spirit of camaraderie and cooperation. Yet the ugliness and xenophobia of the recent debates on the American side echoes the worst of the past. It thus seems more imperative than ever to acknowledge the profound and enduring influence Mexican muralism has had on artmaking in the United States and to highlight the beauty and power that can emerge from the free and vibrant cultural exchange between the two countries. As much as did American artists decades ago, artists in the United States today stand to benefit from an awareness of how dynamically and inventively the Mexican muralists used their art to project the ideals of compassion, justice, and solidarity. They remain a source of powerful inspiration for their seamless synthesis of ethics, art, and action.

NOTES

I wish to thank Leon Botstein for his insights on this essay in its early stages, and more importantly the many scholars listed in the acknowledgments upon whose research this essay drew.

1. Frank Tannenbaum, "Mexico–A Promise," *The Survey* "Graphic Number" 52, no. 3 (May 1, 1924): 132.

2. Ernest Gruening, *Mexico and Its Heritage* (New York: Century Co., 1928), 635.

3. Edward Weston, *The Daybooks of Edward Weston*, ed. Nancy Newhall (New York: Aperture, 1973), 2:244.

4. Charmion von Wiegand, "Mural Painting in America," *Yale Review* 23, no. 4 (June 1934): 790–91, 799.

5. Manuel Gamio, paraphrased in Anita Brenner, *Idols behind Altars* (New York: Harcourt, Brace & Co., 1929), 230.

6. Gerardo Murillo ("Dr. Atl"), paraphrased in Rick A. López, *Crafting Mexico: Intellectuals, Artisans, and the State after the Revolution* (Durham, NC: Duke University Press, 2010), 88.

7. Katherine Anne Porter, *Outline of Mexican Arts and Crafts* (Los Angeles: Young & McCallister, 1922), 4.

8. Katherine Anne Porter, "Old Gods and New Messiahs," *New York Herald Tribune*, September 29, 1929.

9. Carleton Beals, *Mexican Maze* (New York: Book League of America, 1931), 117.

10. Stuart Chase, *Mexico: A Study of Two Americas* (New York: Macmillan, 1931), 221–24.

11. John A. Britton, *Revolution and Ideology: Images of the Mexican Revolution in the United States* (Lexington: University Press of Kentucky, 1995), 120. Britton's phrase was specifically directed toward Joseph Freeman's "The Well-Paid Art of Lying," *New Masses* 7, no. 5 (October 1931): 10–11.

12. The 1922 manifesto is published in English in David Alfaro Siqueiros, *Art and Revolution*, trans. Sylvia Calles (London: Lawrence and Wishart, 1975), 24–25.

13. Octavio Paz, quoted in Rita Eder, "Against the Laocoon: Orozco and History Painting," in *José Clemente Orozco in the United States, 1927–1934*, ed. Renato González Mello and Diane Miliotes (Hanover, NH: Hood Museum of Art, 2002), 230.

14. Bertram D. Wolfe, "Art and Revolution in Mexico," *The Nation* 119, no. 3086 (August 27, 1924): 207; Gruening, *Mexico and Its Heritage*, 640.

15. José Clemente Orozco, *An Autobiography*, trans. Robert C. Stephenson (Austin: University of Texas Press, 1962), 123.

16. Arthur Millier, "Prometheus Reconceived," *Los Angeles Times*, June 1, 1930.

17. "Wall Man," *Time* 16, no. 15 (October 13, 1930): 34.

18. Charles Pollock, quoted in Terence Maloon, *The Art of Charles Pollock: Sweet Reason* (Muncie, IN: Ball State University Museum of Art, 2002), 204.

19. Jackson Pollock, quoted in Robert Storr, "A Piece of the Action," in *Jackson Pollock: New Approaches*, ed. Kirk Varnedoe and Pepe Karmel (New York: The Museum of Modern Art, 1999), 43.

20. Artist Peter Busa recalled Pollock describing the mural as such; see Steven Naifeh and Gregory White Smith, *Jackson Pollock: An American Saga* (New York: Clarkson N. Potter, 1989), 298. Tony Smith shared a similar recollection; see "Tony Smith Interview," circa 1965, transcript, Jackson Pollock and Lee Krasner Papers, Archives of American Art, Smithsonian Institution, Washington, DC.

21. Alvin Johnson, *Pioneer's Progress: An Autobiography* [1952] (Lincoln: University of Nebraska Press, 1960), 328.

22. José Clemente Orozco, quoted in Alma Reed, *Orozco* (New York: Oxford University Press, 1956), 208.

23. Orozco, *An Autobiography*, 149. Edward Alden Jewell, "The Frescoes by Orozco," *New York Times*, January 25, 1931. A week later, Jewell was still distraught, confessing that "seldom, perhaps, does honesty encounter more deeply felt reluctance on the part of a reviewer than that experienced in preparing comment on the Orozco murals"; see Jewell, "About Orozco's New Frescoes," *New York Times*, February 1, 1931.

24. Henry McBride, "The Palette Knife," *Creative Art* 8, no. 5 (May 1931): 323.

25. Ray Boynton, "Rivera," *Mexican Folkways* 2, no. 3 (August–September 1926): 28.

26. Porter Myron Chaffee, "Diego Rivera," *New Masses* 5, no. 3 (August 1929): 16.

27. Victor Arnautoff, quoted in Anthony W. Lee, "Workers and Painters: Social Realism and Race in Diego Rivera's Detroit Murals," in *The Social and the Real: Political Art of the 1930s in the Western Hemisphere*, ed. Alejandro Anreus, Diana L. Linden, and Jonathan Weinberg (University Park: Penn State University Press, 2006), 201–2.

28. Diego Rivera, quoted in Bertram D. Wolfe, *The Fabulous Life of Diego Rivera* (New York: Stein and Day, 1963), 277, 296.

29. Diego Rivera, quoted in Laurance P. Hurlburt, *The Mexican Muralists in the United States* (Albuquerque: University of New Mexico Press, 1989), 122.

30. Frances Flynn Paine, quoted in Bernice Kert, *Abby Aldrich Rockefeller: The Woman in the Family* (New York: Random House, 1993), 348.

31. Henry McBride, "Diego Rivera's Mexican Murals Create a Stir at the Museum of Modern Art: An Artist Who Links Life to Life and Comments on Its Events," *New York Sun*, December 26, 1931.

32. "Draft Manifesto of John Reed Clubs," *New Masses* 7, no. 12 (June 1932): 4.

33. Diego Rivera, "The Revolutionary Spirit in Modern Art," *Modern Quarterly* 6, no. 3 (Fall 1932): 56–57; "Diego Rivera and the John Reed Club," *New Masses* 7, no. 9 (February 1932): 31.

34. Robert Evans [Joseph Freeman], "Painting and Politics: The Case of Diego Rivera," *New Masses* 7, no. 9 (February 1932): 25.

35. What or who, exactly, precipitated Siqueiros's Los Angeles sojourn has been a source of confusion among scholars, as has the origin of the invitation for the artist to teach at the Chouinard Art Institute. The date of Siqueiros's arrival has also been disputed, although contemporaneous newspaper accounts have him arriving mid-April. See, for example, "Notas Locales: Llegada de un Pintor Mexicano," *Los Angeles Times*, Spanish-language edition, April 13, 1932: 18.

36. Reuben Kadish, quoted in Bernard Harper Friedman, *Jackson Pollock: Energy Made Visible* (New York: McGraw-Hill, 1972), 11.

37. Arthur Millier, "'Guns' Turn Patio Wall into Fresco," *Los Angeles Times*, July 3, 1932. Siqueiros drew his speech from one he had delivered on February 18, 1932, at the Casino Español in Mexico City; see David Alfaro Siqueiros, "Rectificaciones Sobre Las Artes Plásticas En México," in *Documentación Sobre El Arte Mexicano* (Mexico City: Fondo de Cultura Económica, 1974), 51. Trans. from the Spanish by Maya Ortiz: "la ideología revolucionaria del proletariado."

38. Though Siqueiros later claimed that the mural was destroyed in an act of censorship, most scholars agree that it was only covered after being effectively destroyed by the elements. See Olivier Debroise, "Action Art: David Alfaro Siqueiros and the Artistic and Ideological Strategies of the 1930s," in *Portrait of a Decade: David Alfaro Siqueiros, 1930–1940* (Mexico City: Instituto Nacional de Bellas Artes, 1997), 46. The topic is also discussed in Al Boime, "Breaking Open the Wall: The Morelia Mural of Guston, Kadish and Langsner," *Burlington Magazine* 150, no. 1264 (July 2008): 458; Shifra M. Goldman, "Siqueiros and Three Early Murals in Los Angeles," *Art Journal* 33, no. 4 (Summer 1974): 323; Hurlburt, *Mexican Muralists in the United States*, 207, 284n35; and Sarah Schrank, "Public Art at the Global Crossroads: The Politics of Place in 1930s Los Angeles," *Journal of Social History* 44, no. 2 (Winter 2010): 441.

39. For Ferenz being a member of the John Reed Club during this period, see Irene Herner, "What Art Could Be: A Revolutionary's Struggle, from Pistol to Palette," *Convergence*, Fall 2010: 21. Ferenz's later membership in the German American Bund and his distribution of Nazi propaganda have led some commentators to overlook his earlier leftist politics.

40. Christine Sterling, quoted in Alvaro Parra, "Olvera Street: The Fabrication of L.A.'s Mexican Heritage," KCET, September 13, 2013: https://www.kcet.org/history-society/olvera-street-the-fabrication-of-las-mexican-heritage.

41. David Alfaro Siqueiros, quoted in Hurlburt, *Mexican Muralists in the United States*, 210.

42. Lorser Feitelson, quoted in Goldman, "Siqueiros and Three Early Murals in Los Angeles," 325.

43. Although conflicting information exists about the origins of this commission, the most likely explanation comes from Irene Herner and Laurance P. Hurlburt, who argue that Siqueiros painted the mural as a show of gratitude for Murphy's hosting of the private exhibition in his home. See Herner, "What Art Could Be," 20; and Hurlburt, *Mexican Muralists in the United States*, 213–14, 285n49.

44. Siqueiros, quoted in Hurlburt, *Mexican Muralists in the United States*, 211.

45. Ibid., 207.

46. John Sloan, "Radio City Murals," *Brooklyn Eagle*, February 7, 1932.

47. Diego Rivera, "The Revolutionary Spirit in Modern Art," *Modern Quarterly* 6, no. 3 (Fall 1932): 56.

48. For communist press denunciation of Rivera, see Kert, *Abby Aldrich Rockefeller*, 360.

49. The two major groups that threatened to withdraw from the exhibition were the American Society of Painters, Sculptors, and Gravers and the Society of Independent Artists.

50. Edward Alden Jewell wrote, "One of the saddest of the season's spectacles has been Diego Rivera's apparent collapse as a mural painter . . . it is very sad." See Jewell, "Art Show Theme Is Social Unrest," *New York Times*, December 16, 1933.

51. In 1941, Wolfe and Lovestone's Communist splinter group dissolved and Rivera's New Workers School mural became the property of the International Ladies Garment Workers Union, which installed thirteen of the panels the following year in its rural Pennsylvania summer retreat, Unity House, storing the remaining eight panels whose depiction of more recent history seemed inappropriate for a nation at war. In 1969, a fire at Unity House destroyed the thirteen panels installed there. The eight remaining panels are dispersed among museums, organizations, and private collections. Three of those panels appear in this volume as plates 95–97.

52. George Biddle to Franklin Delano Roosevelt, May 9, 1933. Franklin D. Roosevelt Papers, Franklin D. Roosevelt Library, Hyde Park, NY.

53. José Clemente Orozco, "New World, New Races, and New Art," *Creative Art* 4, no. 1 (January 1929): xlvi. Edward Bruce, quoted in Andrew Hemingway, *Artists on the Left: American Artists and the Communist Movement 1926–1956* (New Haven, CT: Yale University Press, 2002), 81.

54. Holger Cahill, *New Horizons in American Art* (New York: The Museum of Modern Art, 1936), 14.

55. Thomas Craven, *Modern Art: The Men, the Movements, the Meaning* (New York: Simon and Schuster, 1934), 364.

56. Thomas Hart Benton, *An American in Art: A Professional and Technical Autobiography* (Lawrence: University Press of Kansas, 1969), 61.

57. Thomas Hart Benton, "American Regionalism: A Personal History of the Movement," *The University of Kansas City Review* 18, no. 1 (Autumn 1951): 73.

58. Ibid., 59.

59. Thomas Craven, *Men of Art* [1931] (Garden City, NY: Halcyon House, 1950), 511.

60. John Dos Passos, *The Ground We Stand On* (New York: Harcourt, Brace, 1941), 3.

61. Van Wyck Brooks, "On Creating a Usable Past," *The Dial*, April 11, 1918: 337–41.

62. Edward Bruce, quoted in Richard D. McKinzie, *The New Deal for Artists* (Princeton, NJ: Princeton University Press, 1973), 57.

63. Mitchell Siporin, "Mural Art and the Midwestern Myth," in *Art for the Millions: Essays from the 1930s by Artists and Administrators of the WPA Federal Art Project*, ed. Francis V. O'Connor (Boston: New York Graphic Society, 1973), 64.

64. Pablo O'Higgins to Grace and Marion Greenwood, quoted in James Oles, *South of the Border: Mexico in the American Imagination 1914–1947* (Washington, DC: Smithsonian Institution Press, 1993), 187.

65. Isamu Noguchi, *A Sculptor's World* (New York: Harper & Row, 1968), 23.

66. V. I. Lenin, "On Proletarian Culture," in *Collected Works*, trans. Julius Katzer, vol. 31 (Moscow: Progress Publishers, 1966), 316–17, "Draft Manifesto of John Reed Clubs," 4.

67. Raphael Soyer, "An Artist's Experiences in the 1930s," in *Social Concern and Urban Realism: American Painting of the 1930s*, ed. Patricia Hills (Boston: Boston University Art Gallery, 1983), 28.

68. "The Art of Mexico–Land of Social Protest," *Art Digest* 13, no. 12 (March 15, 1939): 45.

69. Charles White, quoted in Jeffrey Elliot, "Charles White: Portrait of an Artist," *Negro History Bulletin* 41, no. 3 (May–June 1978): 828.

70. John Pittman, "He Was an Implacable Critic of His Own Creations," *Freedomways* 20, no. 3 (January 1980): 191.

71. Charles Henry Alston, interviewed by Al Murray, transcript, October 19, 1968, Archives of American Art, Smithsonian Institution, Washington, DC.

72. Lizzetta LeFalle-Collins and Shifra M. Goldman, *In the Spirit of Resistance: African American Modernists and the Mexican Muralist School* (New York: The American Federation of the Arts, 1996), 30; Patricia Hills, *Painting Harlem Modern: The Art of Jacob Lawrence* (Berkeley: University of California Press, 2009), 46.

73. Luis Cardoza y Aragón, quoted in James Oles, "Orozco at War: Context and Fragment in *Dive Bomber and Tank* (1940)," in González Mello and Miliotes, *José Clemente Orozco in the United States*, 197.

74. Kirk Varnedoe, *Jackson Pollock* (New York: The Museum of Modern Art, 1998), 26.

75. Reuben Kadish recounted this episode in an interview with Steven Naifeh and Gregory White Smith for their biography on Pollock, *Jackson Pollock: An American Saga*, see p. 219.

76. David Alfaro Siqueiros, quoted in Laurance P. Hurlburt, "The Siqueiros Experimental Workshop: New York, 1936," *Art Journal* 35, no. 3 (Spring 1976): 242.

77. Axel Horn, "Jackson Pollock: The Hollow and the Bump," *The Carleton Miscellany* 7, no. 3 (Summer 1966): 85–86.

78. Charles Pollock, quoted in Francis V. O'Connor, "The Genesis of Jackson Pollock: 1912 to 1943," *Artforum* 5, no. 9 (May 1967): 23n9.

79. David Alfaro Siqueiros, "Rivera's Counter-Revolutionary Road," *New Masses* 11, no. 9 (May 29, 1934): 16–17.

80. Stephen Alexander, "Orozco's Lithographs," *New Masses* 17, no. 8 (November 19, 1935): 29; Mary Randolph, "Rivera's Monopoly," *Art Front*, November 1935: 5; Mary Randolph, "Rivera's Monopoly (Conclusion)," *Art Front*, December 1935: 12–13.

81. "Mexican Show," *Time* 35, no. 22 (May 27, 1940): 59.

82. "The Art Galleries," *The New Yorker*, May 25, 1940, 52; "Mexican Show," *Time*, 59; Edward Alden Jewell, "Mexican Art Show Spans 2,000 Years," *New York Times*, May 15, 1940.

83. José Clemente Orozco, quoted in James Oles, *Diego Rivera, David Alfaro Siqueiros, José Clemente Orozco* (New York: The Museum of Modern Art, 2011), 44.

84. Jacob Lawrence, quoted in Alejandro Anreus, *Orozco in Gringoland: The Years in New York* (Albuquerque: University of New Mexico Press, 2001), 122.

85. Ben Shahn, recounted by Bernarda Bryson Shahn, quoted in Anreus, *Orozco in Gringoland*, 123.

86. Timothy G. Turner, "What Happened to Diego Rivera," *Los Angeles Times*, July 14, 1940; Diego Rivera to Emily Joseph, June 28, 1941, Emmy Lou Packard Papers, Archives of American Art, Smithsonian Institution, Washington, DC.

87. James D. Egleson, "José Clemente Orozco," *Parnassus* 12, no. 7 (November 1940): 7.

PLATES

ROMANTIC NATIONALISM AND THE MYTH OF REVOLUTION

Seeking to unite a fractured country devastated by a decade of civil war, Mexico's postrevolutionary government in 1920 embarked on an expansive program to commission monumental works of public art, a sweeping initiative that sparked the greatest cultural renaissance in the contemporary world. Artists created panoramic murals of Mexican history and everyday life using a pictorial vocabulary that was simultaneously modern and distinctively Mexican, eschewing centuries of European aesthetic influence to make work that spoke directly to the public about social justice and national identity. Central to their celebration of the "real" Mexico and its pre-Hispanic traditions were idyllic depictions of the country's Indigenous peasant population. These were joined by mythic narratives of the suffering the people had endured under Spanish rule and the dictatorship of Porfirio Díaz, their heroic struggle for emancipation, and a postrevolutionary world of equality and social harmony. Even as these images arguably mythologized the Mexican Revolution and romanticized the Mexican peasant, they nevertheless captured the imagination of Americans grappling with a sense of the rootlessness and alienation of modern urban and industrial life. As images of the Mexican murals flooded the United States, artists and intellectuals began traveling to Mexico to witness the cultural efflorescence firsthand.

When mural commissions in Mexico declined after 1924, the muralists turned to the United States for patronage. Between 1927 and 1940, the three leading Mexican muralists—José Clemente Orozco, Diego Rivera, and David Alfaro Siqueiros—spent extended periods in the U.S. exhibiting and executing their art. Their presence exerted a profound impact on American artists who were seeking to break free of the art-for-art's-sake ethos of European abstraction and reestablish art's connection with the public. By 1934, Mexico's artists were being declared "a more creative influence in American painting than the modernist French masters. . . . They have brought painting back to its vital function in society."

1 DIEGO RIVERA
Flower Day, 1925
Oil on canvas, 58 × 47 ½ in. (147.3 × 120.7 cm)
Los Angeles County Museum of Art; Los Angeles County Fund 25.7.1



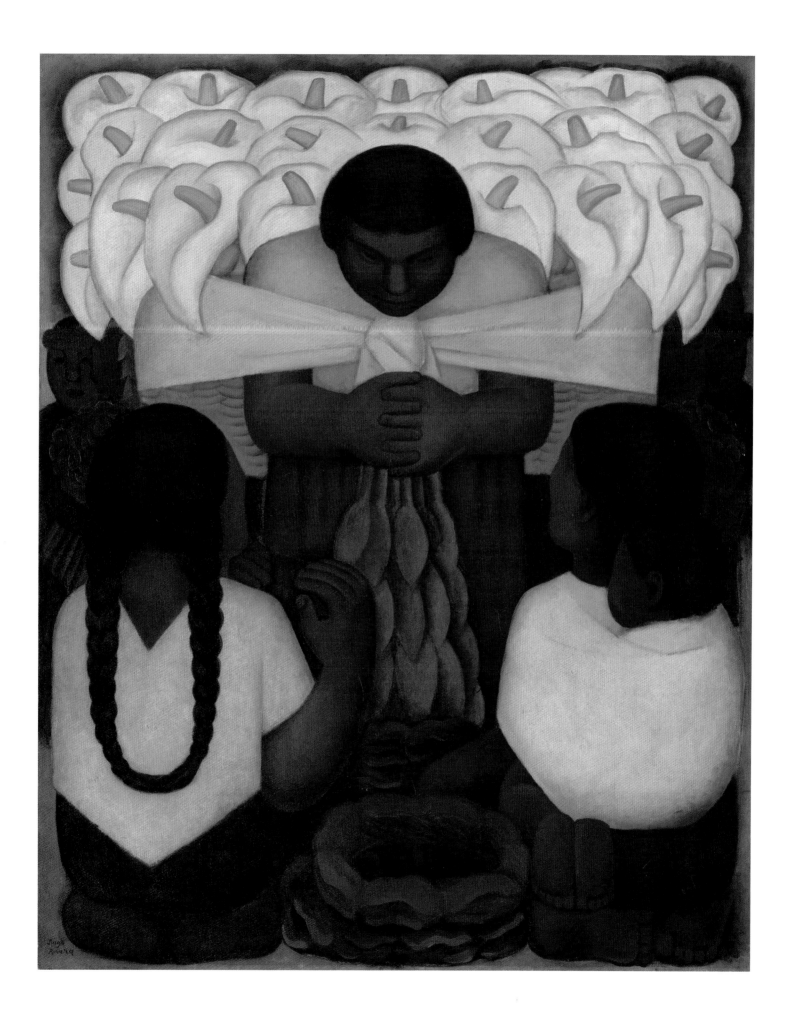

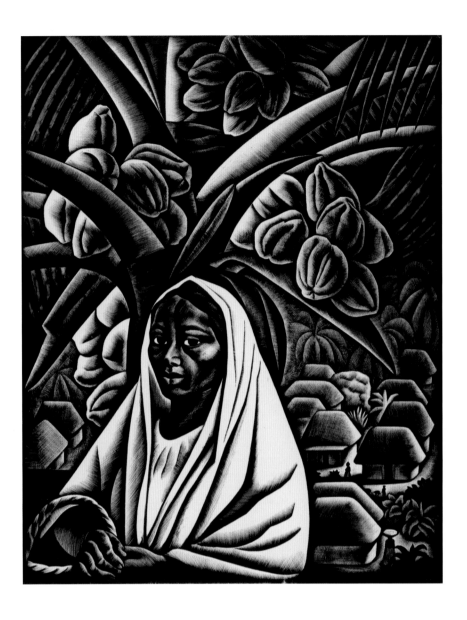

2 HOWARD COOK
Acapulco Girl (Cocoanut Palm), 1932
Wood engraving, sheet: 12 1/16 × 10 3/8 in. (30.6 ×
26.4 cm); image: 10 1/16 × 8 in. (25.6 × 20.3 cm)
Philadelphia Museum of Art; gift of Carl Zigrosser,
1960

3 JOSÉ CLEMENTE OROZCO
Zapatistas, 1931
Oil on canvas, 45 × 55 in. (114.3 × 139.7 cm)
The Museum of Modern Art, New York; given
anonymously

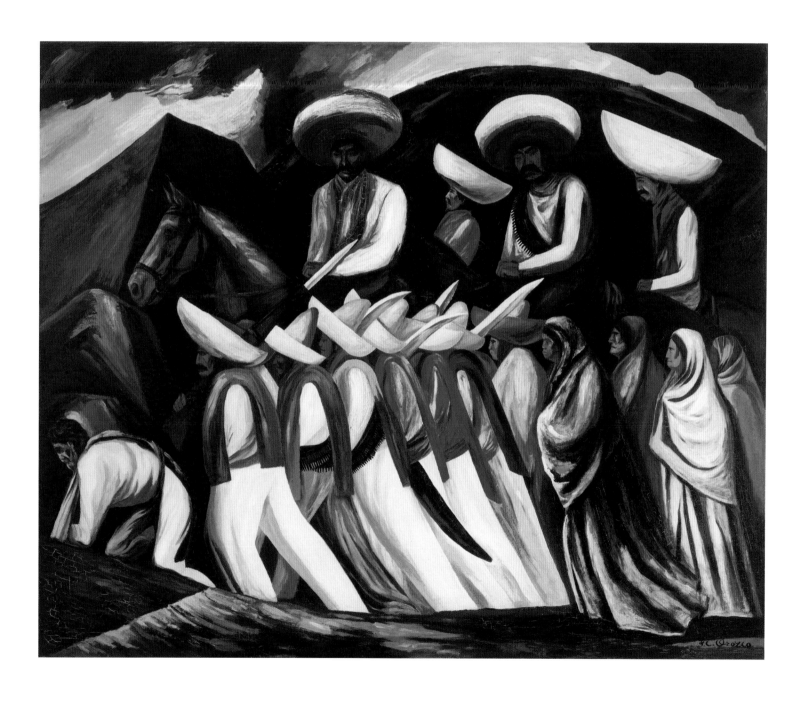

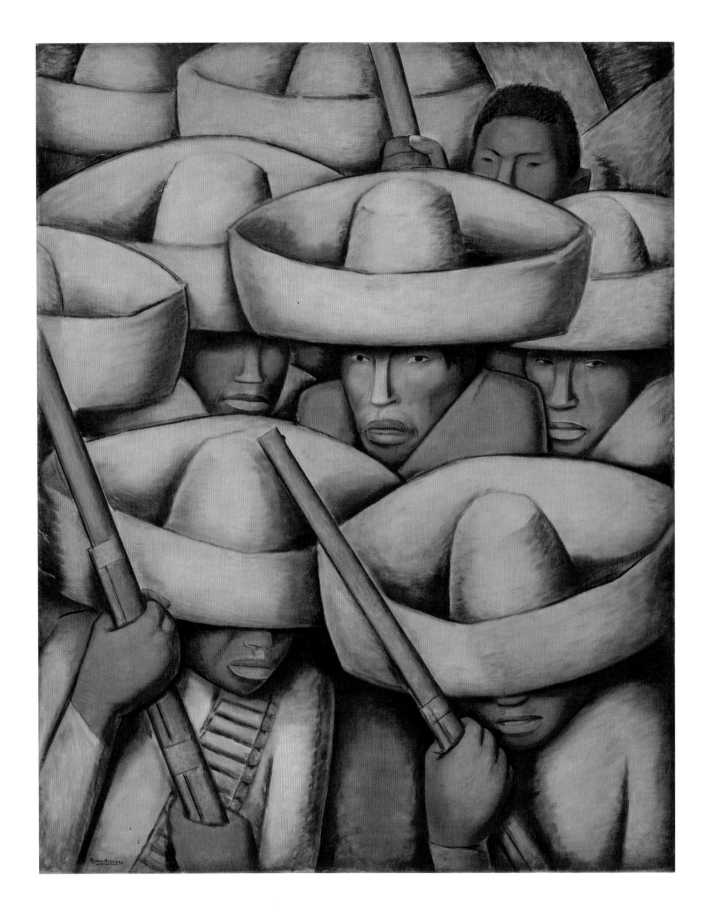

4 ALFREDO RAMOS MARTÍNEZ
Zapatistas, 1932
Oil on canvas, 49 ½ × 39 ½ in. (125.7 × 100.3 cm)
San Francisco Museum of Modern Art; gift of
Albert M. Bender

5 JOSÉ CLEMENTE OROZCO
Zapata, 1930
Oil on canvas, 78 ¼ × 48 ¼ in. (198.8 × 122.6 cm)
Art Institute of Chicago; gift of Joseph
Winterbotham Collection 1941.35

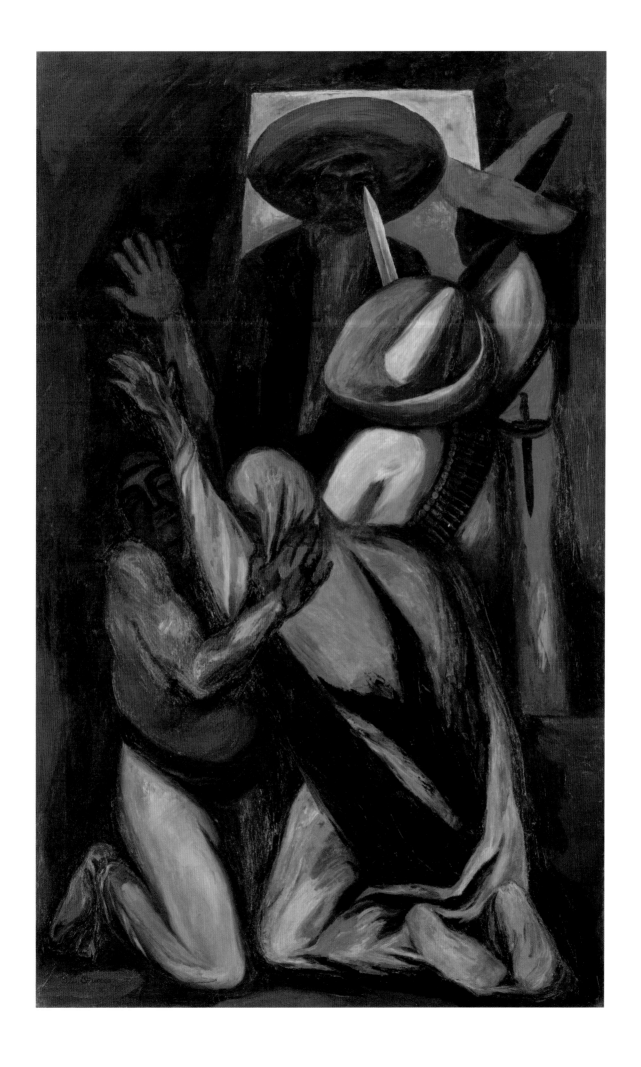

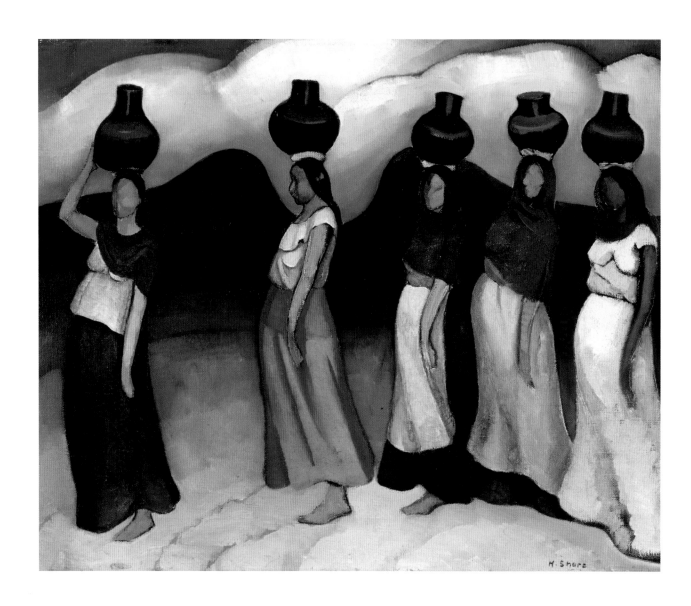

6 HENRIETTA SHORE
Women of Oaxaca, 1927
Oil on canvas, 16 × 20 in. (40.6 × 50.8 cm)
UCI Institute and Museum for California Art,
Irvine; The Buck Collection

7 MARÍA IZQUIERDO
My Nieces, 1940
Oil on composition board, 55 ⅛ × 39 ⅜ in.
(140 × 100 cm)
Museo Nacional de Arte, INBA, Mexico City;
constitutive collection, 1982

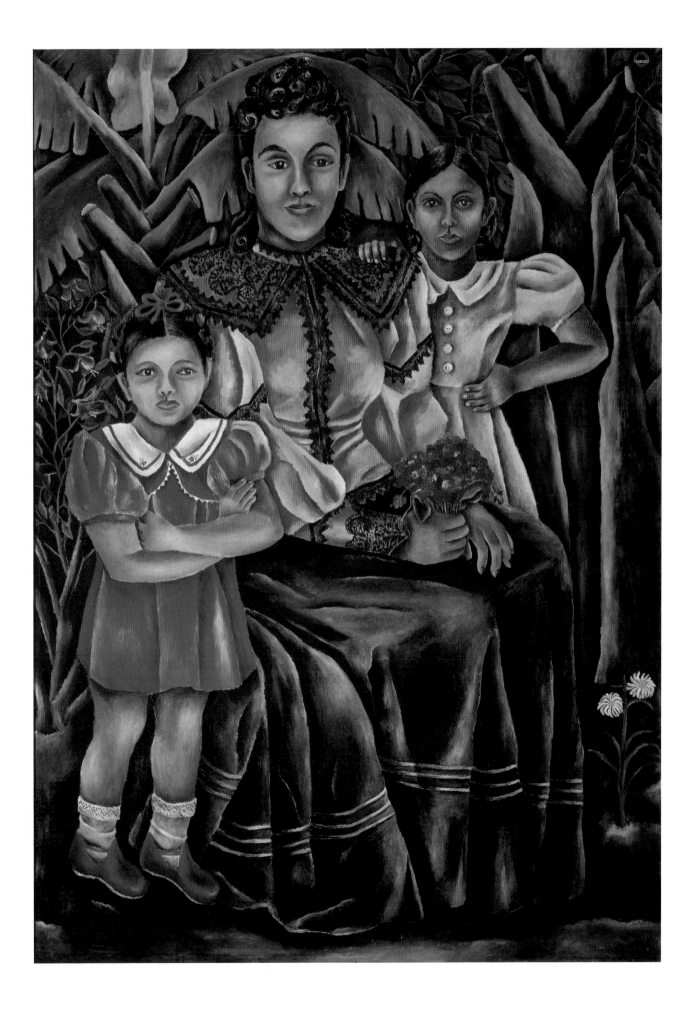

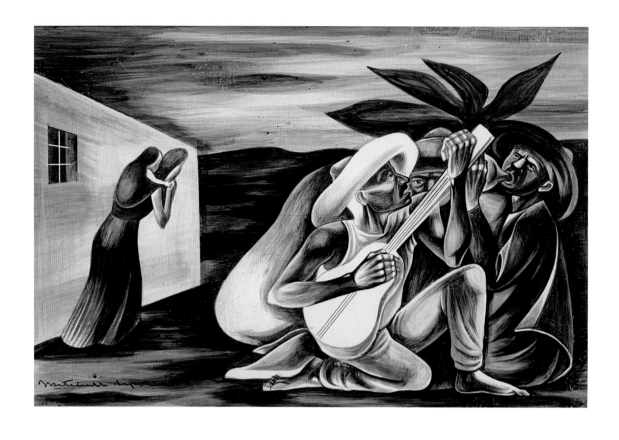

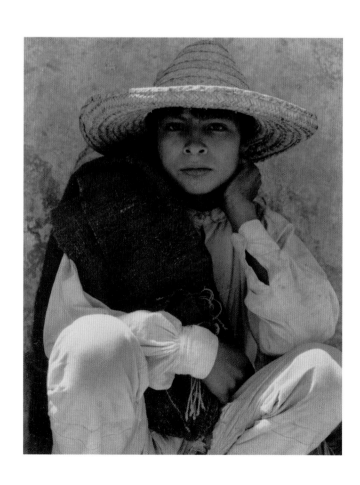

8 MITCHELL SIPORIN
Sweet Georgia Brown in Arizona, 1936
Tempera on panel, 14 × 16 in. (35.6 × 40.6 cm)
Collection of Bernard Friedman

9 PAUL STRAND
Boy, Hidalgo, 1933
Platinum print, 5 ¾ × 4 ⁹⁄₁₆ in. (14.6 × 11.6 cm)
National Gallery of Art, Washington, DC;
Southwestern Bell Corporation Paul Strand
Collection

10 DIEGO RIVERA
Study for Agrarian Leader Zapata, 1931
Charcoal on paper, 98 ⅜ × 78 in. (250 × 198 cm)
Private collection

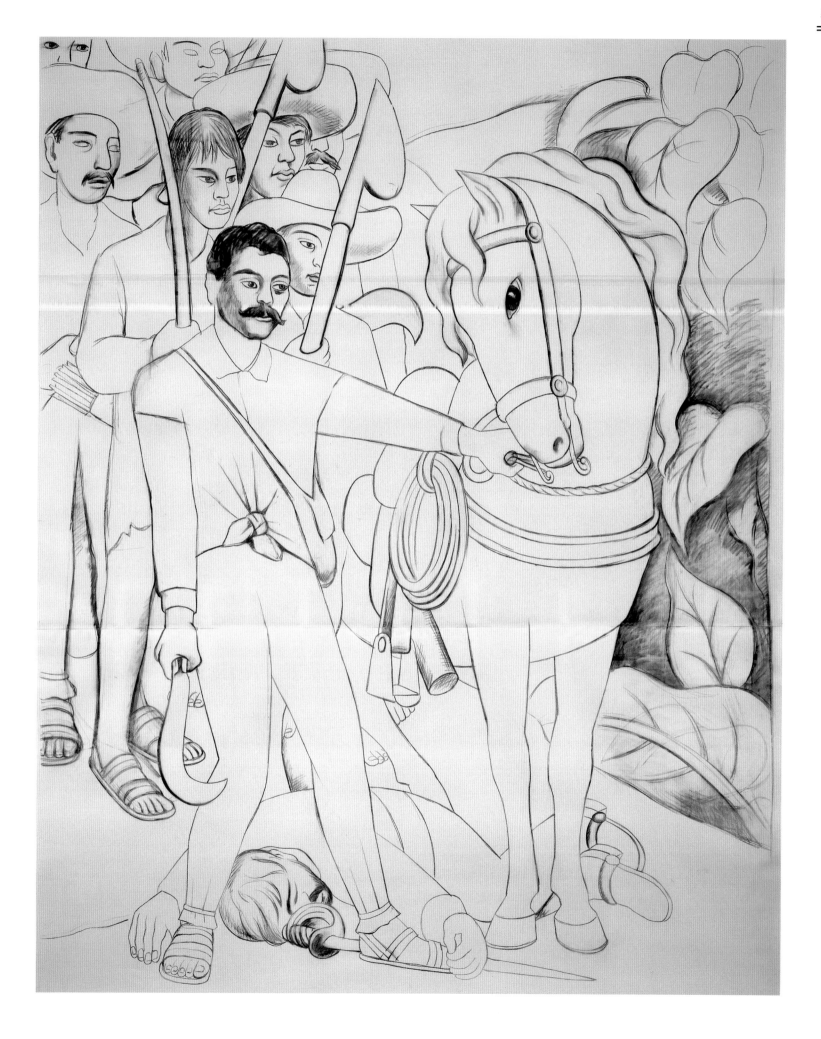

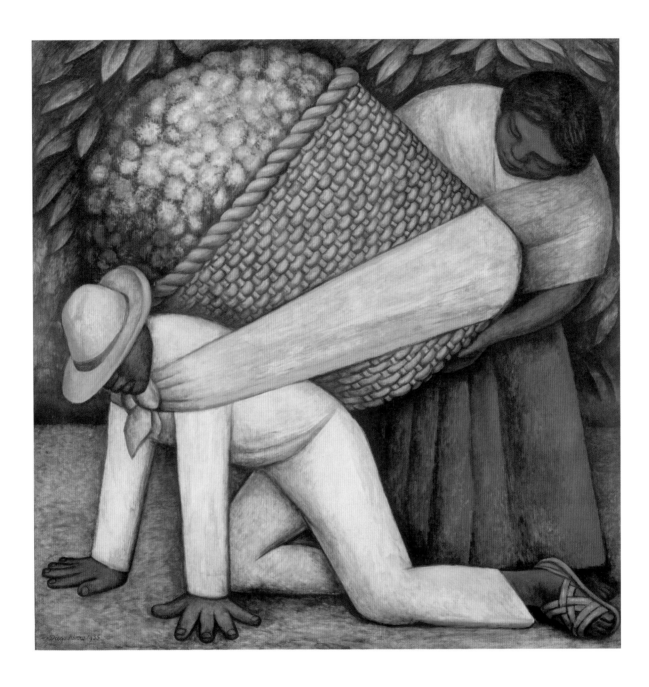

11 DIEGO RIVERA
The Flower Carrier, 1935
Oil and tempera on composition board, 48 × 47 ¾ in.
(121.9 × 121.3 cm)
San Francisco Museum of Modern Art; Albert M.
Bender Collection; gift of Albert M. Bender in
memory of Caroline Walter

12 ALFREDO RAMOS MARTÍNEZ
Calla Lily Vendor, 1929
Oil on canvas, 45 ¹³⁄₁₆ × 36 in. (116.3 × 91.4 cm)
Private collection

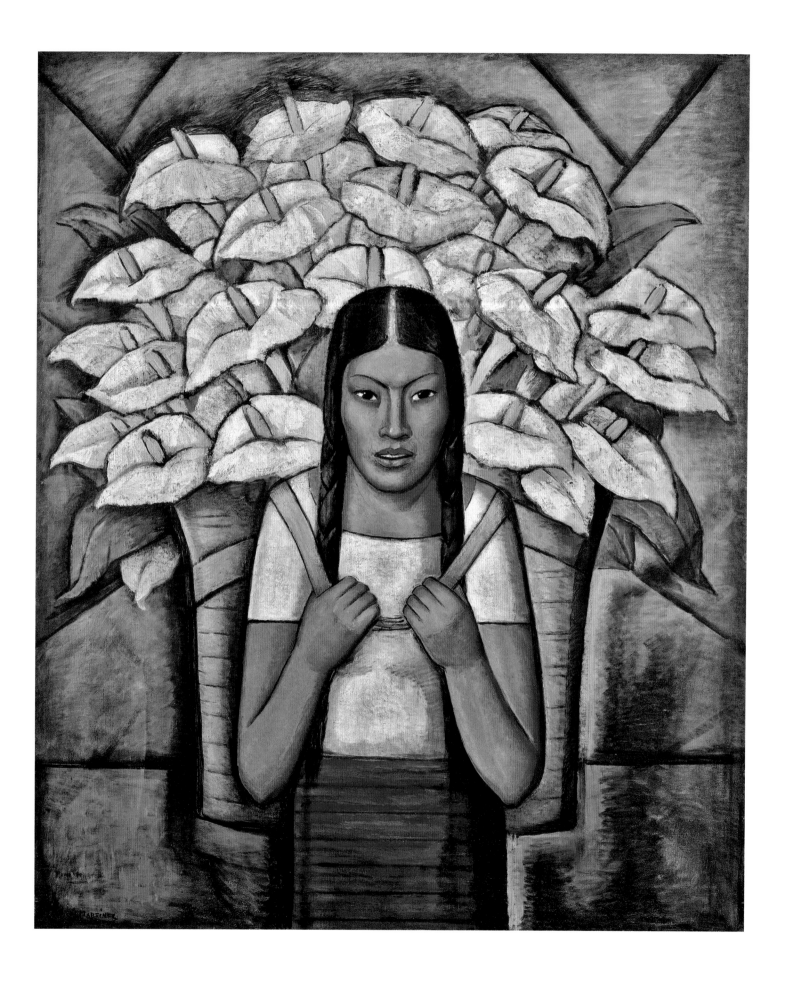

13 DAVID ALFARO SIQUEIROS
Zapata, 1931
Oil on canvas, 53 ¼ × 41 ⅝ in. (135.2 × 105.7 cm)
Hirshhorn Museum and Sculpture Garden,
Smithsonian Institution, Washington, DC; gift of
Joseph H. Hirshhorn, 1966

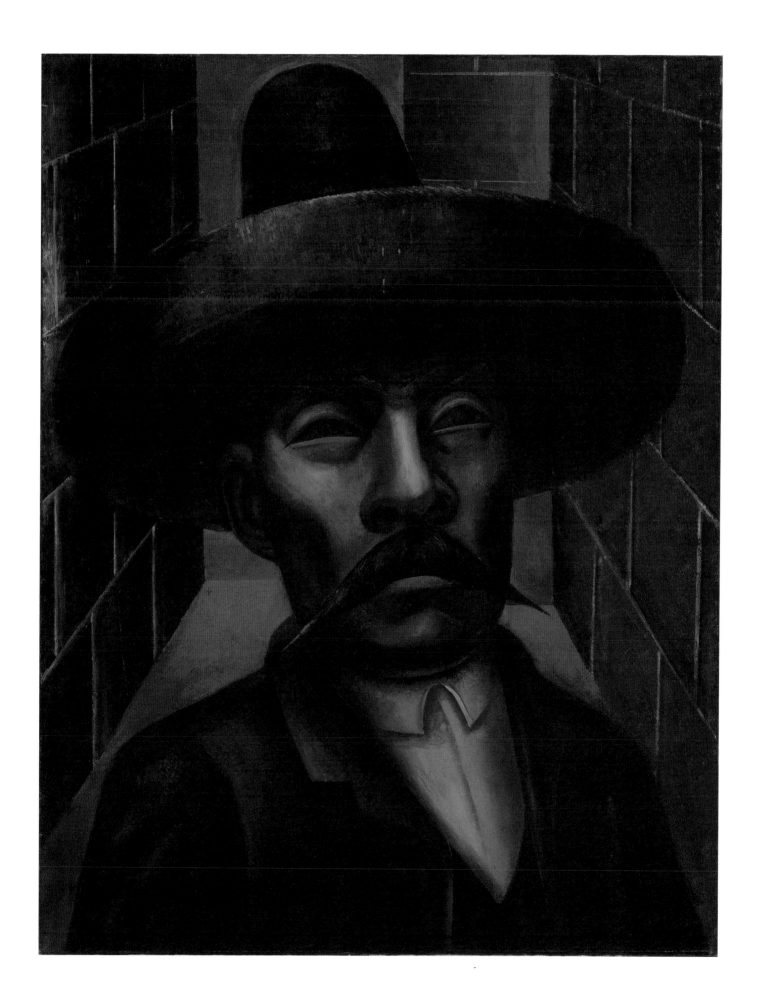

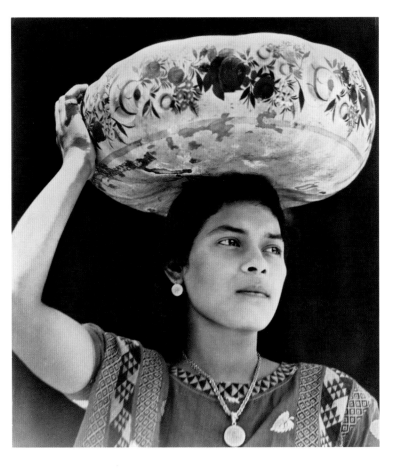

14 TINA MODOTTI
Campesinos Reading "El Machete", 1929
Gelatin silver print, 6 ¾ × 9 ¼ in. (17.1 × 23.5 cm)
Throckmorton Fine Art Inc., New York

15 TINA MODOTTI
Woman of Tehuantepec, 1929
Gelatin silver print, 8 ⅜ × 7 ⅜ in. (21.3 × 18.8 cm)
Philadelphia Museum of Art; gift of Mr. and Mrs.
Carl Zigrosser, 1968

16 MARDONIO MAGAÑA
Man with Sarape and Sombrero, 1935
Wood, 55 ⅛ × 17 ⁵⁄₁₆ × 17 ⁵⁄₁₆ in. (140 × 44 × 44 cm)
Museo de Arte Moderno, INBA, Mexico City

17 MIGUEL COVARRUBIAS
Flower Vendor, late 1940s
Oil on canvas, 15 × 10 in. (70 × 56 cm)
Private collection; courtesy Pablo Goebel Fine Arts
Gallery, Mexico City

18 DIEGO RIVERA
Open Air School, 1932
Lithograph, sheet: 16 × 19 ⁵⁄₁₆ in. (40.6 × 49.1 cm);
image: 12 ½ × 16 ⁵⁄₁₆ in. (31.8 × 41.4 cm)
McNay Art Museum, San Antonio; museum
purchase with funds from the Cullen Foundation,
the Friends of the McNay, Charles Butt, Margaret
Pace Willson, and Jane and Arthur Stieren,
2000.59

19 EDWARD WESTON
Pyramid of the Sun, 1923
Gelatin silver print, 7 ⁹⁄₁₆ × 9 ½ in. (19.2 × 24.1 cm)
San Francisco Museum of Modern Art; gift of
Brett Weston

20 PAUL STRAND
Woman and Boy, Tenancingo, Mexico, 1933
(printed 1960s)
Gelatin silver print, 9 ⅛ × 7 ⁵⁄₁₆ in. (23.2 × 18.6 cm)
Philadelphia Museum of Art; The Paul Strand
Retrospective Collection, 1915–1975; gift of the
estate of Paul Strand, 1980

21 RUFINO TAMAYO
Man and Woman, 1926
Oil on canvas, 30 × 29 ⅞ in. (76.2 × 75.9 cm)
Philadelphia Museum of Art; gift of Mr. and Mrs.
James P. Magill, 1957

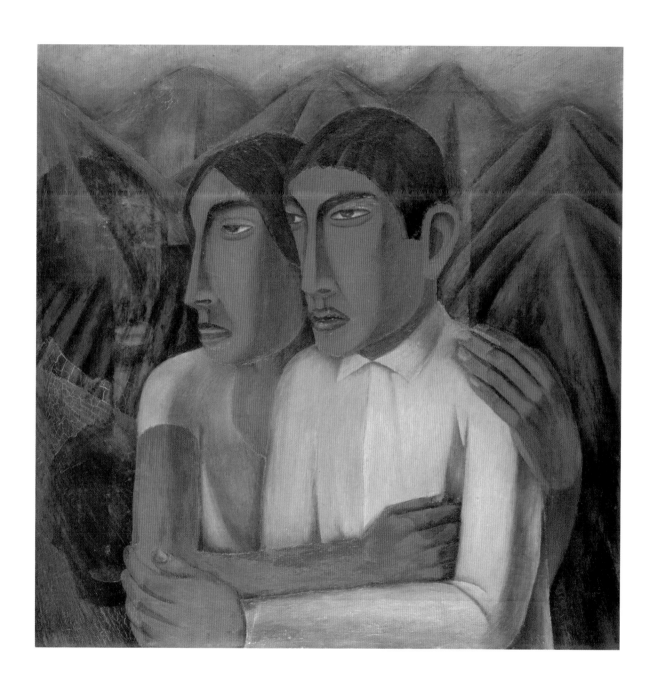

22 FRIDA KAHLO
Self-Portrait with Monkey, 1938
Oil on composition board, 16 × 12 in. (40.6 × 30.5 cm)
Albright-Knox Art Gallery, Buffalo, New York;
bequest of A. Conger Goodyear, 1966

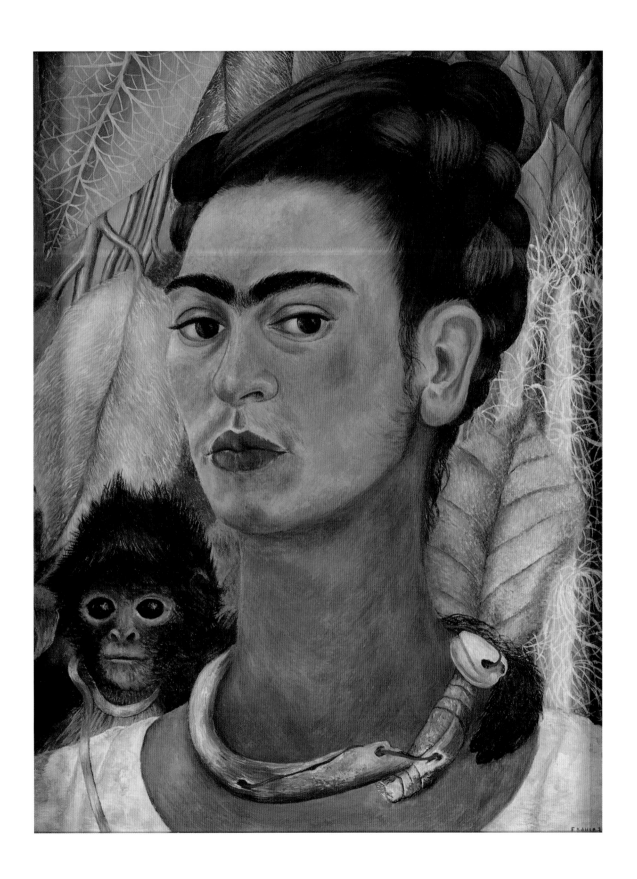

23 JOSÉ CLEMENTE OROZCO
The Flag, 1928
Lithograph, sheet: 12 ¼ × 18 ¾ in. (31.1 × 47.7 cm);
image: 10 ½ × 16 ⅞ in. (26.6 × 42.9 cm)
The Museum of Modern Art, New York; gift of
Mrs. Henry Allen Moe, in memory of Dr. Henry
Allen Moe

24 JOSÉ CLEMENTE OROZCO
Requiem, 1928
Ink on paper, 13 ⅛ × 17 ⁷⁄₁₆ in. (33.3 × 44.3 cm)
Museo de Arte Carrillo Gil, INBA, Mexico City

25 JOSÉ CLEMENTE OROZCO
Barricade, 1931
Oil on canvas, 55 × 45 in. (139.7 × 114.3 cm)
The Museum of Modern Art, New York; given
anonymously

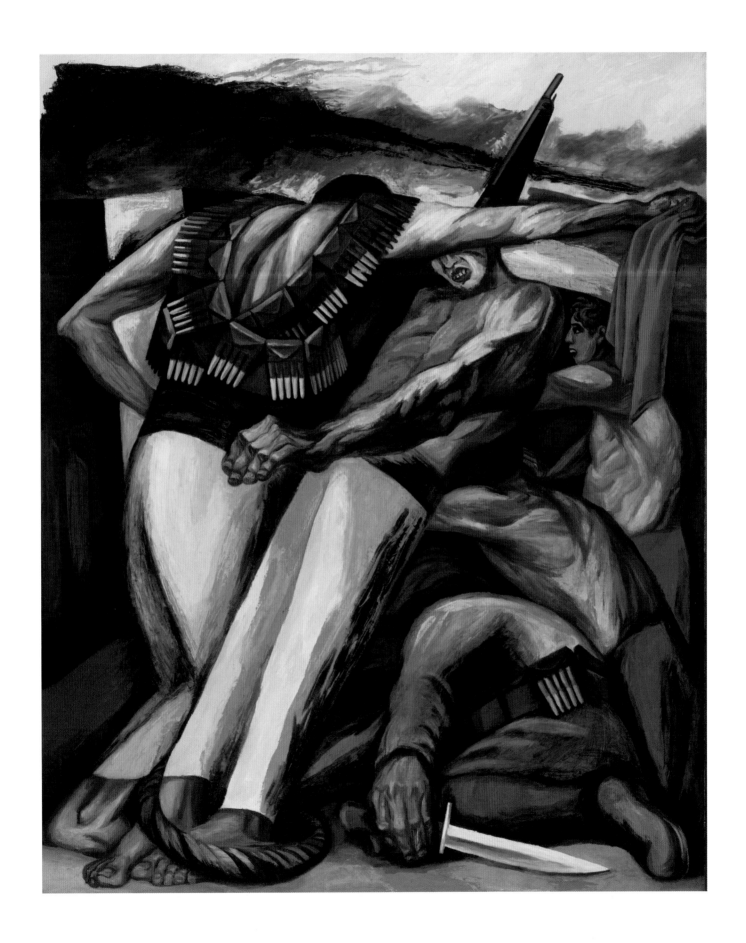

Orozco was the first of the leading Mexican muralists to come to the United States, arriving in New York in December 1927. He spent his first two years making easel paintings and lithographs before receiving his first mural commission in the U.S. in 1930, for the Frary Dining Hall at Pomona College in California. Rejecting the folkloric themes popular with his compatriots, Orozco chose as his subject Prometheus, the mythical Greek Titan who brought fire—and thus knowledge—to humanity, inciting the wrath of the gods. The theme of heroic self-sacrifice for the greater good would remain central to Orozco's work, even as he grew more pessimistic about humanity's capacity to escape the cycle of conflict and struggle, as expressed in his subsequent three U.S. murals: *A Call for Revolution and Universal Brotherhood* (1930–31) in Manhattan's New School for Social Research; *The Epic of American Civilization* (1932–34) at Dartmouth College in New Hampshire; and *Dive Bomber and Tank* (1940), created for the Museum of Modern Art, New York.

Orozco's marriage of figurative imagery, visceral brushwork, and fraught content galvanized artists in the U.S. Inspired by his uncompromising portrayal of struggle and trauma, both personal and collective, they adopted his intense earth tones, volumetric treatment of figures, and iconographical appropriation of ancient rituals and myths. Among them was Jackson Pollock, whose 1930 encounter with *Prometheus* led him to call it "the greatest painting done in modern times" and who, shortly after seeing Orozco's Dartmouth mural in 1936, channeled its volcanic brushstrokes and iconography of anguish and strife into his own pictorial vocabulary.

26 JOSÉ CLEMENTE OROZCO
The Fire, 1938
Oil on canvas, 26 ½ × 22 in. (67.3 × 55.9 cm)
Museum of Fine Arts, Boston; gift in memory of
Rachel Hartzell Thayer from her Family 67.614

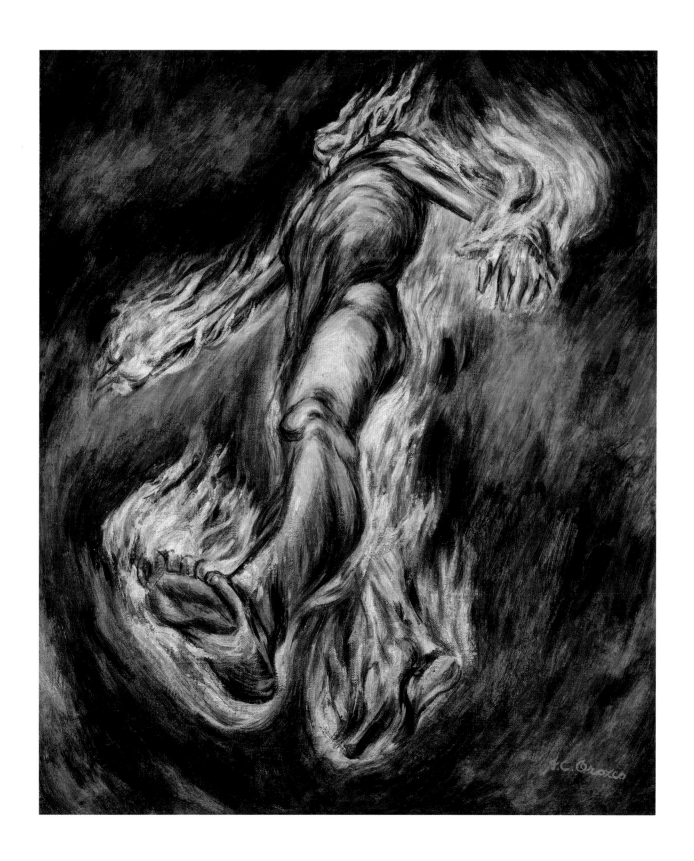

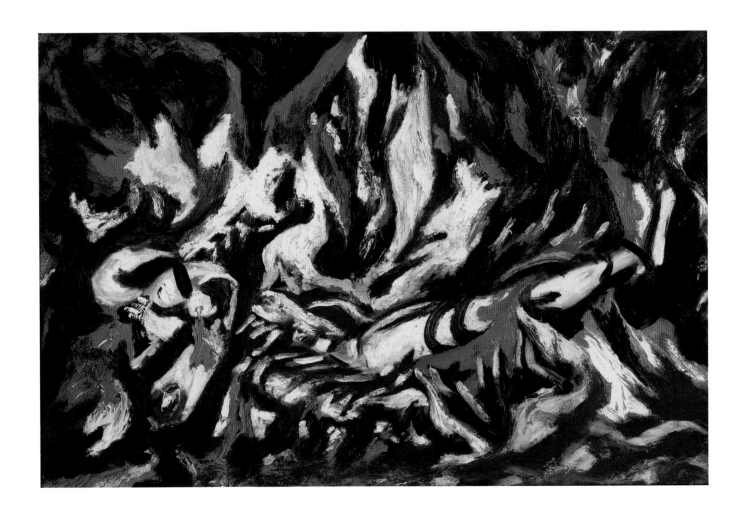

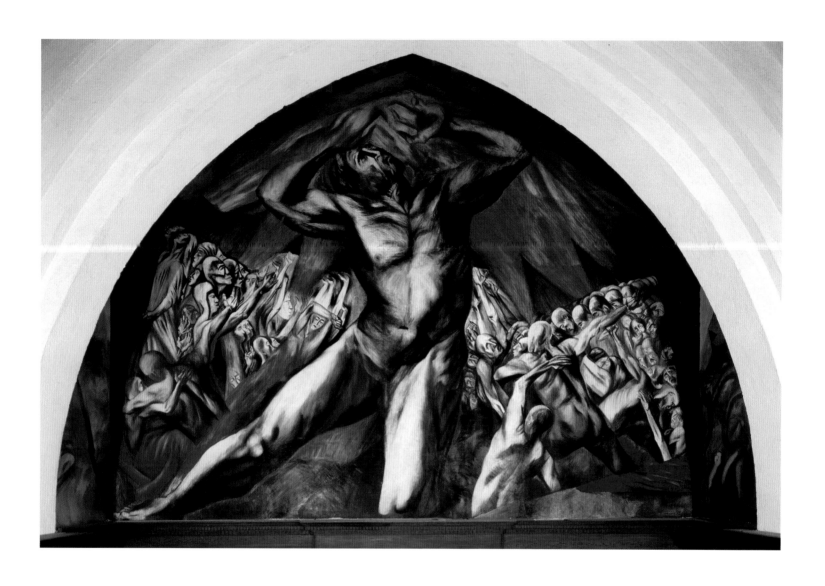

27 JACKSON POLLOCK
The Flame, 1934–38
Oil on canvas mounted on fiberboard, 20 ½ × 30 in.
(51.1 × 76.2 cm)
The Museum of Modern Art, New York; Enid A.
Haupt Fund

28 JOSÉ CLEMENTE OROZCO
Prometheus, 1930
Fresco, 20 ft. × 28 ft. 6 in. (6.1 × 8.7 m)
Pomona College, Claremont, California

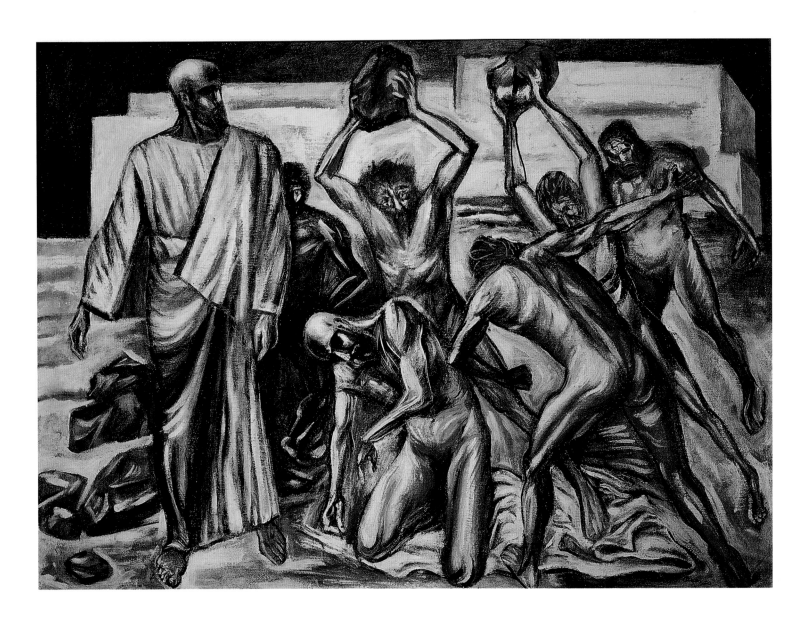

29 **JOSÉ CLEMENTE OROZCO**
Martyrdom of Saint Stephen 1, 1943
Oil on canvas, 37 ½ × 51 ¹⁵⁄₁₆ in. (95.3 × 132 cm)
San Antonio Museum of Art; purchased with the
Mary Kathryn Lunch Kurtz Fund for the
Acquisition of Modern Latin American Art 2003.19

30 **PHILIP GUSTON**
Bombardment, 1937–38
Oil on composition board, 42 in. (106.7 cm), diameter
Philadelphia Museum of Art; gift of Musa and Tom
Mayer, 2011

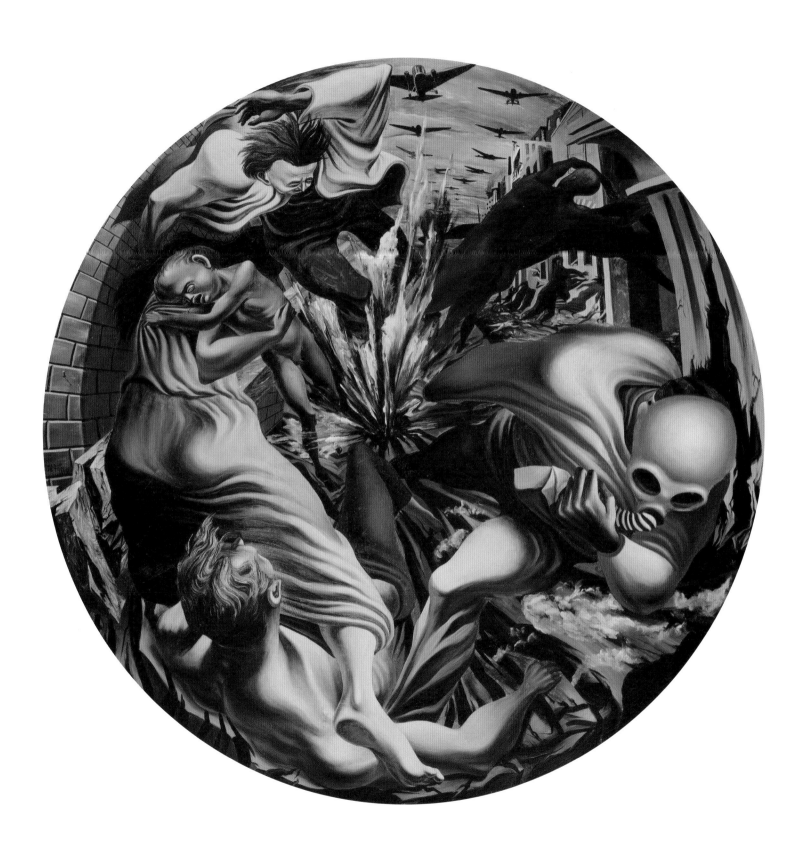

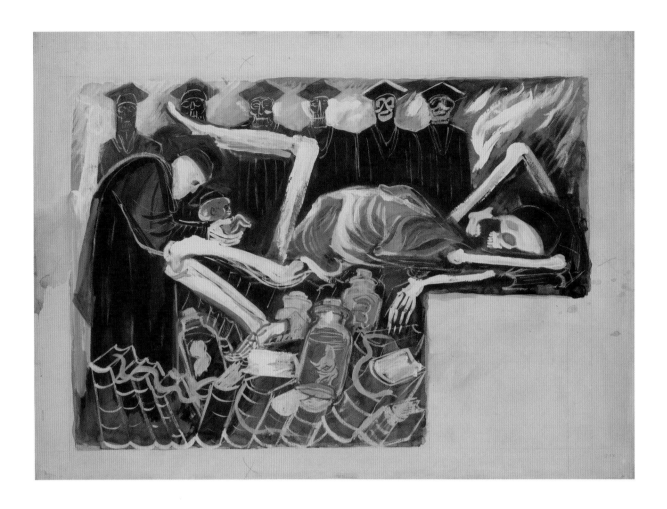

31 JOSÉ CLEMENTE OROZCO
Study for Gods of the Modern World, panel 15
from *The Epic of American Civilization*, 1932–34
Gouache on paper, 18 9/16 × 26 in. (47.1 × 66 cm)
Hood Museum of Art, Dartmouth College, Hanover,
New Hampshire; purchased through gifts from
Kirsten and Peter Bedford, Class of 1989P; Jane
and Raphael Bernstein; Walter Burke, Class of
1944; Mr. and Mrs. Richard P. Lombard, Class of
1953; Nathan Pearson, Class of 1932; David V.
Picker, Class of 1953; Rodman C. Rockefeller,
Class of 1954; Kenneth Roman Jr., Class of 1952;
and Adolph Weil Jr., Class of 1935

32 JACKSON POLLOCK
Untitled (Bald Woman with Skeleton), c. 1938–41
Oil on composition board, 20 × 24 in. (50.8 × 61 cm)
Hood Museum of Art, Dartmouth College, Hanover,
New Hampshire; purchased through the Miriam H.
and S. Sidney Stoneman Acquisitions Fund 2006.93

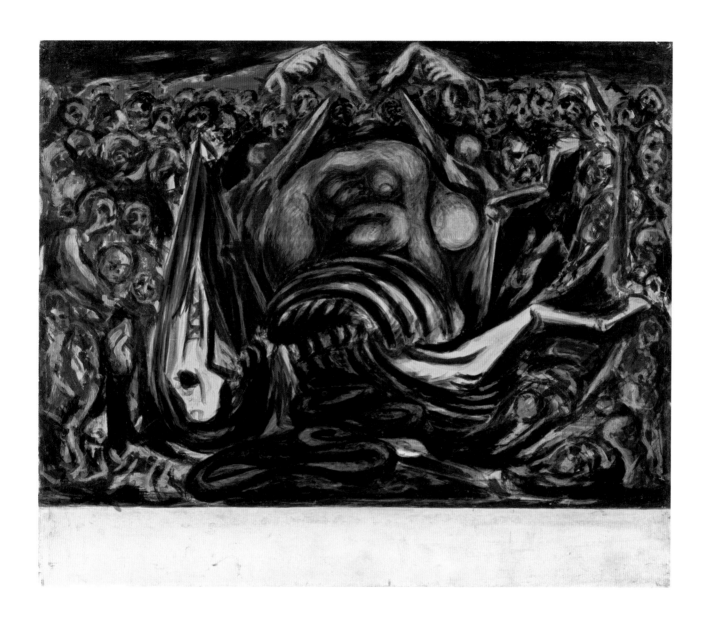

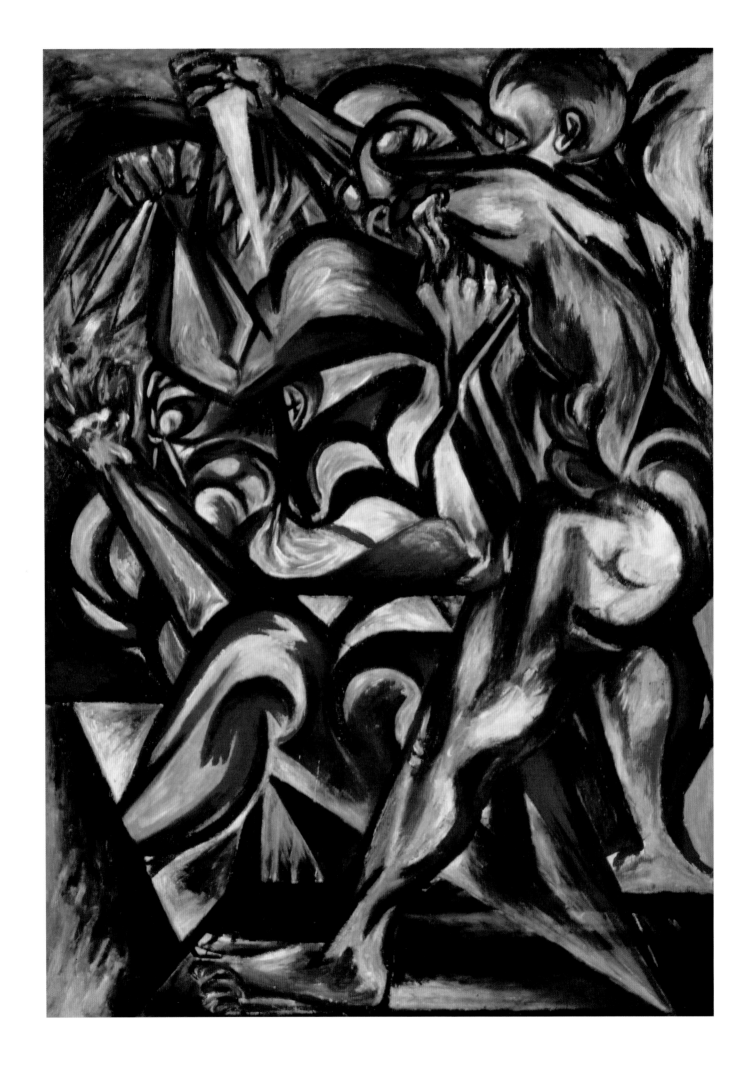

33 JACKSON POLLOCK
Untitled (Naked Man with Knife), c. 1938–40
Oil on canvas, 53 1/16 × 39 in. (134.7 × 99 cm)
Tate, London; presented by Frank Lloyd, 1981

34 CHARLES WHITE
Hear This, 1942
Oil on canvas, 21 1/2 × 29 1/2 in. (54.6 × 74.9 cm)
The Harmon and Harriet Kelley Foundation for the
Arts, San Antonio

35 EVERETT GEE JACKSON
Embarkation, 1938
Oil on canvas, 36 × 44 ⅜ in. (91.4 × 112.7 cm)
Private collection

36 JACKSON POLLOCK
Composition with Ritual Scene, 1938–41
Oil on canvas mounted on composition board,
18 × 47 ¼ in. (45.7 × 120 cm)
Sheldon Museum of Art, University of Nebraska–
Lincoln; Nebraska Art Association Collection,
through the gifts of Mrs. Henry C. Woods, Sr.,
Mr. and Mrs. Frank Woods, Mr. and Mrs. Thomas C.
Woods, and Mr. and Mrs. Frank Woods, Jr. by
exchange; Woods Charitable Fund in memory of
Thomas C. (Chip) Woods, III, and other generous
donors N–767.1999

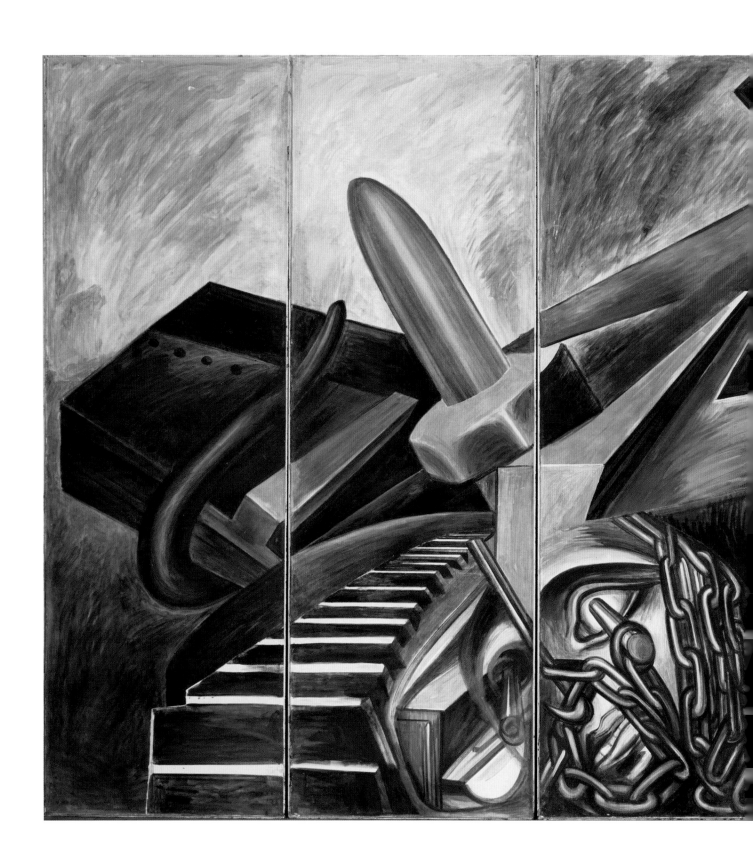

37 JOSÉ CLEMENTE OROZCO
Dive Bomber and Tank, 1940
Fresco, six panels: 108 × 36 in. (275 × 91.4 cm)
each; 108 × 216 in. (275 × 550 cm) overall
The Museum of Modern Art, New York;
commissioned through the Abby Aldrich
Rockefeller Fund

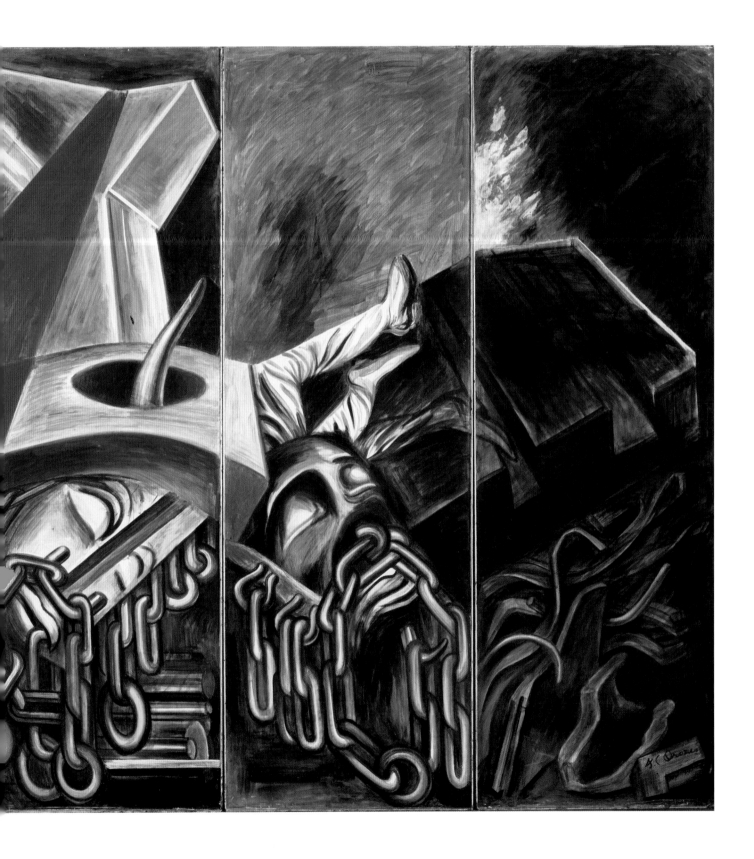

The economic meltdown that followed the crash of the U.S. stock market in 1929 shattered the country's faith in itself. With one third of the country unemployed and droughts devastating the Midwest, many Americans doubted their ability to endure and triumph. More than ever, as the American novelist John Dos Passos asserted, the country needed to know "what kind of firm ground other men, belonging to generations before us, have found to stand on." Guided by the Mexican muralists, whose art they had ample opportunities to study in reproduction and exhibition, American artists responded by seeking elements from the country's past, which they mythologized into epics of strength and endurance in an effort to help the nation revitalize itself.

Thomas Hart Benton led the charge. Long a vociferous critic of European abstraction as elitist and out of touch with ordinary people, Benton hailed the Mexican muralists for the resolute public engagement of their art and for portraying the pageant of Mexican national life, exhorting his fellow American artists to follow their example in forging a similar public art for the U.S., even as he firmly rejected the communist ideology that often inflected the Mexican artists' work. African American artists were likewise inspired by the Mexican muralists, but for them inspiration came from the muralists' celebration of the people's fight for emancipation. In creating redemptive narratives of social justice out of their own racial history of oppression, resistance, and liberation, artists such as Charles White and Jacob Lawrence transformed that struggle for freedom and equality into a new collective identity, one that foregrounded the contribution of African Americans to national life.

38 AARON DOUGLAS
Aspects of Negro Life: From Slavery through Reconstruction, 1934
Oil on canvas, 60 × 143 in. (152.4 × 353.1 cm)
Schomburg Center for Research in Black Culture, New York Public Library; Astor, Lenox, and Tilden Foundations

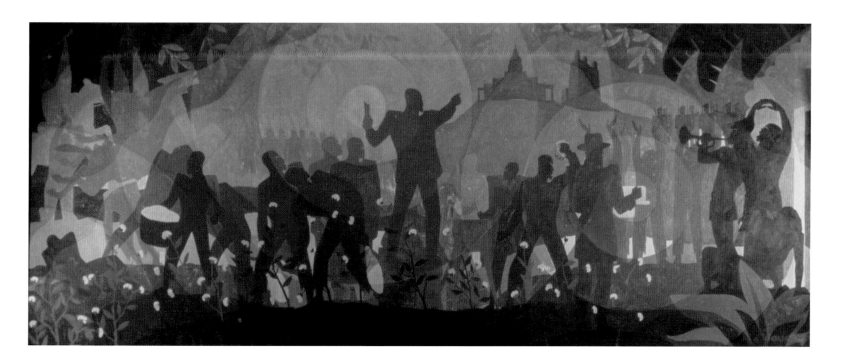

39–43 THOMAS HART BENTON
American Historical Epic, 1926–28
Nelson-Atkins Museum of Art, Kansas City,
Missouri; bequest of the artist F75-21/6–10

FROM LEFT TO RIGHT
The Pathfinder, 1926
Oil on canvas, mounted on aluminum, 60⅛ × 42⅛ in.
(152.7 × 107 cm)

Over the Mountains, 1927–28
Oil on canvas, mounted on aluminum, 66¼ × 72 in.
(168.3 × 182.9 cm)

Jesuit Missionaries, 1927–28
Oil on canvas, mounted on aluminum, 65⅞ × 29 in.
(167.3 × 73.7 cm)

Struggle for the Wilderness, 1927–28
Oil on canvas, mounted on aluminum, 66 ¼ × 72 ¼ in.
(168.3 × 183.5 cm)

Lost Hunting Ground, 1927–28
Oil on canvas, mounted on aluminum, 60 ¼ × 42 ⅛ in.
(153 × 107 cm)

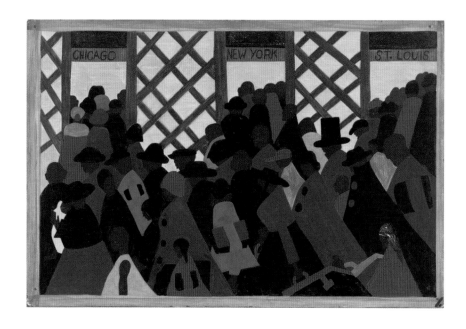

44–48 JACOB LAWRENCE
Selections from the *Migration Series*, 1940–41
The Phillips Collection, Washington, DC;
acquired 1942

TOP
*During World War I there was a great migration
north by southern African Americans.* (panel 1)
Casein tempera on hardboard, 12 × 18 in.
(30.5 × 45.7 cm)

BOTTOM
There were lynchings. (panel 15)
Casein tempera on hardboard, 12 × 18 in.
(30.5 × 45.7 cm)

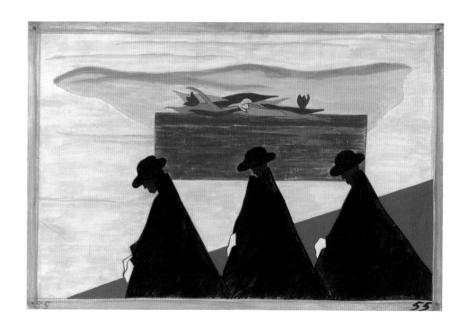

TOP
Tenant farmers received harsh treatment at the hands of planters. (panel 17)
Casein tempera on hardboard, 12 × 18 in.
(30.5 × 45.7 cm)

BOTTOM LEFT
African Americans seeking to find better housing attempted to move into new areas. This resulted in the bombing of their new homes. (panel 51)
Casein tempera on hardboard, 18 × 12 in.
(45.7 × 30.5 cm)

BOTTOM RIGHT
The migrants, having moved suddenly into a crowded and unhealthy environment, soon contracted tuberculosis. The death rate rose.
(panel 55)
Casein tempera on hardboard, 12 × 18 in.
(30.5 × 45.7 cm)

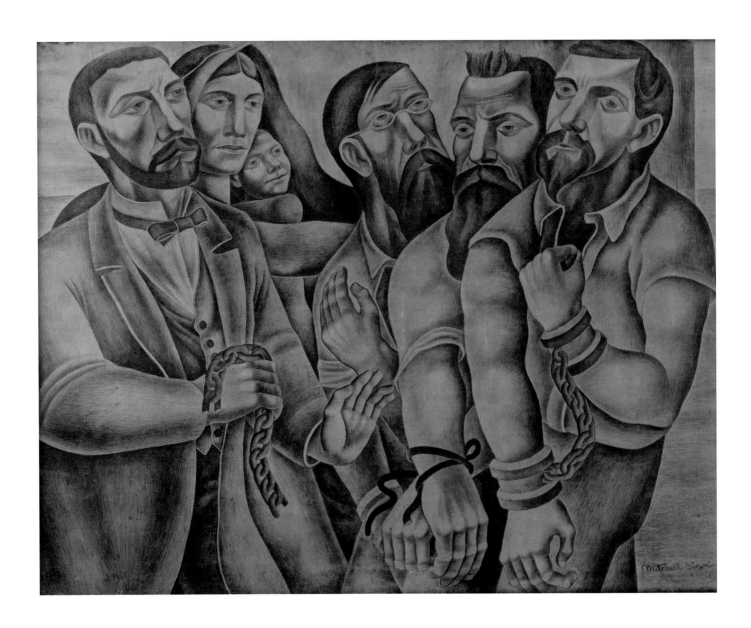

49 MITCHELL SIPORIN
Cartoon for Abraham Lincoln and John Peter Altgeld mural, U.S. Post Office, Decatur, Illinois, c. 1938
Charcoal on paper, 52 × 66 in. (132.2 × 167.7 cm)
University of Kentucky Art Museum, Lexington; allocated by the U.S. Government Federal Art Project 1943.2.31

50 EDWARD MILLMAN
Cartoon for Contribution of Women to the Progress of Mankind mural, Lucy Flower High School, Chicago, Illinois, 1936
Charcoal on paper, 94 ½ × 71 ⅝ in. (239.3 × 181.9 cm)
University of Kentucky Art Museum, Lexington; allocated by the U.S. Government Federal Art Project 1943.2.33

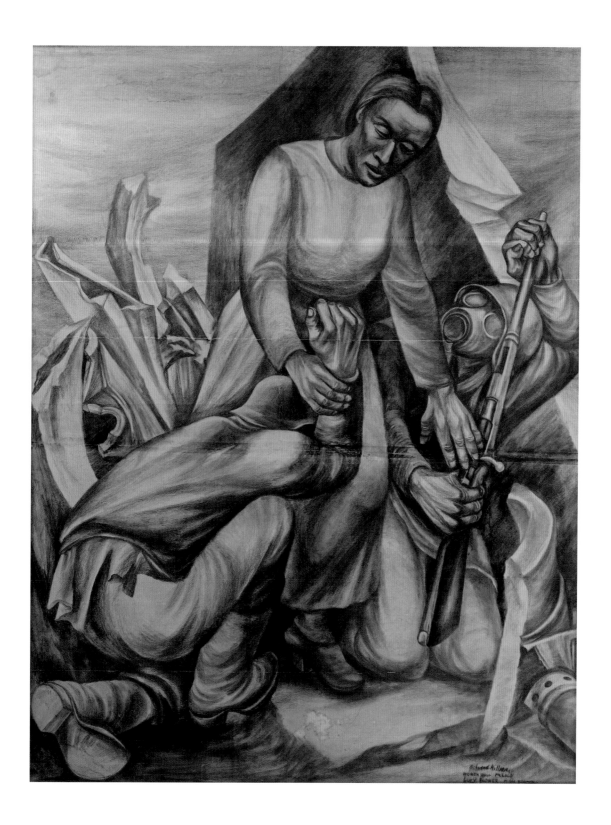

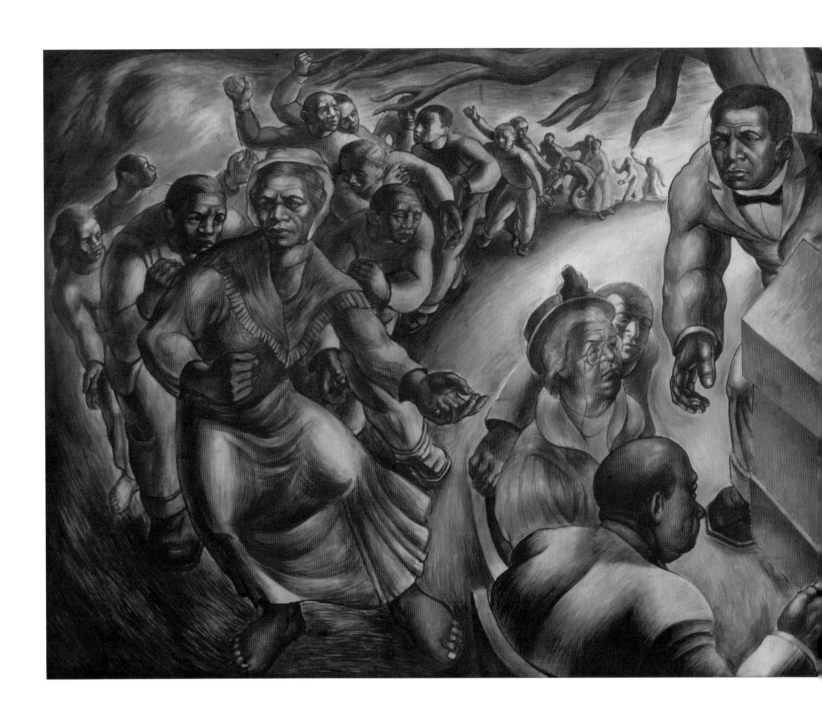

51 CHARLES WHITE
*Progress of the American Negro: Five Great
American Negroes*, 1939–40
Oil on canvas, 60 × 155 in. (152.4 × 393.7 cm)
Howard University Gallery of Art, Washington, DC

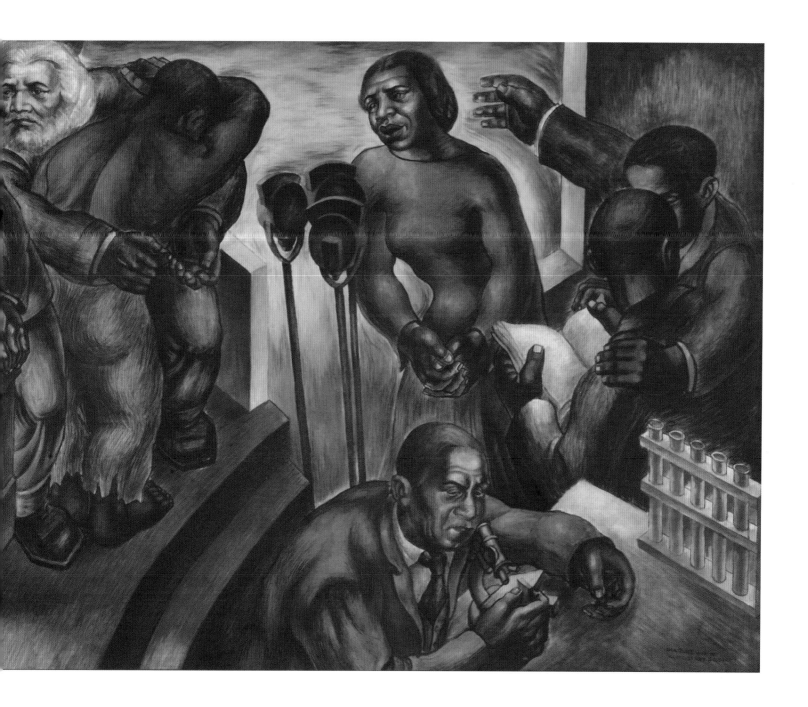

By the time Rivera arrived in California in 1930 for what would be his first extended stay in the United States, he had already garnered an international reputation as the most acclaimed artist to work on the Mexican government's public mural program of the early 1920s. With the opening of his retrospective at the Museum of Modern Art, New York, in 1931, he became "the most talked about artist this side of the Atlantic." Yet while Rivera's art in Mexico was deeply embedded with his fervent Marxist ideology, glorifying the revolution and savaging capitalist corruption, in the U.S. he embraced an altogether different subject matter—the abundance of the country's natural resources and its engineering and industrial achievements—while still maintaining his commitment to portraying the lives and work of everyday people. He expressed these themes in the three murals he created in San Francisco and in the twenty-seven-panel mural cycle he painted in the courtyard of the Detroit Institute of Arts between 1932 and 1933.

Artist George Biddle had spent time with Rivera in Mexico. Upon the inauguration of Biddle's former Harvard classmate Franklin Delano Roosevelt as president, he sent him a letter describing the success of the Mexican government's mural art program in building a sense of national unity, and he encouraged Roosevelt to create a similar program in the United States. A year later, the Roosevelt administration launched the first of what would be a succession of federally sponsored public art programs, putting thousands of artists to work over the next decade decorating public buildings across the country. Rivera's murals, with their detail-rich, descriptive style, crowded scenes, and uplifting imagery that celebrated the hard work of ordinary men and women, became a primary model for artists working under the auspices of Roosevelt's New Deal programs.

52 MARVIN BEERBOHM
Automotive Industry (mural, Detroit Public Library), 1940
Oil on canvas mounted on board, 79 ¾ × 190 ¼ in. (202.6 × 483.2 cm)
Smithsonian American Art Museum, Washington, DC; transfer from the Detroit Public Library 1968.141

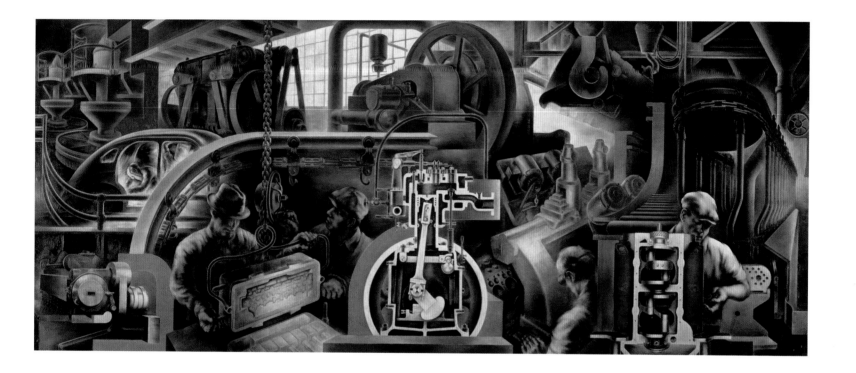

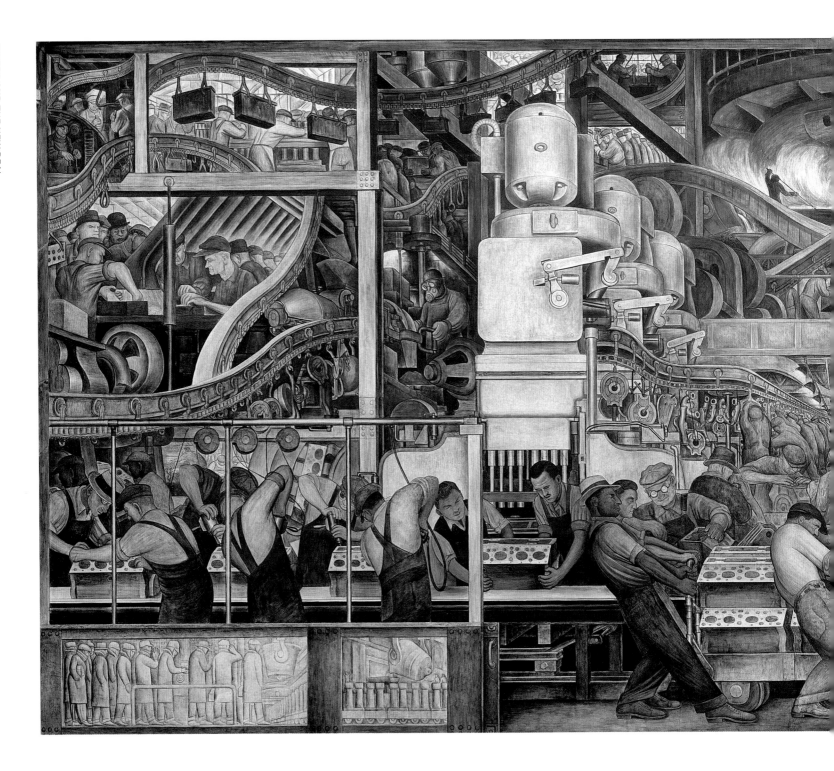

53 DIEGO RIVERA
Lower panel of *Detroit Industry, North Wall,*
1932–33
Fresco, 17 ft. 8 ½ in. × 45 ft. (5.4 × 13 m)
Detroit Institute of Arts; gift of Edsel B. Ford
33.10.N

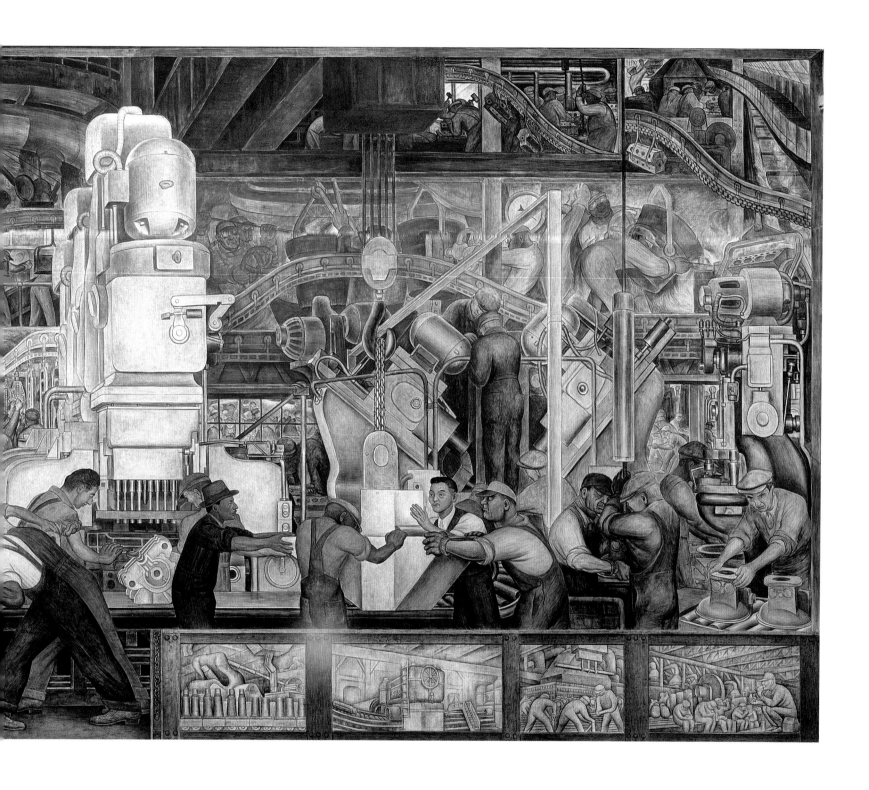

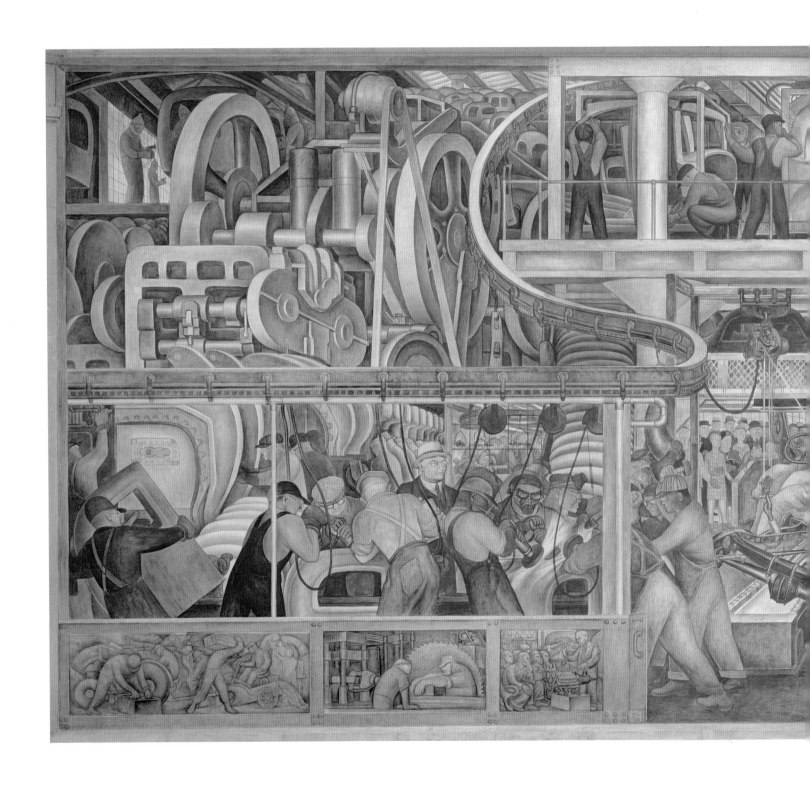

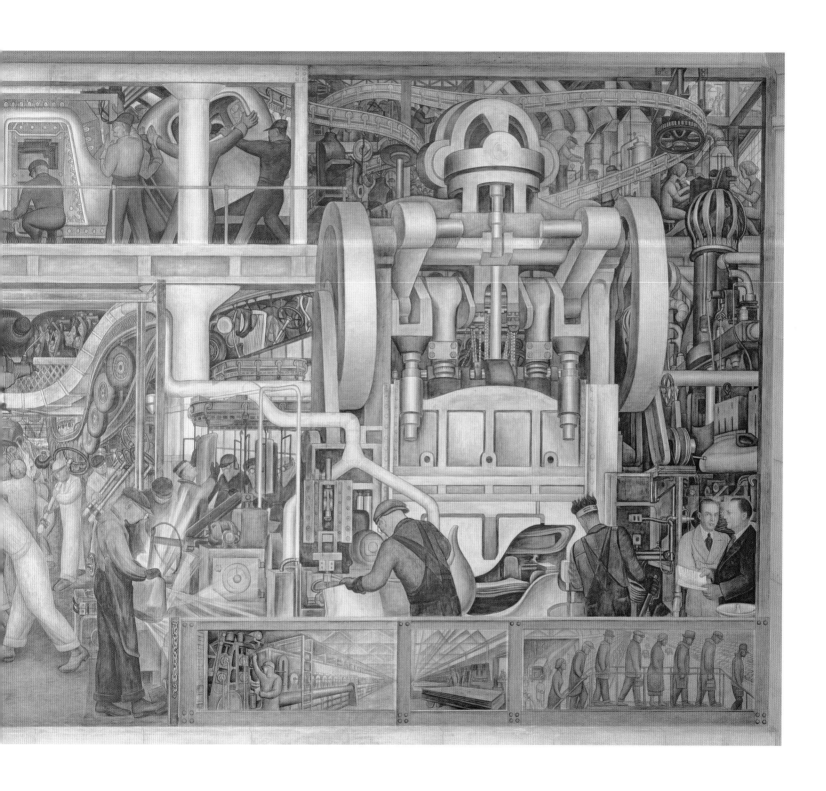

55 PHILIP GUSTON
Study for Queensbridge Housing Project, 1939
Colored pencil and ink on paper, 15 × 24 ¾ in.
(38.1 × 62.8 cm)
Private collection

56 SEYMOUR FOGEL
*Security of the People (Study for mural, Old Social
Security building, Washington, DC)*, 1941
Tempera on cardboard, 20 ⅜ × 26 ½ in.
(51.7 × 67.4 cm)
Smithsonian American Art Museum, Washington, DC;
transfer from the General Services Administration
1974.28.309

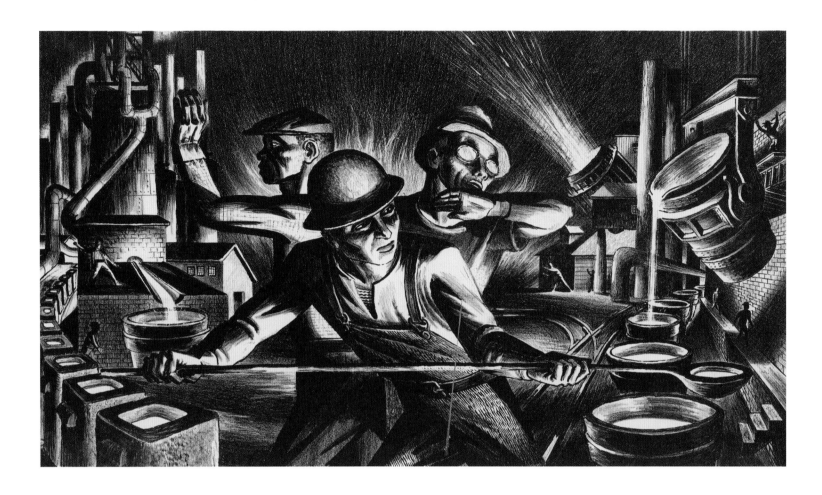

57 HARRY STERNBERG
Steel, 1937
Lithograph, sheet: 16 × 23 ¹⁄₁₆ in. (40.6 × 58.6 cm);
image: 11 ¾ × 20 ¾ in. (29.9 × 52.7 cm)
Whitney Museum of American Art, New York;
purchase with funds from The Lauder Foundation,
Leonard and Evelyn Lauder Fund 96.68.294

58 MARION GREENWOOD
*Construction Worker (study for Blueprint for
Living, a Federal Art Project mural, Red Hook
Community Building, Brooklyn, NY)*, 1940
Fresco mounted on composition board, 18 × 24 ½ in.
(45.7 × 62.2 cm)
Frances Lehman Loeb Art Center, Vassar College,
Poughkeepsie, New York; gift of Mrs. Patricia
Ashley 1976.44.11

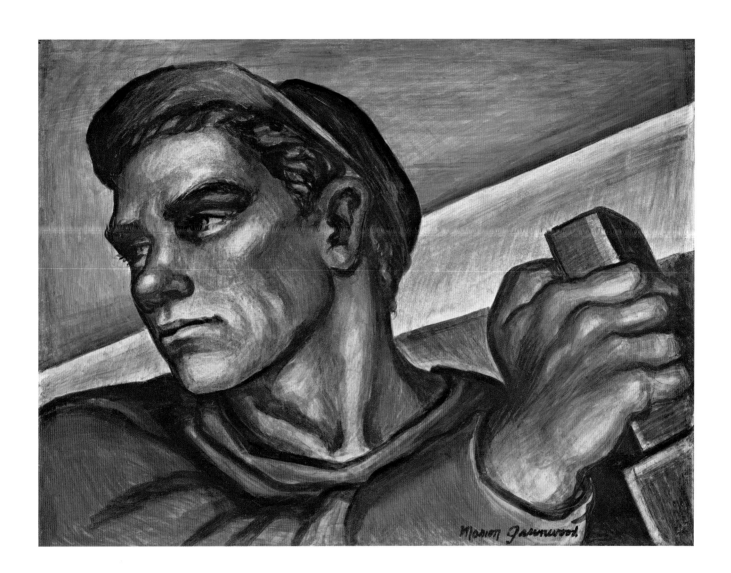

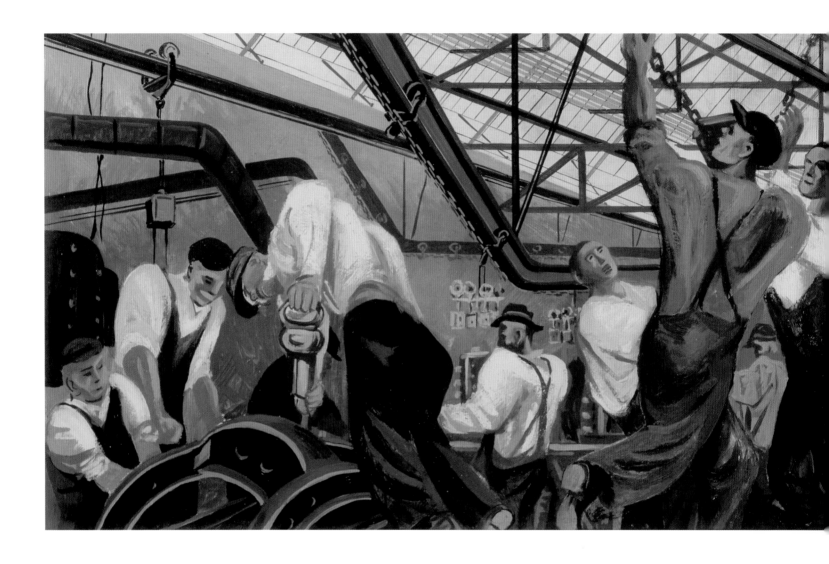

59 WILLIAM GROPPER
Automobile Industry (mural, Detroit, Michigan, Post Office), 1941
Oil on canvas, 72 × 240 in. (182.9 × 609.6 cm)
Smithsonian American Art Museum, Washington, DC; transfer from the Northwestern Post Office, Detroit, Michigan, through the General Services Administration 1971.1.2

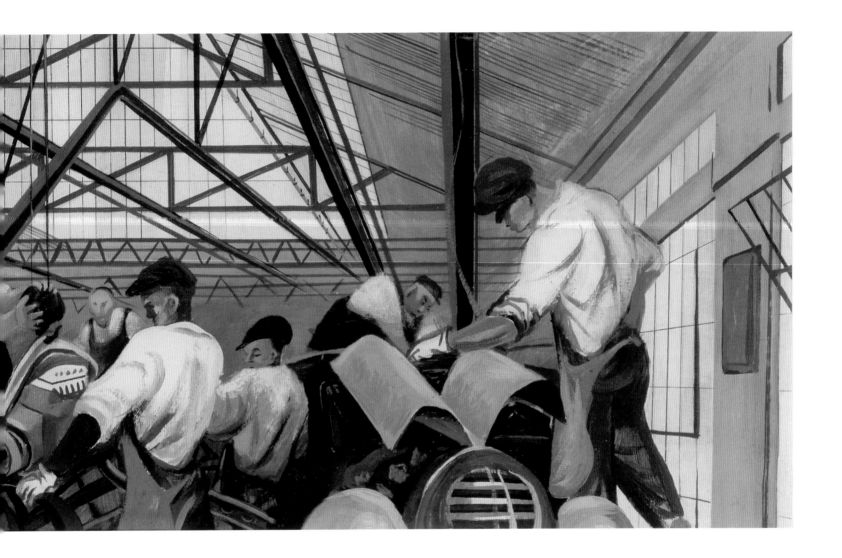

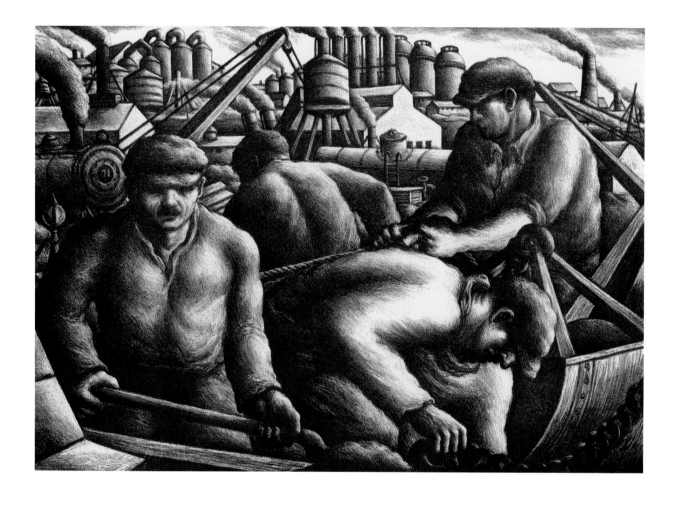

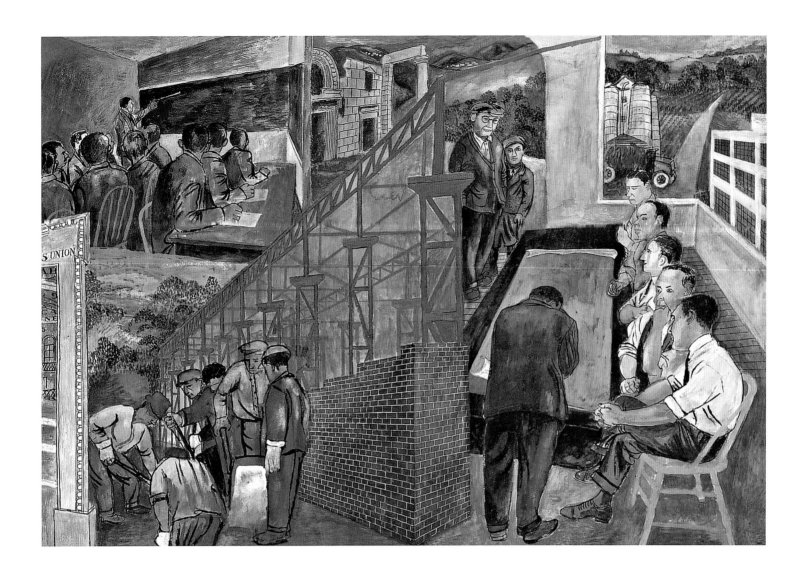

60 PAUL MELTSNER
Industrial Landscape, c. 1937
Lithograph, sheet: 11 7/16 × 15 15/16 in.
(29.1 × 40.5 cm); image: 10 3/8 × 14 5/8 in.
(26.4 × 37.2 cm)
Whitney Museum of American Art, New York;
purchase 38.3

61 BEN SHAHN
Study for Jersey Homesteads Mural, c. 1936
Tempera on paper mounted on composition board,
20 × 29 in. (50.8 × 73.7 cm)
Collection of Charles K. Williams II

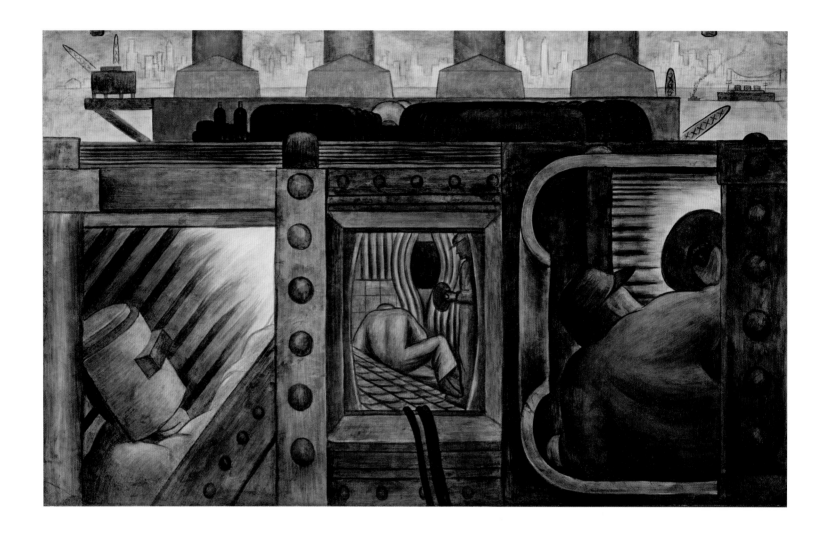

62 DIEGO RIVERA
Electric Power, 1932–32
Fresco on reinforced cement in a galvanized-steel
framework, 58 1/16 × 94 1/8 in. (147.5 × 239 cm)
Collection of Marcos and Vicky Micha Levy

63 THOMAS HART BENTON
Steel from *America Today*, 1930–31
Egg tempera with oil glazing over oil on linen
mounted on wood, 92 × 117 in. (233.7 × 297.2 cm)
The Metropolitan Museum of Art, New York; gift of
AXA Equitable, 2012

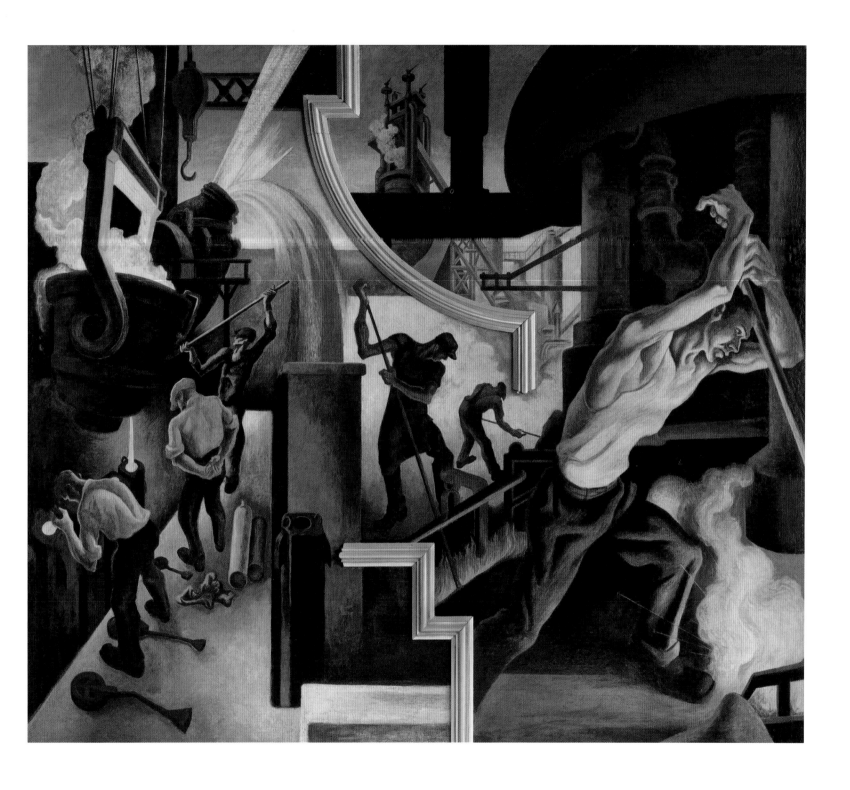

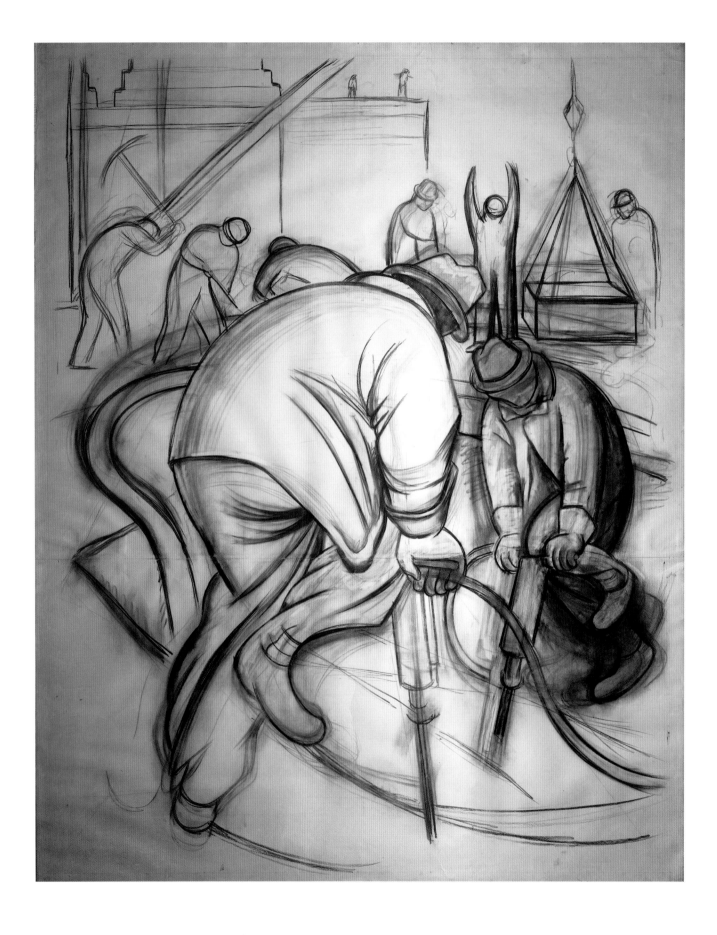

64 DIEGO RIVERA
Pneumatic Drilling, 1932–32
Charcoal on paper, 97 ¼ × 76 ⅞ in. (247 × 195.2 cm)
Museo Dolores Olmedo, Mexico City

65 HAROLD LEHMAN
The Driller (mural, Rikers Island, New York), 1937
Tempera on fiberboard, 92 ⅛ × 57 ⅛ in.
(233.9 × 145 cm)
Smithsonian American Art Museum, Washington, DC;
transfer from the Newark Museum 1966.31.11

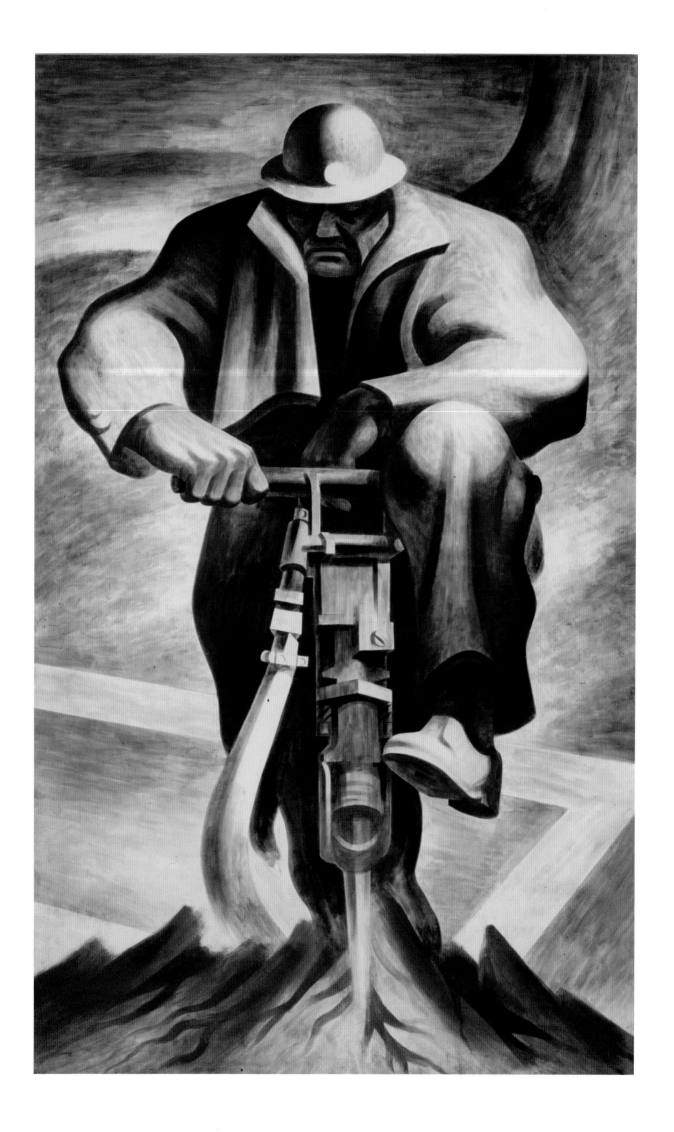

The economic and social turmoil that was unleashed by the 1929 stock market crash caused a reckoning for many Americans with a capitalist system that no longer seemed compatible with the country's democratic ideals. Taking their cue from the Mexican muralists whose work had valorized the struggle of the peasantry against an oppressive economic and political regime, U.S. artists rallied to join the fight against injustice and the abuses of capitalism by producing art that told uncomfortable truths about the nation's past and present. The epicenter of their activities was *New Masses*, the leading journal of the cultural left, and the Communist-affiliated John Reed Clubs that were active across the country from 1929 to 1935. While only a small number of American artists joined the Communist Party, Marxism was in the air, and many artists took as their rallying cry Lenin's admonition that art should be "imbued with the spirit of the class struggle."

For these artists, exposing the darker side of the American experience was necessary in order to provoke outrage and incite action that would lead to a more socially and politically just future. Among the most imperative subjects they addressed was racial injustice, at a time when lynching was still pervasive in the United States. Here too the Mexican artists provided a model, having portrayed the oppression of the Mexican peasant, including lynching, in their Mexican murals. Confronted with the scourge of racial discrimination and extrajudicial killings in the U.S., they took up the cause here as well. Together with American artists, they produced deeply disquieting works in response to the horrors of racist violence, believing that only when viewers were made uncomfortable would they be compelled to act.

66 DIEGO RIVERA
The Uprising, 1931
Fresco on reinforced cement in a galvanized-steel
framework, 74 × 94 ⅛ in. (188 × 239 cm)
Collection of Marcos and Vicky Micha Levy

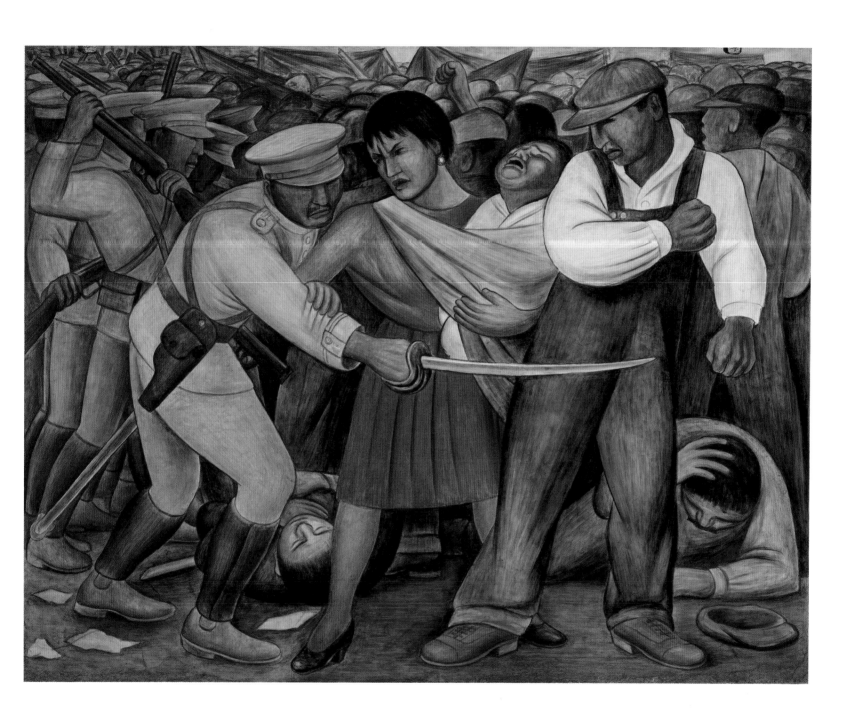

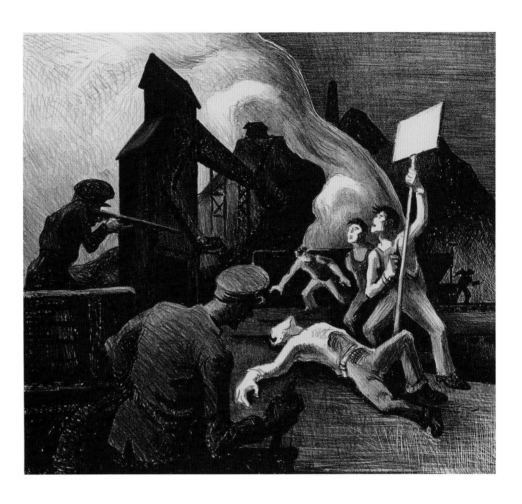

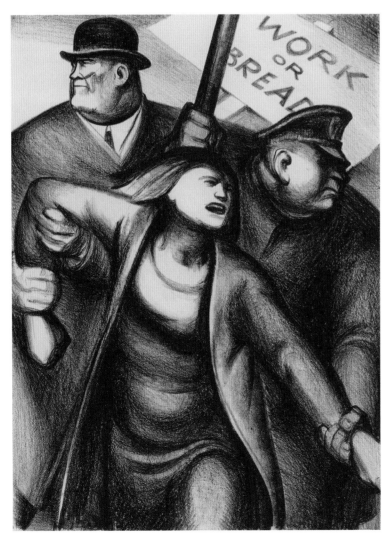

67 THOMAS HART BENTON
Mine Strike, 1933, from the portfolio
The American Scene, Series 2, 1933–34
Lithograph, sheet: 11 ½ × 16 in. (29.2 × 40.6 cm);
image: 9 ⅞ × 10 ¾ in. (25.1 × 27.3 cm)
Whitney Museum of American Art, New York;
purchase 34.37.1

68 JACOB BURCK
The Lord Provides, 1934, from the portfolio
The American Scene, no. 1, 1933–34
Lithograph, sheet: 16 × 11 ⁵⁄₁₆ in. (40.6 × 28.7 cm);
image: 12 × 9 in. (30.5 × 22.9 cm)
Whitney Museum of American Art, New York;
purchase 33.83.2

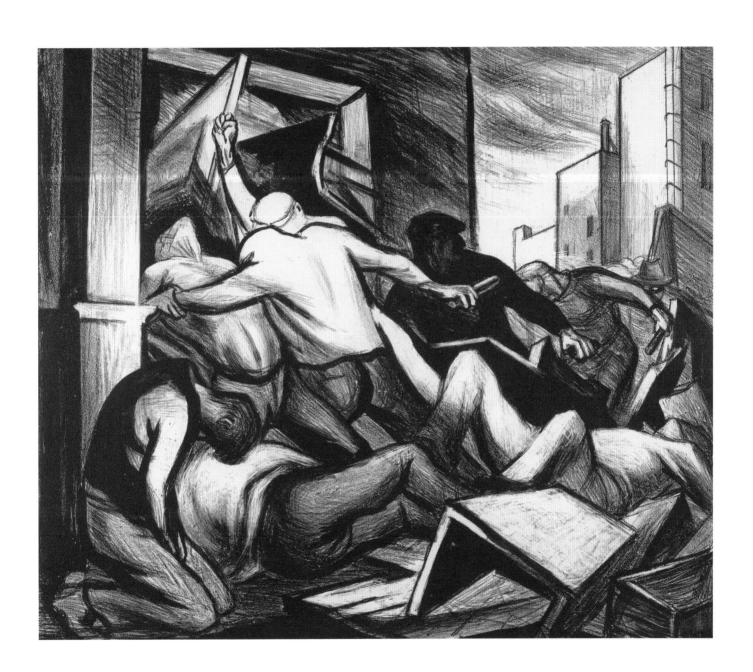

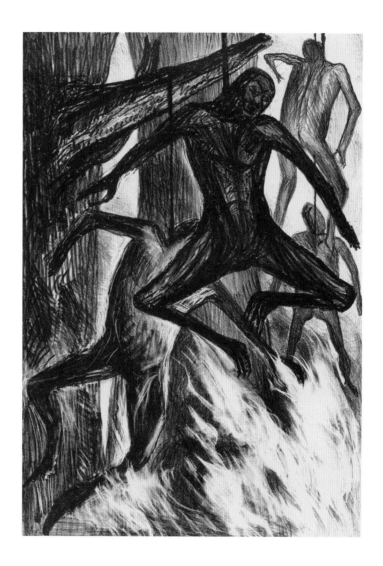

70 JOSÉ CLEMENTE OROZCO
Negroes (Hanged Men; Hanged Negroes; The Lynching), 1930 (printed 1933), from the portfolio *The American Scene, no. 1*, 1933–34
Lithograph, sheet: 15 ¹³⁄₁₆ × 11 ⁷⁄₁₆ in. (40.1 × 29.1 cm); image: 12 ¹¹⁄₁₆ × 8 ¹⁵⁄₁₆ in. (32.2 × 22.7 cm)
Whitney Museum of American Art, New York; purchase 33.83.6

71 ISAMU NOGUCHI
Death (Lynched Figure), 1934
Monel, steel, wood, and rope, 88 ¾ × 31 ⅞ × 22 ⅛ in. (225.4 × 81 × 56.2 cm)
The Isamu Noguchi Foundation and Garden Museum, New York

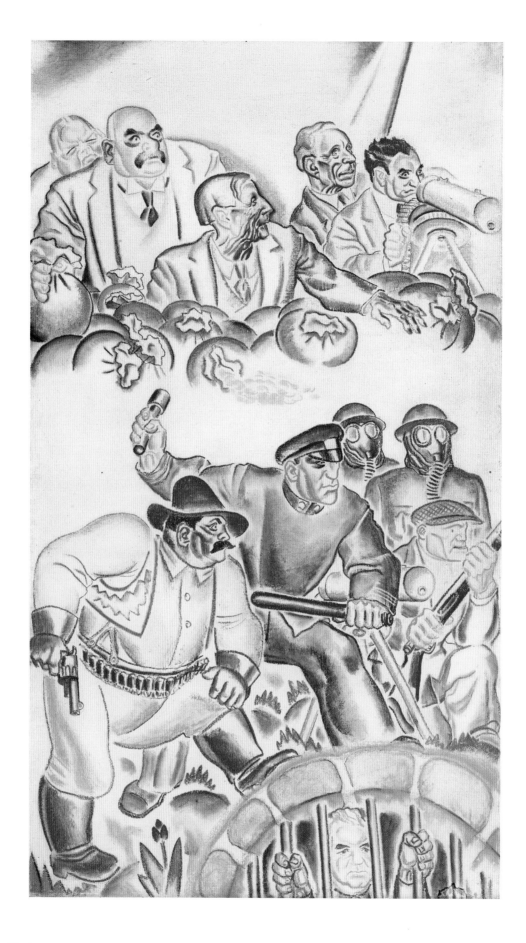

72 HUGO GELLERT
Us Fellas Gotta Stick Together or The Last
Defenses of Capitalism, 1932
Chalk on composition board and plaster, 85 × 49½ in.
(215.9 × 125.7 cm)
The Wolfsonian–Florida International University,
Miami Beach; The Mitchell Wolfson Jr. Collection
87.1462.5.2.2

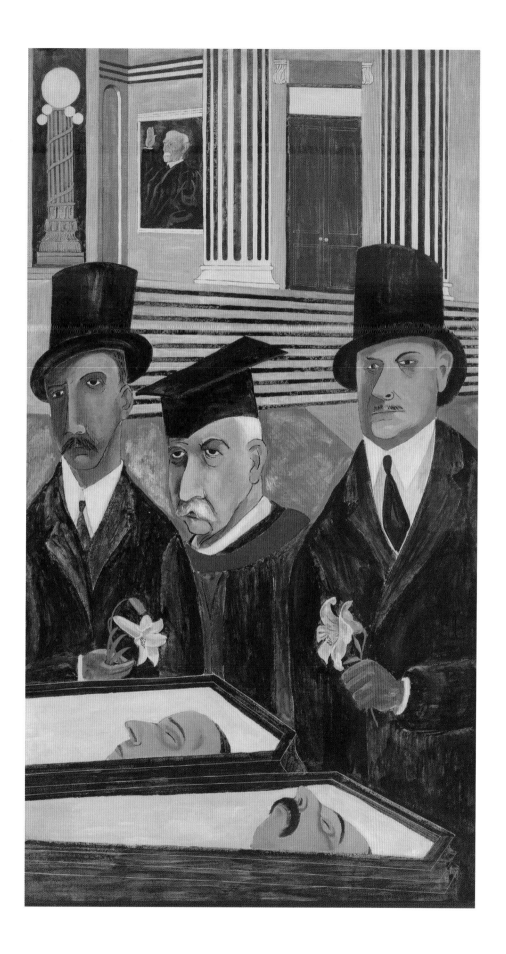

73 BEN SHAHN
The Passion of Sacco and Vanzetti, 1932
Tempera and gouache on canvas, 84 × 48 in.
(213.4 × 121.9 cm)
Whitney Museum of American Art, New York;
gift of Edith and Milton Lowenthal 49.22

74 JULIUS BLOCH
Prisoner, 1934
Lithograph, sheet: 17 ½ × 13 ¹³⁄₁₆ in. (44.5 × 35.1 cm);
image: 13 ½ × 10 in. (34.3 × 25.4 cm)
Whitney Museum of American Art, New York;
purchase 34.35

75 PAUL CADMUS
To the Lynching!, 1935
Graphite pencil and watercolor on paper, 23 ½ × 18 in.
(59.7 × 45.7 cm)
Whitney Museum of American Art, New York;
purchase 36.32

76 JESÚS ESCOBEDO
Discrimination "K K K", 1940
Lithograph, 25 ½ × 19 ⅝ in. (64.8 × 49.9 cm)
Los Angeles County Museum of Art; gift of Jules
and Gloria Heller M.2003.92.42

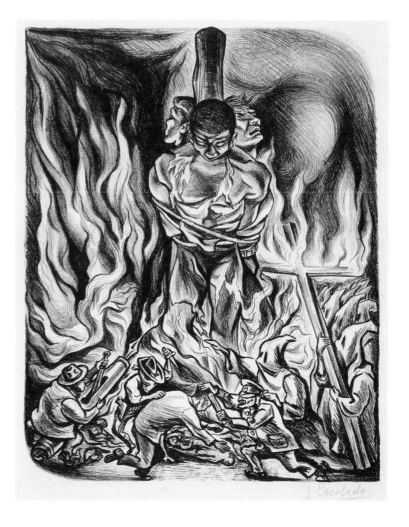

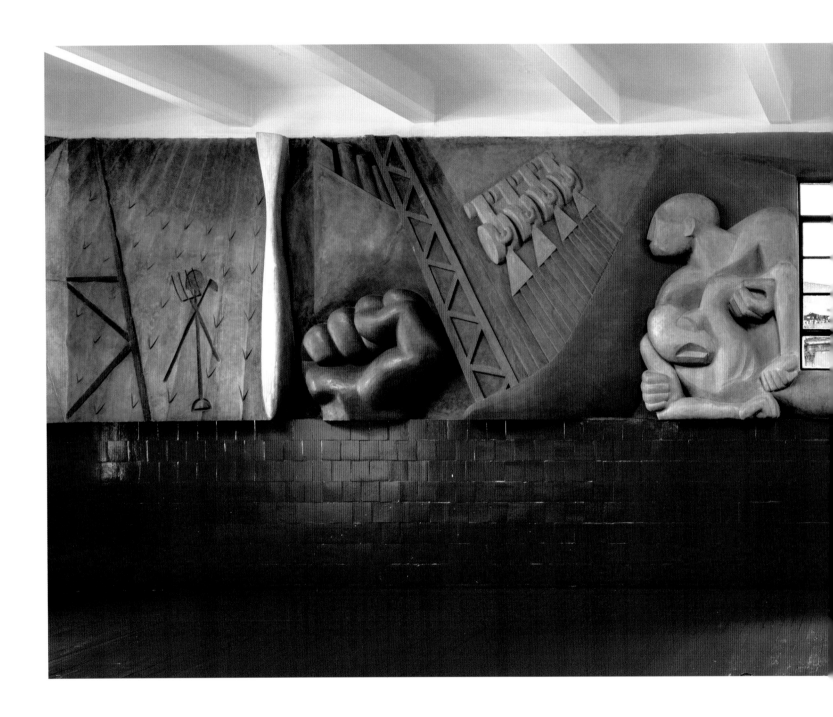

77 ISAMU NOGUCHI
History as Seen from Mexico in 1936, 1936
Cement, brick, and pigment, 7 ft. 9 ¼ in. ×
72 ft. 4 ½ in. × 9 ⅞ in. (2.4 × 22 × 0.3 m) overall
Abelardo L. Rodríguez Market, Mexico City

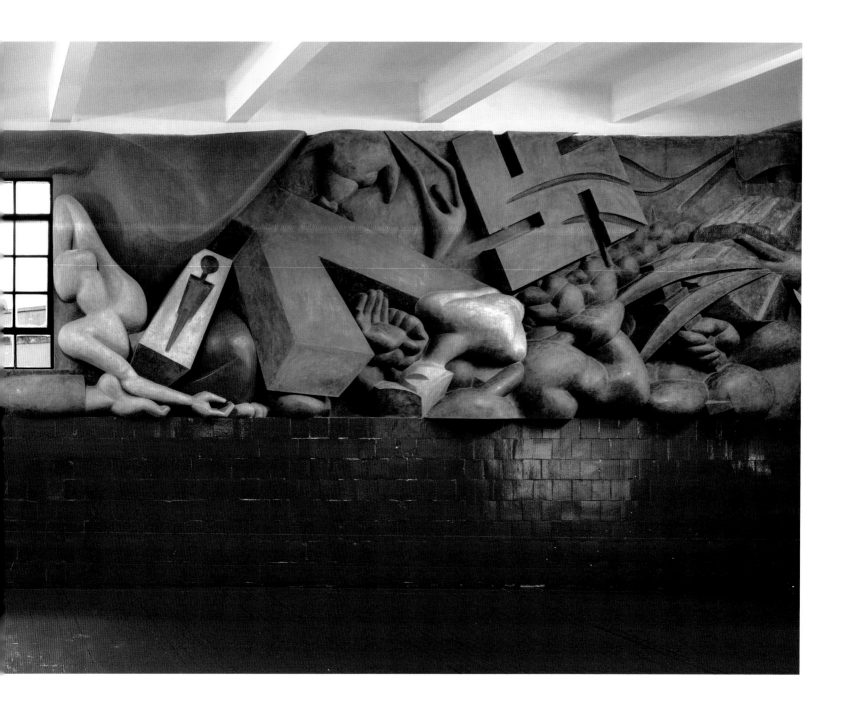

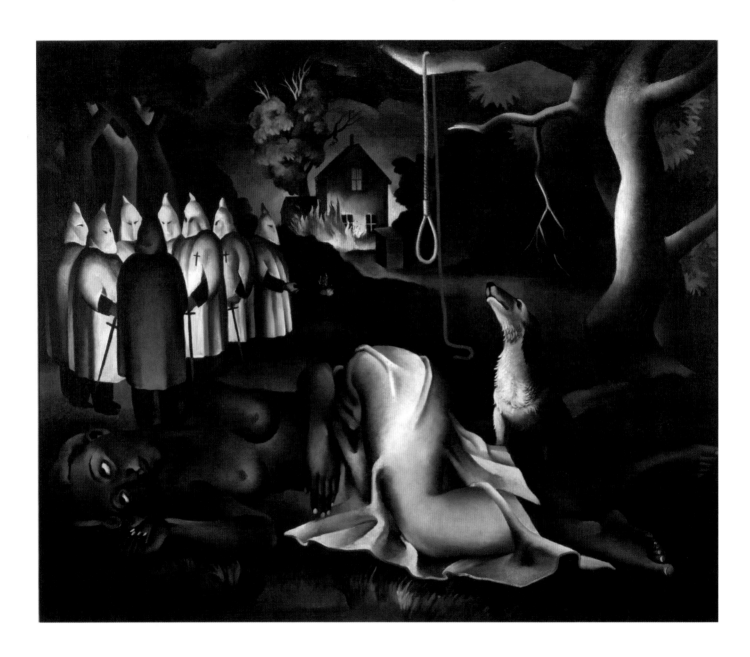

78 JOE JONES
American Justice, 1933
Oil on canvas, 30 × 36 in. (76.2 × 91.4 cm)
Columbus Museum of Art, Ohio; purchase, Derby
Fund, from the Philip J. and Suzanne Schiller
Collection of American Social Commentary Art
1930–1970 2005.012.032

79 DAVID ALFARO SIQUEIROS
Cain in the United States, 1947
Pyroxilin on wood, 30 ⁵/₁₆ × 36 ⁵/₈ in. (77 × 93 cm)
Museo de Arte Carrillo Gil, INBA, Mexico City

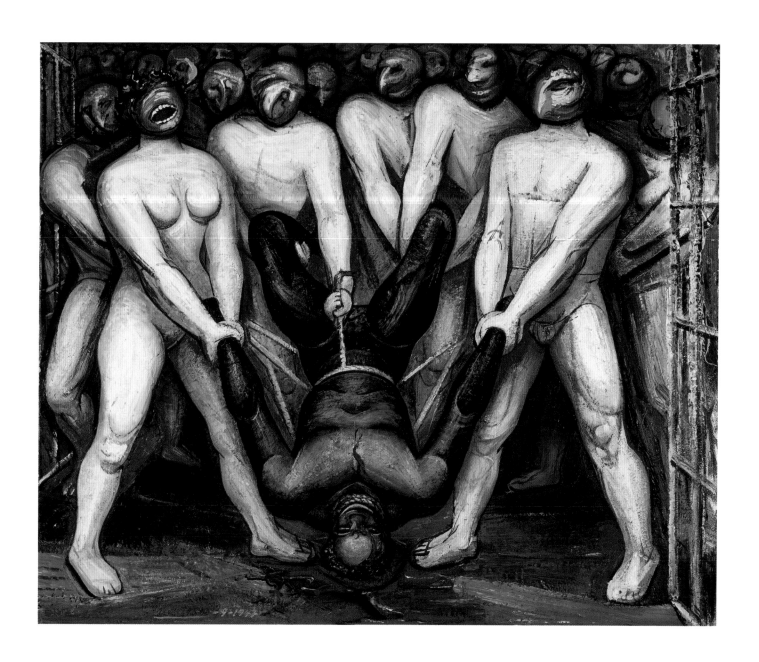

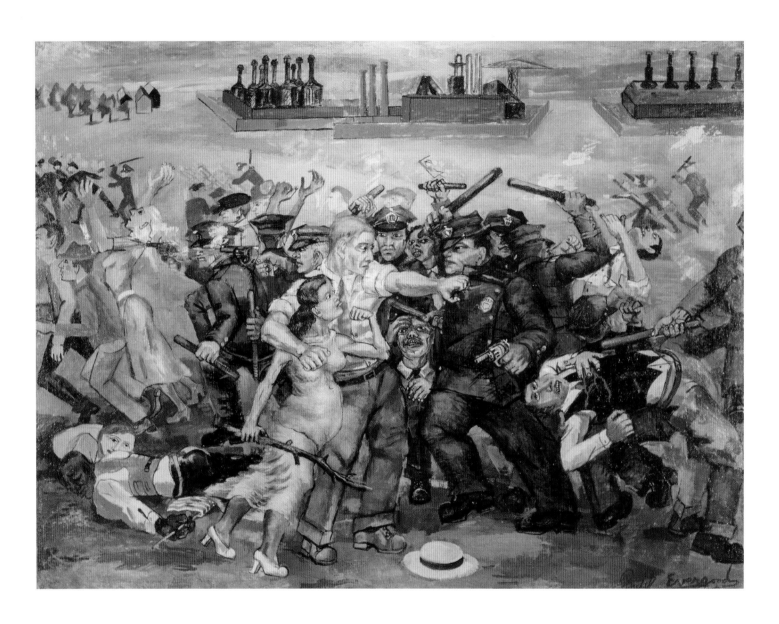

80 PHILIP EVERGOOD
American Tragedy, 1937
Oil on canvas, 29 ½ × 39 ½ in. (74.9 × 100.3 cm)
Collection of Harvey and Harvey-Ann Ross

81 WILLIAM GROPPER
Youngstown Strike, c. 1937
Oil on canvas, 20 × 40 in. (50.8 × 101.6 cm)
The Butler Institute of American Art, Youngstown,
Ohio; museum purchase 1985

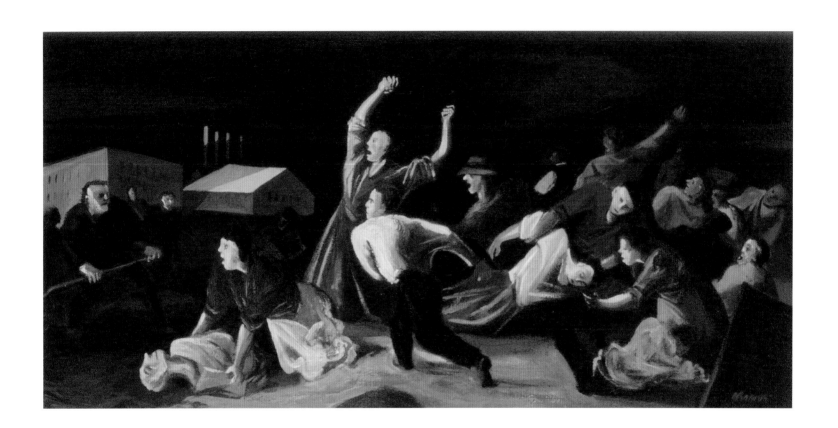

82 THOMAS HART BENTON
Bootleggers, 1927
Egg tempera and oil on linen mounted on
composition board, 65 × 72 in. (165.1 × 182.9 cm)
Reynolda House Museum of American Art,
Winston-Salem, North Carolina; museum purchase
with funds provided by Barbara B. Millhouse
1971.2.1

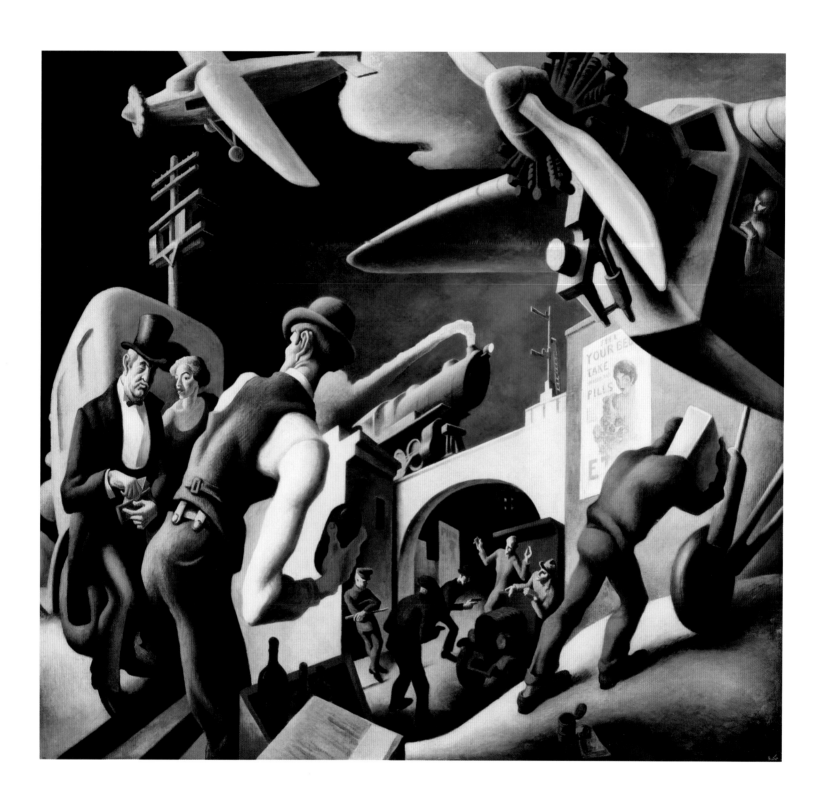

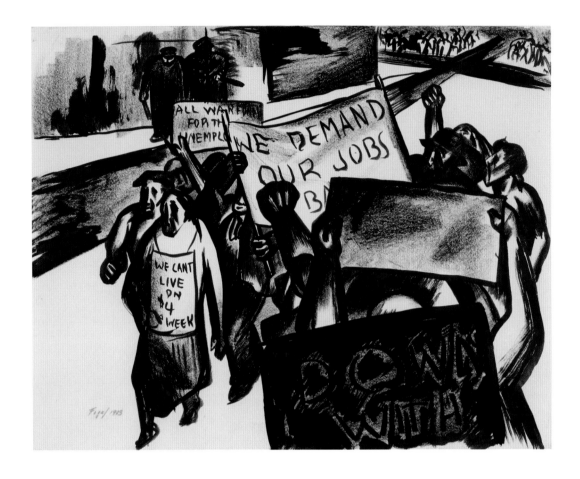

83 SEYMOUR FOGEL
We Demand Our Jobs, 1933
Ink and wash on paper, 16 × 20 in. (40.6 × 50.8 cm)
Childs Gallery, Boston

84 EITARŌ ISHIGAKI
Soldiers of the People's Front (The Zero Hour),
c. 1936–37
Oil on canvas, 58 ½ × 81 ½ in. (148.6 × 207 cm)
The Museum of Modern Art, Wakayama, Japan

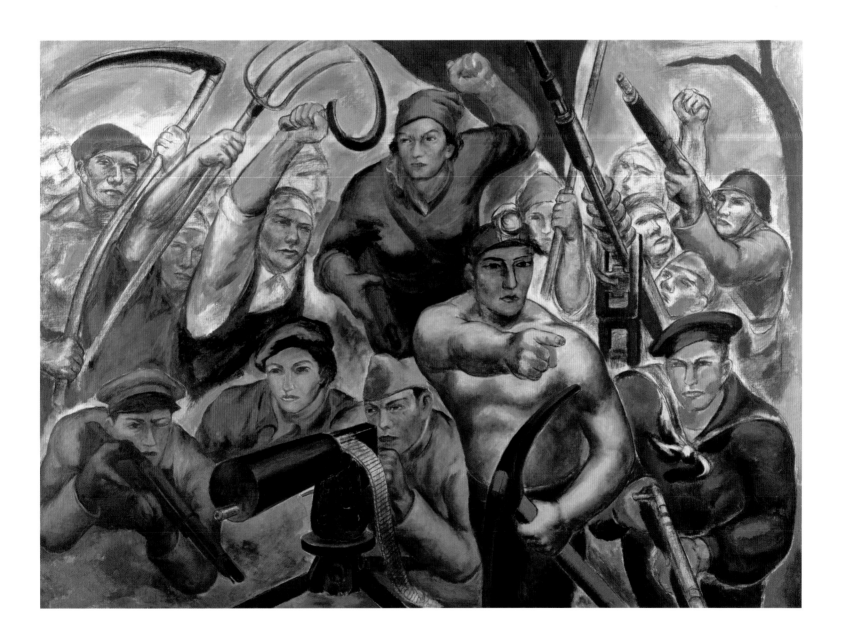

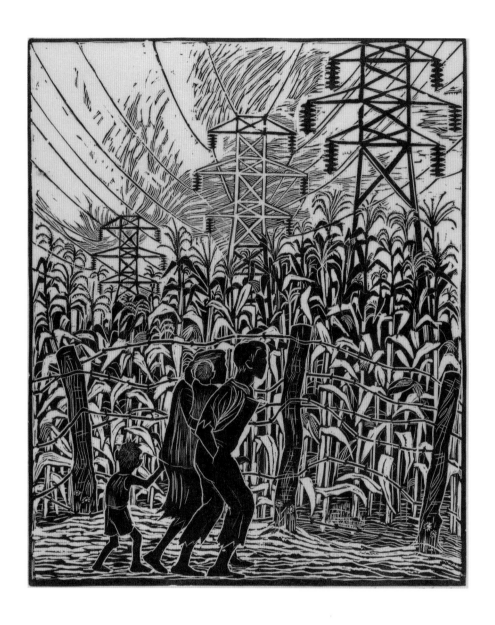

85 LUCIENNE BLOCH
Land of Plenty, 1936
Woodcut, sheet: 16 ¼ × 12 in. (41.3 × 30.6 cm);
image: 10 ⅝ × 8 ¾ in. (27 × 22.3 cm)
National Gallery of Art, Washington, DC; Reba and
Dave Williams Collection; gift of Reba and Dave
Williams 2008.115.944

86 BELLE BARANCEANU
Building Mission Dam, 1938
Pastel and ink on tracing paper, 28 ¼ × 12 ½ in.
(71.8 × 31.8 cm)
San Diego History Center 80.26.7A

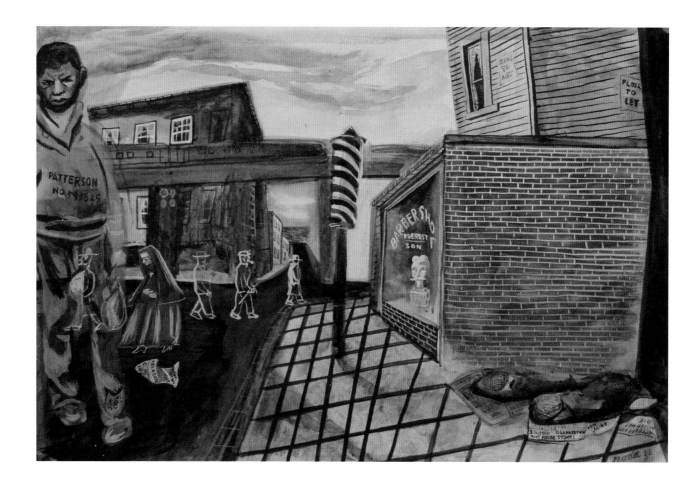

87 HIDEO BENJAMIN NODA
Scottsboro Boys, 1933
Gouache on board, 10 ⅝ × 16 in. (26.9 × 40.6 cm)
Mizoe Art Gallery, Fukuoka/Tokyo, Japan

88 ELIZABETH CATLETT
War Worker, 1943
Tempera on paper mounted to composition board,
11 ¼ × 9 ¼ in. (28.6 × 23.5 cm)
The Johnson Collection, Spartanburg,
South Carolina

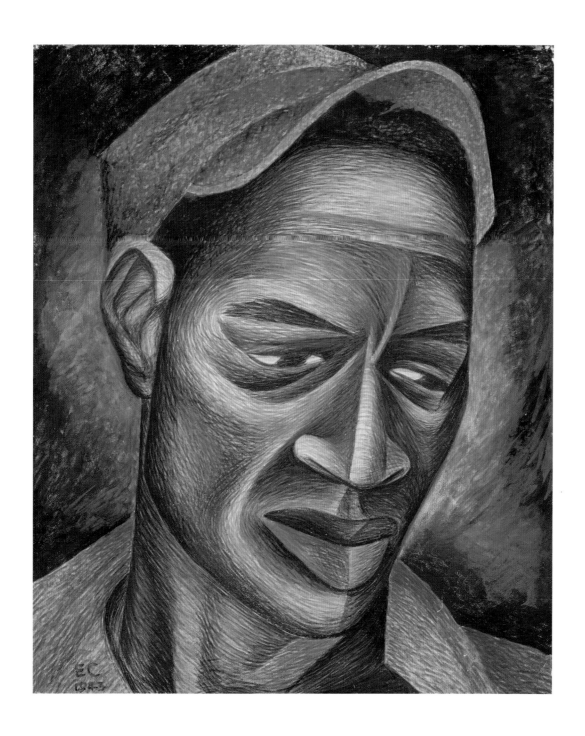

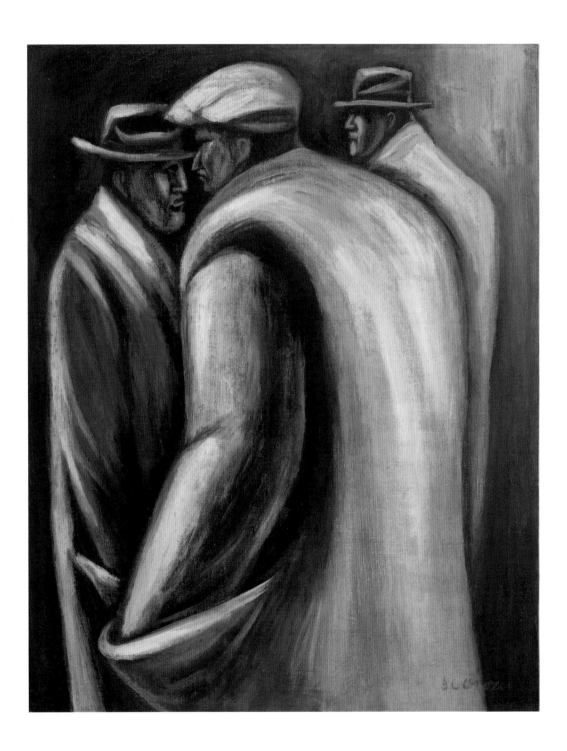

89 JOSÉ CLEMENTE OROZCO
The Unemployed, c. 1929
Oil on canvas, 25 ½ × 20 ½ in. (65 × 52 cm)
Kaluz Collection, Mexico City

90 JOE JONES
We Demand, 1934
Oil on composition board, 48 × 36 in. (121.9 × 91.4 cm)
The Butler Institute of American Art, Youngstown,
Ohio; gift of Sidney Freedman 1948

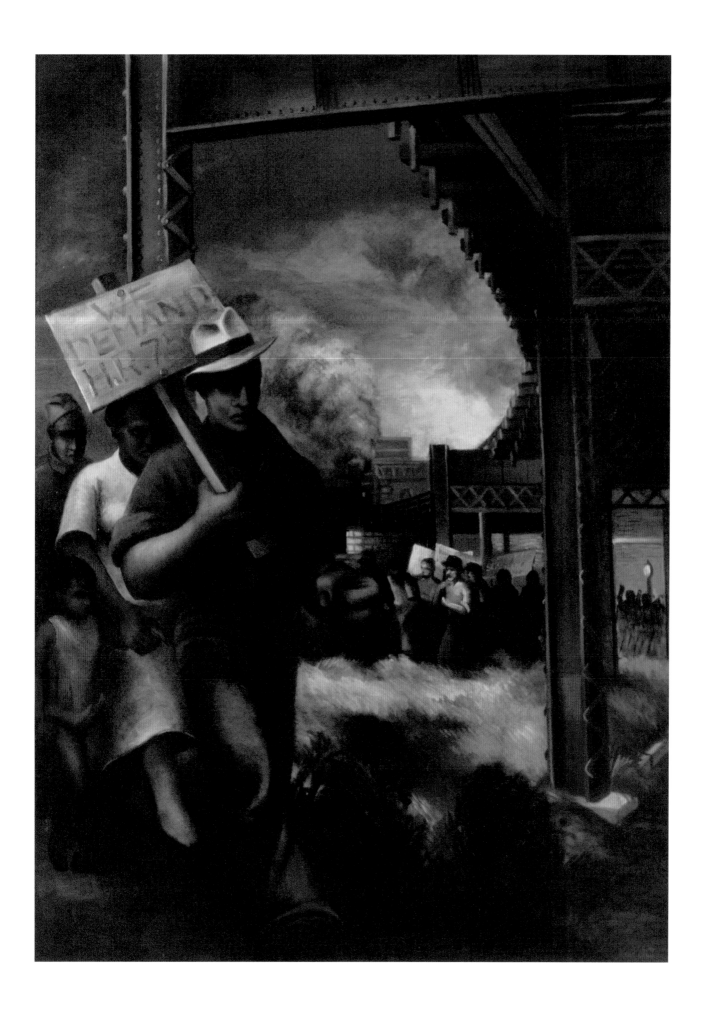

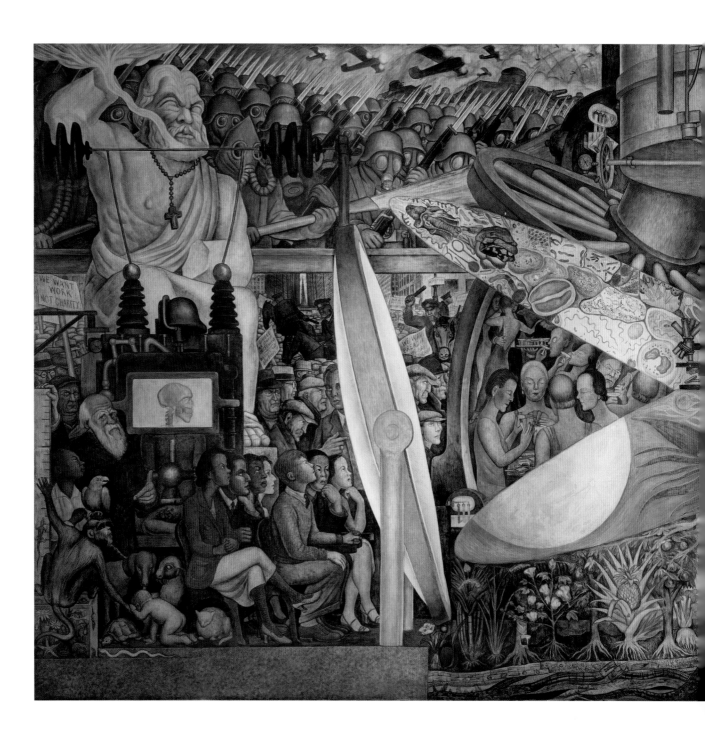

91 DIEGO RIVERA
Man, Controller of the Universe, 1934
Fresco, 15 ft. 9 in. × 37 ft. 6 in. (4.8 × 11.4 m)
Palacio de Bellas Artes, INBA, Mexico City

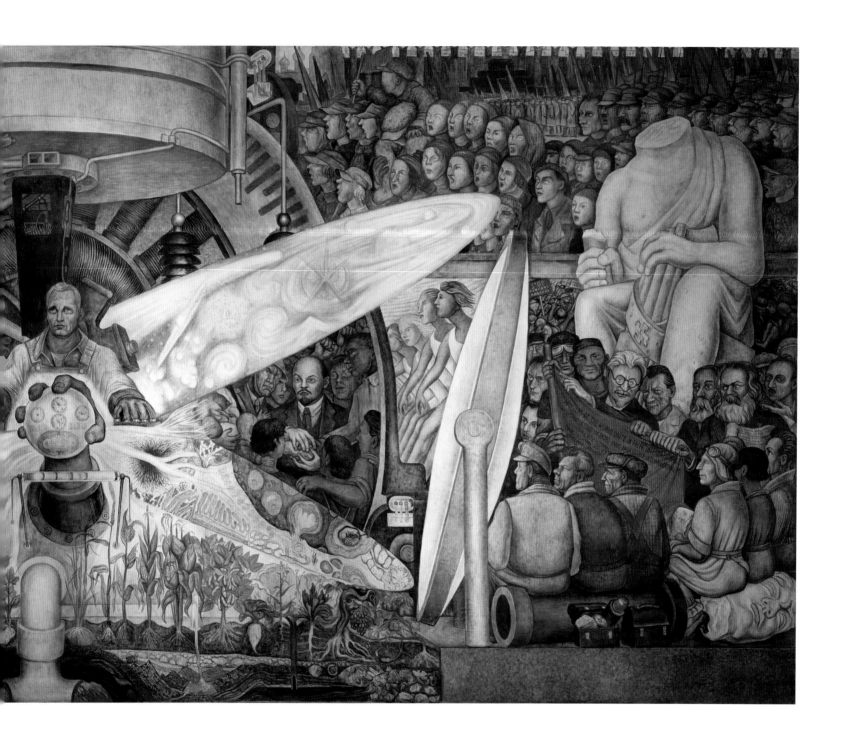

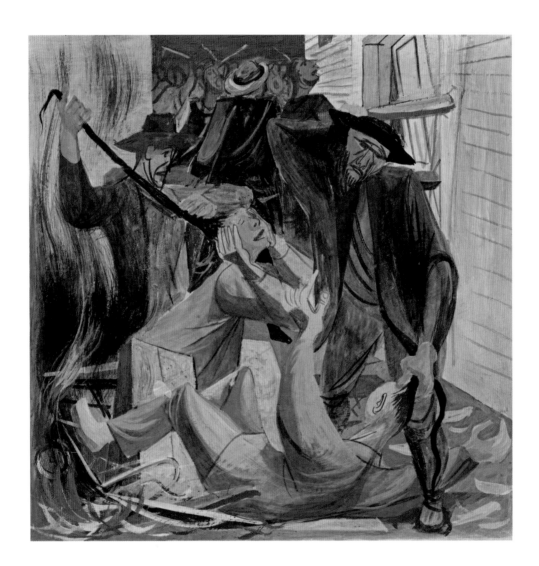

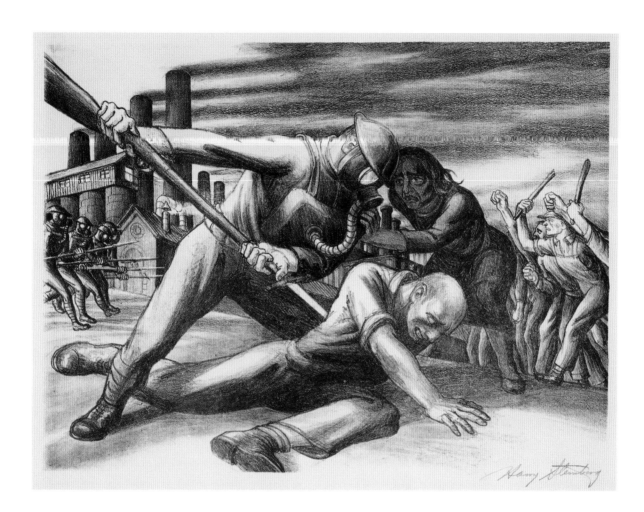

92 ANTON REFREGIER
Sand Lot riots, color sketch for Rincon Annex,
Post Office, San Francisco, California, c. 1946–47
Tempera and watercolor on composition board
with gesso, 18 ¾ × 16 in. (47.6 × 40.6 cm)
Frances Lehman Loeb Art Center, Vassar College,
Poughkeepsie, New York; gift of Susan and Steven
Hirsch, class of 1971 2015.23.1.21

93 HARRY STERNBERG
Industrial Landscape, 1934
Lithograph, sheet: 20 ⅜ × 25 in. (51.8 × 63.5 cm);
image: 13 × 17 ¾ in. (33 × 45.1 cm)
Crystal Bridges Museum of American Art,
Bentonville, Arkansas 2012.425

94 EITARŌ ISHIGAKI
The Bonus March, 1932
Oil on canvas, 56 ⅞ × 41 ¹¹⁄₁₆ in. (144.5 × 105.9 cm)
The Museum of Modern Art, Wakayama, Japan

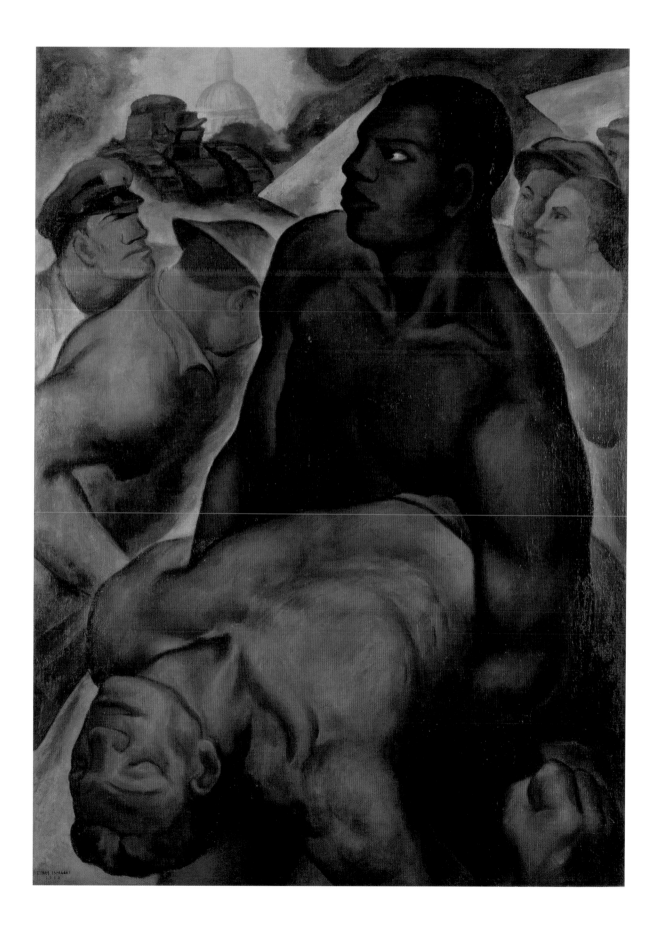

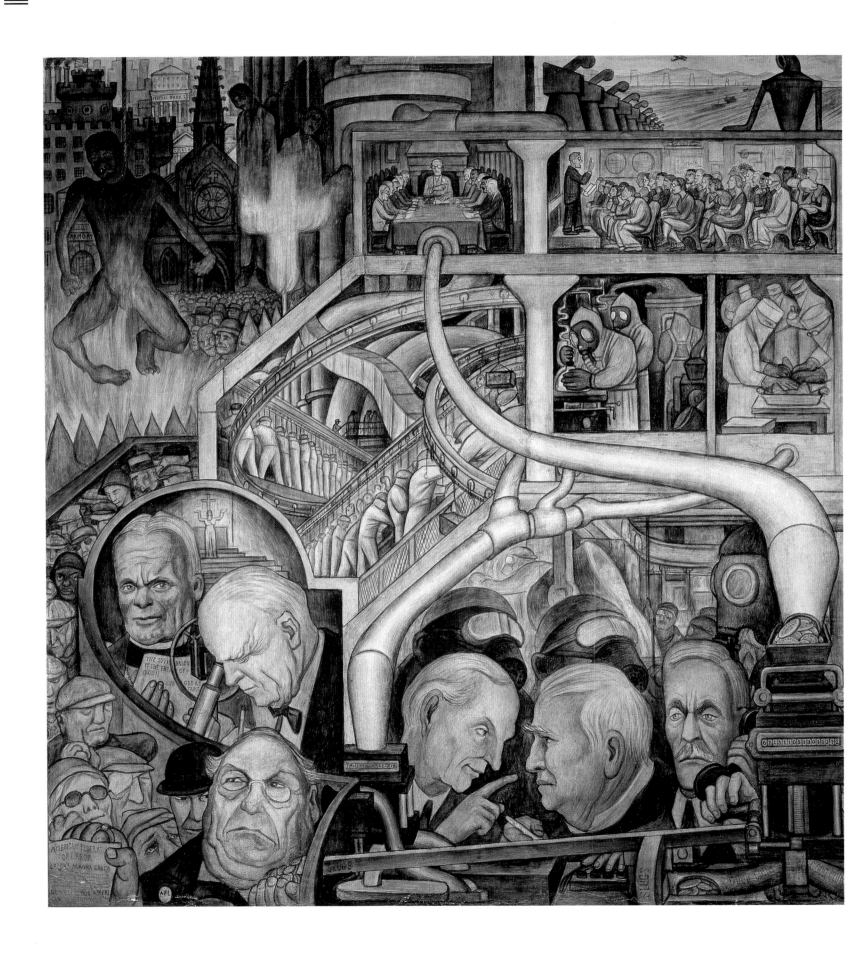

95 DIEGO RIVERA
Modern Industry from *Portrait of America*, 1933
Fresco, 70 $\frac{1}{16}$ × 71 $\frac{5}{8}$ in. (178 × 182 cm)
Sindicato Nacional de Trabajadores de la
Educación, Mexico

96 DIEGO RIVERA
World War from *Portrait of America*, 1933
Fresco, 70 $\frac{1}{16}$ × 71 $\frac{5}{8}$ in. (178 × 182 cm)
Sindicato Nacional de Trabajadores de la
Educación, Mexico

97 DIEGO RIVERA
The New Freedom from *Portrait of America*, 1933
Fresco, 70 $\frac{1}{16}$ × 71 $\frac{5}{8}$ in. (178 × 182 cm)
Sindicato Nacional de Trabajadores de la
Educación, Mexico

SIQUEIROS IN LOS ANGELES AND NEW YORK

The most politically militant and ideologically orthodox of the leading Mexican muralists, Siqueiros arrived in Los Angeles in mid-April 1932 preceded by his reputation as a revolutionary activist and member of the by-then-outlawed Mexican Communist Party. The three murals he made during his eight-month stay in L.A. each embodied his ardent belief that revolutionary art for the people should be revolutionary not only in its content but also in its materials and techniques—as expressed in particular in his largest and most controversial mural, *Tropical America*. Inspired by his encounters with the Hollywood movie industry and, more broadly, with U.S. industrial technology, Siqueiros experimented with the use of spray guns, blowtorches, airbrushes, and photo projections, and emphasized a collectivist approach to art making by assembling a "Bloc of Mural Painters," among them Luis Arenal, Philip Guston (then Goldstein), Reuben Kadish, and Fletcher Martin. Siqueiros's synthesis of the solid, monumental forms of Aztec and Olmec sculpture with the swirling brushwork and sweeping rhythms of Baroque art to portray the Mexican proletarian struggle against racism, imperialism, and capitalist exploitation mesmerized artists in Los Angeles. As Kadish later asserted: "Siqueiros coming to L.A. meant as much then as did the Surrealists coming to New York in the forties."

Siqueiros returned to the United States two more times, in 1934 and 1936, both times to New York. During the latter stay, he established the Experimental Workshop on West 14th Street as a laboratory of modern aesthetic techniques. Under his direction, workshop artists produced large-scale paintings, posters, and floats for political events. Pushing his technical experiments further, Siqueiros encouraged a freewheeling approach that included pouring and dripping paint onto canvas tacked to the floor. Jackson Pollock's participation in the workshop was key to his aesthetic development in alerting him to the possibilities of scale, controlled accidents, and unconventional materials and techniques.

98 DAVID ALFARO SIQUEIROS
Proletarian Mother, 1929
Oil on burlap, 98 1/16 × 70 7/8 in. (249 × 180 cm)
Museo Nacional de Arte, INBA constitutive
collection, 1982

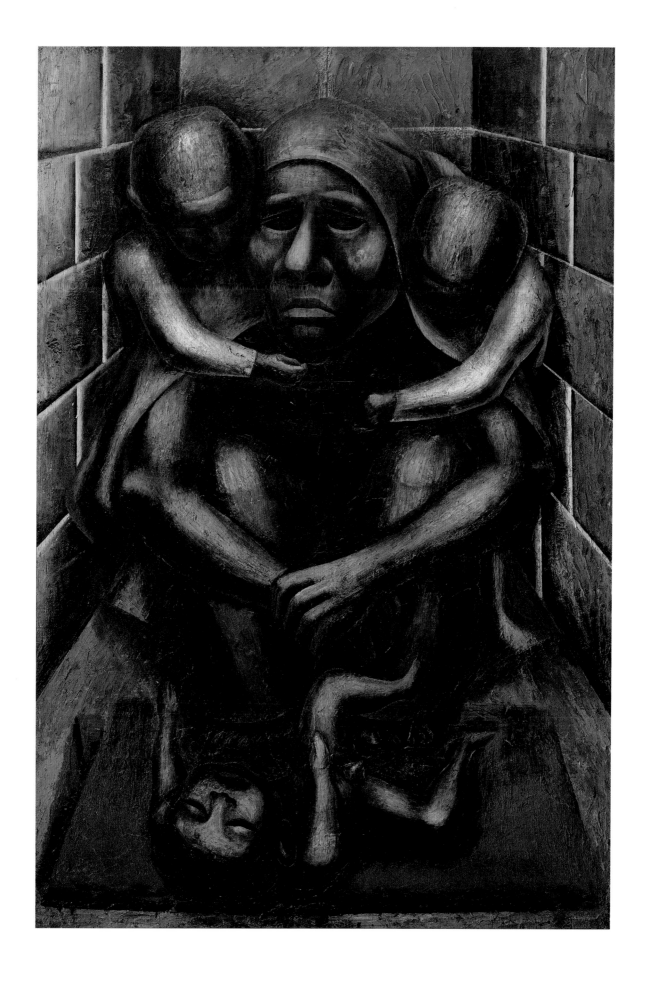

99 DAVID ALFARO SIQUEIROS
Tropical America, 1932
Fresco applied with Arium on cement, 18 × 82 ft.
(5.5 × 25 m)
Italian Hall, El Pueblo de Los Angeles Historic
Monument

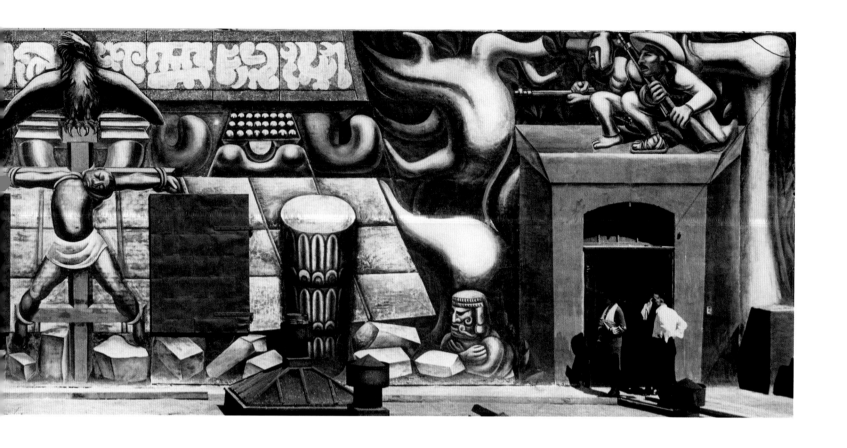

100 LUIS ARENAL
Woman Carrying a Coffin, c. 1936
Nitrocellulose and oil on wood, 27 × 17 in.
(68.6 × 43.2 cm)
Los Angeles County Museum of Art; gift of Electa
Arenal and Julie Arenal Primus M.2001.201

101 DAVID ALFARO SIQUEIROS
Mine Accident, 1931
Oil on burlap, 54 ¾ × 88 ³⁄₁₆ in. (139 × 224 cm)
Museo Nacional de Arte, INBA, Mexico City; INBA
acquisition, 1996

102 FLETCHER MARTIN
Trouble in Frisco, 1938
Oil on canvas, 30 × 36 in. (76.2 × 91.4)
The Museum of Modern Art, New York; Abby
Aldrich Rockefeller Fund

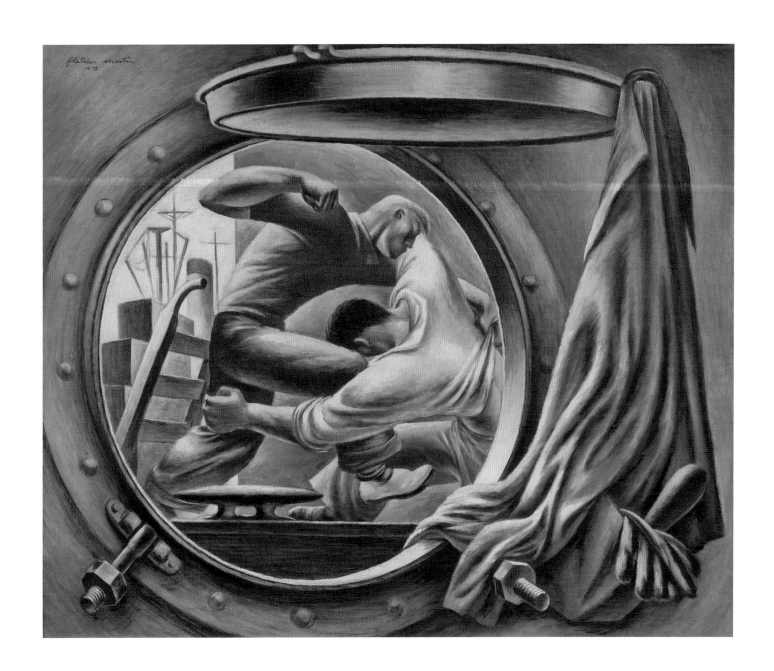

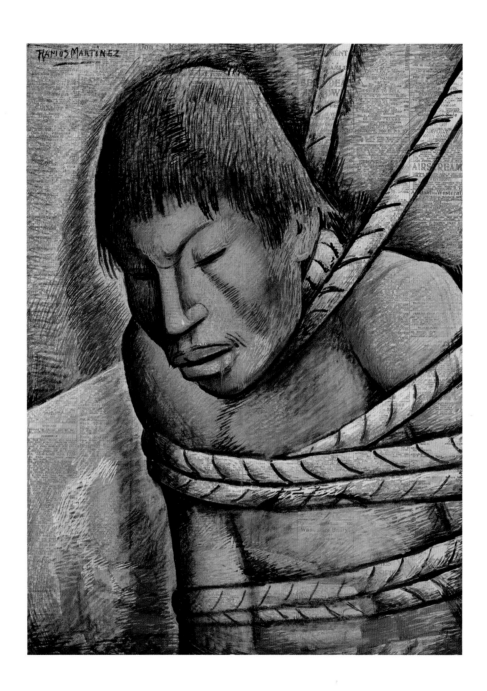

103 ALFREDO RAMOS MARTÍNEZ
The Bondage of War, 1939
Tempera on newsprint, 22 ¹³⁄₁₆ × 17 in.
(57.8 × 43.2 cm)
Private collection; courtesy Louis Stern Fine Arts,
West Hollywood, California

104 DAVID ALFARO SIQUEIROS
Proletarian Victim, 1933
Enamel on burlap, 81 × 47 ½ in. (205.8 × 120.6 cm)
The Museum of Modern Art, New York; gift of the
Estate of George Gershwin

105 BENDOR MARK
Execution, 1940
Oil on canvas, 20 ⅛ × 24 ³/₁₆ in. (51.1 × 61.4 cm)
Los Angeles County Museum of Art; anonymous
gift M.80.194.1

**106 PHILIP GUSTON AND REUBEN KADISH
WITH JULES LANGSNER**
*The Struggle against Terrorism (The Struggle
against War and Fascism)* (detail), 1934–35
Fresco, 40 ft. (12.2 m) high
Museo Regional de Michoacan, Morelia, Mexico

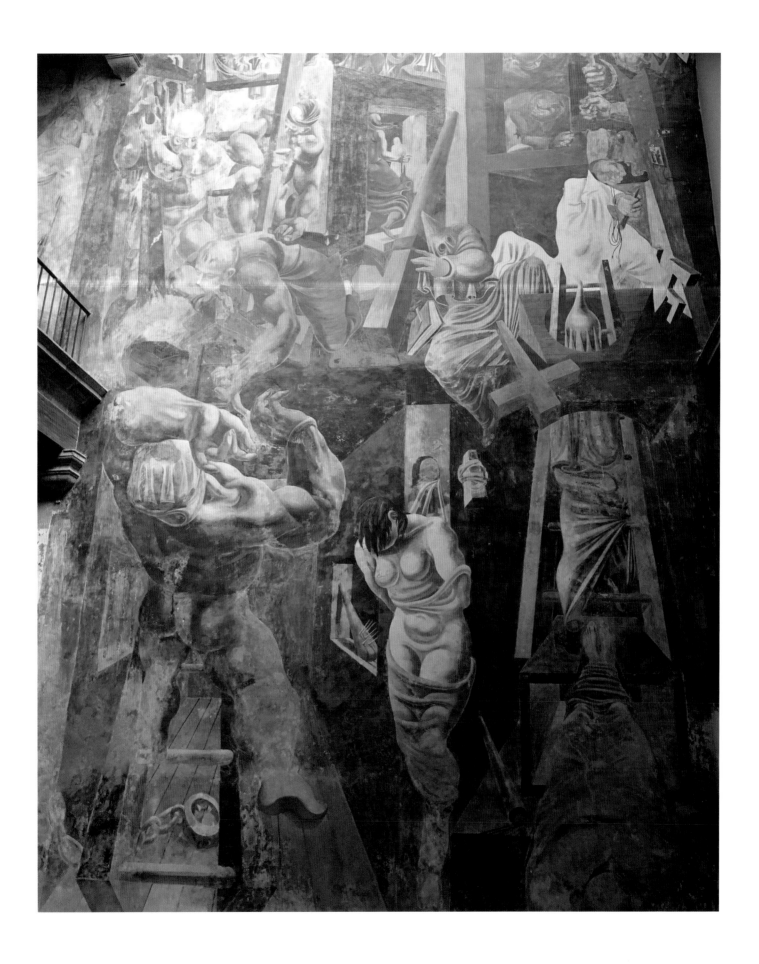

107 LUIS ARENAL
The Fanatic, c. 1935
Oil on laminated cardboard,
46 ½ × 38 ¾ in. (118.1 × 98.4 cm)
Los Angeles County Museum of Art; gift of
Dr. Electa Arenal and Julie Arenal Primus in
memory of Rose Beigel Arenal M.2002.192

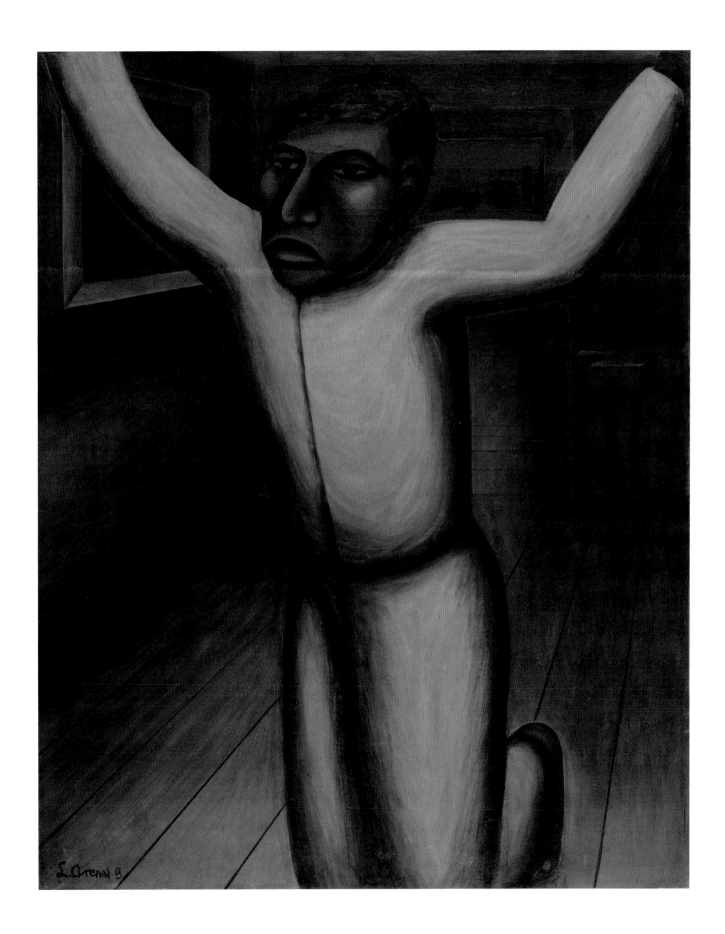

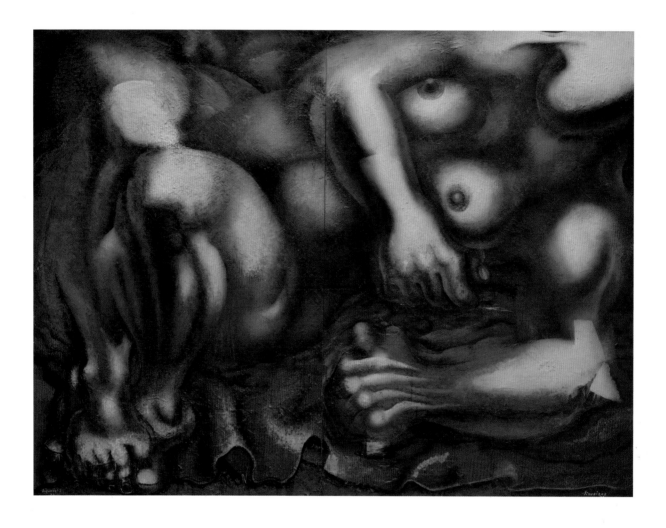

108 DAVID ALFARO SIQUEIROS
War, 1939
Nitrocellulose on two panels, 48 ⅝ × 63 ⅞ in.
(123.5 × 162.2 cm)
Philadelphia Museum of Art; gift of Inés Amor,
1945

109 JACKSON POLLOCK
Untitled, c. 1938–41
Oil on linen, 22 ¼ × 50 ¼ in. (56.5 × 127.6 cm)
Art Institute of Chicago; Major Acquisitions
Centennial Fund; estate of Florene May
Schoenborn; through prior acquisitions of Mr. and
Mrs. Carter H. Harrison, Marguerita S. Ritman,
Mr. and Mrs. Bruce Borland, and Mary L. and
Leigh B. Block 1998.522

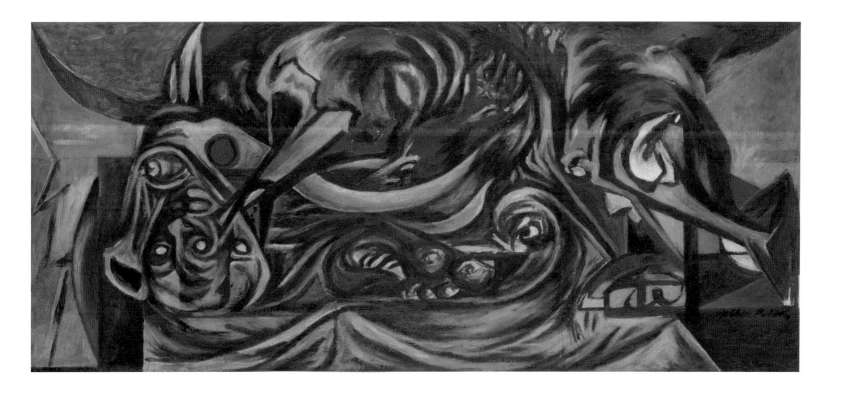

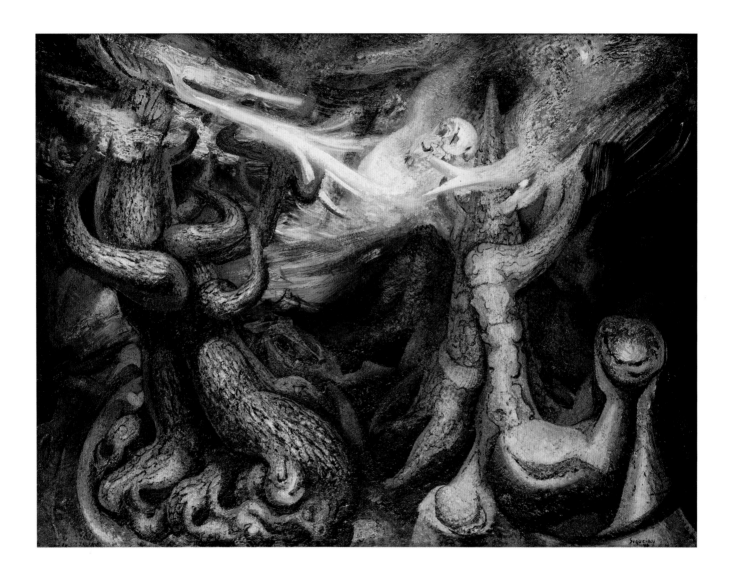

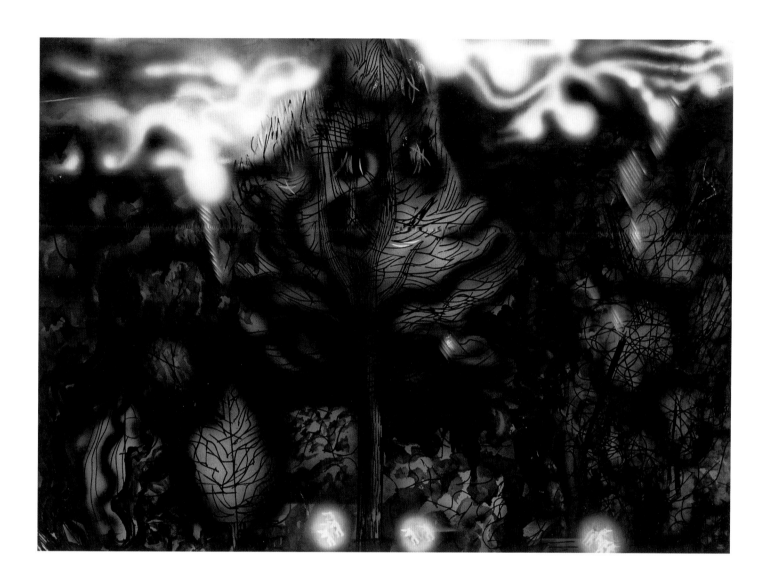

110 DAVID ALFARO SIQUEIROS
Intertropical, 1946
Pyroxylin on wood, 36 ¹³⁄₁₆ × 48 ⁹⁄₁₆ in.
(93.5 × 123.4 cm)
Museo de Arte Carrillo Gil, INBA, Mexico City

111 DAVID ALFARO SIQUEIROS
The Electric Forest, 1939
Nitrocellulose on cardboard, 27 × 34 in.
(71.1 × 89 cm)
Indianapolis Museum of Art at Newfields;
gift in memory of Ann Tyndall Durham 46.74

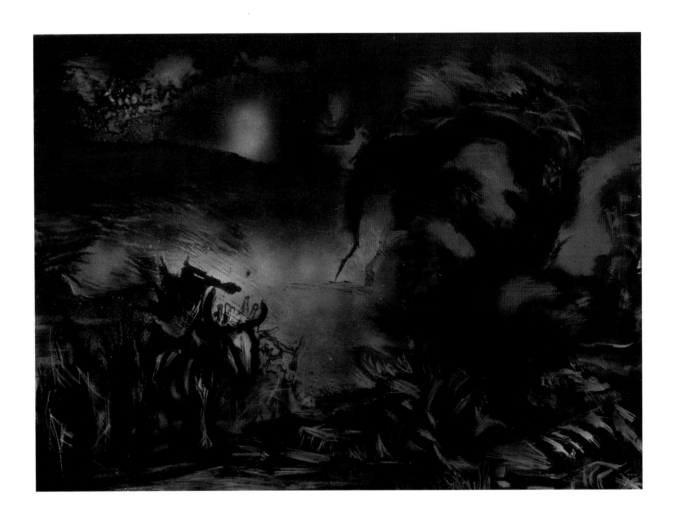

112 JACKSON POLLOCK
Landscape with Steer, c. 1936–37
Lithograph with airbrushed lacquer additions,
sheet: 15 ⅞ × 22 ⅞ in. (40.4 × 58.1 cm);
image: 13 ¹¹⁄₁₆ × 18 ⁹⁄₁₆ in. (34.7 × 47.1 cm)
The Museum of Modern Art, New York; gift of
Lee Krasner Pollock

113 DAVID ALFARO SIQUEIROS
Collective Suicide, 1936
Lacquer on wood with applied sections, 49 × 72 in.
(124.5 × 182.9 cm)
The Museum of Modern Art, New York; gift of
Dr. Gregory Zilboorg

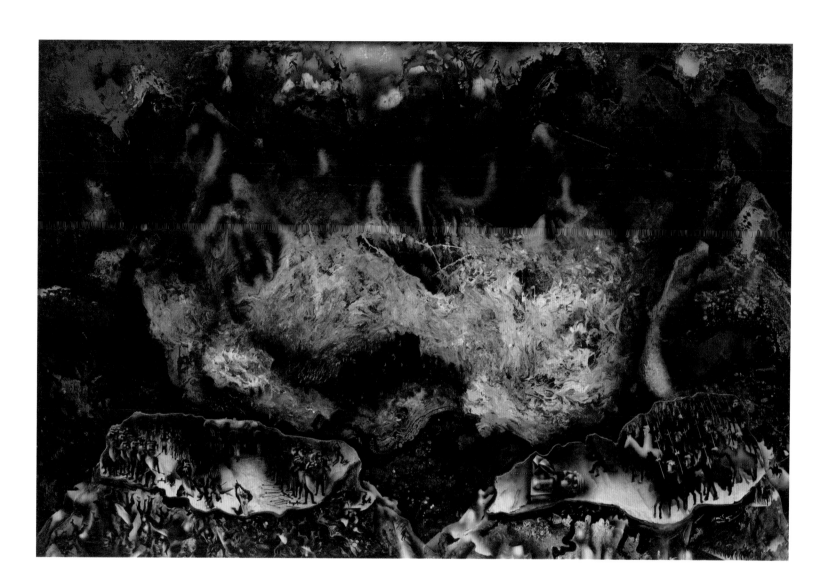

114 DAVID ALFARO SIQUEIROS
Our Present Image, 1947
Pyroxylin on fiberglass, 87 ¹³/₁₆ × 68 ⅞ in.
(223 × 175 cm)
Museo de Arte Moderno, INBA, Mexico City

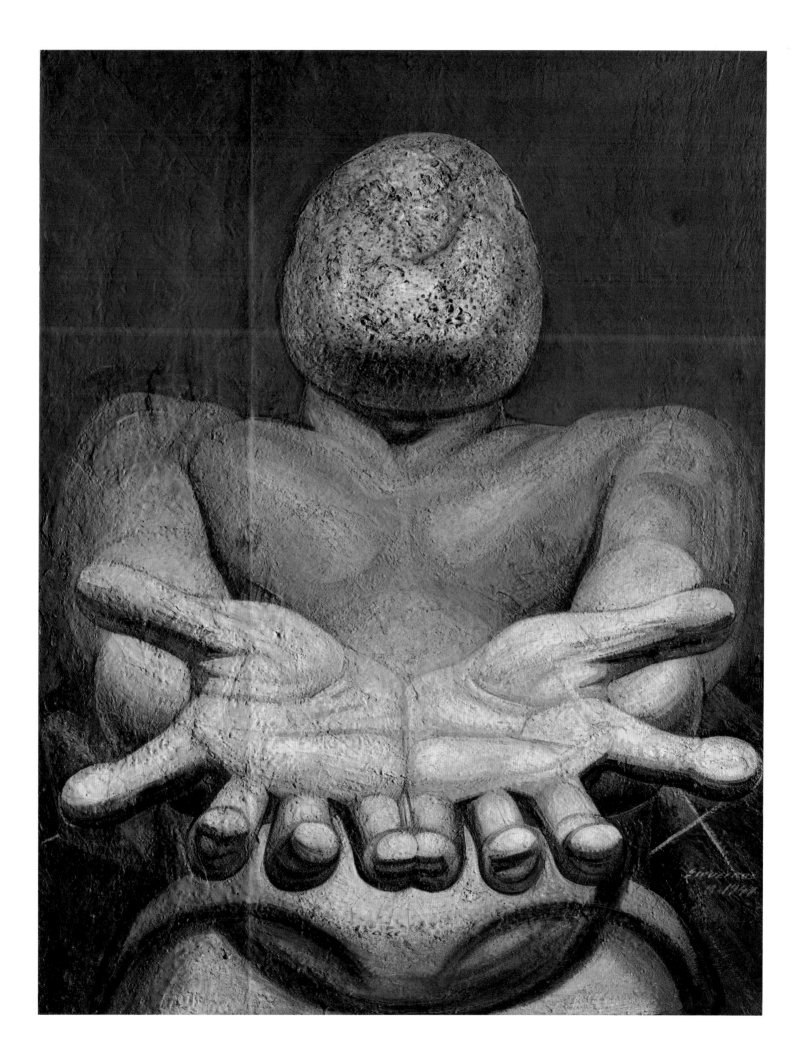

In January 1929, a little more than a year after José Clemente Orozco arrived in the United States for what would be a six-year stay, *Creative Art* published a short manifesto signed by the Mexican painter in which he seemed to embrace what appeared to be a quintessentially modernistic break with the past. The art of the "New World," Orozco claimed, meaning the art of the Americas as a whole, should imitate neither the "ruins" of old-world European art nor the art of ancient Indigenous peoples.[1] However bold a statement, Orozco's practice that ensued proved much more nuanced. The following year at Pomona College in Claremont, California, Orozco would paint a mural featuring no less ancient a character than Prometheus, and the murals he would go on to produce between 1932 and 1934 at Dartmouth College's Baker Library depict life in pre-Columbian Mexico, including a panorama of ancient Teotihuacán and a panel showcasing ancient Indigenous sculpture, much as Diego Rivera had done in his 1929 fresco in the main stairwell of Mexico City's National Palace.[2] How to explain Orozco's seemingly contradictory rejection and embrace of the past? To explore this question, I will concentrate on three important sources of inspiration, dialogue, and innovation. First, as previous scholars have noted, Orozco's iconography shows a clear affinity with Latin American Symbolist art, in particular the work of Julio Ruelas. Second, I will focus on the figure of Joseph (Josep) Pijoan, a professor of art history at Pomona who was crucial in the Orozco commission there; the impact of Pijoan's ideas on Orozco has not been sufficiently examined, even as their influence will prove far from linear. Finally, I will venture some observations as to some of the ways in which Orozco's engagement in the U.S. with Latin American modernism—or more correctly, *modernismo*—impacted certain contemporaneous American artists. Indeed, at the crux of this discussion as a whole is a clarification of the distinctions between the terms *modernism* and the Spanish *modernismo*, which too often are confused as synonymous.

THE MODERNISTA PRECEDENT

The heroic male nude figure of Orozco's *Prometheus*, contained within the Neogothic arch of the back wall of Pomona's Frary dining hall, his face turned upwards, appears as if struggling against some invisible force that thwarts his rise, surrounded by a teeming crowd below (figs. 1, 2, pl. 28). A side panel on the west wall shows the figures of Zeus, Hera, and Io; the east wall's side panel depicts a group of falling centaurs, including one that fights against the grip of a large snake (fig. 3). Overhead, a small panel on the ceiling shows a geometric figure, the abstract representation of divinity. This composition has been the subject of much scholarship, including a recent curatorial project.[3] Orozco's involvement in the Delphic Circle, the esoteric society organized by Eva Palmer-Sikelianos and her husband, Greek poet Angelos Sikelianos, offers the most immediate source of explanation for the artist's turn to classical themes. The Sikelianoses' fervent efforts to revivify for the modern era the ideals embodied in classical Greek art went so far as to include staging two separate festivals at the ancient site of Delphi, in 1927 and 1930, both of which featured an open-air performance of Aeschylus's *Prometheus Bound*. Even if Orozco did not attend these spectacles, he became intimately acquainted with the ideas espoused by the Delphic Circle in New York via his association with a number of the group's enthusiasts, such as Alma Reed (his agent and promoter), Emily Hamblen, Leonard

RENATO GONZÁLEZ MELLO

PROMETHEUS UNBOUND: OROZCO IN POMONA

FIG. 1
José Clemente Orozco's mural *Prometheus* (1930)
in Frary Dining Hall, Pomona College, Claremont, California

FIG. 2
José Clemente Orozco, *Study for central panel,
Prometheus mural*, 1930. Graphite on paper, 17 ⅝ × 23 ⅜ in.
(44.8 × 59.4 cm). Benton Museum of Art, Pomona College,
Claremont, California; museum purchase with funds provided
by the Estate of Walter and Elise Mosher

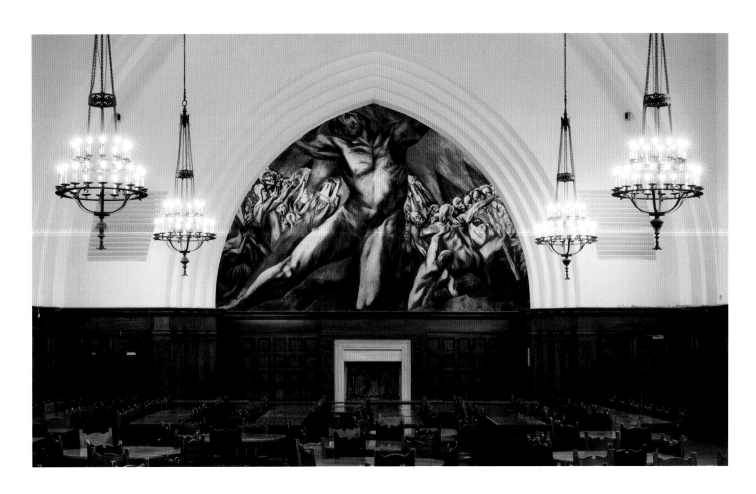

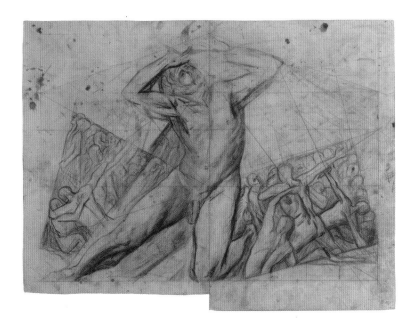

Charles Van Noppen, and Khalil Gibran.[4] Yet Orozco's
interest in European antiquity likely preceded his
involvement with the Delphic Circle. In one of the first
published scholarly works on the mural, U.S. art
historian David Scott noted the strong influence upon
Orozco of Mexican artist and illustrator Julio Ruelas,
and more broadly, Orozco's artistic coming of age in the
culture of Latin American Symbolism, a relationship
Mexican scholar Fausto Ramírez underscored a quarter
century later.[5] Such Symbolist tendencies were
intertwined with the *modernista* literary movement,
which was inaugurated in the late 1880s by Nicaraguan
poet Rubén Darío and flourished in most Spanish-
speaking countries, including Spain.[6] Most *modernistas*
were admirers of nineteenth-century French Symbolism
and Parnassianism, seeking to reflect through new
forms of literary and visual expression timeless
classical ideals, such as truth and beauty. Their project
took on more urgency in the wake of Spain's defeat in
the Spanish-American War of 1898 and the collapse of
the Spanish Empire. Faced with a triumphant United
States poised to exert an outsized influence throughout
the Americas, *los modernistas* sought to combine pride

FIG. 3
José Clemente Orozco, right lateral panel of *Prometheus*,
1930. Fresco, 15 ft. 4 in. × 7 ft. (4.7 × 2.1 m). Pomona College,
Claremont, California

in Hispanic civilization and a shared Hispanic heritage with a turn to the mythology of ancient Greece. Inspired by the Parnassians, *los modernistas* associated aesthetic idealism with ancient Greek tragedy and forms of expression, as in Darío's account of French Parnassian poet Leconte de Lisle: "He was a Greek, he took from the Greeks . . . the conception of a sort of world of forms and ideas, which is the very world of art."[7] Yet the relationship of *los modernistas* with the U.S. was complex: their admiration for Walt Whitman was as strong as their contempt for the imperialistic expansions of President Theodore Roosevelt.[8] They saw French-inspired aestheticism as a way to counter what they perceived as the cultural barbarism, crude materialism, and neocolonial designs of the U.S., an approach exemplified by the Uruguayan writer José Enrique Rodó in his landmark 1900 work, *Ariel*.

As first noted by Scott, Orozco's *Prometheus* strongly suggests the influence of *Revista Moderna*,

the literary magazine published between 1898 and 1903 that was the primary disseminator for the *modernista* movement in Mexico, and the magazine's most prolific illustrator, Julio Ruelas, whose art Orozco specifically recalls in his 1942 autobiography: "Ruelas was a painter of cadavers, satyrs, drowned men, and spectral lovers returning from a suicide's grave."[9] Ruelas's dynamic depictions often reflected the fixation of *los modernistas* on classical mythology and a particular fascination with satyrs and centaurs, the latter of which were the focus of Darío's long poem of 1896, *Colloquium of the Centaurs*. In the poem as in Ruelas's work, the half-man, half-horse creatures serve as the virile animating force for an idealized aestheticism, in contrast to the primitive force of animal desire embodied by the lecherous satyrs. In turn, Orozco's centaurs in Pomona are reminiscent of Ruelas's depictions in such works as the famous *Entrance of Don Jesús Luján to the Revista Moderna* (1904), *The Drowned Satyr*, and numerous ink drawings. Worth considering as well is the participation of Jorge Juan Crespo de la Serna in the production of the mural. The son of a Mexican diplomat who had trained as an artist in Vienna, in 1930 Crespo was a professor at the Chouinard School of Art in Los Angeles (where, two years later, David Alfaro Siqueiros would paint his first mural in the U.S.), and he had been instrumental in convincing Pomona College to invite Orozco.[10] Crespo became Orozco's assistant on *Prometheus*; in fact, scholars have long wondered whether the contrast in style and brushstroke between the main and the side panels of the mural can be attributed to Crespo's intervention in the side panels.[11] Distinct styles in different panels are customary in Orozco's mural cycles, however, yet the high esteem of Crespo for the art of Ruelas may nevertheless have had an influencing effect: after returning to Mexico in the 1940s to become an influential art critic, Crespo would publish a monograph on Ruelas in the late 1960s, where he extolled the work of the *modernista* even as he lamented to some degree the failure of Ruelas, who had lived in Europe just after the turn of the century, to engage with Fauvism and other modernist currents of the time.[12]

FIG. 4
Mithraic Chronos, 126–300 CE. Marble, 66 ¹⁵⁄₁₆ × 17 ⁵⁄₁₆ × 13 ³⁄₈ in.
(170 × 44 × 34 cm). Museo Nacional de Arte Romano, Mérida, Spain

175

AN "INTERNATIONAL" STYLE

Among perhaps the most significant yet little studied figures in relation to Orozco's *Prometheus* was Joseph (Josep) Pijoan, the Pomona professor who first proposed that a fresco should decorate the newly constructed Frary Hall and who successfully lobbied that the artist should be Orozco, following Crespo's recommendation.[13] An art historian and poet, the forty-nine-year-old Pijoan (two years older than Orozco) had already become something of a legendary character by 1930, having served as a founding figure for both the Institut d'Estudis Catalans and the Escuela Española de Historia y Arqueología in Rome, as well as author of a three-volume history of world art. Born in Barcelona, Pijoan came of age in the aftermath of the Spanish-American War (a conflict known simply as *el Desastre*, or "the Disaster," in Spanish culture), but is not commonly associated with the Generation of '98, as the young Spanish artists and intellectuals dealing with that historic event were known. As a Catalonian, albeit with deep reservations in regard to the Barcelona bourgeoisie, Pijoan was more closely aligned with the *noucentisme* movement, the Catalonian cousin of *modernismo* that shared with its Spanish-American kin a cosmopolitan bent and a deep appreciation of Symbolism while at the same time working to articulate its own regional (Catalonian) identity.[14] As a young man, Pijoan had collaborated on the magazine *Luz*, a publication typical of the 1898 generation, which aimed at a renewal of Spanish culture through engagement with modern foreign trends.[15] A poem he published in December 1899, "Song of Prometheus before the Flame of Life," reflects the contemporaneous desire to bring classical themes to bear on the modern experience and centers on the mythological figure who would become central to Orozco's first mural in the United States:

> But on this day I look at you face to face. Oh Vida! Source of my understanding! And on this day— Oh gods of Olympus!—I will not judge you for having forsaken me in this exile, alone, defenseless, and full of doubt.

> Your former cruelty allows me to become a victor, laden with wounds before my loving Mother. And this is the only thing for which I thank you— Oh gods!—for having made me incomplete. Because

within me you will have to confess that now there lies locked away a whole man. Oh Jupiter! You are no longer the sole creator. You go about bringing creatures to life, I transform them into men.[16]

Alma Reed recalls Orozco's mixed feelings for Pijoan: respect for his knowledge, distrust for his attempts to discuss subject matter and form.[17] Yet intriguing connections to Orozco's mural can be found in Pijoan's expansive art-historical surveys. The figure to the right of Prometheus, raising his hand to the hero, may relate to a statue of Dionysus from the provincial museum of Tarragona, Spain, published in 1912 by Pijoan and Manuel Gómez Moreno.[18] The same catalogue also contains an image of the serpent-entwined Mithraic Chronos from the archeological museum in Mérida, Spain (fig. 4), a likely source for the falling centaur in the right panel of the Pomona fresco.[19]

Pijoan's influence may have gone beyond iconographic sources. Telling insight into his thinking at the time perhaps comes from an essay he published in 1930 titled "El Greco–A Spaniard," a rebuttal to an article by August Mayer arguing that the Greek-born

FIG. 5
José Clemente Orozco, *The Epic of American Civilization*
(panels 5–7), 1932–34. Fresco, 10 ft. × 48 ft. 9 in. (3 × 14.9 m).
Hood Museum of Art, Dartmouth College, Hanover, New
Hampshire; commissioned by the Trustees of Dartmouth
P.934.13.5–7

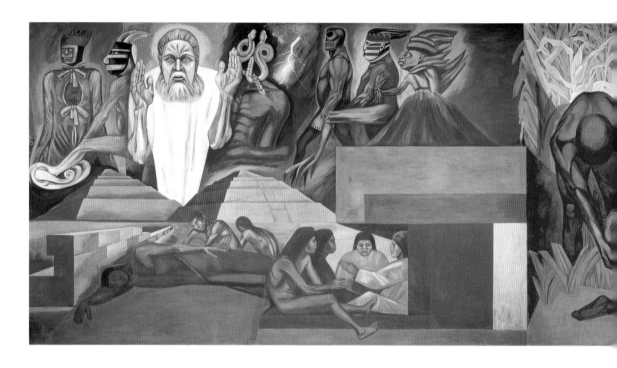

master of the Spanish Renaissance was "an Oriental artist."[20] Pijoan was incensed by Mayer's assertion: "The commonplace, that Spain is an Oriental country, has to be dismissed for educated people. . . . To discuss in front of a Spaniard whether El Greco was insane in his last years, or had a defective vision, is more than a nuisance; it is an insult."[21] It could be said that Mayer's characterization of El Greco as "Oriental" was related to French art-historian Louis Courajod's invention of the "International Gothic Style," an alleged late-medieval trend in painting, as a cultural form akin to the "barbarian," in contrast to the perceived culturally (and racially) superior classical Greek or Latin heritage of European art.[22] Either the liberal Pijoan perceived this nuance or rather he simply felt outrage at the centuries-long demeaning of Spanish culture. Whatever the case—and more to our purpose here—Pijoan goes on to indict the Nazarenes and pre-Raphaelites as "false idealists" and to dismiss almost every attempt to build an "international" style, be it Gothic or Mannerist, as a contraption as fake as those belonging to nationalisms: "Dr. Mayer says that Mannerism is an absolutely international style. Certainly this does not apply to El Greco. No other great artist had so few canvases outside of his country."[23]

An international style.[24] This had been an issue for Pijoan for some time. The first volume of his history of world art had a comprehensive chapter on "primitive"

or non-Western art, building on themes he had explored in Spanish and Catalonian magazines, albeit strongly influenced by nineteenth-century theories of Social Darwinism, such as a 1913 article where he discusses the art of peoples "in a savage state" and with "rudimentary civilization," while at the same time lamenting that such communities were about to disappear.[25] Nevertheless, Pijoan was among the first European scholars to devote attention to ancient Mexican art (in his case, an entire chapter in his book), and he would posit a parallel between ancient Asian, European, and American decoration. "Since it is impossible . . . to believe in direct teachings or relations between different peoples, the idea comes upon us of a common background with an underlying, inborn artistic repertoire in the human soul, setting off the invention and reinvention of the same forms."[26]

Even if Orozco was wary of Pijoan's attempts to supervise his stylistic decisions, this language must surely have resonated with some of his preoccupations. To the former student of a nineteenth-century, Nazarene-oriented national art academy and, in 1930, a Mexican in the United States, vacillating both in his embrace of American culture and his own national heritage, the idea of a parallel evolution in the ancient art of different regions represented a dramatic break from the Mexican brand of Social Darwinism, the narrative that tirelessly elevated the modern, urbanite

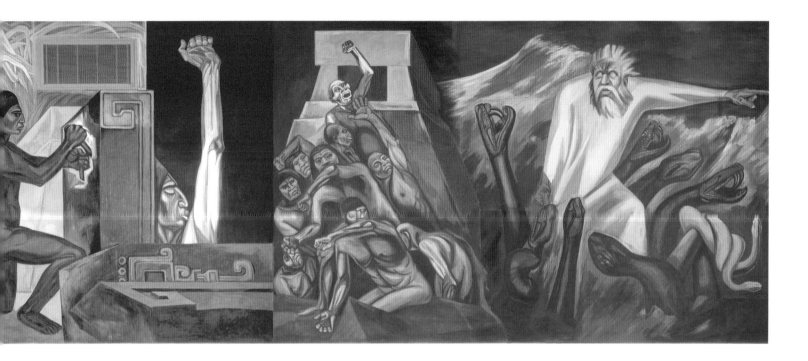

contributions to the national culture above both those of the Indigenous peoples and the colonial Spanish regime. It is quite likely that Pijoan's ideas, innovative for their time (inasmuch as their inflections of Social Darwinism are unacceptable today), made it easier for Orozco to incorporate elements of pre-Columbian art into his work, as he did in his murals at Dartmouth. Panel 6, *Pre-Columbian Golden Age*, and the pyramid in the background of panel 7, *The Departure of Quetzalcoatl* (fig. 5), bear some resemblance to illustrations in Pijoan's history of world art.[27] One might wonder if, at the same time, Orozco's fierce distrust of ideologies might have had some influence upon the at-times-Spanish Catalonian, Pijoan.

—

In the early 1970s, Mexican scholar Alicia Azuela tried to interview Philip Guston about his engagement early in his career with the Mexican muralist movement; the artist declined to discuss it, even as there was perhaps much to say.[28] Commissioned by the state government of Michoacán, Guston and Reuben Kadish along with Jules Langsner in 1934–35 produced the mural *The Struggle against Terrorism (The Struggle against War and Fascism)* (pl. 106), depicting the Ku Klux Klan, torture, the rise of fascism, and the proletarian struggle against the restrictive forces of capitalism.

Their use of a heroic figure with a classical, muscular, monumental spirit was almost certainly inspired by Orozco's *Prometheus*; in turn, both Orozco and Siqueiros were inspired by the young Americans' composition.[29]

The enthusiastic reactions to the murals of Orozco by Guston's contemporary, Jackson Pollock, have been more extensively documented, though as Mary Coffey, Stephen Polcari, and many others have noted, Pollock's drawings in the late 1930s, however inspired by Orozco, avoid the social and political content of the frescoes, not to mention their Hispanic themes.[30] Some of the sketches in Pollock's notebooks from the period, now in the collection of the Metropolitan Museum of Art, are studies and reworkings of a variety of figural and compositional topics that might be traced to easel paintings and murals by Orozco, especially to Orozco's *Catharsis* (1934) and *The Trench* (1926–27), both in Mexico City. A compositional idea that appears in the sketchbooks in several variants seems to share an affinity with either the central group in *Catharsis* or the struggling group in *Barricade* (pl. 25), a structure Pollock would go on to employ in *Untitled (Naked Man with Knife)* (pl. 33). Summarizing Pollock's interest in Orozco, Kirk Varnedoe claimed that what Pollock really got was a "machinery of skeletons, crucifixions, and hallucinatory perspectives," or a repertory for the depiction of visual violence, though tantalizing

connections beyond the iconographic remain, such as those between Pollock's *Eyes in the Heat* (1946), a painting on the verge of abstraction, and Orozco's lithograph *The Masses* (1935).[31]

Although Orozco's influence in the United States following World War II diminished, his work remained highly appreciated by artists and critics who were skeptical of the hegemonic trends dictated by the New York elite. He was characterized by American art historian Selden Rodman as the harbinger of "interiorism," a sort of postwar expressionism born of humanist values.[32] In many ways, Orozco became the reference for artists and theoreticians aiming toward a socially committed art, among them Rico Lebrun, who painted his own mural at Pomona College and was quite appreciative of Orozco's *Prometheus*.[33] In 1959, Lebrun would appear alongside artists such as Jean Dubuffet, Francis Bacon, and Alberto Giacometti, as well as Pollock, in the Museum of Modern Art's *New Images of Man* exhibition, which featured new forms of expressionism in response to the social anxieties of the postwar era, a trend soon to be eclipsed by the emergence of Pop art. It was the first show organized by the museum's new curator of painting and sculpture, Peter Selz—who had come to MoMA from Pomona College, where he had been chair of the art department and a key figure in the commissioning of the Lebrun mural there. Selz would later characterize the show, which showcased "a lot of American [art] from the hinterland," specifically as a counterpoint to the dominance of modernist abstraction in New York: "[W]hen I saw abstract expressionism, I said, 'Well, this is pretty wonderful. But that is not the only option for artists.'"[34]

Indeed, the idea of monumental painting (not just monumental allegory) was something that survived the 1930s to remain a current in American art.[35] The fact that the very "transitional" painting that signaled Pollock's shift to Abstract Expressionism was titled *Mural* (1943) is no coincidence: as noted by Rosalind Krauss, Pollock took pains to produce a very large horizontal canvas in which he tried in his own way to address the problems faced by Orozco and Thomas Hart Benton in their own large horizontal murals at the New School for Social Research.[36] In an application for a Guggenheim grant, Pollock would claim "easel painting to be a dying form" and declare "the tendency of modern feeling is toward the wall picture or mural."[37]

Although art historians have often attributed such statements to the influence of Clement Greenberg, it is hard to dismiss the similarity between Pollock's words and Orozco's 1929 manifesto: "The highest, the most logical, the purest and strongest form of painting is the mural."[38]

NOTES

1. José Clemente Orozco, "New World, New Races, and New Art," *Creative Art* 4 (1929): supplementary xlv–xlvi.

2. I am indebted to Terri Geis and Rebecca McGrew, who first pointed out the contradiction between Orozco's manifesto and his subsequent engagement with the figure of Prometheus. See Geis and McGrew, eds., *Prometheus 2017: Four Artists from Mexico Revisit Orozco* (Claremont, CA: Pomona College Museum of Art, 2017), 25.

3. Geis and McGrew, *Prometheus 2017*. See also Marjorie L. Harth, *José Clemente Orozco: Prometheus* (Claremont, CA: Pomona College Museum of Art, 2001); and Karen Cordero Reiman, "Prometheus Unravelled," in *José Clemente Orozco in the United States*, ed. Renato González Mello and Diane H. Miliotes (Hanover, NH: Hood Museum of Art, 2002), 98–117.

4. For more on Orozco and the Delphic Circle, see González Mello and Miliotes, *José Clemente Orozco in the United States*, 37–49; and Jacqueline Barnitz, "Los Años Délficos de Orozco," in *Orozco: Una Relectura* (Mexico City: UNAM–Instituto de Investigaciones Estéticas, 1983), 103–28.

5. David W. Scott, "Orozco's *Prometheus*: Summation, Transition, Innovation," *College Art Journal* 17, no. 1 (Autumn 1957): 10. Fausto Ramírez, "Artistas e Iniciados en la Obra Mural de Orozco," in *Orozco: Una Relectura*, 74–80.

6. I am relying heavily on Olivier Debroise, ed., *Modernidad y Modernización en el Arte Mexicano, 1920–1960* (Mexico City: Museo Nacional de Arte–INBA, 1991); and Fausto Ramírez, *Modernización y Modernismo en el Arte Mexicano* (Mexico City: UNAM–Instituto de Investigaciones Estéticas, 2008).

7. Rubén Darío, *Los raros* [1896] (Barcelona: Maucci, 1905), 28.

8. Ángel Rama, *La ciudad letrada* (Montevideo: Arca, 1998), 87–88; and Jean Franco, *La Cultura Moderna en America Latina* (Mexico City: J. Mortiz, 1971), 22–47.

9. José Clemente Orozco, *An Autobiography*, trans. Robert C. Stephenson (Austin: University of Texas Press, 1962), 15.

10. Xavier Moyssén, "Jorge Juan Crespo de la Serna (1887–1978)," *Anales del Instituto de Investigaciones Estéticas* 13, no. 49 (August 6, 1979): 161–62.

11. Laurance Hurlburt, relying on a letter from noted conservator Nathan Zakheim, boldly asserted as such in his 1989 survey, *The Mexican Muralists in the United States* (Albuquerque: University of New Mexico Press), 39. While I think highly of Zakheim's conservation work and analysis, I remain skeptical as to the extent of Crespo's involvement, in part based on a personal interview I conducted in 1993 with Maestro Jorge Martínez, Orozco's assistant in Guadalajara. Martínez gave no indication that Orozco would have allowed him to paint an entire panel himself. Rather, Martínez described a process by which the assistant would apply the *verdaccio* (the first layer of pigment in fresco technique), and Orozco would overpaint, many times so boldly as to make any background brushstrokes disappear. Even when Orozco did not feel up to working on a particular day, he would tell Martínez to go ahead and try to paint something in the fresco's *giornata*, but not to worry, "We will throw everything down tomorrow, and I'll paint it all over." It may well have been that Orozco accorded Crespo more autonomy, but I consider it just as likely Orozco himself painted the different panels of his Pomono mural in noticeably different styles, just as he did in Guadalajara.

12. Jorge Juan Crespo de la Serna, *Julio Ruelas en la vida y en el arte* (Mexico City: Fondo de cultura económica, 1968), 31.

13. Hurlburt, *The Mexican Muralists in the United States*, 30–32.

14. Nelson R. Orringer, "Taming the Swan: Globally Refocusing Hispanic Modernism," *South Central Review* 18, no. 1/2 (2001): 26–44.

15. José María Riquier, "Arte Nuevo: La Regeneración Estética en España," *Luz* (Barcelona), 3rd week of November 1898.

16. "Pero hoy te contemplo pero ó pero ¡oh Vida! ¡Fuente de mi criterio! Y hoy ¡oh Dioses del Olimpo! no os criticaré por haberme dejado abandonado en este destierro, solitario, indefenso y lleno de dudas.

"Vuestra anterior crueldad me permite llegar vencedor y cargado de heridas delante de la amorosa Madre. Y esta es la única cosa que os agradezco ¡oh Dioses! el haberme hecho incompleto. Porque dentro de mí tendreis que confesar que ahora se encierra todo un hombre. ¡Oh Júpiter! Ya no eres solo en crear. Tú vas animando criaturas, yo las transformo en hombres." Josep Pijoan, "Canto de Prometeo delante de la llama de la vida," *Luz* (Barcelona), 5th week of December 1898. Translated by Matthew S. Tanico. The Catalonian poet (1881–1963) was also an art historian who published under the Spanish name José Pijoán and the English name Joseph Pijoan, which was how he was known while on the faculty of Pomona College.

17. Alma Reed, *Orozco* (Mexico City: Fondo de cultura económica, 1983), 198.

18. Manuel Gómez Moreno and José Pijoán, *Materiales de arqueología española* (Madrid: Centro de Estudios Históricos, 1912), fig. xvi.

19. Ibid., fig. xxxi.

20. Joseph Pijoan, "El Greco–A Spaniard," *The Art Bulletin* 12, no. 1 (1930): 13–19.

21. Ibid., 14, 16.

22. Eric Michaud, "Barbarian Invasions and the Racialization of Art History," trans. Hélène Amal, *October* 139 (Winter 2012): 59–76.

23. Pijoan, "El Greco–A Spaniard," 19.

24. In the context here, "international" should be read as analogous to "universal" and distinct from what would come to be known as the International Style of modernist architecture following the publication in 1932 of Philip Johnson and Henry-Russell Hitchcock's book of that title.

25. José Pijoán, "El Arte de Los Primitivos Actuales," *Hojas Selectas*, January 1913: 897–98.

26. José Pijoán, *Historia del arte: El arte al traves de la historia*, vol. 1 (Barcelona: Salvat, 1914), iv.

27. Ibid., 497–518.

28. Alicia Azuela to Renato González Mello, 2019.

29. James Oles, *South of the Border: Mexico in the American Imagination, 1914–1947* (Washington, DC: Smithsonian Institution Press, 1993), 196–201; and Renato González Mello, "Reproduction of Victims," in *Mex/L.A: "Mexican" Modernism(s) in Los Angeles, 1930–1985*, ed. Selene Preciado (Ostfildern, Germany: Hatje Cantz, 2011), 34–43.

30. Mary K. Coffey, "An American Idea: Myth, Indigeneity and Violence in the Work of Orozco and Pollock," in *Men of Fire: José Clemente Orozco and Jackson Pollock*, ed. Sarah G. Powers (Hanover, NH: Hood Museum of Art, 2012), 19–34. Stephen Polcari, "Orozco and Pollock: Epic Transfigurations," in Powers, *Men of Fire*, 9–16.

31. Kirk Varnedoe and Pepe Karmel, *Jackson Pollock* (New York: The Museum of Modern Art, 1998), 26.

32. Selden Rodman, *The Insiders* (Baton Rouge: Louisiana State University Press, 1960), 67–83.

33. Peter Selz, "The Genesis of 'Genesis,'" *Archives of American Art Journal* 16, no. 3 (1976): 2–7.

34. Peter Howard Selz, interviewed by Paul J. Karlstrom, transcript, November 3, 1999, Archives of American Art, Smithsonian Institution, Washington, DC.

35. Serge Guilbaut, *How New York Stole the Idea of Modern Art* (Chicago: University of Chicago Press, 1985), 196; and Rita Eder, "Against the Laocoon: Orozco and History Painting," in González Mello and Miliotes, *José Clemente Orozco in the United States*, 230–43.

36. Rosalind E. Krauss, *The Optical Unconscious* (Cambridge, MA: MIT Press, 1994), 265–66, 289, 303–4. Caroline A. Jones argues convincingly that *Mural* was a title that made all the more evident the distance of this work from socialist mural painting, in *Eyesight Alone: Clement Greenberg's Modernism and the Bureaucratization of the Senses* (Chicago: University of Chicago Press, 2005), 225. See also Ellen G. Landau et al., *Jackson Pollock's "Mural": The Transitional Moment* (Los Angeles: J. Paul Getty Museum, 2014). For Orozco's and Benton's processes, see Reed, *Orozco*, 229; and Erika Lee Doss, *Benton, Pollock, and the Politics of Modernism: From Regionalism to Abstract Expressionism* (Chicago: University of Chicago Press, 1995), 81.

37. Jackson Pollock, quoted in Varnedoe and Karmel, *Jackson Pollock*, 43.

38. Orozco, "New World, New Races, and New Art," xlvi.

In 1933, the artist Marcel Duchamp returned to New York after having been away some seven years. Interviewed for *Art News* by Laurie Eglington, he was pressed to give his impression of mural art, then described as being "rampant" in the United States. Although initially Duchamp demurred, saying that it had yet to "claim his attention," he went on to explain, "It takes too much in sheer muscular activity to leave a great deal of creative energy in a man. It is a very nice idea, but by the time the subject is enlarged it is apt to have some of the qualities of the moving picture . . . it is an ungrateful medium at best."[1] Eglington conceded that Duchamp had pointed out one of the medium's main defects: "It was agreed that the average artist today does not think in terms of big enough forms to create really great mural art, and that, on the whole, only a Rivera with the vitality to work fourteen hours a day on huge scaffoldings would be even physically fitted to the job. Monsieur Duchamp, although favorably disposed toward the artist from what he knows, has not actually seen any of his murals."[2] Eglington's identification of Rivera as the only artist physically capable of executing great murals is in keeping with contemporary accounts of the painter. In *Idols behind Altars*, published four years earlier, Anita Brenner would open her chapter on the artist with a description of his prodigious energy and grueling work schedule.[3]

Duchamp's tepid appraisal of the potential of mural art and his ambiguous praise for Rivera's "vitality" was in keeping with the realignment of his artistic priorities some two decades earlier. The French-born artist had scandalized viewers at New York's Armory Show in 1913 with his *Nude Descending a Staircase, No. 2* (1912), which helped to precipitate a reckoning among American artists, critics, and the public at large with the European avant-garde. Although the controversy brought Duchamp fame and status in the U.S., it came just as he was abandoning the physicality of painting to explore more conceptual modes of artmaking. In a country grappling with questions surrounding the role of art and of artists in society, Rivera offered a distinct counterpoint to Duchamp's example; the sociopolitical messages of Rivera's murals were dependent on their monumental scale and figural style.

Already famous in his homeland, Rivera would gain equally widespread recognition in the United States, where he would complete a sequence of important mural commissions, producing compositions that were increasingly complex and cohesive in their design. Like his earlier murals in Mexico, they often explore themes through both a historical and contemporary lens, creating visual narratives that speak to the artist's views on issues confronting the modern world, such as industrialization, technology, and economic inequity. Arriving in the U.S. at the start of the Great Depression, Rivera held strong convictions on the potential for art to foment change, developed from his experiences working in Mexico in the wake of its violent revolution. Beyond the formal impact of his work, Rivera's role as a commentator on larger social issues via his murals offered a new model for artists in the U.S., many of whom became interested in the development of a visual language that reflected contemporary America and spoke directly to its concerns, much in the way Mexican artists had in the 1920s.

MARK A. CASTRO

"ONLY A RIVERA": THE MURAL PAINTER IN THE UNITED STATES

FIG. 1
Diego Rivera, *Allegory of California*, 1931. Fresco. City Club
(formerly the Pacific Stock Exchange Luncheon Club),
San Francisco

The United States, in turn, exerted its own influence on Rivera. The artist had received his first show in this country, in New York, in 1916 and interest in his work continued in the press over the next decade, contributing to the publication of the artist's first monograph in English, *The Frescoes of Diego Rivera* by Ernestine Evans, in 1929.[4] By then, Rivera's position in Mexico was becoming increasingly tenuous. Although he became the director of the National School of Fine Art that same year, his proposal to drastically overhaul the curriculum was met with resistance from both students and faculty, stymieing his efforts to lead the nation's foremost art school. At the same time, the Mexican government banned the Communist Party of Mexico, forcing it underground. Rivera had been distancing himself from the party's openly anti-government stance, partly due to his own changing politics, which failed to align with the group's growing adherence to Stalinism, but also to protect his relationship with his main patron.[5] Yet that relationship was also strained, as the politicized content of many of his murals began to draw criticism from the increasingly anticommunist government. Thus, the United States offered Rivera the opportunity to spread his vision of mural painting to a receptive audience at a time when interest in it had cooled in Mexico, but it also confronted him with a society in the midst of its own upheavals. The wonders of mass industrialization had been eclipsed by economic turmoil, making Rivera's themes of worker-driven reform particularly timely. What he could not have foreseen were the ways in which the nascent forces of celebrity and commercialization would complicate the expression of his ideals.

Accompanied by his wife, Frida Kahlo, Rivera arrived in San Francisco in November 1930, having secured mural commissions for the Luncheon Club of the Pacific Stock Exchange and at the California School of Fine Arts, now known as the San Francisco Art Institute.[6] Although Rivera's communist beliefs led to criticism in the press over the commissions, the first mural he completed, *Allegory of California* (fig. 1), lacks any overt political statements. Instead it seems to express admiration for American enterprise, showing the development of California's natural resources while offering no critique of the capitalist system that the exploitation of those resources—or the Pacific Stock Exchange itself—support. *The Making of a Fresco Showing the Building of a City* (p. 20, fig. 5) at the San Francisco Art Institute similarly celebrates North American technology and industry. A mural about the making of a mural, Rivera's depiction of himself and fellow artists perched atop scaffolding speaks to the school's mission of art education. Yet the fictitious mural's themes of modern construction and progress portray the artist and his assistants as active participants in this development, rather than as critics of the larger economic systems it represents.[7]

Rivera completed both murals in 1931, vacationing between the two projects at the estate of Rosalie Meyer Stern, a philanthropist and widow of the former president of Levi Strauss and Company, Sigmund Stern. In his host's outdoor dining space, Rivera painted one of his most overlooked murals, *Still Life and Blossoming Almond Trees* (fig. 2), on a metal structure that allowed the mural to be transported indoors as needed.[8] Originally intended to showcase

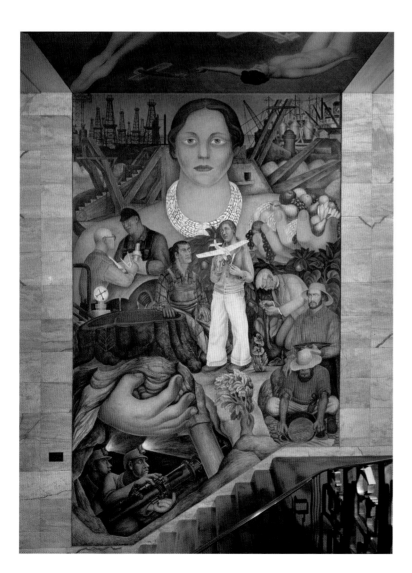

FIG. 2
Diego Rivera Painting the Fresco [Still Life and Blossoming Almond Trees], 1930–31. Photograph by Ansel Adams.
San Francisco Museum of Modern Art; Albert M. Bender Collection, gift of Albert M. Bender

modern farmers at work, the mural's central concept was changed at the request of Stern.[9] In the foreground, three children take fruit from a laden basket: two of Stern's grandchildren, Rhoda and Peter, and a mestizo child who has been identified either as the daughter of one of the estate's gardeners or a representation of Rhoda's imaginary friend, "Diaga."[10] To the left, another of Stern's grandsons, Walter, kneels to plant a seed in an orchard carefully tended by workers. The tractor that one worker drives in the background again evokes American technological modernity, as with the other San Francisco murals. Yet the artist's willingness to defer to his patron and to create this image of social tranquility amid an agricultural bounty is striking. As scholars have pointed out, Rivera was undoubtedly aware of the exploitative conditions suffered by the multitude of Mexican immigrants who were working as agricultural laborers in California, yet they have only a veiled presence in this mural.[11]

Rivera returned to Mexico City in June 1931 to resume work on his murals at the National Palace, but he would embark for New York in the fall to attend his retrospective exhibition at the Museum of Modern Art, which opened in December.[12] In addition to paintings, watercolors, and drawings from throughout the artist's

career, the show featured eight portable frescoes produced on-site.[13] While five of these depict Mexican scenes, three explore American industry and technological advancement. *Pneumatic Drilling* and *Electric Power* (pl. 62) depict anonymous workers engrossed in the construction of New York's modern buildings, and it is not until the final portable fresco, *Frozen Assets* (fig. 3), that Rivera at last introduces a counterpoint to his images of American progress. Decades later, Rivera would call it "the most ambitious" of the New York frescoes, describing it as a representation of "the various strata of life in New York during the Great Depression." He goes on: "At the top loomed skyscrapers like mausoleums reaching up into the cold night. Underneath them were people going home, miserably crushed in the subway trains. In the center was a wharf used by homeless unemployed as their dormitory, with a muscular cop standing guard. In the lower part of the panel, I showed another side of this society: a steel-grilled safety deposit vault in which a lady was depositing her jewels while other persons waited their turn to enter the sanctum."[14]

A scathing rebuke of the economic inequities brought about by capitalism, *Frozen Assets* feels incongruent with the generally serene tone of the

FIG. 3
Diego Rivera, *Frozen Assets*, 1931–32. Fresco on reinforced
cement in a galvanized-steel framework, 94 ⅛ × 74 ³/₁₆ in.
(239 × 188.5 cm). Museo Dolores Olmedo, Mexico City

San Francisco murals. In the wake of its completion,
public responses to Rivera and the work demonstrated
the difficulties he faced in navigating the opinions and
expectations of various audiences. The artist was
heckled at a lecture at the John Reed Club of New York
over his willingness to work for American capitalists
and denounced in *New Masses* as a "supporter of
American imperialism."[15] At the same time, critics like
Henry McBride condemned *Frozen Assets* and some
of the other MoMA frescoes as products of an artist
too entrenched in his communist ideology to truly
understand the United States.[16]

In spring 1932, Rivera and Kahlo left New York for
Detroit, where he had been commissioned to paint a
mural within the Garden Court of the Detroit Institute
of Arts.[17] The initial agreement with the museum's
director, William R. Valentiner, called for the artist to
paint two large panels that explored the city's history
and flourishing industry. The project was funded by
Edsel Ford, then president of the Ford Motor Company,

who granted Rivera access to the company's
manufacturing complex in Dearborn. Eventually growing
to include twenty-seven individual panels, *Detroit
Industry* (pls. 53, 54) is among the most cohesive mural
cycles in Rivera's career. It explores the complex
relationship between man, the natural world, and tech-
nology, creating a narrative of unstoppable human
progress. Controversy surrounded the mural even
before it was publicly unveiled, with various constituent
groups railing against portions of its content and
Rivera's politics. The publicity storm contributed to
Detroit Industry's success, with more than ten
thousand visitors cramming into the Garden Court on
a single Sunday.

While still in Detroit, Rivera signed a contract to
paint a mural in the RCA Building in Rockefeller Center,
returning to New York with Kahlo in March 1933. *Man
at the Crossroads Looking with Hope and High Vision
to the Choosing of a New and Better Future* was to be
the artist's crowning achievement in the United States,
placing his work at the center of one of New York's
newest landmarks. After beginning to paint in March, a
new controversy erupted in the local and national press
over Rivera's inclusion of a portrait of Vladimir Lenin in
the righthand section of the mural. Nelson Rockefeller,
acting on behalf of his family, requested Rivera remove
the portrait; the artist refused. In May, Rivera was paid
his full fee and dismissed from the project. The move
incited further controversy, with vocal supporters
on either side commenting in the press, yet unlike the
controversy in Detroit, it did nothing to fuel public
engagement with Rivera's work: the mural was covered
and hidden from view.

Rivera used the fee he received from the
Rockefellers to complete a cycle of twenty-one fresco
panels for the Marxist-oriented New Workers School in
New York. *Portrait of America* (pls. 95–97; p. 29, fig. 10)
is undoubtedly one of the most triumphant statements
of Rivera's career, although not well known today, in
part due to the eventual destruction of many of the
panels.[18] Aggressively polemic, the cycle chronicled the
history of the United States from the colonial era to
the present day, with each panel featuring key events
and movements, such as the Revolutionary War, Shays's
Rebellion, and the Civil War. The panels utilized portraits
of historical figures and other symbols to narrate the
history of the nation's working classes, culminating
in a central panel, *Proletarian Unity*, which exhorts

FIG. 4
Victor Arnautoff, *City Life* (detail), 1934. Fresco, 10 × 36 ft.
(3 × 11 m). Coit Tower, San Francisco

FIG. 5
Thomas Hart Benton, *City Building* from *America Today*,
1930–31. Egg tempera with oil glazing over oil on linen mounted
to wood, 92 × 117 in. (233.7 × 297.2 cm). The Metropolitan
Museum of Art, New York; gift of AXA Equitable, 2012

workers to unite in the face of the contemporaneous
threats of Nazism and fascism. Despite being
celebrated by the workers who made up the school's
clientele, Rivera remained dispirited over the
Rockefeller scandal and the resulting loss of several
other U.S. commissions. He and Kahlo returned to
Mexico in December, where two months later they
heard of the final destruction of his mural at Rockefeller
Center. Writing to the press from Mexico, Rivera would
denounce the Rockefellers for committing an act of
"cultural vandalism."[19]

Rivera produced some of the pivotal works of his
long career during his time in the United States and
had a profound impact on his contemporaries here.[20]
As Francis O'Connor explored in a 1986 essay, Rivera's
impact went beyond our traditional notions of artistic
influence.[21] The formal effect of Rivera's paintings can
certainly be found in the work of a number of artists,
particularly many of the young American painters who
began to produce murals under the auspices of such
New Deal programs as the Public Works of Art Project
and later the Works Progress Administration. The
murals in Coit Tower in San Francisco are perhaps the
best example (fig. 4), where the influence of Rivera's
style is apparent in the work of almost all of the twenty-
six artists who completed murals there. Many had

direct contact with the Mexican artist, including
Victor Arnautoff and Maxine Albro, both of whom had
worked with Rivera in Mexico, and Clifford Wight, who
would assist on several of Rivera's projects in the
United States.

Although examining Rivera's aesthetic influence
is important, what is more interesting, as O'Connor
points out, is the model he offered to artists in the
United States as the maker of ideologically driven art
for public spaces. Many of Rivera's murals in Mexico
in the 1920s, following the charge of the Obregón
government, aimed to construct a new shared history
for Mexico in the wake of its violent revolution. At the
same time, these works provided Rivera an opportunity
to comment on society at large, often presenting his
vision for a communist-influenced future. The notion
of an artist as a community-engaged figure, what today
we might call an activist-artist, would, to borrow
O'Connor's language, fill a "cultural and ideological
vacuum" in the United States.[22]

Rivera's murals demonstrated art's potential as
a method for national self-reflection, coming as the
nation was just beginning to comprehend the crisis of
the Great Depression and as a number of U.S. artists
who had vocally rejected European modernism were
seeking to create a national art for the United States

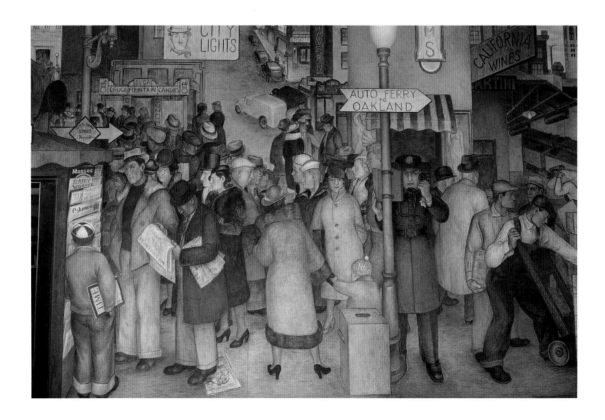

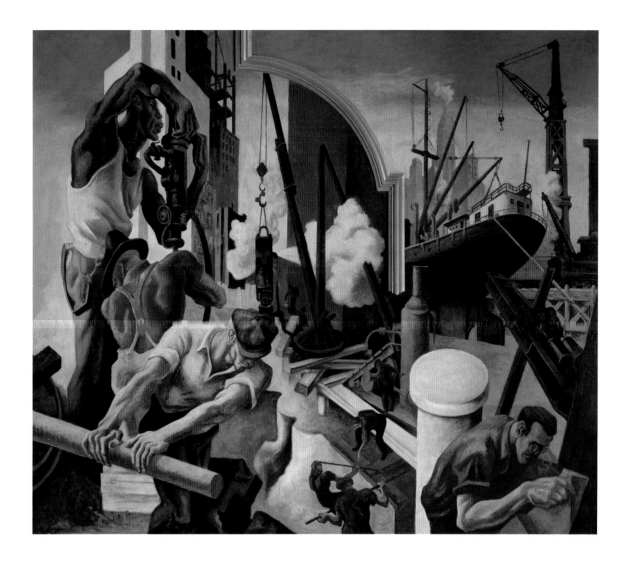

much as artists in Mexico had done a decade earlier. Chief among these "American Regionalists" was Thomas Hart Benton, whose early enthusiasm for the work of Rivera and other Mexican muralists would be tempered by his rejection of communism. When he was asked to comment on the Rockefellers' destruction of *Man at the Crossroads*, Benton replied: "I respect Rivera as an artist, as a great one, but I have no time to enter affairs concerning him because I am intensely interested in the development of an art which is of, and adequately represents, the United States—my own art."[23] Yet Benton's paintings from this period suggest he was paying more attention to Rivera than such comments let on. As Anna Indych-López has recently pointed out, Benton's *America Today* (fig. 5), made in 1930–31 for the New School of Social Research in New York, recalls many of the compositional structures Rivera used in his murals in Mexico and the U.S. Benton's Art Deco frames, for example, which break up the dense array of nonlinear scenes, are reminiscent of those found in Rivera's *History of the Conquest of Mexico* (1929–30) at the National Palace in Mexico City and the later Detroit mural.[24] Equally important, however, is the model Rivera and his compatriots

offered for creating public art that addressed the political, social, and cultural conditions in this country. As Benton would ultimately admit some thirty years later: "I had looked with much interest on the rise of the Mexican school during the mid-1920s. In spite of the Marxist dogmas, to the propagation of which so much of its work was directed, I saw in the Mexican effort a profound and much-needed redirection of art towards its ancient humanistic functions. The Mexican concern with publicly significant meanings and with the pageant of Mexican national life corresponded perfectly with what I had in mind for art in the United States. I also looked with envy on the opportunities given Mexican painters for public mural work."[25]

At the same time that Rivera was changing his North American contemporaries' views of the role of art and artists, Rivera's own conception of a modern artist also expanded. In the United States, he transitioned from famous artist to American celebrity, rubbing elbows with actors, politicians, and members of the moneyed elite. These associations led to widespread criticism from his Marxist comrades and fellow artists. David Alfaro Siqueiros vocally criticized Rivera as both a political and artistic opportunist,

FIG. 6
Diego Rivera, *Edsel B. Ford*, 1932. Oil on canvas, mounted on composition board, 38 ½ × 49 ¼ in. (97.8 × 125.1 cm). Detroit Institute of Arts; bequest of Eleanor Clay Ford 77.5

lacking any real convictions in either. Looking beyond some of this rivalry and bluster, it is clear that Rivera's time in the U.S. undoubtedly relaxed the painter's views of the wealthy, while in his mind his political principles and self-image as a worker remained intact. In many cases it was these rich capitalists who funded his murals in this country, earning him fees that were higher than he had typically received. Rivera would later describe the $4,000 fee he received for his first two murals in San Francisco as "the most munificent sum I had ever been offered to paint a wall."[26] Two years later he would receive more than $20,000 each for his mural commissions in Detroit and at Rockefeller Center.

Along those lines, Rivera capitalized as well on his new extensive network of patrons, supporters, and friends in the U.S., even after his return to Mexico. The artist had made easel paintings and smaller scale works throughout his career, but their production appears to have taken on new value in the U.S. Portraits of his patrons, such as Edsel Ford (fig. 6), foreshadow Rivera's renewed interest in the genre following his return to Mexico. Similarly, small-scale depictions of everyday rural life in Mexico become more of a staple of the artist's production, even as these became increasingly standardized over the course of his career.

These works call to mind Rivera's short essay "Mickey Mouse and American Art," published in February 1932, in which he praises American cartoons

for "the standardization of the drawing of details, the infinite variety of the groupings, as in the painted friezes of the Egyptians and the earthenware vases of the Greeks!"[27] Rivera goes on to claim that following the future revolution of the masses, it will be cartoons, with their established language and clear messaging, that will be looked upon most fondly, not for any role they played in fomenting change but instead for the pure pleasure that they bring to everyday people. In a similar fashion, Rivera's abundant scenes of life in Mexico seem increasingly driven by the visual pleasure they provide, rather than any sociopolitical aim. This drive to create works predicated on the enjoyment of the viewer could be seen as another byproduct of Rivera's sojourn in the United States.

The contrasting images of Rivera as the worker-painter and artist-celebrity speak to his own complex and often contradictory nature. What remains clear is that his experiences in the United States transformed him and his legacy, as much as they also impacted artists in the U.S. Even before his arrival, Rivera's murals drew attention in this country for the model they offered of works that were socially engaged and civic-minded. In the U.S., however, his murals developed new thematic content that depict an increasingly nuanced view of the triumphs and pitfalls of modernity. At the same time, his extraordinary production of portable works that could more readily circulate in exhibitions expanded the reach of his art. Today, many are housed in U.S. museums and collections, functioning alongside his murals as a collective reminder of the artist's legacy in the United States, one that, in its expansiveness and popular reception, perhaps "only a Rivera" could have achieved.

NOTES

I wish to thank Dafne Cruz Porchini, Kristoffer E. Hewitt, and John Vick for their generous thoughts on this essay.

1. Laurie Eglington, "Marcel Duchamp Is Back in America and Is Interviewed," *Art News*, November 18, 1933: 11. My thanks to Matthew Affron for sharing this article with me.

2. Ibid.

3. Anita Brenner, *Idols behind Altars* (New York: Harcourt, Brace, 1929), 277.

4. Ernestine Evans, *The Frescoes of Diego Rivera* (New York: Harcourt, Brace, 1929). Rivera's first solo show in the U.S., *Exhibition of Paintings by Diego M. Rivera and Mexican Pre-Conquest Art*, was held at Alfred Stieglitz and Marius de Zayas's Modern Gallery. It featured a selection of the artist's Cubist works alongside examples of Mexican pre-Columbian art.

5. Rivera's relationship with the party also soured over his acceptance of a mural commission from the U.S. ambassador to Mexico, Dwight Morrow, a former J. P. Morgan executive. The artist was ultimately expelled from the party in September 1929.

6. For a comprehensive overview of Rivera's murals in San Francisco, see Anthony W. Lee, *Painting on the Left: Diego Rivera, Radical Politics, and San Francisco's Public Murals* (Berkeley: University of California Press, 1999).

7. The only sign of Rivera's political beliefs in the mural is a red star in a circle that appears on the front pocket of the worker in the center. For a number of years, the more overt communist emblem of a hammer and sickle appeared there, but a 1990 cleaning of the mural revealed this to be a later addition, one that is not visible in photographs of the mural from the 1930s. The meaning of the red star in a circle is further complicated, however, by the fact that it was also employed in the 1930s as a logo for Red Man, a popular brand of chewing tobacco. See Paul J. Karlstrom, "Rivera, Mexico and Modernism in California Art," in *Diego Rivera: Art & Revolution*, ed. Luis-Martín Lozano et al. (Mexico City: Consejo Nacional para la Cultura y las Artes, 1999), 218–33.

8. The mural was eventually donated to the University of California, Berkeley.

9. Luis-Martín Lozano, "Revolutions and Allegories: A Mexican Muralist in the United States," in *Diego Rivera: The Complete Murals*, ed. Lozano (Cologne: Taschen, 2007), 267.

10. Ibid. See also Stanton L. Catlin, "Mural Census. Stern Residence, Atherton, California," in *Diego Rivera: A Retrospective*, ed. Cynthia Newman Helms (Detroit: Detroit Institute of Arts, 1986), 281.

11. Lozano, "Revolutions and Allegories," 270n21.

12. *Diego Rivera* (New York: The Museum of Modern Art, 1931).

13. Rivera completed five of the murals prior to the opening of the exhibition, while the three American-themed frescoes were completed a month later. For the most comprehensive study of these works, see Leah Dickerman et al., *Diego Rivera: Murals for The Museum of Modern Art* (New York: The Museum of Modern Art, 2011).

14. Diego Rivera with Gladys March, *My Art, My Life: An Autobiography* [1960] (New York: Dover Publications, 1991), 110.

15. The John Reed Club of New York, "Diego Rivera and the John Reed Club," *New Masses*, February 1932.

16. Henry McBride, "The Palette Knife," *Creative Art*, February 1932: 93–97.

17. For the most complete study of Rivera's Detroit murals, see Linda Bank Downs, *Diego Rivera: The Detroit Industry Murals* (Detroit: Detroit Institute of Arts, 1999).

18. The panels were removed from the New Workers School before its building was demolished in 1936, and the series was transferred to the school's new location at 131 West 33rd Street. After the school's parent organization dissolved at the end of December 1940, the frescoes were offered to the International Ladies Garment Workers Union (ILGWU). The panels were moved in 1942 to Unity House, an ILGWU retreat in Forest Park, Pennsylvania. Only thirteen of the panels were exhibited there, and these were destroyed in a fire in 1969. The surviving panels have been dispersed to several private collections, organizations, and museums.

19. "Rivera RCA Mural Is Cut from Wall," *New York Times*, February 13, 1934. Following the mural's destruction, Rivera received support from the Mexican government to re-create the work, with some adaptations, at the newly opened Palace of Fine Arts in Mexico City. The portrait of Lenin remained.

20. Rivera returned to the United States in 1940, to San Francisco, where he participated in events surrounding the Golden Gate International Exposition and completed his final mural in the U.S., *Pan-American Unity*, at San Francisco Junior College (now City College of San Francisco).

21. Francis V. O'Connor, "The Influence of Diego Rivera on the Art of the United States during the 1930s and After," in Helms, *Diego Rivera: A Retrospective*, 157–83.

22. Ibid., 159.

23. Thomas Hart Benton, "Unpublished Lecture to the John Reed Club, New York (February 11, 1934)." Jackson Pollock Papers, Archives of American Art, Smithsonian Institution, Washington, DC.

24. Anna Indych-López, "Mexican Muralism in the United States in the Early 1930s: The Social, the Real, and the Modern," in *Paint the Revolution: Mexican Modernism, 1910–1950*, ed. Matthew Affron et al. (Philadelphia: Philadelphia Museum of Art, 2016), 343.

25. Thomas Hart Benton, *An American in Art: A Professional and Technical Autobiography* (Lawrence: University Press of Kansas, 1969), 61–62.

26. Rivera, *My Art, My Life*, 105. Despite his claim, the artist had received three times that amount just the previous year for his cycle of murals *History of the State of Morelos: Conquest and Revolution*, in the Palacio de Cortés in Cuernavaca, commissioned and funded by Dwight Morrow.

27. Diego Rivera, "Mickey Mouse and American Art," *Contact: An American Quarterly Review*, February 1932: 37–39.

The new industrial country radically modified my sense of the plastic.

—David Alfaro Siqueiros, 1934

"Cine-photogenic art," "pictorial-cinematographic-art," "scenographic painting"—these are just some of the neologisms David Alfaro Siqueiros marshaled as a means to articulate his experimentations with realism through photography, film, painting, and mass-media spectacle in the service of creating a revolutionary public art, a radical exploration of the potential for filmic mediums to inform other artmaking that Siqueiros also termed *plástica fílmica*.[1] As other scholars have elaborated, the cinematic had preoccupied Siqueiros since 1921, the same year he praised the early Mexican film *El caporal* for its affinities with U.S. film, specifically its "dynamism" and "vigor," and his intellectual exchanges a decade later with Sergei Eisenstein, while the Russian filmmaker was in Mexico to shoot *Que viva México!*, expanded his aesthetic theories.[2] But it would be during his seven-month stay in Los Angeles in 1932 when Siqueiros would have more firsthand access to the world of cinema than at any other period in his career, interacting directly with filmmaking experts and coming to understand their equipment, materials, and working methods. With a few key exceptions, however, the significance of Hollywood and its culture industry has remained relatively unexplored in relation to understanding Siqueiros's development of his theories of the cinematic in relation to politicized public

artmaking, specifically on his aesthetics.[3] In seeking to analyze the impact Siqueiros's time in Los Angeles had on *his* art and ideology, this essay situates the artist within a network of Hollywood players and visual modes to reveal their effect on his evolving theories in regards to the productive contact zones between painting, photography, cinema, and other visual forms as a means to create a dynamic realism that activates the masses.

Although Siqueiros was in Los Angeles for a short period—April to November—he completed three murals and gave several public lectures, including one at the Hollywood John Reed Club, the main institutional base for communist and fellow-traveling artists and writers at the time.[4] The revolutionary aesthetic he called for encompassed a technical revolution within a collective practice in the service of radical politics. It was precisely in Los Angeles that he put his ideas into action and later used those experiences as a foundation for his experimentations elsewhere, significantly in Argentina and then later at the Experimental Workshop he founded in New York in 1936. Siqueiros's direct contact in Los Angeles with industry artists, the technical and material innovations of U.S. film culture, and its social contexts profoundly affected his development of *plástica fílmica*, his conceptual aesthetic mode that engaged mass-media techniques in the creation of elastic expressive forms, embodying a dynamic, engaging, and politicized modernity. Implying movement, kinetic sensation, the subjectivity of the spectator, and representational concerns, *plástica fílmica* takes formal cues from cinema to propose an active and experimental realism. Engaging the masses through street art,

ANNA INDYCH-LÓPEZ

CELLULOID AMÉRICA: SIQUEIROS, HOLLYWOOD, AND *PLÁSTICA FÍLMICA*

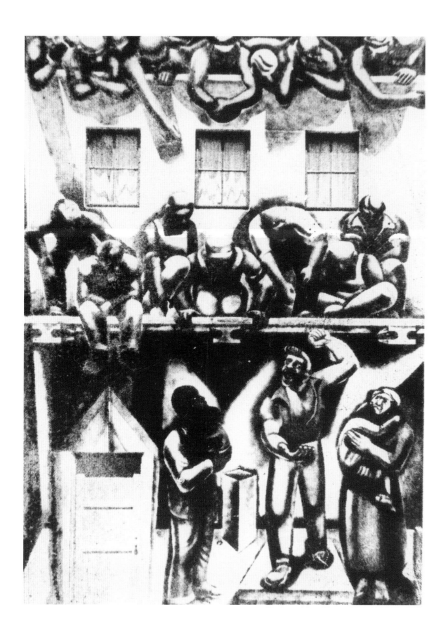

FIG. 1
David Alfaro Siqueiros, *Street Meeting*, 1932. Fresco on
cement, 24 × 19 ft. (7.3 × 5.8 m). Chouinard Art Institute,
Los Angeles. Archivo El Centro Nacional de Investigación,
Documentación e Información de Artes Plásticas (CENIDIAP),
INBA, Mexico City

training. As part of a broader Los Angeles film culture, Chouinard provided the context within which Siqueiros's "Bloc of Mural Painters," as he called his mural team, were predisposed to think in a filmic way, introducing Siqueiros to new mass-media techniques through their collaboration.[6]

Street Meeting (fig. 1), painted on an outdoor wall 24 by 19 feet, depicted construction workers listening to a labor organizer's speech. Although the mural was the product of his fresco painting course, it instead reveals the ways in which Siqueiros used this opportunity to move away from the confines of frescoes in order to experiment with modern industrial materials and techniques, including waterproof cement (instead of traditional *buon* fresco), spray guns to apply the pigment, stencils to produce the effect of cast shadows, pneumatic drills to roughen the surface and allow for greater paint adhesion, and the use of an airbrush, "an essential instrument in the plastic production of our decoration."[7]

The Chouinard mural also marked the first time that a camera played a role in Siqueiros's working process. "After making our first sketch we used the camera and motion picture to aid us in elaboration of our first drawing," the artist recounted at the time. "To replace the slow and costly method of pencil tracing and pounce pattern projection we used the camera projection. A method of enlarging our drawing and thereby projecting our design directly to the wall."[8] Beyond replacing the cartoon of fresco painting with the quicker photographic sketch, by projecting drawings directly onto the wall, Siqueiros and his team mobilized a uniquely cinematic mode, turning the Chouinard wall essentially into a filmic screen in the process of creating the mural.

Within a few weeks after the unveiling of *Street Meeting*, Siqueiros lined up a commission to paint his second public mural in Los Angeles, at the Plaza Art Center, where he continued to advance his ideas surrounding *plástica fílmica*. At 18 by 82 feet, the mural was considerably larger than the Chouinard mural and painted on a more public site, an exterior second-story wall in downtown Los Angeles visible from multiple thoroughfares, including historic Olvera Street. Commissioned to depict a scene of "tropical America," Siqueiros instead painted a contemporary Indigenous laborer crucified on a double cross set against the backdrop of an overgrown jungle and

it also influenced the artists with whom he worked in his artistic collectives, stimulating aesthetic and theoretical discussion across the Americas.

Not long after Siqueiros arrived in Los Angeles, he began teaching fresco painting at the Chouinard Art Institute, and soon he parlayed the teaching assignment into his first public mural project in the United States (also the first street-facing mural in the history of Mexican muralism). Chouinard had become a major school in the 1920s for fashion and costume design, producing prominent film-industry designers such as Oscar-winner Edith Head, and in 1929, Walt Disney began sending young illustrators to the school for professional training.[5] Chouinard, therefore, was a nexus of the film industry, animation, and high-art

FIG. 2
David Alfaro Siqueiros, *Portrait of Sternberg*, 1932.
Oil on burlap, 30 × 39 ¾ in. (101.6 × 121.9 cm).
Private collection

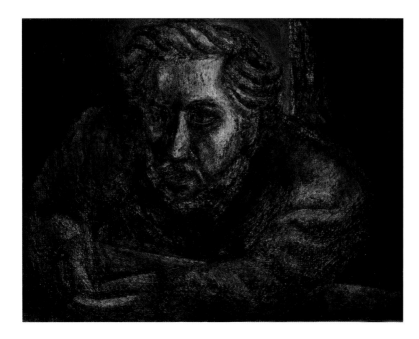

pre-Columbian ruins while two armed soldiers point their rifles at a symbolic U.S. eagle (pl. 99). According to contemporary news accounts, Siqueiros once again led as an "instructor" a team that included "art teachers, professional decorators, motion picture directors, scenic painters, and a caricaturist"; the team worked mostly at night by "electric light" provided by floodlights used in the film industry.[9] Yet rather than use the camera to project drawings on the wall, the group enlisted photography to plot the spectator's movement. As Siqueiros recalled, an unnamed young "half-crazy" team member followed the others "relentlessly with his machine [photographic camera] . . . tracing the movement of the spectator of the work, photographing [the] wall from every angle."[10] Siqueiros realized the camera's potential to activate the surface of the wall. As Shifra Goldman explained: "Rather than passively receiving moving images, the spectator substitutes for the active role of the movie camera," laying the foundation for his concept of *plástica fílmica*. While Siqueiros's theories were often a couple of steps ahead of his visual implementation, a contemporary reviewer noted that the mural seemed to "recede and advance," signaling how Siqueiros's direct contact with Hollywood's modern film industry helped him to work toward a radical cinematographic muralism that merged popular, commercial, and vanguard expressive forms.[11]

Among the industry artists who joined Siqueiros's mural team to work on *Tropical America* were U.S. art director Wiard Boppo Ihnen and German set designer Richard Kollorsz, both of whom had worked on the films of Josef von Sternberg. Indeed, the Austrian-born director, who had facilitated Siqueiros's visit to Los Angeles, became the linchpin for the artist's engagement with Hollywood. Siqueiros's portrait of von Sternberg (fig. 2)—his first U.S. commission—was unveiled as part of an exhibition devoted entirely to portraits of the director, which took place on a soundstage at Paramount on June 18, 1932, a working day on the production of von Sternberg's film *Blonde Venus* (fig. 3).[12] While we do not know if Siqueiros attended the exhibition, others have suggested he visited the director at Paramount in order to realize the portrait of him sitting at his desk at the studio.[13] *Blonde Venus* itself, with its plot centered on a former cabaret performer, played by Marlene Dietrich, who returns to the stage to pay for her husband's medical treatment only to be seduced by an American millionaire, marked von Sternberg's first foray into representing class experiences in the United States, a topic surely of interest to Siqueiros.[14] Meanwhile, Siqueiros created his third U.S. mural, a private commission, for director Dudley Murphy's Pacific Palisades home (*Portrait of Mexico Today*; now at the Santa Barbara Museum of Art).

In Siqueiros's ongoing effort to translate his rhetorical and discursive imagining of *plástica fílmica* into visual form, Hollywood film aesthetics played a central role. For example, he found inspiration in art direction, which became established under the studio system during this era. As film historian Beverly Heisner has noted, by the 1930s film studios employed large art departments, with art directors becoming increasingly central to creating "the total look of the film" as they oversaw a team of artists trained in art, architecture, and theater design.[15] Art direction typically included myriad components, most notably continuity sketches (which established camera angle, location of actors, and positioning of sets and props), construction of sets, set decoration, and lighting design. Von Sternberg's go-to art director was German émigré Hans Dreier, who stressed "accuracy in detail" in set design.[16] Siqueiros's team members would have been steeped in the Dreier aesthetic, which Heisner describes as "moody" and comprised of "arresting

effects."[17] In terms of lighting, von Sternberg preferred spotlit faces, backlit hair, and soft contours.[18] The dramatic chiaroscuro of such films clearly would have appealed to Siqueiros, who had already been painting with heavy light-dark contrasts and who was developing a signature baroque style. In the early 1930s, directors used floodlights for key lighting effects, especially to create soft-edged shadows on the face—the same type of floodlights Siqueiros used to illuminate work on *Tropical America*.[19] Significantly, Siqueiros's experimentation with actual film equipment to make his murals —even beyond a camera—allowed him to forge an aesthetic that could conjure the cinematic.

The settings and compositions of Siqueiros's public murals in Los Angeles demonstrate his awareness of other characteristics that were trademarks of contemporaneous filmmaking. Marked by their shallow depth of field or focus, the result of mostly close-ups and medium shots, early 1930s films do not use deep focus, and they were often staged like theater, with backgrounds that were not viewed as anything other than flat space and thus yielded a distinct shallow-stage look.[20] The mise-en-scène-like appearances of both *Street Meeting* and *Tropical America* bear striking formal resemblances to such films, fusing the filmic perspectives of the day with the flattened spaces of modern realism.

Those murals and Siqueiros's developing concept of *plástica fílmica* also embraced the tensions between abstraction (as reflected in the frontality of stage sets) and the broader concept of illusionism

that were hallmarks of both the big screen and realist artmaking. Despite the ubiquity of flat spaces, Hollywood studios emphasized "realism" in terms of production design and the creation of "a world that the audience recognized."[21] Similarly, while the shallow, close-knit, designed space of *Street Meeting* shares the artificiality of a film set, Siqueiros employed naturalistic strategies, most notably his integration of the physical wall itself into the composition so that the laborers appear to hang over it or to sit upon scaffolding attached to it. The conceit of the wall activates the fictive picture plane with a heavy cast of shadows, furthering the notion of an illusionistic space that the spectator can enter. In contrast, *Tropical America* mitigates illusionistic space to create a scene of ominous excess verging on surreality as a means to attack the realities of the historical oppression of Mexican laborers, the tyrannies of colonialism and imperialism, and U.S. racial politics. The émigré artists of Paramount, including von Sternberg, Dreier, and Kollorsz, who had engaged a German Expressionist style, punctuated any sense of realism with similar dramatic flourishes that also appealed to a sense of the unreal.[22] This particular group, who navigated both European and U.S. modes of art direction, nourished a distinctive transnational hybrid aesthetic caught between the real and the expressive that aligned with Siqueiros's own experimental realist aesthetics.

Siqueiros's vanguard form of realism was always founded on his belief in a radical and collective form of public artmaking rooted first in muralism and expanded later into other art forms, including protest art. With its collective and collaborative nature, the Hollywood studio system aligned with Siqueiros's working practices. Indeed, as Heisner states: "Aside from the WPA projects . . . there has been no more significant gathering together of American visual artists than in the movie industry when it flourished in Hollywood in the first half of [the twentieth] century. Painters, illustrators, and architects were assembled under one roof, working for a single patron, on communal tasks."[23] That communal aspect of Hollywood art dovetailed both with the ideas behind the project of Mexican muralism and with its historical leftist associations, promulgated in the early 1930s by the liberally minded émigrés from Nazi Germany and newly arrived cultural workers from New York.[24] Early U.S. film theorists and critics helped to foment a radical perspective, rooted in

FIG. 4
David Alfaro Siqueiros, *Self-Portrait with Mirror*, 1937. Cellulose nitrate
paint on board coated with phenolic resin, 30 × 24 in. (76.2 × 61 cm).
Museum of Fine Arts, Boston; Charles H. Bayley Picture and Paintings
Fund, Sophie M. Friedman Fund, Ernest Wadsworth Longfellow Fund,
Tompkins Collection—Arthur Gordon Tompkins Fund, William Francis
Warden Fund, and Gift of Jessie H. Wilkinson—Jessie H. Wilkinson Fund
2017.390

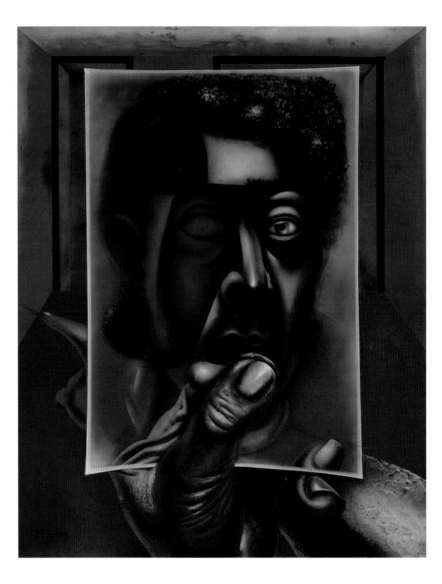

critiques of industrial capitalism but which included analyses of avant-garde Soviet Social Realist and commercial cinema forms as a means for assessing sociopolitical structures and organizing political action.[25] Historian Sarah Schrank elaborates that "Siqueiros's murals, created with the technologically advanced tools borrowed from the film industry, reflected the cultural front's progressive views about social justice in a public, commercial venue."[26] Even as Hollywood continued to cater to U.S. consumer culture, the industry paradoxically became a place for creative expressions focused on international solidarity and oppositional political practices. Siqueiros enthusiastically entered that cultural ferment.

At the John Reed Club, where he first publicly mentioned the use of a cinematic (or photographic)

camera in the formation of "pictoric-plastic form," Siqueiros proclaimed in his characteristically florid and dogmatic rhetorical style that "[without the] photographic document—the modern painter will not extract a single drop of the new plastic truth which lives intensely in the mechanical lightning flash and in the torrent of the great masses agitated by the final class-struggle. Without the photographic document he will know nothing plastically about the daily blood repression of the exploiting class."[27] For Siqueiros, the cinematographic represented a documentary visual mode with which to link the spectacle of the real, mass media, and class struggle in outdoor murals that could, as contemporary reviewers noted, "possess" and "command" audiences from "miles away."[28] Expelled from the United States as a result of his expired visa (and his denunciation of U.S. imperialism in *Tropical*

America), Siqueiros had to wait until he left L.A. to further develop his ideas of *plástica fílmica*.

Beginning in 1936 at his Experimental Workshop near Union Square in New York, the artist continued to explore the tools, materials, and techniques of industrialization. Workshop members experimented with reproducibility, the creation of mobile art (such as parade floats) with industrial tools and materials, the use of photography and industrial paint (Duco cellulose nitrate), and the invention of controlled accidents through the spilling of paint, activities that shaped a generation of U.S. artists, including Jackson Pollock.[29] In the workshop Siqueiros continued to experiment as well with photography, "photostatic reproduction," and "photogenic graphics" in the service of radical politics. The artists created, for example, monumental portraits of Communist Party USA presidential candidates from enlarged photographs to be held by attendees of the party's national convention in New York in 1936.[30]

Although Siqueiros was far from Hollywood film culture, a painting he created in the workshop, *Self-Portrait with Mirror* (fig. 4), appears as a remarkable embodiment of his thematic and material reflections on illusionism and technology, preoccupations bolstered by his Los Angeles experiences and rehearsed through the genre of portraiture that was so central to his activist art. Made with cellulose nitrate paint on board coated with phenolic resin, *Self-Portrait* depicts the artist and his montaged "reflection," in which he gazes

back at the viewer (and supposedly himself in the process of making the work). Siqueiros focuses painterly attention on his hand in the foreground, especially his thumb that juts out of the picture plane in trompe l'oeil fashion, but while the object he holds is identified as a mirror in the work's title and indeed seems to reflect the artist's hand, the way it curves at the bottom in response to Siqueiros's grasp suggests instead a photograph, an interpretation enhanced by the thin white border around its edges. The mediated status of the depicted self-portrait within the overall painting, an abstracted background space, and the multiple layers of the mirror/photograph reveal the painting's concerns with representation itself. In this work, subjectivity and embodiment coalesce to contradictory expressions of illusionism. In her extensive study of the self-portrait, Siqueiros scholar Irene Herner states that it "creates the sensation of a sequenced game of celluloid planes mounted one on top of each other from back to front."[31] Indeed, Siqueiros's use of Duco cellulose nitrate in his works of this period allowed him to experiment with gelatinous surfaces, creating an aesthetic that evokes the materiality and effects of film, especially the "opulence of surface" that characterized Paramount's style under Dreier.[32]

Because of Duco's connection to modernity as a lacquer used in the automotive industry, scholars have rightly focused on Siqueiros's interest in its industrial associations. Others have pointed out the historical roots of cellulose nitrate pigments as an explosive known as guncotton, a bellicose "revolutionary" association that clearly would have appealed to him.[33] It bears mentioning that film stock (cellulose nitrate film) is chemically related to Duco pigment, although it is a much older material.[34] Siqueiros's interest in Duco cellulose nitrate was also tied to his preoccupations with industrial plastics, a modern medium that could also help him visualize his abstract concept of the plasticity, or elasticity, of visual form. *Self-Portrait with Mirror* is not only painted with plastic pigment, but its support is a board coated with phenolic resin, a plastic compound that could also be compression molded (like Bakelite) "to become," as design historian Jeffrey L. Meikle states, "whatever one wanted," an industrial concept related to an expressive realism.[35] Broadly speaking, the development of the plastics industry as Meikle describes it in the first half of the

twentieth century elicits a matrix of issues concerning imitation and innovation, concerns at the heart of Siqueiros's practice.[36] In using a form of plastic paint and a plastic-coated support in order to convey what he called a "plastic art," Siqueiros engaged the elastic in a clever reflexive interplay of medium, technique, and message in his mobilization of an experimental realism that, in turn, explores the theme of mirroring and illusion so prominent in cinema.

These representational concerns connect Siquerios's work to von Sternberg's, specifically his 1928 film *The Last Command*, which is about acting and filmmaking and includes sets within sets in the same way that Siqueiros's self-portrait is about artmaking and includes self-portraits within a self-portrait. In turn, von Sternberg's *The Blue Angel* from 1930 contains multiple mirror scenes and a critical close-up shot of the main protagonist's hand holding up photo postcards (all with white borders), closely resembling Siqueiros's self-portrait (fig. 5).[37] Portraiture and mass-media film culture align here with a plastic medium and support allowing Siqueiros to conjure a *plástica fílmica* that would continue to preoccupy him long after his U.S. sojourn. While his time in Hollywood provided Siqueiros with the opportunity to experiment with the camera in the service of visually codifying a temporal and kinetic experience, his evolving theory of *plástica fílmica* also encompassed the tensions among cinematic visuality, popular forms, and an expressive realism in the formation of a public radical art to engage the masses, a pursuit he would continue intensely for the next thirty years.

NOTES

I have relied on the expertise of numerous scholars for this essay and acknowledge their critical input: Chris McGlinchey, Anny Aviram, Irene Konefal, Layla Bermeo, Mia Curran, Hadley Newton, Whitney Graham, Dafne Cruz Porchini, Mireida Velázquez, Mónica Montes Flores, Lynda Klich, Barbara Haskell, Jason Best, and the entire Whitney team. For the epigraph, see "Catalog essay by Siqueiros," typescript, Delphic Studios 1934. Series IV, box 4, folder 16, Siqueiros Papers, Getty Research Institute, Los Angeles.

1. David Alfaro Siqueiros, "Qué es 'ejercicio plástico' y cómo fue realizado" [1933], reprinted in *Palabras de Siqueiros*, ed. Raquel Tibol (Mexico City: Fondo de Cultura Económica, 1996). See also Siqueiros, "Nueva era, plástica fílmica," *Siempre*, September 29, 1954: 24–25.

2. Siqueiros, "Cinematografía Mexicana," *Vida Americana* (1921), reprinted in Tibol, *Palabras de Siqueiros*, 21–22. On Eisenstein and Siqueiros, see Olivier Debroise, "The Vertical Screen," in *Inverted Utopias: Avant-Garde Art in Latin America*, ed. Mari Carmen Ramírez and Héctor Olea (New Haven, CT: Yale University Press, 2004), 239–45. On the relationship of Élie Faure's concept of *cinéplastique* to Siqueiros, see Natalia de la Rosa, "Épica escenográfica. David Alfaro Siqueiros: Acción dramática, trucaje cinemático y la construcción del realismo alegórico en la Guerra (1932–1945)" (Ph.D. diss., Universidad Nacional Autónoma de México [UNAM], Mexico City, 2016).

3. Mari Carmen Ramírez was the first to delve into Siqueiros's concepts of the cinematic. See Ramírez, "The Masses Are the Matrix: Theory and Practice of the Cinematographic Mural in Siqueiros," in *Portrait of a Decade: David Alfaro Siqueiros, 1930–1940* (Mexico City: Instituto Nacional de Bellas Artes, 1997), 68–95. More recently, Sergio Delgado has looked at the photographic and the filmic within the realm of the commercial as a way to support what he calls Siqueiros's "billboard muralism" of the 1950s. Delgado, *Delirious Consumption: Aesthetics and Consumer Capitalism in Mexico and Brazil* (Austin: University of Texas Press, 2017). Other key texts include: Sarah Schrank, *Art and the City: Civic Imagination and Cultural Authority in Los Angeles* (Philadelphia: University of Pennsylvania Press, 2009); Shifra Goldman, "Siqueiros and Three Early Murals in Los Angeles," *Art Journal* 33, no. 4 (Summer 1974): 321–27; and Laurance P. Hurlburt, *The Mexican Muralists in the United States* (Albuquerque: University of New Mexico Press, 1989).

4. There are various typescript versions of Siqueiros's John Reed Club speech in the Sala de Arte Público Siqueiros (SAPS), Mexico City, including unpublished versions analyzed by Delgado in *Delirious Consumption*, 44–57.

5. Schrank, *Art and the City*, 22.

6. The Chouinard team included: Tom Beggs, Robert Merrell Gage, Donald Graham, Philip Guston, Reuben Kadish, Henry De Kruif, Harold Lehman, Katherine McEwen, Barse Miller, Phil Paradise, Paul Sample, and Millard Sheets.

7. Siqueiros, "The New Fresco Mural Painting," *Script*, July 2, 1932: 5.

8. Ibid.

9. Arthur Millier, "Huge Mural for El Paseo," *Los Angeles Times*, August 24, 1932: i, 15. See series II, box 3, folder 18, "Siqueiros Fresco Unveiled Sunday Night at Plaza Art Center," undated typescript, Siqueiros Papers, Getty Research Institute. Otto K. Oleson company provided "floodlights for night work." See also Schrank, *Art and the City*, 47. The *Tropical America* team included: Jean Abel, Maria Andrade, Jacob Assanger, Luis Arenal, Peter Ballbusch, Victor Hugo Basinet, Roberto Berdecio, F. H. Bowers, Dean Cornwell, Károly Fülöp, Robert Merrell Gage, Dorothy Groton, Philip Guston, W. D. Hackney, Murray Hautman, Arthur Hinchman, Stephen de Hospodar, James Hyde, Wiard Boppo Ihnen, Harold H. Jones, Reuben Kadish, John Kehoe, Richard Kollorsz, Harold Lehman, Sanford McCoy, Martin Obzina, Tony Revels, Frederick Schwankowsky, Myer Shaffer, Jean Stewart, Ivan Stoppe, Jeannette Summers, Wolo von Trutzschler, and John Weiskal.

10. Unpublished version of Siqueiros's lecture at the John Reed Club ("Los vehículos de la pintura dialéctica-subversiva"), "Folio 9.1.15," 272, SAPS. Delgado attributes Siqueiros's recollection about the camera to the Chouinard mural, but Siqueiros refers to Los Angeles generally (*Delirious Consumption*, p. 58). In 1960, Siqueiros recounted the story in relation to *Tropical America*. Siqueiros, *Mi respuesta* (Mexico City: Ediciones de Arte Público, 1960), 58–59.

11. "Don Ryan's Parade Ground," *Illustrated Daily News*, October 11, 1932: 17.

12. Von Sternberg sponsored Siqueiros's exhibitions at the Stendahl Galleries at the Ambassador Hotel and at Jake Zeitlen's bookshop. The portrait by Siqueiros hung in von Sternberg's Paramount office, and he supposedly also purchased another (unidentified) work by Siqueiros. See Peter Baxter, *Just Watch!: Sternberg, Paramount and America* (London: British Film Institute, 1993), 85, 88–89, and James Oles, "Portrait of Josef von Sternberg," in *Portrait of a Decade*, 155.

13. Ibid. and Goldman, "Siqueiros and Three Early Murals in Los Angeles," 322.

14. Notably Siqueiros arrived in Los Angeles precisely when "battles over the script and the imagery of *Blonde Venus* were fought over the kind of world that Hollywood would portray." Baxter, *Just Watch!*, 178–79, 182.

15. Beverly Heisner, *Hollywood Art: Art Directors in the Days of the Great Studios* (Jefferson, NC: McFarland, 1990), 23.

16. Ibid., 168–69. While he did not work directly on *Blonde Venus*, by 1932 Dreier was supervising director for the studio.

17. Ibid., 172.

18. Ibid., 173.

19. Barry Salt, *Film Style and Technology: History and Analysis*, 2nd ed. (London: Starwood, 1992), 201.

20. Ibid., 202. The extent to which Hollywood backdrops, especially photomurals, had an impact on Siqueiros's murals needs to be explored further.

21. Heisner, *Hollywood Art*, 4.

22. Von Sternberg sometimes used gauzes over the camera lens, which lent a dreamlike aspect to his films. Ibid., 173.

23. Ibid., 1.

24. See Chris Robé, *Left of Hollywood: Cinema, Modernism, and the Emergence of U.S. Radical Film Culture* (Austin: University of Texas Press, 2010), 13.

25. Ibid., 37.

26. Schrank, *Art and the City*, 52.

27. Siqueiros, "The Vehicles of Dialectic Subversive Painting," 9. English-language typescript in SAPS.

28. "Don Ryan's Parade Ground," 17.

29. For Duco cellulose nitrate, see Elsa Arroyo, Anny Aviram, et al., eds., *Baja viscosidad: El nacimiento del fascismo y otras soluciones/Low Viscosity: The Birth of Fascism and Other Solutions* (Mexico City: Instituto de Investigaciones Estéticas/UNAM, 2013). For more on the Experimental Workshop, see Emily Schlemowitz, "David Alfaro Siqueiros's Pivotal Endeavor: Realizing the 'Manifiesto de New York' in the Siqueiros Experimental Workshop of 1936" (master's thesis, Hunter College, New York, 2016).

30. James Wechsler, "Seeing Red: Mexican Revolutionary Artists in New York," in *Nexus/New York: Latin/American Artists in the Modern Metropolis* (New York: El Museo del Barrio; New Haven, CT: Yale University Press, 2009), 162.

31. Irene Herner, with Mónica Ruiz and Grecia Pérez, "David Alfaro Siqueiros: *Self-Portrait with Mirror*" (New York: Mary-Anne Martin Fine Art, 2017). Accessed at: https://mamfa.com/wp-content/uploads/Siqueiros-Self-Portrait-with-Mirror-Essay-by-Dra.-Irene-Herner-Reiss.pdf.

32. John Baxter, *Hollywood in the Thirties* (San Diego: A. S. Barnes, 1971), 46; cited in Heisner, *Hollywood Art*, 170.

33. For the authoritative study on Siqueiros's materials, see Elsa Arroyo, Anny Aviram, Chris McGlinchey, and Sandra Zetina, "David Alfaro Siqueiros and the Domain of Industrial Materials, 1931–1945," in *Baja viscosidad*, 215–51.

34. Chris McGlinchey, email correspondence with author, October 3, 2018.

35. Jeffrey L. Meikle, *American Plastic: A Cultural History* (New Brunswick, NJ: Rutgers University Press, 1997).

36. Meikle reveals that celluloid was associated with "imitation," used to mimic luxury materials such as ivory, tortoiseshell, and horn in products such as combs, knife handles, and piano keys, whereas materials such as phenolic resin and Bakelite established "plastic's novelty, its protean versality." Ibid., 30.

37. See Elisabeth Bronfen, "Seductive Departures of Marlene Dietrich: Exile and Stardom in 'The Blue Angel,'" *New German Critique* 89 (Spring–Summer 2003), 9–31.

While it may be argued that the expansive works painted by *los tres grandes* constituted the foundation of Mexico's modern artistic development, a closer look reveals an analogous yet no less important contribution made by a diverse cadre of women in both the United States and Mexico who championed the "Mexican Renaissance." Indeed, these women were essential to Mexico's postrevolutionary artistic and cultural renewal both at home and, perhaps more conspicuously, abroad. Yet likely owing to the hyper-masculine facade publicly assumed by the muralists themselves and reflected in the works they produced, the contributions of these women and their advocacy for Mexican muralism have been long overlooked. These "transcultural modernists" personified unique bicultural bridges that helped narrow the gap between two nations whose relationship had long been fraught.

The cultural endeavors of Mexican scholar, editor, author, and entrepreneur Anita Brenner (1905–1974) (fig. 1) are representative of this transcultural promotion of the arts. The daughter of Jewish immigrants, Brenner was born in Aguascalientes, though her family would soon flee to Texas when the Mexican Revolution broke out. Brenner began her education in local Catholic schools in San Antonio, where she would first experience anti-Semitism. After two semesters at Our Lady of the Lake University, an eighteen-year-old Brenner convinced her parents to let her return to Mexico, arriving in the capital in 1923. Bilingual and transnational, she soon became involved in the vibrant international communities that thrived in Mexico's postrevolutionary effervescence, and in that

context, met U.S. journalist and activist Carleton Beals and scholar Ernest Gruening, whom she would later assist with research for his volume *Mexico and Its Heritage* (1928). After five years in Mexico City, Brenner returned to the U.S., where she completed her Ph.D. in anthropology at Columbia University under Franz Boas, considered the father of modern anthropology. In 1929, she published *Idols behind Altars*, her chronological study of Mexican art and artists from the pre-Hispanic era to the present, which

MICHAEL K. SCHUESSLER

TRANSCULTURAL MODERNISTS AS BICULTURAL BRIDGES: ANITA BRENNER, ALMA REED, AND FRANCES TOOR

included photographs by Tina Modotti and her partner at the time, Edward Weston.[1] Brenner's groundbreaking book offered some of the first texts in English dedicated to José Clemente Orozco, Diego Rivera, and David Alfaro Siqueiros, as well as to lesser-known yet significant painters of the "Mexican School," such as Francisco Goitia and Jean Charlot, a French-born artist active in Mexico who would become a constant presence in her life and work. Indeed, Beals hailed Brenner as the "Vasari of the Mexican school," equating her work to that of Giorgio Vasari vis-à-vis the artists of the Italian Renaissance.[2] She would go on to write many articles for various U.S. publications, such as the *New York Times*, the *Brooklyn Daily Eagle*, and *The Nation*. Brenner has also recently been credited for her important yet historically overlooked role in the translation of Mariano Azuela's *The Underdogs* (1928), one of the most significant novels of the Mexican Revolution. In 1932 she added *Your Mexican Holiday* to the growing number of books promoting tourism in Mexico, and her fourth book, *The Wind that Swept Mexico*, published in 1943, provided the first complete account in English or Spanish of the Mexican Revolution.

Brenner encouraged Orozco to come to New York, where he arrived in 1927 anxious to find patrons for his canvases and perhaps even a wall to paint on. Fortunately for him, Brenner, who had brought a number of the artist's works with her to Manhattan, was also in touch with San Francisco–born journalist and promoter of the arts Alma Marie Sullivan Reed (1889–1966) (fig. 2). In 1921, Reed had waged a spirited press campaign in defense of sixteen-year-old Mexican migrant worker Simón Ruiz, who had been sentenced to hang by a California court on trumped-up charges he did not even understand, for he was denied a Spanish-speaking lawyer or even an interpreter. News of Reed's success saving Ruiz and lobbying state lawmakers to abolish the death penalty for juveniles reached the office of Mexican president Álvaro Obregón, who invited her to visit the capital in September 1922 as his guest of honor. It would be during her second visit to Mexico City, in 1923, that Obregón's secretary of education, José Vasconcelos, accompanied Reed to view the progress on some of the government's earliest mural commissions, including Orozco's cycle at the National Preparatory School. All in all, Reed's first two visits to the capital evidently made a pronounced impression on her, for in an

interview with the Mexican daily *Excelsior* she declared: "Mexico should be considered the Mecca of artists from all over the world, for here every object and every scene is in itself reason enough for art and beauty."[3]

FRANCES TOOR
AND MEXICAN FOLKWAYS

Reed's initial enchantment with Mexican arts and culture occurred almost simultaneously to that of Frances Toor Weinburg (1882–1956) (fig. 3). Toor likewise had arrived in 1922 in Mexico City, but in her case to enroll in the National University's "Summer School for Foreigners," established the year prior to attract foreign students to study the Spanish language and Mexican history, arts, and culture.[4] Toor had just received her master's degree in anthropology from the University of California, Berkeley, where she studied under Herbert E. Bolton, a pioneer of Mexican–U.S. "border studies." It was, by Toor's own account, the landmark exhibition of Mexican arts and crafts conceived by the Obregón government to celebrate the centennial of Mexico's independence that changed her destiny.[5] "Like most foreigners, when I came to Mexico I was ignorant of what Mexico really is," she

FIG. 3
Frances Toor holding a copy of *Mexican Folkways*, c. 1930.
Instituto Nacional de Antropología e Historia (INAH),
Mexico City

FIG. 4
Mexican Folkways 4, no. 2, 1928

later recalled, yet in the sprawling show of more than
five thousand objects that included "textiles, pottery,
lacquer work, [and] gold and silver jewelry," she
experienced something of a revelation. "I saw the
exhibit many times; and I grew ever more enthusiastic
over the beauty of an art produced by a humble and
practically enslaved people and also over the work of
the modern artists, so alive, virile, passionate."[6] The
forty-year-old gay American woman separated from
her dentist husband and began teaching English in
Mexican public schools. Three years later, she
inaugurated her pioneering bilingual journal *Mexican
Folkways*, which would endure, largely without
interruption and with limited support from the Mexican
government, until 1937. "It is my hope that *Mexican
Folkways* may be of use to the many high school and
university students of Spanish as material for the
study of social background, which gives insight into
literature and language, as well as to those who are
interested in folklore and the Indian for their own
sakes," Toor wrote in the first issue.[7] Both Charlot and
Rivera would serve as the journal's artistic directors,
designing covers and other illustrations in addition to
providing articles about contemporary Mexican artistic
trends (fig. 4); Rivera even contributed an article about
Mexico City's notorious *pulquerías*, the saloons where
pulque, a pre-Hispanic beverage made of fermented
maguey juice, was served, which were typically
decorated with ingenious mural paintings that often
incorporated double-entendres stemming from the
effects of the popular drink.[8] Other noted contributors
to *Mexican Folkways* included poet-playwrights
Salvador Novo and Xavier Villaurrutia, both members of
the avant-garde literary group *los contemporáneos*, as
well as Modotti, who published her foundational article
"On Photography" within its pages, illustrated with
some of her most representative photographs.[9] From
the United States came collaborations by Beals and
anthropologist Robert Redfield, among others, such as
William Spratling, who in 1931 reestablished Mexico's
silver-working tradition in the colonial town of Taxco.
Toor devoted an entire issue to the engravings of
José Guadalupe Posada, whose work greatly influenced
Orozco, Rivera, and other Mexican painters of the
period, and whose famous *Catrina* ("fancy lady")
skeleton portraits would become an emblem of post-
revolutionary Mexican art, especially muralism, by
promoting imagery that condemned the excesses of

FIG. 5

Cover of the catalogue for José Clemente Orozco's exhibition
Ink and pencil drawings from a series "Mexico in revolution"
at the Marie Sterner Galleries, 1928

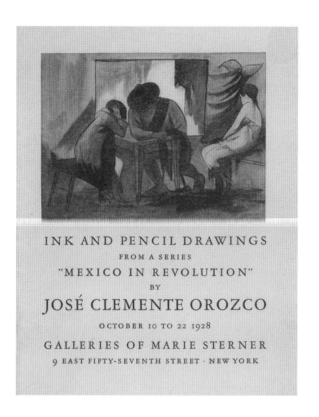

INK AND PENCIL DRAWINGS

FROM A SERIES

"MEXICO IN REVOLUTION"

BY

JOSÉ CLEMENTE OROZCO

OCTOBER 10 TO 22 1928

GALLERIES OF MARIE STERNER

9 EAST FIFTY-SEVENTH STREET · NEW YORK

what were generally viewed as the lazy and corrupt upper classes.[10]

Mexican Folkways lasted longer than any other analogous publication, for example *Vida Mexicana* (1922–23), *Nuestro México* (1932), and *Mexican Art and Life* (1938–39), though its existence was often precarious, even as it received some financial support from the Mexican government under President Plutarco Elías Calles, and Toor reported that she filled "every job from errand girl to editor for the mere joy of seeing the magazine published."[11] Her persistence paid off. President Calles hailed *Mexican Folkways* for "making known to our own people and to foreigners the real spirit of our aboriginal races and the expressive feeling of our people in general, rich in beautiful traditions."[12] By 1932 Toor could rightly proclaim that "*Mexican Folkways* has played an important role in the formation of the new Mexican attitude towards the Indian by making known his customs and art; and for the same reason the magazine has had an important influence on the modern art movement."[13] At her Frances Toor Studios, which she founded in Mexico City in 1931, she also edited several pioneering tourist guides as well as a book dedicated exclusively to *Mexican Popular Arts* (1939), another first of its kind in Mexico. The culmination of her ethnographic work is

to be found in *A Treasury of Mexican Folkways* (1947), which constitutes an encyclopedia of traditional Mexican rituals, dances, fiestas, and ceremonies, illustrated by the Guatemalan artist active in Mexico, Carlos Mérida.

ALMA REED AND JOSÉ CLEMENTE OROZCO

In 1928, Reed and Orozco would meet again, this time in Manhattan. Reed had become involved in the Delphic Circle, the quasi-mystical, intellectual society founded by Eva Palmer-Sikelianos and her husband, Greek poet Angelos Sikelianos, in part to rekindle contemporary engagement with classical ideals embodied in Ancient Greek culture. Since arriving in New York the year before, Orozco had struggled, and after meeting him at his studio in the West Twenties, Reed convinced him to attend the Delphic Circle and resolved to help him, "a great artist [who] was friendless and in need at a crisis in his creative life," as she later recalled in her 1956 biography of him. "I was fully aware that to launch the uncompromising Orozco upon New York's already monopolized field would be no easy task. I had, however, absolute faith in his genius and in his ultimate triumph."[14]

In September, Orozco's first solo exhibition in the U.S. opened at the Delphic Circle, with more than fifty guests attending. "The interest in your exhibit grows," Reed later enthused to the artist, in a note Orozco transcribed in a letter to his wife. "Yesterday we had several very important people here, some of whom are returning today with the owners of galleries and with wealthy prospective purchasers," with Marie Sterner among the former.[15] Indeed, the success of Orozco's first show promptly led to a two-week exhibition of his *Mexico in Revolution* series at Sterner's gallery on East 57th Street, an important venue established in 1920 that during its thirty-year run showcased many significant artists, such as Alexander Calder, Isamu Noguchi, Rockwell Kent, George Bellows, and Elie Nadelman.[16] According to Orozco, Reed herself paid for the framing of his canvases as well as the printing and mailing of exhibition catalogues (fig. 5).[17] She continued to advocate for his work as what Orozco described as his self-appointed "mother, sister, agent and 'bootlegger,'" going so far as to establish her own formal gallery, Delphic Studios, in the same building as

FIG. 6
Party at Alma Reed's Delphic Studios, c. 1936. Enrique
Riverón papers, 1918–1990s. Archives of American Art,
Smithsonian Institution, Washington, DC

Sterner's (fig. 6).[18] It was there, in October 1930, that
Reed presented Edward Weston's first solo exhibition
in New York, an idea born during a trip to Carmel,
California, where Reed and Orozco met the photographer
and where Weston made Orozco's commanding portrait.
Reed had been accompanying Orozco in Claremont,
California, where she negotiated the artist's first mural
commission in the U.S., at Pomona College. Buoyed by
the publicity generated by Orozco's completion there
of his heroic *Prometheus* (pl. 28), Reed secured
another mural commission, from the New School for
Social Research in Manhattan. When presented with
Reed's proposal, the school's president, Alvin Johnson,
exclaimed: "What could have been my feeling when
Orozco, the greatest mural painter of our time,
proposed to contribute a mural. All I could say was,
'God bless you. Paint me the picture. Paint as you
must. I assure you freedom.'"[19] In 1932, as Orozco
embarked on his third mural commission in the U.S.—
his monumental cycle at Dartmouth College—Reed
published the first book dedicated to his art, art she
described as "an integral part of the drama evoked by
the crash of age-old systems and the reversal of once
immutable scientific laws."[20] The large volume included
more than a hundred black-and-white photographs,
many of them pictures of the artist's frescoes taken by
Modotti and Weston, as well as by Mexican painter and

photographer José María Lupercio. It was Reed herself
who published this landmark book under her own
Delphic Studios imprint, which would later produce
other significant works, some illustrated by Orozco.

Throughout this essay I have attempted to
illustrate how a select group of North American and
Mexican women became essential players in the
careers of some of the most important artists of
Mexico's post-revolutionary period, and more broadly,
how these women promoted the rediscovery of
Mexico's rich cultural heritage by both the citizens of
Mexico and the United States, a goal they accomplished
through persuasive networking, cultural journalism,
and gallery exhibits, at times using their own resources
in order to advocate for an artist and his work. They
also shared a keen interest in showing how, against
popular belief, the cultures of both Mexico and the
United States held many things in common, elements
here to be discovered within the plastic arts, in
particular that of muralism, which would be employed
to great success on the walls of Mexican schools,
markets, former churches, and monasteries, as well as
those of universities and other public buildings in the
United States. Moreover, these artists and their
female advocates saw the cultural and political
divisions among the countries of the Americas as the
artificial partitions they really are, and therefore did
not hesitate to recognize the United States's deep-
rooted connection to the most advanced cultures that
prospered and perished in what is today Mexico, the
Latin American nation that provided the U.S. with its
most direct window into the Hispanic world.

NOTES

1. The same year, another woman, American journalist Ernestine Evans, published the first book on Diego Rivera in English: *The Frescoes of Diego Rivera* (New York: Harcourt, Brace, 1929).

2. Carleton Beals, "Goat's Head on a Martyr," *Saturday Review of Literature* 6, no. 20 (December 7, 1929): 505.

3. Helen Delpar relays Reed's quote from an article in *Excelsior* dated October 22, 1922, in *The Enormous Vogue of Things Mexican: Cultural Relations Between the United States and Mexico, 1920–1935* (Tuscaloosa: University of Alabama Press, 1992), 35.

4. Virtually all published sources give Toor's birth year as 1890, but in fact, she immigrated to New York from Riga, Latvia, at age six with her mother and two sisters to join her father, who had arrived the year prior, in 1887. My thanks to Jeremy R. Wilson and his meticulous genealogical research from 2013, whose unpublished findings have been crucial to the understanding of Toor's early biography.

5. Gerardo Murillo (Dr. Atl), Jorge Enciso, and Roberto Montenegro served as curators of the exhibition in Mexico City, and the show would travel to Los Angeles, its sole U.S. destination, where Xavier Guerrero reportedly served as "artistic director" and four thousand visitors flocked to the two-week run. See Delpar, *The Enormous Vogue of Things Mexican*, 135.

6. Frances Toor, "Mexican Folkways," *Mexican Folkways* 7, no. 4 (October–December 1932): 205.

7. Frances Toor, "Editor's Foreword," *Mexican Folkways* 1, no. 1 (June–July 1925): 3–4.

8. Diego Rivera, "Mexican Painting: Pulquerías," *Mexican Folkways* 2, no. 2 (June–July 1926): 6–15.

9. Tina Modotti, "On Photography," *Mexican Folkways* 5, no. 4 (October–December 1929): 196–98.

10. *Mexican Folkways* 4, no. 3 (July–September 1928).

11. Frances Toor, "Announcement," *Mexican Folkways* 1, no. 5 (February–March 1926): 29.

12. Plutarco Elías Calles, quoted in Frances Toor, "Our Anniversary," *Mexican Folkways* 2, no. 2 (June–July 1926): 4.

13. Frances Toor, "Mexican Folkways," *Mexican Folkways* 7, no. 4 (October–December 1932): 205.

14. Alma Reed, *Orozco* (New York: Oxford University Press, 1956), 29.

15. José Clemente Orozco, *Cartas a Margarita (1921–1949)*, introduction and notes by Tatiana Herrero Orozco (Mexico City: Ediciones Era, 1987), 130.

16. Entry for "Sterner, Marie (Marie Walther)," Archives Directory for the History of Collecting in America, The Frick Collection, http://research.frick .org/directoryweb/browserecord.php?-action =browse&-recid=6405.

17. Less than six months later Orozco would have his third one-man show in the U.S., *Paintings of New York City*, this time at Edith Halpert's Downtown Gallery, where his work was shown from March 25 to April 14, 1929. Barbara Haskell, personal communication with the author, March 12, 2018.

18. Orozco, *Cartas a Margarita*, 137.

19. Alvin Johnson, quoted in "Orozco's New School Murals," University Art Collection webpage, The New School, https://www.newschool.edu/university-art -collection/re-imagining-orozco-new-school-murals/.

20. Alma Reed, *J. C. Orozco* (New York: Delphic Studios Press, 1932), i.

Well before the arrival of José Clemente Orozco, Diego Rivera, or David Alfaro Siqueiros in the United States, key promoters of Mexican art in New York during the early 1920s helped to ignite what would, by 1933, be described by the *New York Times* as "the enormous vogue for things Mexican" in the U.S., paving the way for such large-scale shows at major museums as *Mexican Arts* (1930) at the Metropolitan Museum of Art, *Diego Rivera* (1931) and *20 Centuries of Mexican Art* (1940), both at the Museum of Modern Art, and *Mexican Art Today* (1943) at the Philadelphia Museum of Art. In addition, I would argue that through the exhibitions these enthusiasts organized at smaller alternative venues, sometimes in close contact with the artists themselves, they sought to convey a vision of Mexican modern art that not only retained notions of its distinct *mexicanidad* ("Mexicanness") but also established a critical transnational dialogue among Mexican, American, and European modernist artistic production.

One of the most significant of these early promoters was Mexican poet and cultural diplomat José Juan Tablada (fig. 1). Born in 1871, Tablada had spent significant time in Paris, Japan, and South America before he settled in for a more than decade-long stint in New York, where in 1924 he opened Libreria de los Latinos, a bookstore in Midtown Manhattan that not only served to distribute Spanish-language literature but which became a gathering place for Spanish-speaking artists, such as Miguel Covarrubias and Rufino Tamayo. Tablada himself had garnered attention for his early modernist verse, and his cosmopolitan adventures imparted an array of cross-cultural enthusiasms, from the poetry of Baudelaire to Japanese haiku. Yet Tablada also remained an ardent champion of the literature and visual arts of his home country, and with his bookstore as his base, in part funded by grants from the Mexican government, he published widely on Mexican art in such U.S.-based publications as *International Studio*, *Parnassus*, *Survey Graphic*, and *The Arts*. Tablada both called attention to ancient pre-Columbian art as well as elevated the profiles of such contemporary Mexican artists as Covarrubias, Adolfo Best Maugard, Luis Hidalgo, and Manuel Rodríguez Lozano as they tried to make their way in a city Tablada called the "Iron Bablyon," including securing a train ticket to New York and a six-month stipend for Covarrubias from the Mexican government.[1] In 1923, in one of the first English-language articles to herald the Mexican Renaissance, Tablada wrote: "Beauty which was about to die in the clutch of the old academicism is blossoming again in Mexico through the modern and free means of artistic visual expression. Renouncing their slavishness to the old European masters, Mexican artists are discovering infinite and undreamed-of possibilities in the new field. Mexican art is at the dawn of a brilliant revival succeeding both art periods of its past—the indigenous, thrilling, and masterful, and the creole–Hispanic, flowering in the ecclesiastic crafts and architecture."[2]

Among the exhibition venues with which Tablada became involved was the Whitney Studio Club, opened by sculptor and collector Gertrude Vanderbilt Whitney in 1918 and the forerunner to her establishment of the Whitney Museum in 1930. Whitney's keen interest was the promotion of contemporary American artists, whose work she felt was being neglected in the wake of the 1913 Armory Show and the fever it unleashed on the U.S. art scene for European modernism. Although

DAFNE CRUZ PORCHINI

MEXICAN/MODERN: EARLY PROMOTION OF MEXICAN ART IN THE UNITED STATES

FIG. 1
José Juan Tablada in the doorway of his Spanish-language
bookstore, c. 1924. José Juan Tablada Archive, Instituto de
Investigaciones Filológicas, Universidad Nacional Autónoma
de México

Whitney would prove receptive to the European-inflected nonrepresentational art of American artists like Stuart Davis, she championed artists of the Ashcan School and others, like Edward Hopper, who were bringing distinctly modernistic sensibilities to bear on their figurative art, which may explain her embrace of Mexican modern artists as well. In 1923, the Whitney Studio Club—with the organizational assistance of Tablada—arranged a three-person show dedicated to Covarrubias, Hidalgo, and Orozco, which marked one of the earliest U.S. showings of the latter's work. From Tablada's notes, it is clear that the works exhibited had a caricatural and ironic sense, which allowed him to link them with the art of Francisco de Goya, Honoré Daumier, and Henri de Toulouse-Lautrec. In a dispatch regarding the show, Tablada reported: "The Whitney Club is now presenting ten paintings by Orozco of excellent chromatic quality, with delicious neutral harmonies of somber distinction and mysterious atmospheres, as well as other drawings that are so precise, wise, and simple that they seem to anticipate the philosophy and vision of Picasso fifteen years ago when they were made."[3]

Considering Walter Pach's legendary role in helping to organize the Armory Show and his zealous advocacy for bringing European—particularly French—modernists to the attention of American patrons and the public at large, it may surprise that he was also a key figure in promoting Mexican art in the U.S. (fig. 2). Pach was the New York–born son of German immigrants, and his early twentieth-century European sojourns during which he befriended artists who would eventually become foundational figures in the Western modernist canon, such as Claude Monet, Paul Cézanne, and Marcel Duchamp, are well known. Often overlooked has been Pach's decades-long engagement with Mexican art. In 1918, a thirty-five-year-old Pach had spent the summer lecturing on modern art at the University of California, Berkeley, where he became friends with the artist Xavier Martínez and the writer Pedro Henriquez-Ureña.[4] Four years later, Henriquez-Ureña helped to facilitate a teaching assignment for

Pach at the National University in Mexico City. It was there, between June and October 1922, that Pach met such leading artists as Tamayo, Jean Charlot, and Carlos Mérida, not to mention Rivera and Orozco, both of whom reportedly attended some of his lectures at the university. The richness and vibrancy of Mexico's art scene exhilarated Pach. "I think Mexico is more different from the United States than any place I know in Europe," he wrote. "There is the most remarkable art instinct here I ever saw anywhere."[5]

Pach had encouraged his artist friends in Mexico to form an organization similar to the Society of Independent Artists in New York, itself based on the Société des Artistes Indépendants in Paris. The annual "no jury, no prizes" exhibitions of these avant-garde alternatives to traditional art academies were open to any artist who could afford the nominal entrance fee. Upon his return to the U.S., Pach immediately began corresponding with artists in Mexico, in particular Rivera and Charlot, eager to include a section devoted to Mexican art in the 1923 annual exhibition of the society in New York, a group with which Pach had been intimately involved since its founding in 1916, to be held at the Waldorf Astoria hotel in September. Rivera's selection of artists included those who had already

received a fair amount of attention outside Mexico (including himself and Orozco, as well as Charlot, Tamayo, and Maugard), in addition to emerging figures of the moment, such as Siqueiros, Mérida, Fermín Revueltas, Nahui Olin, Gerardo Murillo ("Dr. Atl"), Emilio Amero, and Manuel Rodríguez Lozano, among others. For Pach, the curatorial criterion of the Mexican section was based on a particular mix of the arts' condition of *mestizaje* (or "cultural mixing," a term based on *mestizo*) and modernity. As he would later express, "Mexicans are not afraid of modernism."[6] The show's catalogue warmly highlighted the binational collaboration: "A body of artists in the City of Mexico, having organized a society and given a first exhibition on the same principle as our own, the directors of the present society, desirous of manifesting the cordiality of American artists toward their colleagues in Mexico, voted unanimously to ask the new Independent organization to be represented as a guest at the exhibition of 1923. A prompt and sympathetic response from the Mexican artists, promising contributions from many of the most distinguished and able workers in the country, was the result, and it is this group which we have the pleasure of welcoming here."[7]

Indeed, the exhibition was one of the most extensive presentations of contemporary Mexican art in the United States to that moment, one which even prompted critic Thomas Craven, who would soon emerge as one of the most vociferous advocates of the nativist-inflected American Regionalism art movement, to judge, "The outstanding contribution to the exhibition came from the City of Mexico." While his praise was far from unambiguous, he went on to declare, "The critic must needs keep an eye on the Mexicans: they are close to actualities, and if they can be saved from the vitiating formulas of the Parisian cafés, they will undoubtedly arrive at high achievement."[8]

Another important promoter of Mexican art in New York during the 1920s was the Weyhe Gallery, established by Erhard Weyhe in 1919 (fig. 3). A German national, Weyhe had closed the bookshop he owned in London when World War I broke out and left Britain to start over from scratch in the United States. He ultimately set up his gallery, which specialized in prints and drawings, in a townhouse on Lexington Avenue in Midtown Manhattan, and installed as the gallery's director Carl Zigrosser (fig. 4), who would go on to become the curator of drawings and prints at

the Philadelphia Museum of Art. Like Tablada, Weyhe's personal interests and tastes ranged widely; like Pach, he and Zigrosser maintained an avid enthusiasm for the European avant-garde, mounting shows dedicated to Matisse and Picasso, as well as giving early exposure to figures such as Alexander Calder. But the gallery was no less keen to promote contemporary American artists like John Sloan, Rockwell Kent, and Reginald Marsh, and to bring to the fore the work of Mexican modernists. By the late 1920s, the gallery had presented solo shows dedicated to Tamayo, Rivera, and Orozco, in addition to a number of group shows dedicated to Mexican art, and Weyhe had published lithographs of the work of each of *los tres grandes*.

Coupled with the enthusiastic dispatches from Americans such as Alma Reed who had gone to Mexico to witness firsthand its postrevolutionary cultural renaissance and the increasing dissemination of Mexican art in the U.S. press, the early advocacy of figures such as Tablada, Pach, and Weyhe and Zigrosser helped fuel a momentum that would lead other gallerists to engage with Mexican art throughout the rest of the 1920s and into the early 1930s, often in ways that both acknowledged its

mexicanidad while situating the work of Mexican modernists in a broader transnational context. Reed herself opened her influential gallery Delphic Studios in 1929 with displays of works by both Orozco and Thomas Hart Benton. Her show *Contemporary Mexican Artists and Artists of the Mexican School* presented nearly two hundred works encompassing both nationalist and modernist subjects, arguing for an understanding of Mexican art as heterogeneous. Marie Sterner exhibited Orozco's art alongside that of Matisse and five other French painters at her gallery in 1928, while Frances Flynn Paine, who curated the Rivera retrospective at MoMA, organized a series of three Mexican art shows in 1931 at the John Levy Gallery, a surprising venue as it had been primarily centered on European old-master art. The first show was devoted to Jean Charlot; the second to the work of Joaquín Clausell and Tamayo. That the *mexicanidad* of such art continued to be a defining characteristic even as it mingled with other international art on the New York scene is evidenced in two reviews of the third show, devoted to Pablo O'Higgins, the American artist born Paul Stevenson who settled permanently in Mexico in 1924. His art was "so characteristically 'Mexican' that only his name betrays his nationality,"

FIG. 4
Carl Zigrosser, c. 1916. Carl Zigrosser Papers, Kislak Center
for Special Collections, Rare Books and Manuscripts,
University of Pennsylvania

artists would find their work received among
perceptive supporters in New York as both inherently
Mexican and vital to the rich narrative that was
unfolding vis-à-vis the profusion of modernisms that
were developing around the world, which was far more
diverse than the modernist canon that would solidify
at many major museums during the postwar years.

remarked *Art Digest*, while the *Herald Tribune* noted,
"to all intents and purposes he is a dyed-in-the-wool
Mexican, in feeling as well as point of view and
expression."[9] Meanwhile, across the country in
Los Angeles, gallerist Earl Stendahl and gallery-
owner/rare-book-dealer Jake Zeitlin both organized
shows of Mexican popular art as well as presentations
of Mexican photography and the work of various
contemporary artists, such as Best Maugard, and
they each hosted separate simultaneous showings of
Siqueiros's work immediately following the artist's
arrival in the city in April 1932.

 In the context of the flourishing art market and
burgeoning gallery scene in the U.S. during the
"Roaring '20s," Orozco's simple comment in a 1928
letter to his wife is somehow telling: "There are some
small galleries in which it is possible to exhibit,
without much commitment, drawings, prints, and
small paintings, and it is a good idea to always have
work available for exhibitions."[10] Indeed, even as
Mexican art would endure many struggles with regard
to stereotypes and marginalization, Mexican modern

NOTES

I would like to thank John Charlot, Malia Van Heukelem, and Sami Esfahani for their invaluable assistance.

1. Aram Shepherd, "Mexico en New York: José Juan Tablada as Cultural Ambassador," in *The Contours of America: Latin America and the Borders of Modernist Literature in the United States* (Ph.D. diss., University of North Carolina, Chapel Hill, 2012), 9.

2. José Juan Tablada, "Mexican Painting of Today," *International Studio*, January 1923.

3. José Juan Tablada, *Obras Completas: VI. Arte y Artistas* (Mexico City: Universidad Autonoma de México, 2000), 395.

4. Laurette E. McCarthy, *Walter Pach (1883–1958): The Armory Show and the Untold Story of Modern Art in America* (University Park: Pennsylvania State University Press, 2011), 131.

5. Walter Pach, quoted in ibid., 132.

6. Walter Pach, "El arte en México," *Forma* 7 (1928): 20.

7. *1923 Catalogue of the Seventh Annual Exhibition of the Society of Independent Artists* (New York: Society of Independent Artists, 1923), n.p.

8. Thomas Craven, "The Independent Exhibition," *New Republic*, March 14, 1923: 71.

9. Both quoted in Helen Delpar, *The Enormous Vogue of Things Mexican: Cultural Relations Between the United States and Mexico, 1920–1935* (Tuscaloosa: University of Alabama Press, 1992), 158.

10. José Clemente Orozco, *El artista en Nueva York* (Mexico City: Siglo XXI, 1993), 89.

"Detroit acquaintance of Rivera." That is the only additional information we have for the figure labeled "Mexican" in notes detailing the real-life identities of the multiethnic workforce that mans the assembly line in the foreground of the north-wall fresco of Diego Rivera's colossal *Detroit Industry* mural cycle.[1] Most of the men wear blue overalls, but the "Mexican" figure is distinguished from his peers by his aquiline nose and by his white Panama hat, which contrasts with his dark complexion (fig. 1). Yet unlike the figure of Paul Boatin, an Italian-American acquaintance of Rivera, or Andrés Hernando Sánchez Flores, Rivera's assistant and sometimes driver, the man marked as "Mexican" remains anonymous, as do countless others with whom the artist crossed paths, like the "unexpected contingent of Mexicans living in Detroit" whom Rivera described as greeting him and his wife, Frida Kahlo, upon their arrival in the city in April 1932.[2]

The lack of specificity yet prominence (both visually and discursively) given to Mexican Detroiters in the examples above speaks to the complicated relationship between the Mexican muralists and Mexican Americans in the 1930s.[3] During the time that *los tres grandes* were welcomed into the United States, the country was also experiencing a xenophobic wave that, for Mexican Americans, would result in the coercive and sometimes forced "repatriation" of an estimated one to two million people.[4] This essay attempts to provide a fuller picture of the life conditions of Mexican Americans in the cities where Rivera, David Alfaro Siqueiros, and José Clemente Orozco lived and worked while in the United States, as well as to explore how Mexican Americans responded to the artists' presence, and vice versa. Some questions that I consider include: How involved were the muralists in the social turmoil affecting their fellow countrymen? How important was it for Mexican Americans to have prominent artists depicting scenes of oppression that were not dissimilar to what they were experiencing? How accurately can any of this be captured when the disenfranchised are always already voiceless and nameless?

The dialectical tension between the hypervisibility of Mexican Americans in the news and in the cities where Rivera and Siqueiros painted their murals in 1932 and the absence of a continuous engagement between the muralists and this community was even more pronounced in the case of Orozco. The first of *los tres grandes* to come to the U.S. and the one to spend the most time in this country, Orozco found it difficult to live here and did not care to return.[5] He was also the most taciturn of the three, leaving one to wonder whether the hardships he endured had anything to do with the fact that he was a Mexican living in a country that since the late 1920s had been plotting ways to deport people across the border. None of the three muralists was exempted from this xenophobia: Siqueiros was deported after his visa expired right before he completed his third public mural in Los Angeles; he and Rivera both had their public artworks censored here; and all three were subject to FBI investigations. However, unlike the lack of documentation supporting a connection between Orozco and Mexican Americans, there is substantial evidence that demonstrates Rivera

MARCELA GUERRERO

FRIENDS, FOES, OR STRANGERS: MEXICAN AMERICANS AND THE MEXICAN MURALISTS IN THE 1930S

FIG. 1
Diego Rivera, *Detroit Industry, North Wall* (detail of pl. 53),
1932–33. Fresco, 17 ft. 8 ½ in. × 45 ft. (5.4 × 13.7 m). Detroit
Institute of the Arts; gift of Edsel B. Ford 33.10.N

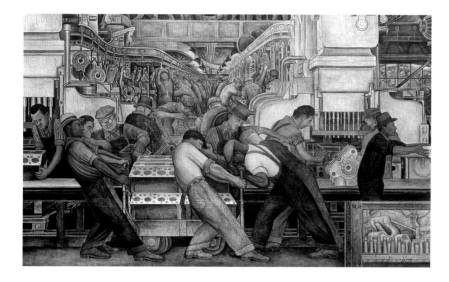

and Siqueiros were concerned with, albeit not deeply committed to, the Mexican American cause.

What is indisputable and well documented is that while Rivera was in Detroit during 1932–33 working on his mural commission at the Detroit Institute of Arts, the artist himself played a key role in advocating *for* the voluntary repatriation of Mexican Detroiters. What is less clear, however, are his reasons for at first supporting repatriation and then changing his mind. An ad-hoc effort by state and local governments across the country to address the perceived competition for jobs and welfare relief posed by Mexican Americans after the start of the Great Depression, the repatriation campaign began in the late 1920s and continued through the early 1930s. In Michigan, repatriation was voluntary; however, the coercion, harassment, and racist sentiment directed toward the Mexican American community, similar to that which surrounds the controversy over deportation practices today, surely had an impact, with state agencies like the Department of Public Welfare exerting pressure on Mexican Americans seeking relief benefits to opt for repatriation instead.[6] More surprising, perhaps, was the support for repatriation among prominent officials in the Mexican American community, including Mexican Consul Ignacio Batiza, who upon Rivera's arrival was able to galvanize a more concerted effort to convince his poverty-stricken brethren in Detroit to pursue hopes of a better future in Mexico.

As Rivera traveled across the state visiting Ford Motor Company plants, he also saw unemployed autoworkers waiting on breadlines. These appalling

conditions moved him to form the Liga de Obreros y Campesinos (League of Workers and Farmers) in 1932, initially comprised of 264 Mexican Americans, most of whom had worked at Ford.[7] With chapters in Detroit and other cities in Michigan and Ohio, the league aimed to protect the interests of those who wished to go to Mexico as well as those who preferred to stay. For those who self-repatriated, the league helped with "colonization," as the resettlement program of worker collectives was called, which involved creating self-sufficient communities of 150 to 200 people. Indeed, the artist-celebrity Rivera appeared in the local press as the principle moving force behind repatriation, which was billed as a compassionate response to the plight of his fellow countrymen in the U.S., an effort to return them to their homeland "where life among the peasants is usually a continuous song and unemployment does not mean unhappiness."[8] The railroads organized ten special trains to make the forty-hour trip to the Mexican border, and Michigan governor Wilber Brucker announced that five thousand Mexicans had "consented to return to their native land," their journey funded in part by Rivera, who pledged $4,000.[9] In total, the league organized four repatriation parties, the first of which left Detroit on November 15, 1932, comprised of 432 Mexicans Americans (fig. 2). It is said that Rivera and Kahlo went to the station to bid the passengers farewell.[10]

For his efforts, Rivera received "sincere thanks" from Governor Brucker, who said that the repatriation project "would not have been possible without him."[11] Yet Rivera's own recollections, recounted more than a decade later and published posthumously in his 1960 autobiography, involve a certain level of equivocation if not outright revisionism over his involvement. Although he admits that he spent a significant amount of time in Detroit "attempting to help migratory Mexicans" who were then living "in constant dread of being deported," his characterization of that assistance is distinctly at odds with contemporaneous accounts: "There were some among my former countrymen who thought that conditions were better back in Mexico. Nostalgically, they dreamed of establishing agricultural colonies south of the Rio Grande. The task I set myself was to convince them, through a series of lectures, that a return to Mexico would not solve their problems, that having established roots in the U.S., they must act with all other Americans to achieve a betterment of their

FIG. 2
"Adios Detroit," *Detroit Free Press*, November 16, 1932

economic situation. Unfortunately, I failed in my purpose. So that they would not think I was exaggerating the difficulties of colonization in order to avoid helping them, I gave them most of the money I had earned painting the Arts Institute frescoes."[12]

In fact, it was not until Rivera and Batiza heard back on December 10, 1932, that the land conditions in the farm colonies were far from optimal and that the Mexican government could no longer handle the masses of returnees that they began encouraging Mexican Detroiters to stay. Rivera's arguably self-aggrandizing historical revisionism can almost be qualified as gaslighting and victim-blaming, perhaps made easier by the subtle sense of distance he introduces between himself and the Mexican Americans he was trying to help: Rivera encourages his "former countrymen" with "roots in the U.S." to "act with all other Americans," at once recognizing their common heritage while inserting a degree of alienation or otherness.

It might be said the feeling was mutual, at least when it came to the Spanish-language press in the United States. The nationally distributed, Los Angeles–based *La Opinión*, which reported on the activities of *los tres grandes* in the U.S., published an article on October 19, 1932, with the headline "Diego Rivera más

americano que mexicano" ("Diego Rivera More American than Mexican"). While the gist of the story was Rivera's admiration for American industry, which he was about to celebrate in his Detroit murals, the headline suggests his admiration perhaps came at the expense of loyalty to his native country while implying Rivera enjoyed the privilege of a fluid identity by virtue of his status, an advantage that Mexican American workers in Detroit and elsewhere did not enjoy.[13]

Five months earlier, *La Opinión* had heralded the arrival in Los Angeles of Siqueiros, with a front-page article on May 15 tied to the artist's exhibition of fifty paintings at the Stendahl Galleries in the Ambassador Hotel written by the promising twenty-two-year-old journalist José Pagés Llergo. Born in Mexico but trained in Los Angeles where he lived for nearly a decade, Pagés Llergo would become one of Mexico's most prolific and distinguished journalists, glimpses of which are evident in his admiring article on Siqueiros, "A golpes de pincel fija nueva etapa" ("With Strokes of a Brush, He Sets a New Stage").

Less a review of the show than a profile of the artist, the article includes amusing exchanges between Pagés Llergo and Siqueiros where a clear comradeship based on nationality and social class is established.

FIG. 3
The partially whitewashed mural *Tropical America* on a
second-story exterior wall on Olvera Street, Los Angeles,
c. 1933

"Some people with money who have been criticizing the works of Siqueiros have called him later on to ask him to paint their portraits," writes Pagés Llergo. "'It's an American thing, mate. Do you understand them?,' said the painter."[14] More striking than this banter at the expense of *gringos* is the section that captures Siqueiros's disavowal of anything that would resemble Mexican curios. He declares such art geared toward the capitalist-consumerist gaze "the greatest threat facing Mexico's modern pictorial movement," which may have suggested a brewing angst that would end up finding an outlet in *Tropical America* (pl. 99).[15]

On July 7, *La Opinión* announced there would be a ceremony to unveil Siqueiros's first public mural in Los Angeles, *Street Meeting* (p. 189, fig. 1) at the Chouinard School of Art.[16] As the newspaper reported, the artist planned to address the crowd in Spanish with a translator on hand, who very well could have been Luis Arenal (whose sister Siqueiros would later marry), one of the artists in Siqueiros's "Bloc of Mural Painters."[17] While Siqueiros could simply have been more comfortable speaking in his native language, he clearly had a target audience in mind: "I am interested that Mexicans attend this ceremony," the newspaper reported the artist saying, "because I would like to

show that Mexicans are concerned with the progress that painting is undergoing in Mexico."[18] While the reaction of the Mexican American community to the speech is unknown, it was recorded that eight hundred people attended the unveiling, and Siqueiros himself claimed that his controversial depiction of a union organizer's fiery speech met with support from workers' and peasant groups.[19]

Shortly thereafter Siqueiros received an invitation from F. K. Ferenz, director of the Plaza Art Center, to paint an outside wall on the second floor of the Italian Hall overlooking Olvera Street in downtown Los Angeles. The neighborhood had recently undergone a radical transformation from an area populated by newly arrived Mexican and Italian immigrants—many of whom brought with them the anarchist politics of their home countries—to a saccharine, tourist-oriented version of "old Mexico," as William Estrada has described it, "a timeless, romantic, homogenous" vision of Spanish-Mexican culture.[20] Siqueiros was given the theme "tropical America," presumably with the idea that he would paint a folkloric vision that would harmonize with the neighborhood's abundant colorful and kitschy interpretations of Mexico. Instead, the artist seized the opportunity to contradict his patrons

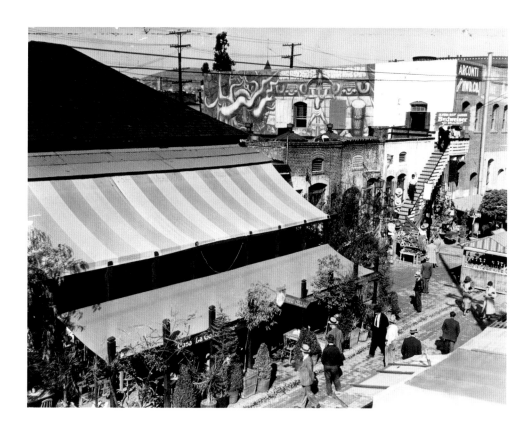

FIG. 4
David Alfaro Siqueiros, *Heroic Voice*, 1971. Lithograph,
23 × 17 ¼ in. (58.4 × 43.8 cm). Museum of Latin American Art,
Long Beach, California; gift of the Morgan Family

with proletarian and anti-imperialist images, to "stick it up their noses, get them used to it."[21]

The fate of *Tropical America* is well known. The main image of a brown-skinned Indigenous figure bound to a cross with his neck broken and an American eagle perched above created a backlash that would ultimately lead to the whitewashing of the mural (fig. 3). Siqueiros was unapologetic about his chosen subject matter, as he elaborated the following year: "Naturally, when the manager made his request, he thought we could paint a tropical America bursting with joy, colors, dancing, but this could not be the Latin American tropics. Brazil was dominated by the Ford house; it was the Brazilian tropics where generals are sold out to English imperialism and tear the country apart. These tropics are exploited by the allied bourgeoisie from the diverse imperialistic nations in the same way as tropical Mexico is, where Indians work in gum factories for a petty pay, and where there is no authority but that of the imperialistic company itself. . . . So we painted, as best as we could, the Mexico of Latin America."[22] The artist would also connect his motivation specifically to the plight of Mexican Americans at the time, as relayed by Shifra Goldman, one of the first scholars to write about Siqueiros's murals in Los Angeles and who corresponded with him beginning in 1968: "Of particular significance to the artist, and of direct import to his

choice of a theme for [*Tropical America*], were the mass deportations of Mexican nationals and the wretched conditions of Mexican migratory workers, whose efforts to organize for collective bargaining were repeatedly crushed by vigilantes and repressive laws."[23]

It was not until a few years before his death, however, that Siqueiros returned his attention to the Mexican American population of Los Angeles, albeit from afar. In 1971, a young Luis Garza, photographer for the Chicano magazine *La Raza*, met the artist in Budapest where the septuagenarian welcomed him with a warm "*Compañero*, tell me about this Chicano movement."[24] From this encounter and others, including with Goldman, a deeper relationship was established between the Mexican artist and those L.A. Chicanos who were invested in keeping alive the memory of his time in Southern California. Of particular importance was the restoration and conservation of *Tropical America*, a conversation that had started while Siqueiros was still alive. A reproduction of the mural the artist began at his workshop in Cuernavaca remained incomplete upon his death in 1974.

This essay opened by making reference to a figure summarily described as "Mexican" in the notes about Rivera's *Detroit Industry* mural, and it closes with the identification of Rubén Salazar in a 1971 lithograph by Siqueiros titled *Heroic Voice* (fig. 4). The print depicts Salazar, a journalist for the *Los Angeles Times* and news director for television station KMEX, who was killed by a tear-gas projectile fired by the Los Angeles County Sheriff's Department during a Chicano Moratorium demonstration against the Vietnam War on August 29, 1970. The lower register of the print shows a sketch of Siqueiros's *The New Democracy* mural from 1944–45 painted for the Palace of Fine Arts in Mexico City in which a female figure is seen breaking the bonds of oppression. The limited-edition lithograph honoring Salazar represented another example of Siqueiros's stated interest—though late in his life— in the Mexican American population and in decrying the abuses and unfair treatment to which they were subject, and still are in uncannily similar ways.

NOTES

1. Linda B. Downs, *Diego Rivera: The Detroit Industry Murals* (New York: W. W. Norton, 1999), 97, 123.

2. Diego Rivera with Gladys March, *My Art, My Life: An Autobiography* [1960] (New York: Dover Publications, 1991), 111.

3. "Mexican Americans" is herein defined as both Mexican nationals and American citizens of Mexican descent.

4. For a comprehensive study of the repatriation of Mexican Americans, see Francisco Balderrama and Raymond Rodriguez, *The Decade of Betrayal: Mexican Repatriation in the 1930s* (Albuquerque: University of New Mexico Press, 2006).

5. Alejandro Anreus, "Orozco in Gringoland: The Years in New York, 1927–34, 1940" (Ph.D. diss., City University of New York, 1997), 200–202.

6. For more information on the discrimination against Mexican Detroiters, see Zaragosa Vargas, *Proletarians of the North: A History of Mexican Industrial Workers in Detroit and the Midwest, 1917–1933* (Berkeley: University of California Press, 1999), 171, 186–87; and Dennis Nodín Valdés, "Mexican Revolutionary Nationalism and Repatriation during the Great Depression," *Mexican Studies/Estudios Mexicanos* 4, no. 1 (Winter 1988): 7–8.

7. Vargas, *Proletarians of the North*, 178.

8. "State Will Transport 5,000 Mexicans Back to Homeland," *Detroit Free Press*, October 9, 1932: 4.

9. Ibid.

10. Vargas, *Proletarians of the North*, 182.

11. "State Will Transport 5,000 Mexicans Back to Homeland."

12. Rivera, *My Art, My Life*, 124.

13. Rivera himself said he was more American than Mexican in his remarks to the newspaper: "He estado en muchas ciudades norteamericanas, y creo que soy más verdaderamente norteamericano que mexicano, puesto que siempre me he interesado más en los asuntos industriales, y que la industria de México, casi toda en su totalidad, es producto del desarrollo iniciado por norteamericanos." ["I have been to many North American cities, and I believe that I am more truly American than Mexican, since I have always been more interested in industrial matters, and the Mexican industry, almost all of it, is a product of the development initiated by North Americans."]

14. "Algunas personas de dinero que han estado criticando las obras de Siqueiros lo han llamado más tarde para que les haga sus retratos: 'Son cosas de los americanos, compañero. ¿Usted los entiende?'– dice el pintor."

15. "El más grande peligro que tiene ante sí el moderno movimiento pictórico mexicano."

16. "Siqueiros será objeto de un homenaje hoy" ["Siqueiros Will Be Honored Today"], *La Opinión*, July 7, 1932.

17. Arenal could not afford tuition for the fresco class at Chouinard, so he convinced Siqueiros to let him serve as his translator in exchange for enrolling in the course. Philip Stein, *Siqueiros: His Life and Works* (New York: International Publishers, 1994), 76.

18. "'Tengo interés,' dijo Siqueiros ayer, 'en que muchos mexicanos asistan a esta ceremonia, porque quisiera demostrar que los mexicanos están interesados en la evolución que está sufriendo la pintura en México.'"

19. Héctor Jaimes and David Alfaro Siqueiros, *Fundación del muralismo mexicano: Textos inéditos de David Alfaro Siqueiros* (Mexico City: Siglo XXI Editores, 2012), 47.

20. William D. Estrada, "Los Angeles' Old Plaza and Olvera Street: Imagined and Contested Space," *Western Folklore* 58, no. 2 (Winter 1999): 107.

21. "Metérselas en las narices, acostumbrarlos," in "A golpes de pincel fija nueva etapa," *La Opinión*, May 15, 1932.

22. "Naturalmente el director cuando nos encargaba eso pensaba que íbamos a pintar una América tropical llena de alegría, de música, de colores, de danzas pero aquello no podia ser el trópico latinoamericano sino el del Brasil dominado por la casa Ford; era el trópico del Brasil donde los generales se venden al imperialismo inglés y desgarran al país; era el trópico explotado por la burguesía aliada de los diversos imperialismos lo mismo que el México tropical también, donde el indio trabaja en empresas chicleras por salarios miserables y donde no existe más autoridad que la de la compañía imperialista. . . . Y entonces nosotros, lo mejor que pudimos, pintamos al México de la América Latina," in Jaimes and Siqueiros, *Fundación del muralismo mexicano*, 30.

23. Shifra Goldman, "Siqueiros and Three Early Murals in Los Angeles" [1974], in *Dimensions of the Americas: Art and Social Change in Latin America and the United States* (Chicago: University of Chicago Press, 1994), 90.

24. "Compañero, cuéntame de este movimiento Chicano," in Luis Garza, "Siqueiros in Los Angeles: Censorship Defied," *Convergence*, Fall 2010: 37.

A photograph of a charred and mangled body hanging from a tree accompanied the article "As If to Slaughter" in the June 1930 issue of the communist-affiliated U.S. magazine *Labor Defender*, in which writer Abraham Jakira decried the senseless murder of George Hughes, an African American farmworker in Sherman, Texas, who was burnt alive by a lynch mob while still in jail. Unsatisfied with Hughes's horrific death, the mob proceeded to drag his body behind a car through the town's Black neighborhood, dangle it from a tree, and light another fire under it.[1] The brutality inflicted on Hughes was hardly unusual or "accidental," Jakira reported, considering the wave of lynchings of African Americans that had occurred in the weeks preceding Hughes's murder. Yet Jakira framed such heinous acts less as expressions of racism than as the result of mass unemployment due to the imperialist wars of the capitalists, who sought to leverage racial conflict to suppress and squash any transracial alliance in proletariat uprising. Jakira instead emphasized the "growing unity of Negro and white workers, who both feel the iron heel of exploitation," thousands of whom, "both white and black," are "fighting against unemployment and exploitation, [and] are thrown into prisons."[2]

Jakira's conflation of racial and socioeconomic injustice illustrates the kind of representational tactics that communists in the U.S. and, more broadly, many on the left deployed. While recognizing that those occupying the economic underclass were often people of color, leftist advocates sometimes ended up trading the racially specific challenges that those workers faced for attributing all society's ills to economic/class warfare. In other words, the individuality and specificity of victims like Hughes were generalized, arguably rendered anonymous, in service of the universal fight for the rise of the oppressed class and, ultimately, the destruction of capitalism. As seen in the work of Mexican muralists and American artists of color— Asian Americans in this discussion—the Black figure(s) served as a multivalent signifier, carrier, or "proxy" for artists to grapple with critical sociopolitical issues and to form transracial/transnational, ideological alliances through deploying various visual strategies.

The image of Hughes's hanging body indeed became a motif of sorts for artists on the left to register their abhorrence and anger in response to the epidemic of racist violence manufactured by the capitalists, as Jakira proposed. José Clemente Orozco expressed his disgust toward such inhumanity when he first made *Hanged Men* (pl. 70) shortly after seeing the *Labor Defender* photo in 1930, when he was residing in the U.S.[3] The lithograph appears to have been a personally significant work, for Orozco showed it in a series of exhibitions in the U.S.—the John Reed Club's *Hunger, Fascism, War* in 1933; *An Art Commentary on Lynching* at the Arthur U. Newton Galleries in 1935; and the ACA Gallery's *Struggle for Negro Rights* in 1935—as well as contributing it to *The American Scene*, a portfolio of lithographs by six artists published by the Contemporary Print Group in 1933–34.[4] Orozco quadrupled Hughes's charcoaled body to depict a forest of seemingly endless horror and intensified the scene by including swirling white flames licking the hanged bodies. Incidentally, the menacing fires might have been on Orozco's mind at the time, considering that he had finished his fiery *Prometheus*

SHIPU WANG

PICTURING TRANSRACIAL ALLIANCES: MEXICAN MURALISTS AND ASIAN AMERICAN ARTISTS

FIG. 1
Eitarō Ishigaki, *Undefeated Arm (Arm)*, 1929. Oil on canvas,
35 13/16 × 41 3/4 in. (91 × 106 cm). National Museum of
Modern Art, Tokyo

FIG. 2
Cover of *New Masses* featuring Eitarō Ishigaki's *Undefeated
Arm (Arm)*, July 1929

mural at Pomona College in June 1930 (pl. 28), the
same month when the Hughes photo circulated.[5]
By multiplying the lynched figure, Orozco arguably
universalizes Hughes's tragedy to make a broader
argument against human brutality and its
pervasiveness even as he minimizes or even empties
Hughes's individuality and his identity as both an
African American and a farmworker, whether
intentionally or inadvertently.

A similar approach of turning Hughes's tortured
body into a universal motif is evident in Isamu
Noguchi's *Death (Lynched Figure)* (pl. 71). Exhibited
alongside Orozco's lithograph in the two antilynching
exhibits in 1935, Noguchi's imposing stone-and-metal
sculpture amplifies the lynched figure's suffering and
commends the viewer's attention, due in part to the
visceral reaction elicited by its sheer physicality. The
sight, and recognition, of the terror this featureless
figure represents could stop anyone in her or his
tracks. Yet Noguchi's semi-abstracted rendition offers
no specific reference to Hughes himself—his murder
by then four years prior and long succeeded by other
equally horrendous lynchings.[6] The irony is that

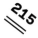

FIG. 3
Eitarō Ishigaki, *South U.S.A. (Ku Klux Klan)*, 1936. Oil on canvas, 30 ⅛ × 36 ⅛ in. (76.5 × 91.8 cm). The Museum of Modern Art, Wakayama, Japan

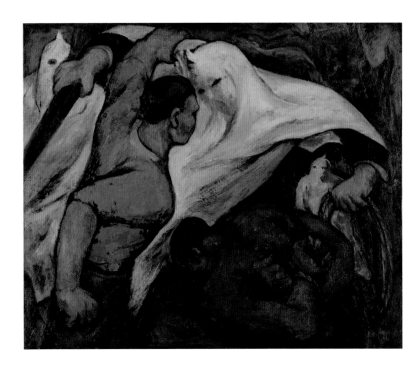

Noguchi's effort in universalizing a racially motivated murder attracted some unfavorable and racialized attention, most notably art critic Henry McBride's derision, calling Noguchi's work a "little Japanese mistake."[7] In part disheartened by such negative reaction, Noguchi appears to have avoided creating politically overt work after *Death*. Instead, as seen in the relief mural for Mexico City's Abelardo L. Rodríguez market (pl. 77) and *News* (1940), the stainless-steel relief mural at 50 Rockefeller Plaza, he opted for conveying broader but sympathetic views toward the underclass and proletariat struggle, among other things.[8]

Noguchi's universalizing approach represents only one of the viable solutions for leftist artists to tackle the complicated task of leveraging imagery as protest against socioeconomic injustice. Their efforts produced divergent results from artists of heterogenous racial, ethnic, and national backgrounds, and they sometimes shared visual affinity through deploying similar pictorial motifs.[9] For instance, Noguchi's hammer-wielding arm in his 1936 Mexico City mural is reminiscent of Eitarō Ishigaki's tightly focused rendition of a muscular arm in *Undefeated Arm* (fig. 1), which became the cover image of the July 1929 issue of *New Masses* that also inaugurated Ishigaki's contributions to the magazine in subsequent years (fig. 2). Ishigaki, a Japanese painter active in New York since the 1920s, was a protégé of sorts of Sen Katayama, Japan's "first Bolshevik" and

the so-called father of Japanese communism.[10] And as an early adaptor of proletariat subject matter—*Undefeated Arm* and *Man with a Whip* (1925), for example—many of Ishigaki's pictorial motifs predate those of other well-known American Social Realist artists. Like them, Ishigaki also created imagery during the 1930s about lynching, slavery, and oppression, as seen in the lynch mob's murder-in-progress in *The Noose* (1931) and the fight to free chained Blacks in *South U.S.A. (Ku Klux Klan)* (fig. 3). The Black figures appear as victims in these paintings, a critique that scholars have rightly posed: the prevailing visual representations in the 1930s reinforced the narrative of victimization, rendering African American subjects as helpless and, by implication, in need of rescue, presumably from progressive-minded whites, as seen in the much-reproduced *Southern Holiday* by Harry Sternberg and Paul Cadmus's *To the Lynching!* (pl. 75) (both 1935).[11] Yet in Ishigaki's imposing *The Bonus March* (pl. 94) and two powerful mural studies from 1935–37 (fig. 4), his Black figures assume agency, as one leads a coalition of marchers in the former and as they battle for freedom in the latter.[12] *The Bonus March*, in particular, serves as a pictorial intervention on Ishigaki's part to not only foreground the overlooked contributions of African American veterans but also to link the visible issue of race with patriotism, socioeconomic inequality, betrayal of democratic ideals, and proletariat struggle.

Hideo Benjamin Noda, Ishigaki's fellow John Reed Club artist and a California-born Japanese American, also deployed the pictorial strategy of elevating a racially charged subject matter to engage with broader battles of class and social justice in his *Scottsboro Boys* (pl. 87). Many artists created imagery about the infamous trials, such as Aaron Douglas's meticulous portraits of Clarence Norris and Haywood Patterson (c. 1935), two of the nine so-called Scottsboro Boys unjustly condemned to death after being falsely accused of sexually assaulting two white women on a Southern Railroad train in 1931. Hugo Gellert's bleak depiction of the nine awaiting execution in his *Bourgeois Virtue in Scottsboro*, which appeared in the June 1931 issue of *New Masses*, is based on an ACME news photo of the teenagers reproduced the previous month in *Chicago Defender*, the same source image for Noda's *Scottsboro Boys*. In contrast to Gellert's unflinching confrontation with the viewer, however,

FIG. 4
Eitarō Ishigaki, study for Harlem Courthouse mural,
c. 1935–37. Charcoal on paper, 91 ¹¹/₁₆ × 108 ⅛ in.
(232.9 × 274.6 cm). The Museum of Modern Art, Wakayama,
Japan

Noda opted for a collage-like composition of an eerie
cityscape with a singular Scottsboro figure serving as
a "composite" to stand in not only for the wrongfully
accused nine but for all those wronged by a racist
and unjust system.[13] In invoking three renowned
international activists on the political left—the names
of Sergeĭ Ivanovich Gusev, Clara Zetkin, and Rose
Pastor Stokes appear in the painting's lower-right
corner—Noda also expanded his painting of a specific
trial to speak about socioeconomic injustice on a global
scale. It is a statement for a kind of transnational, and
transracial, proletarianism, in other words, that Ishigaki
and Orozco also seem to propose in the aforementioned
visual works—indeed, Noda exhibited *Scottsboro
Boys* (originally titled *Alabama*) alongside Ishigaki's
I Will Not Speak (c. 1933) and Orozco's *Hanged Men*
in the John Reed Club's *Hunger, Fascism, War* show in
December 1933.[14]

Noda's pictorial intervention about the Scottsboro
case was likely inspired by Diego Rivera's advocacy for
the accused teenagers and his portable mural panels
for the New Workers School earlier in 1933 (fig. 5).
Noda had been a student at the California School of
Fine Arts in 1930 when Rivera arrived in San Francisco,
and although it remains unclear whether Noda assisted
the muralist on his commissions there, he was among
the team of assistants who worked on Rivera's ill-fated
Rockefeller Center mural. Their reunion of sorts in
New York also involved Noda's new wife at the time,
Ruth Noda, who served as a model for and befriended
Frida Kahlo. Noda himself would go on to receive
commissions to create murals for the Ellis Island
project and for his alma mater Piedmont High School in
California, completing only the latter in 1937.[15] Rivera
had been vocal about the Scottsboro injustice and
traveled around New York to speak about the case on
behalf of the Scottsboro Defense Club. He also
featured Black figures—African American activists as
well as lynching victims—throughout his mural panels,
including portraits of the Scottsboro Boys in jail in his

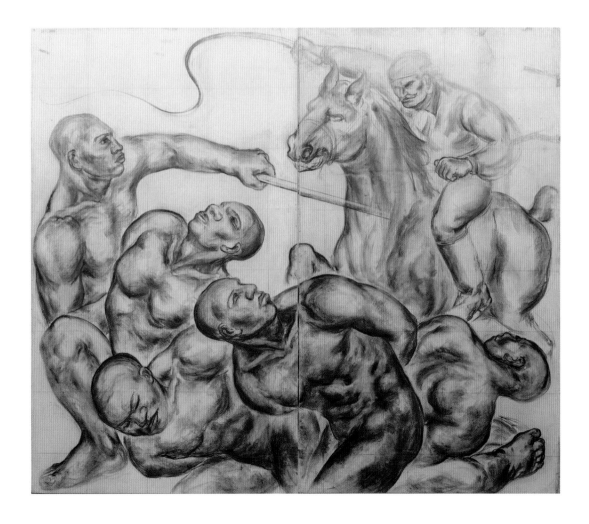

FIG. 5
Diego Rivera, *Study for Colonial America* from *Portrait of America*, c. 1933. Graphite on paper, 72 ¹/₁₆ × 59 in. (180 × 150 cm). Frida Kahlo and Diego Rivera Archives, Anahuacalli Museum, Mexico City

ironically titled *The New Freedom* (pl. 97), as well as George Hughes's tortured body in *Modern Industry* (pl. 95).[16] Through Bertram Wolfe as his interpreter, Rivera unequivocally declared: "There is a Scottsboro in every country. . . . The Race problem was never solved by a capitalistic nation . . . the true persecution is economic as well as social. It is, indeed, fundamentally economic."[17] In elevating the Scottsboro case to an international (universal) level and conflating racism with economic oppression of "the Negro and other minority groups," Rivera's claim encapsulates the ideological positions and pictorial strategies shared by many leftist artists in the 1930s.

It could be argued that it was the traversing and transcending of national and cultural boundaries by the Mexican muralists through their visual rhetoric of universal humanism and advocacy for socioeconomic justice, often via African American and working-class figures, that appealed to racioethnic minority American artists in particular. The highly charged and mixed reception of the Mexican artists in American art circles demonstrated that art could serve as a critical means of generating debate and even challenging racism and socioeconomic inequality in the public discourse. Their example was vital in encouraging minority artists to consider their art's added responsibility and the urgency not only to affirm their rightful place in American society but also to counteract the pervasive anti-Asian, anti-immigration, and exclusionist policies and sentiments of the time.[18]

Ironically, while works by artists such as Ishigaki and Noda were indeed embraced by their colleagues in various American art circles, they have over the years been obscured or erased from the American art-historical narratives due to their departure from collections in the U.S. Ishigaki moved back to Japan in 1952 amid the McCarthy-era furor, taking with him almost all of his artwork. Noda's painting *Street Scene*, acquired by the Whitney Museum in 1934, was deaccessioned in 1954; his Piedmont mural was removed and auctioned off by the Piedmont School District in 1989.[19] *Vida Americana* thus presents a crucial intervention in reasserting not only the vital place of the Mexican muralists in twentieth-century American art but that of minority American artists as well—bringing their works "home," in effect, acknowledging their contributions and expanding historical narratives that will impact future research and scholarship.

NOTES

1. For Hughes's murder, see Edward H. Phillips, "The Sherman Courthouse Riot of 1930," *East Texas Historical Journal* 25, no. 2 (1987).

2. A. Jakira, "As If to Slaughter," *Labor Defender*, June 1930: 126.

3. Thanks to Alejandro Anreus for confirming *Labor Defender* as Orozco's source for this print. See Anreus's *Orozco in Gringoland: The Years in New York* (Albuquerque: University of New Mexico Press, 2001).

4. For studies of the exhibitions, see Marlene Park, "Lynching and Anti-lynching: Art and Politics in the 1930s," in *The Social and the Real: Political Art of the 1930s in the Western Hemisphere*, ed. Alejandro Anreus, Diana L. Linden, and Jonathan Weinberg (University Park: Penn State University Press, 2006), 155–80; and Helen Langa, "Two Antilynching Art Exhibitions: Politicized Viewpoints, Racial Perspectives, Gendered Constraints," *American Art* 13, no. 1 (Spring 1999): 10–39.

5. David W. Scott, "Orozco's *Prometheus*: Summation, Transition, Innovation," *College Art Journal* 17, no. 1 (1957): 2–18; and Stephen Polcari, "Orozco and Pollock: Epic Transfigurations," *American Art* 6, no. 3 (Summer 1992): 36–57.

6. Notable books on the history of lynching include: Christopher Waldrep, *Lynching in America: A History in Documents* (New York: New York University Press, 2006); Jennie Lightweis-Goff, *Blood at the Root: Lynching as American Cultural Nucleus* (Albany: State University of New York Press, 2011); and Karlos K. Hill, *Beyond the Rope: The Impact of Lynching on Black Culture and Memory* (New York: Cambridge University Press, 2016); among others. Exhibitions and studies about lynching imagery include: *Without Sanctuary: Lynching Photography in America* (Santa Fe, NM: Twin Palms Publishers, 2000); Dora Apel, *Imagery of Lynching: Black Men, White Women, and the Mob* (New Brunswick, NJ: Rutgers University Press, 2004); and Shawn Michelle Smith, *Photography on the Color Line: W. E. B. Du Bois, Race, and Visual Culture* (Durham, NC: Duke University Press, 2004).

7. Henry McBride, "Attractions in the Galleries," *New York Sun*, February 2, 1935: 33. Noguchi also recalled this hurtful comment in his *A Sculptor's World* (New York: Harper and Row, 1968), 23.

8. Among studies of Noguchi's Mexico City mural, see James Oles, "Noguchi in Mexico: International Themes for a Working-Class Market," *American Art* 15, no. 2 (Summer 2001): 10–33; and Ellen Landau, "Body Si(gh)ting: Noguchi, Mexico, and Martha Graham," in Landau, *Mexico and American Modernism* (New Haven, CT: Yale University Press, 2013), 2–33. For in-depth studies of Noguchi's work vis-à-vis modernism and his identity, see Bert Winther Tamaki, "The Rejection of Isamu Noguchi's Hiroshima Cenotaph: A Japanese American Artist in Occupied Japan," *Art Journal* 53, no. 4 (Winter 1994): 23–27; and Amy Lyford, *Isamu Noguchi's Modernism: Negotiating Race, Labor, and Nation, 1930–1950* (Berkeley: University of California Press, 2013).

9. See, for example, studies in Andrew Hemingway, *Artists on the Left: American Artists and the Communist Movement, 1926–1956* (New Haven, CT: Yale University Press, 2002).

10. Hyman Kublin, *Asian Revolutionary: The Life of Sen Katayama* (Princeton, NJ: Princeton University Press, 1964). Ishigaki met Katayama in San Francisco in 1914 and recalled their friendship in "Sen Katayama and His Comrades," *Chuo Koron* 67, no. 14 (December 1952): 232–41.

11. See Park's and Langa's articles for discussions of the artists' problematic representations.

12. The studies relate to Ishigaki's Federal Art Project mural commission for the Harlem Courthouse in New York, which he began in 1936. It was unveiled in March 1938 but attracted a firestorm of criticism that led to its removal. Richard D. McKinzie, *The New Deal for Artists* (Princeton, NJ: Princeton University Press, 1975), 111; and ShiPu Wang, *The Other American Moderns: Matsura, Ishigaki, Noda, Hayakawa* (University Park: Penn State University Press, 2017), 39–67.

13. ShiPu Wang, "We Are Scottsboro Boys: Hideo Noda's Visual Rhetoric of Transracial Solidarity," *American Art* 30, no. 1 (Spring 2016): 16–20.

14. Wang, *The Other American Moderns*, 69–96.

15. Special thanks to Ruth Noda's daughters, Kathleen and Laurel Hulley, for sharing their mother's personal effects and stories, which included Ruth's serving as one of Rivera's many models. Edward Laning took over the Ellis Island mural after Noda abandoned the project, reportedly due to his conflict with Rudolph Reimer, the commissioner of immigration. Laning, "Edward Laning: The New Deal Mural Projects," in *The New Deal Art Projects: An Anthology of Memoirs*, ed. Francis O'Connor (Washington, DC: Smithsonian Institution, 1972), 86, 91–92.

16. T. R. Poston, "Scottsboro Case May Be Depicted for Posterity in Murals of Diego Rivera," *New York Amsterdam News*, May 17, 1933: 9; and Poston, "Historic Role of Negro in U.S. Shown in Murals," *New York Amsterdam News*, September 6, 1933: 16.

17. "Race Problem Universal, Says Famous Artist," *Chicago Defender*, September 2, 1933: 11. See also Anthony W. Lee, "Workers and Painters: Social Realism and Race in Diego Rivera's Detroit Murals," in *The Social and the Real*, 201–22.

18. Among the rich body of literature on U.S. exclusionary laws against Asians, see Hyung-Chan Kim, ed., *Asian Americans and Congress: A Documentary History* (Westport, CT: Greenwood Press, 1996); and Lon Kurashige, *Two Faces of Exclusion: The Untold History of Anti-Asian Racism in the United States* (Chapel Hill: University of North Carolina Press, 2016); to name only two.

19. *Street Scene* was acquired from the 153 works in the 1934 Biennial for $500. Darlene Oden, Registration Department, Whitney Museum of American Art, to Sharon Spain, the Asian American Art Project at Stanford University, August 15, 2005. California Asian American Artists Biographical Survey Records (SC0929), series 1, box 12, folder 13. The Kumamoto Prefectural Museum of Art in Japan acquired, restored, and now displays Noda's Piedmont mural in its grand hall.

The revisionist historical imagery and radical socialist politics visible in many of the works made by Mexican muralists on their visits to the United States had a significant and lasting impact on the art produced by African Americans associated with the New Negro movement of the interwar period. Like their Hispanic counterparts, African-descended artists in the United States were seeking to create a class-conscious artistic vision that foregrounded the fight for racial justice in the face of inequality and systematic repression. Hale Woodruff in his 1938 *Amistad* murals at Talladega College in central Alabama (fig. 1), illustrating the true story of a violent revolt at sea by kidnapped Africans against their oppressors, took his cue from close study of Diego Rivera's murals and José Clemente Orozco's *The Epic of American Civilization* at Dartmouth College.[1] In solidarity with their Mexican counterparts, socially conscious African American artists like Woodruff often found it difficult to reconcile their ambitions with the desires of their patrons as they sought to use art to raise political, class, and racial consciousness within their own communities. These African American artists were acutely aware of the difficulties encountered by their Mexican counterparts, whose status as international celebrities did not always insulate them from censorious backlash against their more controversial works, especially when that work challenged the racial mores of the day. One of the primary challenges shared by these politicized artists was how to balance the creation of work that revealed and honored the struggles of one's proletarian ancestors or contemporary comrades while simultaneously depending financially on elitist individuals or government programs invested in maintaining a status quo based on social stratification and racial inequality.

During the 1930s, as labor unrest in the United States intensified, work made by prominent Mexican muralists was increasingly under attack by repressive institutions and individuals. In 1931, Orozco's mural *Table of Universal Brotherhood* at the New School for Social Research in New York (p. 19, fig. 4), which featured a conference of "people of all races being presided over by a black," caused significant controversy, including the school's loss of a number of donors, over a scene that depicted interracial cooperation and equality.[2] The following year, David Alfaro Siqueiros's highly charged public mural *Tropical America* in Los Angeles (pl. 99), showing an Indigenous man crucified beneath a U.S. eagle, was deemed undesirable and was eventually whitewashed. And two years later in New York, Rivera's mural at Rockefeller Center was demolished upon orders of its wealthy commissioners after the artist refused to paint over the unwelcome face of Bolshevik leader Vladimir Lenin that he had included in one of its crowd scenes.

The chilling effect of the censorship by white American elites of work by celebrated Mexican muralists in the United States is evident in the work of contemporaneous African American artists who held similar anticapitalist political beliefs. In November 1934, when painter and illustrator Aaron Douglas completed his ambitious *Aspects of Negro Life* mural cycle at the 135th Street Library in Harlem, it quickly became apparent that the artist had engaged in self-censorship in order to realize the majority of his artistic vision. At the time, Douglas was one of the premiere artists associated with New Negro culture and racial

GWENDOLYN DUBOIS SHAW

MIGRATION AND MURALISM: NEW NEGRO ARTISTS AND SOCIALIST ART

FIG. 1
Hale Woodruff, *The Mutiny on the Amistad* (second version),
c. 1941. Oil on canvas, 12 × 20 in. (30.5 × 50.8 cm). New Haven
Museum, Connecticut

uplift politics of the day. His art had been championed by philosopher Alain Locke, whose 1925 book *The New Negro* had helped define the intellectual and aesthetic aspirations of a generation of young writers and visual artists. Sociologist and civil rights activist W. E. B. DuBois had also featured Douglas's drawings on numerous covers of *The Crisis* magazine, the organ of the National Association for the Advancement of Colored People, which DuBois had helped found and which he directed during the 1920s and 1930s. But by the mid-1930s, Douglas, like many American artists, was largely dependent on New Deal government programs for his income. Working for the government came with different expectations and restrictions than a practice of creating art solely based on one's own political convictions.

Today, Douglas's mural *Aspects of Negro Life* features a set of four panels: *The Negro in an African Setting*, *From Slavery through Reconstruction* (pl. 38), *The Idyll of the Deep South*, and *Song of the Towers* (fig. 2). Originally, Douglas had planned a fifth panel in which he had intended to depict the plight of the Black worker under an anti-union state. When

interviewed by *The New York Amsterdam News*, the most important African American–owned newspaper of the day, about the ideological ramifications the work, the artist treaded carefully, explicating his passion for the project while lamenting the issues involved in creating the frescoes for the federal Public Works of Art Project.[3] While he struggled with the decision to omit the final section, Douglas ultimately decided that it would be career suicide to include it.

Since the onset of the Great Depression, Douglas's politics had been steadily drifting left until he had arrived at a place where he felt fully "bolshevized by conditions."[4] He had shifted from a 1920s Jazz Age practice that depicted the performance-based creativity and supposedly natural musicality of African Americans toward works that focused on urban workers' struggle against the social ills, race-based discrimination, and violence that increasingly characterized Black life during the early 1930s. A significant contributor to his artistic development, Douglas told the *Amsterdam News*, was the Marxist social consciousness that he saw in the work of Rivera, Siqueiros, and Orozco, whom

FIG. 2
Aaron Douglas, *Aspects of Negro Life: Song of the Towers*,
1934. Oil on canvas, 7 ft. 10 ½ in. × 7 ft. 4 in. (2.4 × 2.2 m).
Schomburg Center for Research in Black Culture, New York
Public Library; Astor, Lenox, and Tilden Foundations

FIG. 3
Charles Alston, *Magic in Medicine: Study for Harlem Hospital
Mural, New York City*, 1936. Graphite on paper, 16 ¾ × 13 ½ in.
(42.6 × 34.3 cm). Library of Congress, Washington, DC

he believed painted "what they personally think the
proletariat feels."[5]

Song of the Towers, the last completed panel in
the chronological progression of Douglas's *Aspects
of Negro Life*, depicts the economic aspirations of
the American descendants of the kidnapped and
enslaved Africans shown in the first three murals. At
the center of the composition, the silhouetted form
of a man in a modern-day suit stands at the crest of a
giant cog wheel. He holds a saxophone in his left hand
while gesturing with his right to the characteristic
skyscrapers of the New York skyline, which part to
reveal the iconic shape of the Statue of Liberty in the
distance. His path is traced by another silhouetted
man, who climbs the wheel while carrying a valise that
presumably contains all his worldly belongings. Framed
by industrial smokestacks and rural vegetation, the
upward momentum of the second man's climb is
powerfully conveyed, and he gestures forward as
though exhorting a caravan of African American
strivers behind him. *Song of the Towers* is a siren song
of economic and social promise: the modern metropolis
with its promise of liberty awaits as a sanctuary from
the company-store serfdom of sharecropping and the
systematic and casual violence of the South.

The 135th Street Library, the site of Douglas's
murals, was an important gathering place for many

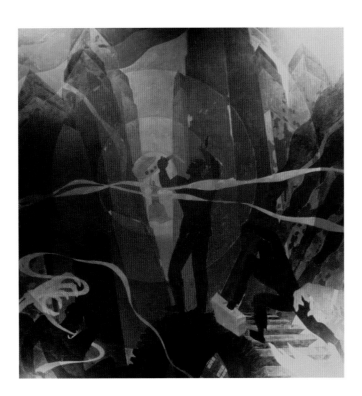

recent African American migrants enticed by such a
promise for themselves and their children. One young
library patron was aspiring artist Jacob Lawrence,
whose family had left South Carolina and migrated
north to Pennsylvania before eventually settling in
Harlem. As a youth, Lawrence attended classes at
Utopia Children's House and then received studio art
training at the Harlem Art Workshop, where he was
taught by Charles Alston, whose Harlem Hospital
murals had been strongly influenced by the work of
Orozco (fig. 3).[6] In 1939, using resources available at
the 135th Street Library, Lawrence began researching
the history of African American migration with the goal
of creating an epic work of art. This project resulted
in a group of sixty tempera paintings, the *Migration
Series* (1940–41), which chronicle the experiences
of African Americans who moved north en masse
following the end of World War I. Some of the most
powerful pieces in the series address the race- and
class-based violence experienced in the North by those
who were fleeing similar oppression in the South, such
as panel 50 (fig. 4) and panel 51 (pl. 47).[7] Shortly after
its completion, a portion of the series was published
in *Fortune* magazine, and it was collected jointly, with
the even-numbered pieces remaining in New York at the

FIG. 4
Jacob Lawrence, *Race riots were very numerous all over the North because of the antagonism that was caused between the Negro and white workers. Many of these riots occurred because the Negro was used as a strike breaker in many of the Northern industries.*, panel 50 from the *Migration Series*, 1940–41. Casein tempera on hardboard, 18 × 12 in. (45.7 × 30.5 cm). The Museum of Modern Art, New York; gift of Mrs. David M. Levy 28.1942.25

Museum of Modern Art while the odd-numbered panels traveled south to become an important part of the Phillips Collection in Washington, DC.

While Aaron Douglas chose to self-censor his government-commissioned murals and Jacob Lawrence used a private grant from the Julius Rosenwald Foundation to complete his monumental interpretation of the history of Black migration in the non-public format of serial tempera paintings, other African American artists who were inspired by the Mexican muralists to address issues of discrimination, racism, and exploitation in their work often decided that they had to leave the United States in order to more fully realize their artistic goals.[8]

Sculptor and printmaker Elizabeth Catlett and her first husband, painter and draughtsman Charles White, had spent the late 1930s creating antiracist work inspired by the Mexican muralists' social ideals. By the 1940s, the couple found themselves targeted by the FBI for their art and for their involvement with social organizations focused on interracial cooperation.[9] With funds from a Rosenwald grant, Catlett and White left the United States in 1946 to work at the Taller de Grafíca Popular (People's Print Workshop) in Mexico City. Although they divorced soon after and White returned to the U.S., Catlett chose to remain in Mexico, eventually adopting Mexican citizenship. During the McCarthy era, she served as one of the primary liaisons for persecuted American socialists fleeing the United States for Mexico and revolution-era Cuba. The works she created at the Taller, including *. . . and a special fear for my loved ones* (fig. 5) and *Civil Rights Congress* (fig. 6), exemplify her continuing emphasis on concerted political action as a way of addressing the targeted racial violence of lynching. In both prints, Catlett uses the imagery of the noose as a way to represent the specter of racial violence, which permeated African American life in both the North and the South.

One of the most significant attractions of Mexican muralism to African American artists was the movement's emphasis on calling out economic inequality and migration-related racial violence, in both the history and contemporary reality of both nations. Whether artists were addressing the atrocities of the Spanish conquistadors during the colonial era or the grim legacy of the Confederacy and the de facto racism of the *Plessy v. Ferguson* doctrine of "separate but equal" segregation, Mexican and New Negro artists often found common cause in the ongoing fight for racial justice.

It is a sad fact that many of these issues of migration and racial violence are still a part of our world today, and as such they remain at the center of socially engaged activism by politically radical artists and cultural workers nearly a century after the Mexican muralists began working in the United States. In December 2018, as I began writing this essay, the organizer of this exhibition, the Whitney Museum, became the focus of intense protest, both from within the institution as well as publicly online and on-site, demanding the ouster of Warren B. Kanders, a vice-chair of the museum's board of trustees. One of Kanders's companies, Safariland, had been identified as the manufacturer of tactical tear-gas canisters that U.S. border agents had used to repel Central American migrants making desperate attempts to cross the southern border of the United States near Tijuana, Mexico, to seek asylum.[10] While shocked at the show of force displayed by federal agents, protesters were specifically concerned that a significant supplier of tactical gear to the military-, police-, and prison-

FIG. 5
Elizabeth Catlett, . . . *and a special fear for my loved ones*, 1946 (printed 1989). Linoleum cut: sheet, 10 × 7 9/16 in. (25.4 × 19.2 cm); image, 8 3/8 × 6 1/16 in. (21.3 × 15.4 cm). Whitney Museum of American Art, New York; purchase with funds from the Print Committee 95.202

FIG. 6
Elizabeth Catlett, *Civil Rights Congress*, 1949. Linoleum cut: sheet, 19 11/16 × 12 13/16 in. (50 × 32.5 cm); image, 12 1/8 × 7 1/8 in. (30.8 × 18.1 cm). Philadelphia Art Museum; gift of Fern and Hersh Cohen, 2015

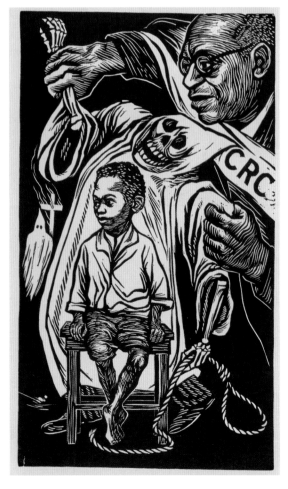

industrial complexes was using the museum to "artwash" profits that had been made from selling products used to violate the human rights of poor and Indigenous people.[11]

After eight months of lively protests, and a growing number of artists choosing to distance themselves from the Whitney by pulling their works from the museum's prestigious Biennial, Kanders resigned from the board. His departure in late July of 2019 was hailed by many as evidence of the power of artistic activism to make meaningful change in the art world and its institutions.

To many of the concerned artists, art historians, and cultural workers who publicly objected to the museum's continued association with Kanders, the fracas at the border was part of longer histories of colonialism, racism, and the economic and military oppression of the poor and disenfranchised. I would argue that the contemporary Central American refugees trying to breach the wastelands of concertina wire and steel slats guarding the "promised land" are not really that dissimilar from the African Americans depicted in Lawrence's *Migration Series* and Douglas's *Aspects of Negro Life*. Whether migrating north of the Mason-Dixon line in the 1920s and 1930s to escape the grinding poverty and extralegal lynching parties of Catlett's prints, or crossing the southern border in the 2010s to escape unemployment and gang violence, desperately poor folk will always seek a better life despite the odds. Similarly, socially concerned and politically engaged artists, regardless of race or nationality, will always seek to call out injustice through their work.

In this very contemporary controversy around art and migration resound the loud echoes of the conflicts between conservative art patrons and radical artists that characterized the interwar period, when African American and Mexican artists working in the United States found that their radical messages of social justice for poor and working-class people were not always welcomed by those in power. In a twenty-first-century online meme, Kanders's visage could have easily replaced one of the predating capitalists seated in the *Wall Street Banquet* panel of Diego Rivera's 1928 murals at the Ministry of Public Education in Mexico City.

NOTES

1. For more on the Talladega College murals, see Stephanie Mayer, Renée Ater, and Hale Woodruff, *Rising Up: Hale Woodruff's Murals at Talladega College* (Atlanta: High Museum of Art, 2012).

2. José Clemente Orozco, *Autobiografía* (Mexico City: Ediciones Occidente, 1945), 65, as quoted in Raquel Tibol, "Foreword: In the Land of Aesthetic Fraternity," in *In the Spirit of Resistance: African American Modernists and the Mexican Muralist School* (New York: The American Federation for the Arts, 1996), 11.

3. T. R. Poston, "Murals and Marx: Aaron Douglas Moves to the Left with PWA Decoration," *New York Amsterdam News*, November 24, 1934: 9.

4. Douglas, quoted in ibid.

5. Ibid.

6. James Prigoff and Robin J. Dunitz, *Walls of Heritage, Walls of Pride: African American Murals* (San Francisco: Pomegranate, 2000), 17–18.

7. Leah Dickerman et al., *Jacob Lawrence: The Migration Series* (New York: The Museum of Modern Art; Washington, DC: The Phillips Collection, 2015).

8. See Rebecca M. Schreiber, "Dislocations of Cold War Cultures," in *Imagining Our Americas: Toward a Transnational Frame*, ed. Sandhya Shukla and Heidi Tinsman (Durham, NC: Duke University Press, 2007), 283.

9. For more on Catlett and her politics, see Mary Helen Washington, *The Other Blacklist: The African American Literary and Cultural Left of the 1950s* (New York: Columbia University Press, 2014), 268–69.

10. The Kanders-Safariland-Whitney connection was first reported by Hyperallergic on November 27, 2018. See Jasmine Weber, "A Whitney Museum Vice Chairman Owns a Manufacturer Supplying Tear Gas at the Border," https://hyperallergic.com/472964 /a-whitney-museum-vice-chairman-owns-a -manufacturer-supplying-tear-gas-at-the-border/. Three days later, a letter signed by more than a hundred Whitney staff members was delivered to the museum's leadership voicing outrage and demanding the museum respond to the Hyperallergic report. See Hrag Vartanian, Zachary Small, and Jasmine Weber, "Whitney Museum Staffers Demand Answers after Vice Chair's Relationship to Tear Gas Manufacturer Is Revealed," Hyperallergic, November 30, 2018: https://hyperallergic.com/473702/whitney-tear-gas -manufacturer-is-revealed/. The first public protest was organized by Decolonize This Place and staged at the museum on December 9. See Ilana Novick and Hakim Bishara, "Activists Protest at Whitney Museum Demanding Vice Chairman and Owner of Tear Gas Manufacturer 'Must Go,'" Hyperallergic, December 9, 2018: https://hyperallergic.com /475198/activists-protest-at-whitney-museum -demanding-vice-chairman-and-owner-of-tear-gas -manufacturer-must-go/. The following month, Decolonize This Place organized a town hall meeting at Cooper Union in New York to strategize further protest action against the Whitney. See Alex Greenberger, "'Whitney Museum, Shame on You': Decolonize This Place Holds Town Hall on Warren B. Kanders Controversy," *Art News* online, January 26, 2019: http://www.artnews.com/2019/01/26/whitney -museum-decolonize-this-place-town-hall-warren-b -kanders/.

11. In addition to manufacturing tear gas, Safariland sells gun holsters, zip-tie handcuffs, hoods, and other restrictive equipment for controlling and transporting prisoners and detainees.

Diego Rivera, José Clemente Orozco, and David Alfaro Siqueiros have long been recognized as *los tres grandes* ("The Big Three" or "Three Greats") of Mexican modern art, a term said to have been coined in 1932 by Anita Brenner. However, while the three are indeed the most significant Mexican artists of the twentieth century, it can be misleading to use the term in historical discussions of their murals. If, for instance, we compare the attention each received during the 1920s, Rivera so overshadows the others that it hardly seems appropriate to refer to each muralist as "big." This discrepancy appears even more pronounced in the American press as art magazines, progressive cultural journals, and leftist periodicals began reporting on the cultural renaissance that was taking place in Mexico after the country's bloody, decade-long revolution. How each artist came to be introduced as a muralist to American audiences via the press would inform public perception of the mural movement long before 1930, when Orozco became the first of the three to paint a mural in the United States.

José Vasconcelos, secretary of public education in the postrevolutionary administration of President Álvaro Obregón, initiated the government-sponsored mural program in 1921 when he provided a colonial-era wall in the former College of Saint Peter and Saint Paul to Roberto Montenegro and another in the Preparatory School in the former Jesuit seminary of San Ildefonso to Rivera. While Katherine Anne Porter's description the following year of how "two enormous clasped hands, on paper pinned in place over the charcoal outline" in Rivera's half-finished "Indian fresco" made her feel "like weeping with pity for struggling, suffering human life" may have been the first printed reference to one of the artists' murals in the American press, the earliest photographs of these projects seem to have appeared in the January 1, 1923 issue of *The Survey*, a popular illustrated biweekly edited by social activist Paul Kellogg.[1] As José Juan Tablada, Mexican poet and de-facto cultural ambassador to the U.S., informed readers, the photographic reproductions showed "some of the exquisite decorative design and mural painting by two Mexican artists, who, though hardly known in this country, are famous in Europe."[2] Although neither of the murals included overtly revolutionary subject matter, their locations in "old ecclesiastical buildings lately converted into halls for college meetings, lectures and concerts," as Tablada wrote, demonstrated that "the cultivation of taste has ceased to be a privilege of the leisured class."[3]

In December, the explicitly revolutionary *Liberator* magazine featured the first of Rivera's frescoes for the recently completed Ministry of Public Education building along with Frederic W. Leighton's article "Pro-Proletarian Art in Mexico." Whereas the subject of Rivera's Preparatory School mural portrayed allegorical figures representing Mexican national identity as a combination of Indigenous and European cultures, his new murals showed the humiliating exploitation Indigenous workers endured before the revolution. As Leighton observed, Rivera was "a member of the central committee of the communist party of Mexico" and leader of the Syndicate of Technical Workers, Painters, and Sculptors, an organization that "adheres to the Moscow International" and strove "to substitute from the very foundation the government of the producers for the government of the exploiters."[4] He also noted that Rivera had "inscribed

JAMES WECHSLER

INTRODUCING THE "BIG THREE": RIVERA, OROZCO, AND SIQUEIROS IN THE 1920S AMERICAN PRESS

verses by Gutiérrez, a young revolutionary poet" on a depiction of miners that encouraged them to make weapons with the ore and overthrow the capitalist ruling class, but Obregón and Vasconcelos made him remove them.[5]

The following year, *The Survey* devoted its entire May 1 issue to cultural and political developments that had taken place in Mexico since the revolution. Featuring on its cover Miguel Covarrubias's streamlined modernist rendering of the Mexican national symbol of an eagle with a snake in its beak resting on a nopal cactus (fig. 1), the volume's table of contents reads like a who's who of Mexican arts and letters, including contributions by Vasconcelos, the anthropologist Manuel Gamio, American journalists Carleton Beals and Frank Tannenbaum, and the artists Dr. Atl and Rivera. Rivera's contribution, "The Guild Spirit in Mexican Art," described the syndicate in nationalist terms as a guild for the muralists working on government-commissioned murals. Among its members Rivera lists Emilio Amero, Ramón Alva de Canal, Jean Charlot, Amado de la Cueva, Xavier Guerrero, Fernando Leal, Carlos Mérida, Fermín Revueltas, and Siqueiros, all of whom "went under contract as a labor union to decorate the walls of the Preparatory School and the Ministry of Education building" for a wage of four pesos per square meter.[6] Highlighting the collective's egalitarian approach, Rivera explained: "Each artist is at liberty to paint on his own particular wall in his own way, obeying the general plan, but in no wise hampered as to style of technique other than the physical requirements of fresco painting. He is only bound in this: he must not interfere with the freedom of his brother artists, and he must remember that he is a laborer subject to the rules of the syndicate. All are, then, free, but free as morally responsible members of a community."[7] While Rivera did not comment on government censorship, he did recount that the upper class who emulated European standards of beauty considered the murals' depictions of Indigenous Mexicans in the Preparatory School to be vulgar and attacked the artists: "We were called *Bolsheviki*, revolutionists, communists, socialists, and anarchists by men who had no conception of what these things meant, but intended them as terms of insult."[8] According to Rivera, however, this uproar only served to arouse public interest in the new art, especially among the Indigenous population,

FIG. 1
Miguel Covarrubias's cover design for the May 1, 1924, issue of *The Survey, Mexico: A Promise*

227

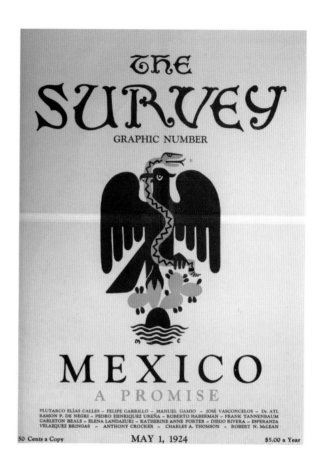

who "finding something recognizable and human, came to love the paintings."[9]

For Rivera, art went hand in hand with revolution, yet his friend Bertram Wolfe, in a 1924 article in *The Nation*, suggested that despite the syndicate's affiliation with the Red International, "these wielders of brushes" were better equipped to represent revolutionary viewpoints and create a revolutionary culture than to effect the overthrow of the bourgeois ruling class.[10] Wolfe recognized Rivera as "Mexico's greatest painter and, in the judgement of competent foreign critics, one of the biggest figures in contemporary art."[11] However, as a member of the Executive Committee of the Communist Party of Mexico, Wolfe also understood that a serious commitment to party activity meant obligations of time and energy that the great painter could ill afford to spend away from painting. A significantly more articulate critical perspective on the communist question as it related to Mexican artmaking came from Anita Brenner, whose early writings for American publications such as *The Arts*, *Creative Art*, and *The Nation* introduced ideas that would inform her pivotal

FIG. 5
Diego Rivera's unfinished *Man at the Crossroads* in the lobby
of the RCA Building, 1933. Photograph by Lucienne Bloch

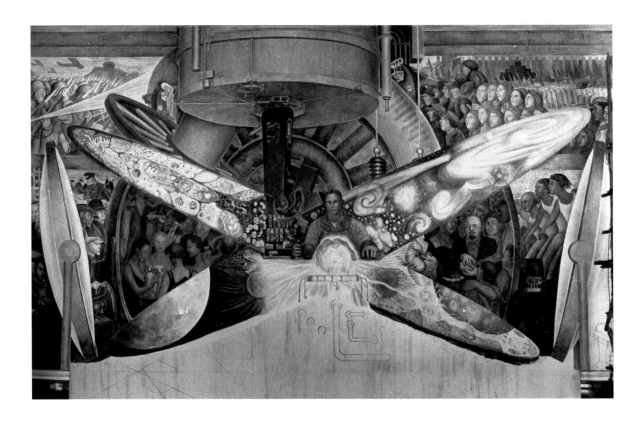

temple of capitalism," the *San Francisco Chronicle* mused in 1930 shortly before Rivera arrived to paint his first public mural in the U.S., at the Luncheon Club of the Pacific Stock Exchange.[20] The accompanying illustration shows a photograph of the club's stairwell doctored to include a superimposed image of Rivera's notorious 1926 fresco *Wall Street Banquet*, which featured eviscerating caricatures of John D. Rockefeller, J. P. Morgan, and Henry Ford. Within two years, as the controversy over Rivera's mural for Rockefeller Center raged, the artist would find himself no longer in control of his own narrative as he had been a decade before. Critiquing the mural cycle Rivera painted for the New Workers School after he was dismissed from his notorious Rockefeller commission, *New York Times* critic Edward Alden Jewell lamented the panels' "discouraging" effect, comparing them to "lurid propaganda posters."[21] "One understands that Rivera has been commissioned to do another building in Mexico," Jewell snarked. "Perhaps returning to his native soil, he will regain the stride so manifestly lost in the United States."

Because the Mexican mural movement cannot be separated from the revolutionary political ideology that propelled it, it was excluded from the predominant canonical narrative of modern art that emerged in the United States during the Cold War era that followed World War II. Today, as the discourse expands from an early twenty-first-century perspective, the pioneering contributions of those writers and critics who first introduced "The Big Three" to the English-reading public nearly a century ago continue to enhance our understanding of the muralists' profound legacy and their enduring impact in shaping a more expansive vision of modernism.



NOTES

1. Katherine Anne Porter to G. S. L. [George Sills Leonard], reprinted as "A Letter from Mexico and the Gleam of Montezuma's Golden Roofs," *Christian Science Monitor*, June 5, 1922: 22.

2. José Juan Tablada, "Art in Mexican Education," *The Survey* "Graphic Number" 44, no. 7 (January 1, 1923): 448–49.

3. Ibid.

4. Frederic W. Leighton, "Pro-Proletarian Art in Mexico," *The Liberator* 12, no. 68 (December 1923): 14.

5. Ibid.

6. Diego Rivera, "The Guild Spirit in Mexican Art," *The Survey* "Graphic Number" 52, no. 3 (May 1, 1924): 175.

7. Ibid.

8. Ibid., 178.

9. Ibid.

10. Bertram D. Wolfe, "Art and Revolution in Mexico," *The Nation* 119, no. 3086 (August 27, 1924): 207.

11. Ibid.

12. Anita Brenner, "A Mexican Renascence," *The Arts* 8, no. 3 (September 1925): 138.

13. Anita Brenner, "A Mexican Rebel," *The Arts* 12, no. 4 (October 1927): 205.

14. Ibid., 207.

15. Ibid., 201.

16. Ibid., 205.

17. Anita Brenner, quoted in Olivier Debroise, "Action Art: David Alfaro Siqueiros and the Artistic and Ideological Strategies of the 1930s," in Debroise et al., *Portrait of a Decade: David Alfaro Siqueiros, 1930–1940* (Mexico City: Museo Nacionale de Arte, Instituto Nacional de Bellas Artes, 1997), 44.

18. "California Group Studies Fresco Technique with Siqueiros," *Art Digest*, August 1, 1932: 13.

19. David Alfaro Siqueiros, "Rivera's Counter-Revolutionary Road," *New Masses* 11, no. 9 (May 29, 1934): 18, 19.

20. "Will Art Be Touched Pink?," *San Francisco Chronicle*, September 25, 1930.

21. Edward Alden Jewell, "America to the Wall!," *New York Times*, October 8, 1933.

For American liberal and leftist intellectuals in the interwar years, two societies in particular stood for alternative values to the industrial capitalism of the United States: the Soviet Union and Mexico. Although both were products of revolution, they were revolutions of radically different types. While the Soviet Union embodied technocratic modernity and the planned economy, Mexico was seen as a centuries-old agrarian culture in which the beliefs and attitudes of pre-Columbian societies continued to hold sway behind a facade of modernization. If the Soviet Union promised to show how the Russian *muzhik* could be forged into the new men and women of the international proletariat, Mexico demonstrated the enduring virtues of pre-capitalist forms of communal life manifested in the *peón* and in Native heritage. The first claimed the authority of the degraded Marxist doctrine of the Third International; the second was grounded in the type of critical thinking that would come to be known as romantic anticapitalism—a term not yet in currency and associated with no single political outlook but which is defined by a profound skepticism towards positivism and bourgeois norms of progress and looks to pre-capitalist societies for alternatives. While the Soviet model of art was thoroughly instrumentalized, the Mexican arts were seen as the product of a culture pervasively aestheticized.[1] However, the arts of both countries expressed collective values, which distinguished them from the individualistic culture of bourgeois societies in which modernist aestheticism in its various forms was seen as the most advanced art. Both countries would attract pilgrims from the American intelligentsia, and artistic representatives of both the Soviet Union and Mexico visited the United States and produced or exhibited works there.

Attitudes toward modern Mexican art were inflected by the political alignments of critics and writers as the international communist movement shifted tactics in the interwar years in response to the changing international situation and to internal developments within the Soviet Union—that is, by that sequence of developments that constituted the dynamic of Stalinism. It is notable that three of the most astute commentators on the Mexican Renaissance—Bertram Wolfe, Anita Brenner, and Meyer Schapiro—all passed through phases as party members or sympathizers before breaking with the communist movement, and in the case of Brenner and Schapiro, gravitating towards Trotskyism.

Wolfe, a founding figure of American communism, lived in Mexico from 1923 to 1925 and worked for the Mexican Communist Party, a tiny organization in which artists played an unusually large role.[2] His 1924 essay "Art and Revolution in Mexico," published in the liberal magazine *The Nation*, already illustrated features of the myth that would form around Mexican art.[3] The Mexican Revolution, Wolfe wrote, was "a very patchy and unsystematic affair," a fragmentary attempt to institute democracy and to distribute parts of the large estates to landless peasants. Political power was "an uncertain balance . . . between the partially awakened workers and peasants on the one hand and the influence of foreign capital, especially that of American interests, on the other." The revolution was given shape by artistic will: "Only in the work of the philosopher, the artist, and the poet have the effects of the revolution assumed system and unity."

ANDREW HEMINGWAY

THE MEXICAN REVOLUTION AS AN AESTHETIC EVENT: EARLY MYTHS AND PERCEPTIONS

FIG. 1
Diego Rivera and Frida Kahlo leading the Syndicate of Revolutionary Painters, Sculptors, and Engravers in the May Day parade, May 1, 1929. Photograph by Tina Modotti

By Wolfe's account, Diego Rivera and his comrades in the Syndicate of Technical Workers, Painters, and Sculptors (formed in 1922) refused "to paint for the bourgeoisie" (fig. 1); Rivera would paint only for "the revolutionary departments of the Government," i.e., the departments of education and of agriculture. Wolfe renamed the syndicate the "Communist Union," and the questions of to what degree the artists' vision aligned with communism and whether their radicalism could be squared with the non-socialist nature of the regime were to remain tricky issues in muralism's reception.

Anita Brenner, the daughter of Latvian Jewish immigrants to Mexico, moved in the same international circles of artists, writers, and activists in Mexico City as Wolfe in the 1920s before leaving to study for a Ph.D. in anthropology at Columbia University from 1927 to 1930 under Franz Boas.[4] Already at age twenty, in 1925, she published a long article in *The Arts*, a progressive American art magazine, proclaiming a "Mexican Renaissance," a concept partly forged in dialogue with her long-term friend, the painter Jean

Charlot.[5] Brenner stressed the defining legacy of pre-Hispanic Indigenous cultures as including a predisposition to religiosity, although this was synthesized with the Catholicism of the Spanish conquerors. Of the syndicate she wrote: "These painters turned to the Indian, first for matter and then also for manner. Nationalism straddles rampant upon their energetic brushes." The artists were guided by a "new religion of the people," which was not communism, "although most of the painters call themselves communists", nor was it socialism or syndicalism, but "Mexicanism." For Brenner, as for Wolfe, Mexico itself was like "a great symphony or a great mural painting," "nowhere as in Mexico has art been so organically a part of life."[6]

Brenner developed these ideas in her 1929 book *Idols behind Altars*, the first major account in English of the mural movement and profusely illustrated with photographs by Tina Modotti and Edward Weston (fig. 2). Influenced by the nationalist anthropologist Manuel Gamio—a key ideologue of *indigenismo*— Brenner argued that contemporary Mexican artists

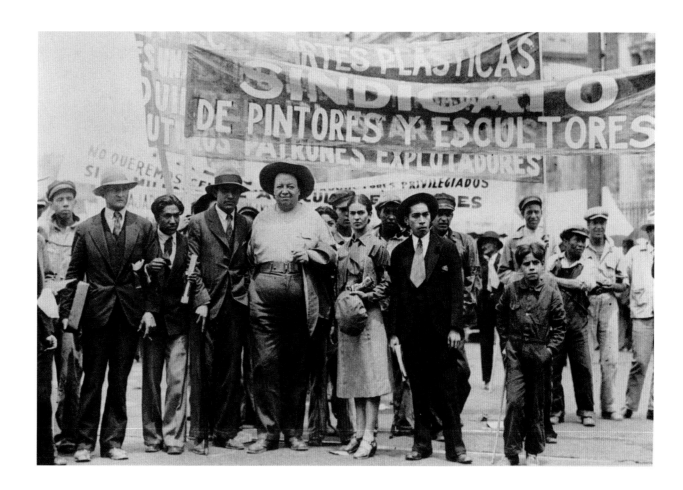

FIG. 2
Title spread from Anita Brenner's *Idols behind Altars*, 1929,
with Edward Weston's photograph *Hand of the Potter Amado
Galvan* (1925)

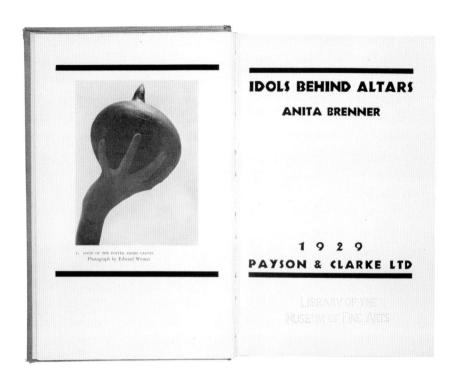

I. HAND OF THE POTTER AMADO GALVAN
Photograph by Edward Weston

IDOLS BEHIND ALTARS

ANITA BRENNER

1 9 2 9

PAYSON & CLARKE LTD

LIBRARY OF THE
MUSEUM OF FINE ARTS

were building on "an American racial heritage of essential grandeur," whose shaping force was also to be found in Aztec temple decorations, church murals, *pulqueria* wall paintings, and ex-voto images.[7] Dismissing "art for art's sake" as an "aesthetic fallacy," she claimed that medium was defined by the demands of expression. But this did not mean some prescriptive political program either. Art was of the people, not for the people. Consequently, the syndicate repudiated easel painting and espoused the mural as an intrinsically popular form that dovetailed with the "Mexican tradition."[8] The revolution was first and foremost an artistic event: "Sanitation, jobs, and reliably workable laws are attended to literally as a by-product of art; for the revolution is a change of regime, because of a change in artistic style, or, if one wishes a more usual description, of spirit."[9]

In 1925 Brenner was emphatic that Rivera was the leader of the new movement, but four years later she claimed—quite incorrectly—that David Alfaro Siqueiros had "plotted the painters' revolution and foretold its artistic results a year before it occurred."[10] Although Siqueiros's pictorial achievements seemed paltry compared to other painters, "his achievement is much greater, for the entire mood of modern artistic Mexico is shot through with the national wishes and abilities crystallized by him."[11] Conversely, Brenner described

Rivera as a Machiavellian figure, a master of "social agility" and the "plausible facade," who held in play a range of aesthetic and philosophical ideas.[12] Siqueiros had great physical beauty and personal charm, but he also had an unshakable commitment to the labor movement and spent part of 1928–29 in risky organizational work.[13] By contrast, in 1929 Rivera accepted the post of director of the Academy of San Carlos and began work on the stairway of the National Palace in Mexico City, just as the Mexican Communist Party's relations with the government of Emilio Portes Gil reached a crisis point. In September he accepted a commission from the American ambassador (a former J. P. Morgan executive) to decorate the loggia of the Palacio de Cortés in Cuernavaca. That month the party expelled him, and he announced his sympathy for Trotskyism.

Rivera's artistic successes in the United States during the years 1930 to 1934 provided more grist for charges of opportunism from communist artists and critics. Neither Siqueiros's two exhibitions in Los Angeles in 1932 nor the three experimental murals he painted in California that year attracted critical attention of the same order. That only came with his 1934 exhibition at Delphic Studios in New York and the artist's visit to the city.[14] In addition to several addresses to communist groups, in May Siqueiros

contributed a long article to the communist magazine *New Masses* (fig. 3) on the publication of Wolfe and Rivera's book *Portrait of America*, which illustrated all of Rivera's murals in the United States but was mainly devoted to the twenty-one movable panels depicting American history that Rivera had painted for the New Workers School in New York, with an accompanying text by Wolfe, the school's director, who had helped plan the murals.[15] Siqueiros's article was less a review of the book than an appraisal of Rivera's career, which Siqueiros charged was replete with moral and political failings, most significantly Rivera's practice of an "opportunistic technique" that was "ideologically obscure."[16] The New Workers School murals, he wrote, were "painting conceived for the static contemplation of the parasite or of the elite."

There was more to this than personal rivalry and Stalinist boilerplate. Siqueiros *did* represent a different model of the revolutionary artist from Rivera, and he was committed to a modernization of pictorial technique that made Rivera's practice seem *retardataire*. Admittedly, this was hard to judge from Siqueiros's own Delphic Studios exhibition, since the display was confined primarily to easel paintings—a medium the artist disparaged—and his technical experiments with outdoor murals based on filmic projections and painted with industrial spray brushes were represented only by photographs. Nonetheless, the reviewer for *New Masses*—the painter and critic Charmion von Wiegand—gave an eloquent account of Siqueiros's political and artistic careers and claimed that "more than any of the Mexican painters, perhaps Siqueiros has managed to fuse revolutionary content and form in his art, while making his art but one form of revolutionary action."[17] The "perhaps" should not be ignored, since von Wiegand saw in Siqueiros's work and actions an element of "romantic irresponsibility," that had no place in the revolutionary movement.

Ironically it was Orozco, the most politically neutral of *los tres grandes*, who received the most favorable response in the communist press.[18] In *Idols behind Altars* Brenner emphasized Orozco's firsthand experience of the revolution but also his refusal to associate his desolate and sometimes caricatural imagery—some of which she clandestinely commissioned him to create—with any "political or artistic doctrine."[19] His was an art of direct emotional expression not tempered by European study. Four years later, in an article in *New Masses*, she sharpened her characterization of the artist, describing him as what "is generally called a revolutionary artist," in that "all the forces of his nature set him squarely against the social status quo, and in that he does not espouse any liberal or reformist cause, he is wholly a revolutionary."[20]

Orozco might be, in Brenner's words, "always a lone man committed to neither side of the class struggle," but he was also an ally of the communists, exhibiting at John Reed Club exhibitions in 1933–35 and making occasional contributions to *New Masses*. Major examples of his work were accessible to the American public in the murals at the New School for Social Research (1930–31) and at Dartmouth College. Writing in the magazine in 1935, von Wiegand acknowledged that the message of the Dartmouth murals was not revolutionary—it would have flouted the institutional environment if it were—but "[i]t is no exaggeration to say that these frescoes, in regard to color, composition, organic relation to architecture, and grandeur of concept, surpass by far any other frescoes in this country."[21] She would pit Orozco's art explicitly against Rivera's in a later review: "In Orozco's stark and savage line . . . the passion of a great mass movement" was palpable.[22] His "Mexican revolutionary art" was totally

Rivera's Counter-Revolutionary Road

DAVID ALFARO SIQUEIROS

I DO NOT propose to deal merely with Diego Rivera's *Portrait of America* and its accompanying monograph. Such a particularized form of analysis seems to me to be mistaken. I shall discuss first the sum total of his work and of his actions and the nature of the movement that he represents.

Up to now, the method of criticism in the case of Rivera has been one-sided and scholastic, similar to that used by the academic critics. That is to say, a mechanical analysis has been applied (an anti-dialectic method), to his individualist, isolated work, to his personality as though it were a static and utterly detached thing. Only one of the effects has been studied—his opportunism—with entire neglect of the causes.

For this reason the discussion has become a vicious thing. And for this reason the arguments thus stated do not explain completely the subtle elements that the problem implies.

The controversy has unmasked the opportunist; that is evident. But the true nature of his actions remain in shadow. The revolutionary intellectuals and the workers by now recognize the demagogue. But little do they understand the "technique" he uses in his tasks. The microbe has been isolated, but the sources of its origin are still unknown. That is, the true technical and ideological nature (as well as methodology and strategy) of the incubator, the so-called "Mexican muralist movement," is still unknown.

The criticism must be a complete one in order to draw from it useful lessons for the making of a true revolutionary art. For this end, the political path of Rivera provides material of great eloquence.

Portrait of America, by Diego Rivera. Covici-Friede. $3.50.

DAVID ALFARO SIQUEIROS

Oscar Newman

But, is it possible to portray in one article, the ever-tortuous political and artistic path of Rivera? Only in the form of synopsis. That is what I am going to do. Naturally, by doing so, I will only be able to make concrete statements, which I shall enlarge upon later in case objections should arise.

What is the "Mexican muralist movement?"

The "Mexican muralist movement" or the "Mexican Renaissance" is the first attempt at collective revolutionary art in the modern age. It is the first modern collective attempt at public art. It is the first modern collective attempt at mural art.

These characteristics have given it international fame. The "left" intellectuals boost it. The professional critics advertise it in the bourgeois press. Its reverberations have conquered even real revolutionary ideologists.

The Mexican muralist movement comprises the works which we did from the time of the frescoes in the Preparatory School up to the paintings done by Rivera and Orozco in the United States. Those which I did in Los Angeles belong to a new impulse of revolutionary art.

What does Rivera represent in that movement?

Diego Rivera is the most spectacular representative of that Mexican movement. More than that—he is its most mature painter.

How did the Mexican mural movement burst forth?

The Mexican mural movement emerged from the Mexican revolution; I mean, it emerged out of a popular revolution (primarily a peasant one). This revolution was directed theoretically and in its military aspects by the artisan petit-bourgeoisie of the country. With that revolution it came into being, with it, it flourished, and with it, decayed. From the Mexican revolution it took its characteristics, at first, its Utopian confusionism, and always its constant opportunism.

Its founders and promoters, we were subjected on arriving to all the whirlwind and natural confusion of its ideology: its anarchic chauvinism. We shall thus be able to see how some were poisoned permanently and how others saved themselves from the venom.

Traditional Bohemianism—Dilettantes, we began to function. Nevertheless, we were not

FIG. 4
Cover of *Portrait of Mexico* by Diego Rivera and Bertram D. Wolfe, 1937

different from European art, "condensing the faith and tenderness of a people into calligraphs of such naked simplicity that the most illiterate peon can read them, yet expressed in terms of pure plastic." Rivera was a mere decorator, who depicted "even oppression and agitation in hushed and static tones with deep religious awe."

The Marxist art historian Meyer Schapiro, who regarded Rivera's art as the nearest thing to "a modern epic painting," contracted to write a study of Orozco for a Soviet publisher in September 1936 but abandoned the project the following year when he broke with Communist Party front organizations. We can get some idea of his less idealized judgment of Orozco from Wolfe, who reported Schapiro's thinking about Orozco as such: "Modern society is too complicated for [Orozco] to grasp; his migrations . . . are of nude men devoid of any baggage of intellectual and material civilization as they move over the face of the earth. Their social hierarchy is reduced to varying qualities of physical energy, their leaders being distinguished merely by their dynamism of movement. As with the migrants, so with all the other types he has portrayed: they are socially naked, static, unhistorical, their energy the mechanics of mere change of position—a dynamics often vivid, sometime violent,

occasionally over-energetic to the point of becoming declamatory."[23]

I conclude with Wolfe and Rivera's *Portrait of Mexico* (fig. 4) and Schapiro's review of it. The book is less a political commentary on Rivera's art like *Portrait of America* and more a popular Marxist history of Mexico for which Rivera's works in a range of mediums serve as illustrations, collected at the end rather than appearing in sections throughout the volume. Although Wolfe used anthropological descriptions to suggest the beauty and wholeness of Mexican folk cultures, his is not like Brenner's *Idols behind Altars* a romantic critique. Mexico is not yet a nation, it is "many distinct socio-economic cultures existing side by side in uneasy cohabitation."[24] It was a land "in the process of changing from pre-capitalist to capitalist, from handicraft to machinofacture, from local to national-international economy."[25]

As Schapiro noted, Wolfe's historical sketch of combined and uneven development was praiseworthy, but his failure to provide an account of the 1920s artistic culture that helped form the muralists left the relationship between their image of Mexico and the historical process unexplained. Despite genuine insights, the tendency of left-wing criticism of the murals tended to turn the careers of *los tres grandes* into a picaresque morality play of "vague ideas," "charges and countercharges" that obscured "the paintings themselves."[26] Only Schapiro raised the really big questions: What did the intentions of the muralists count for by comparison with the demands of their patrons? If the "official socialism" of the Mexican regime was actually "counter-revolutionary," what did this mean for the political valency of murals that arguably "indirectly helped to preserve the existing state"? Did popular understanding—supposing it could be measured—amount to artistic value? Was value equal to agitational power? Could an artist without revolutionary intentions produce revolutionary art nonetheless? These questions remain.

NOTES

1. Two representative texts that made this claim and went through multiple printings are: Stuart Chase, *Mexico: A Study of Two Americas* (New York: Macmillan, 1931), 37, 170; and Carleton Beals, *Mexican Maze* (Philadelphia: J. B. Lippincott, 1931), 50, 60–61, 119. Both have copious illustrations by Rivera.

2. In 1928, the Mexican Communist Party had a mere 1,500 members; see Barry Carr, *Marxism and Communism in Twentieth-Century Mexico* (Lincoln: University of Nebraska Press, 1992), 10–11. Wolfe was expelled from the Communist Party USA along with other supporters of Jay Lovestone in 1929.

3. Bertram D. Wolfe, "Art and Revolution in Mexico," *Nation* 119, no. 3086 (August 27, 1924): 207.

4. Susannah Joel Glusker, *Anita Brenner: A Mind of Her Own* (Austin: University of Texas Press, 1998).

5. Anita Brenner, "A Mexican Renaissance," *The Arts* 8, no. 3 (September 1925): 138.

6. Anita Brenner, *Idols behind Altars* (New York: Harcourt, Brace, 1929), 15, 32.

7. Ibid., 229–31. For all his reevaluation of pre-Columbian art, Gamio was a liberal anticlerical ideologue and state functionary; Brenner's taking up of his ideas was distinctly selective. See David A. Brading, "Manuel Gamio and Official *Indigenismo* in Mexico," *Bulletin of Latin American Research* 7, no. 1 (1988): 75–89.

8. Brenner, *Idols behind Altars*, 240.

9. Ibid., 314.

10. Ibid., 240. Brenner's journals provide a fascinating register of her shifting perceptions. See Anita Brenner, *Avant-Garde and Artists in Mexico: Anita Brenner's Journals of the Roaring Twenties*, ed. Susannah Joel Glusker, 2 vols. (Austin: University of Texas Press, 2010). For Brenner's misrepresentations of the muralists' ideology, see Tatiana Flores, "An Art Critic in a Contested Field: Anita Brenner and the Construction of the Mexican Renaissance," in *Another Promise Land: Anita Brenner's Mexico / Otra tierra Prometida: el México de Anita Brenner*, ed. Karen Cordero Reiman (Los Angeles: Skirball Cultural Center, 2017), 86–97.

11. Brenner, *Idols behind Altars*, 266.

12. Ibid., 278, 279–80. Compare Wolfe's malicious description of Siqueiros as an ideologue in his *Diego Rivera: His Life and Times* (New York: Alfred A. Knopf, 1939), 170–71.

13. Brenner, *Idols behind Altars*, 265.

14. For Siqueiros in the United States and his technical experiments, see Olivier Debroise et al., *David Alfaro Siqueiros: Portrait of a Decade, 1930–1940* (Mexico City: Museo Nacionale de Arte, Instituto Nacional de Bellas Artes, 1997).

15. Diego Rivera, *Portrait of America* (New York: Covici Friede, 1934).

16. David Alfaro Siqueiros, "Rivera's Counter-Revolutionary Road," *New Masses* 11, no. 9 (May 29, 1934): 19.

17. Charmion von Wiegand, "David Alfaro Siqueiros," *New Masses* 11, no. 5 (May 1, 1934): 18.

18. Renato González Mello and Diane Miliotes, eds., *José Clemente Orozco in the United States, 1927–1934* (New York: W. W. Norton, 2002).

19. Brenner, *Idols behind Altars*, 270.

20. Anita Brenner, "Orozco," *New Masses* 8, no. 7 (February 1933): 22.

21. Charmion von Wiegand, "Our Greatest Mural Art," *New Masses* 15, no. 1 (April 2, 1935): 34.

22. Charmion von Wiegand, "Portrait of an Artist," *New Masses* 23, no. 6 (April 27, 1937): 23.

23. Meyer Schapiro as reported in Wolfe, *Diego Rivera*, 174–75.

24. Diego Rivera and Bertram D. Wolfe, *Portrait of Mexico* (New York: Covici Friede, 1937), 20, 24.

25. Ibid., 22.

26. Meyer Schapiro, "The Patrons of Revolutionary Art," *Marxist Quarterly* 1, no. 3 (October/December 1937): 462–66. Wolfe responded in "Discussion," 466–70. Although Wolfe and Schapiro were both editors of *Marxist Quarterly*, Wolfe's correspondence in the Schapiro papers (Columbia University) indicates a prickly relationship.

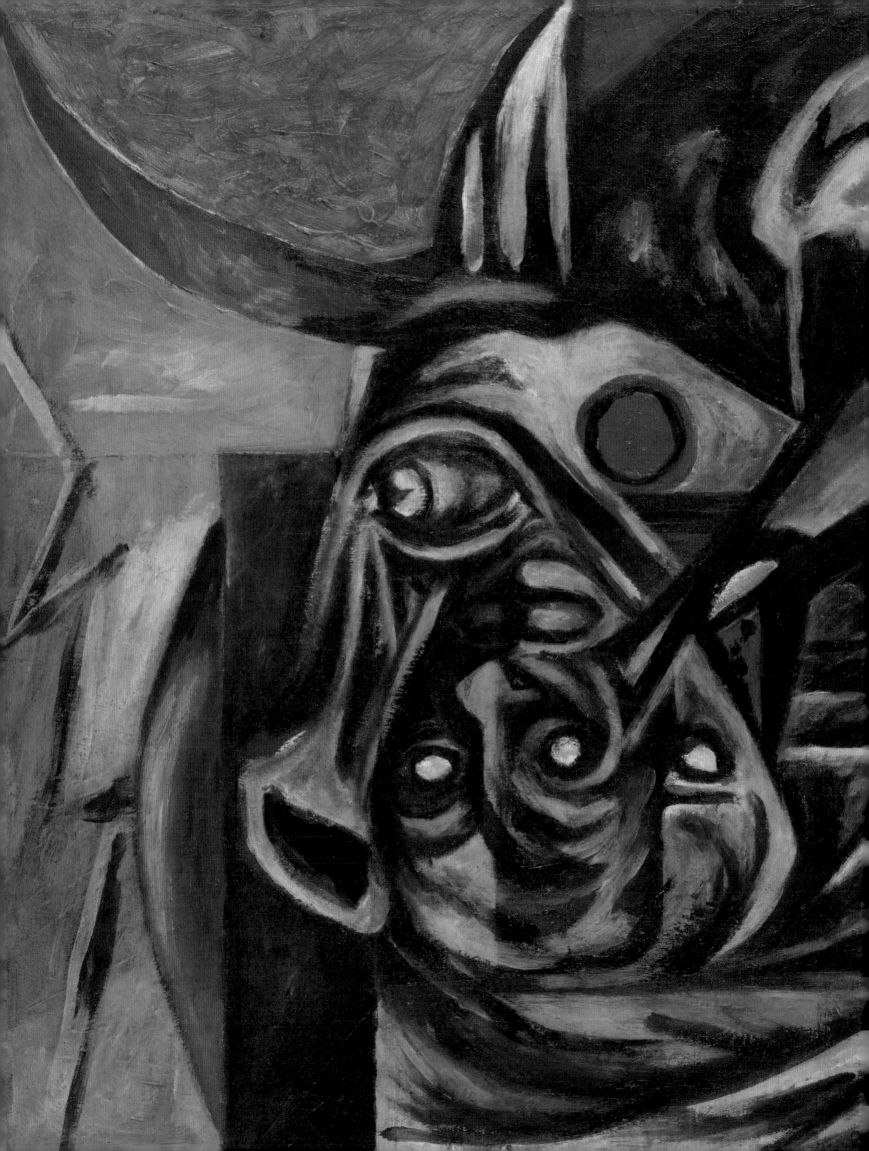

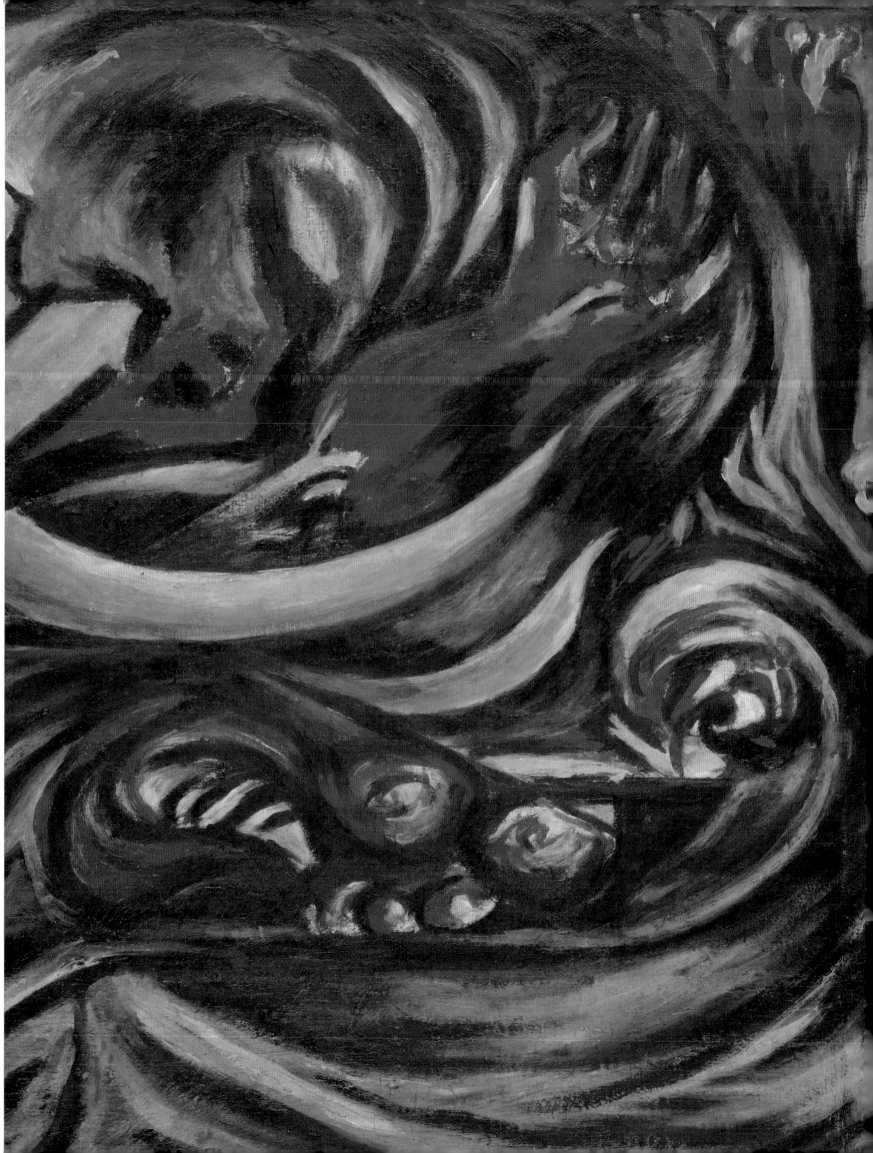

ACKNOWLEDGMENTS

A project of this scope necessarily requires the support and contributions of a great many people. First and foremost, I would like to thank Adam D. Weinberg, Alice Pratt Brown Director, and Scott Rothkopf, senior deputy director for programs and Nancy and Steve Crown Family Chief Curator, for recognizing the significance and timeliness of *Vida Americana* and for providing support and advice that were essential to its implementation and success as well as that of this accompanying catalogue.

Organizing and mounting an exhibition of sixty artists and over 180 works of art requires an exemplary level of aesthetic discernment, intelligence, and attention to detail. In this regard, my greatest debt is to the project's core curatorial team—senior curatorial assistant Sarah Humphreville, assistant curator Marcela Guerrero, and former curatorial project assistant Alana Hernandez—for the central role they played in all facets of the endeavor. They were joined by former curatorial fellow Michelle Donnelly in the project's early phase and by a number of interns, in particular Ben Green, Sabrina Lefkowitz, Susana Montañés-Lleras, Maya Ortiz, Roma Patel, and Armando Pulido Jr. Without their collective wisdom and diligence, producing this publication and the exhibition it accompanies would have been unimaginable. In addition, Alejandro Anreus, Sari Bermúdez, Luis-Martín Lozano, and Irene Herner provided critical support at key moments in the project's development. I am indebted to them and to the authors who lent their expertise and insights to this publication: Mark A. Castro, Dafne Cruz Porchini, Renato González Mello, Andrew Hemingway, Anna Indych-López, Michael K. Schuessler, Gwendolyn DuBois Shaw, ShiPu Wang, and James Wechsler. This book benefitted tremendously from the scholarship of these individuals as well as from that of numerous other historians upon whose research and insights this project depended: Dawn Adès, Matthew Affron, Donald Albrecht, Agustín Arteaga, Alicia Azuela, Jacquelynn Baas, Holly Barnet-Sanchez, David Craven, Patrick Charpenel, Mary K. Coffey, Karen Cordero Reiman, Deborah Cullen, Olivier Debroise, Helen Delpar, Leonard Folgarait, Robin Adèle Greeley, Jennifer Jolly, Lynda Klich, Ellen Landau, Anthony Lee, Adrian Locke, Rick A. López, Thomas Mellins, Diane Miliotes, James Oles, Rubén Ortiz-Torres, Catha Paquette, Stephen Polcari, Breanne Robertson, Desmond Rochfort, Timothy Rub, Rebecca Schreiber, Philip Stein, and Alejandro Ugalde.

I likewise extend my heartfelt thanks to the publications department of the Whitney Museum, led by director of publications Beth Huseman, and to Yale University Press's art and architecture division, helmed by publisher Patricia Fidler, for their exemplary management of every aspect of this publication. In this regard, I especially want to recognize Beth Turk, editor at the Whitney, for expertly and graciously steering this project from start to finish. My thanks also go to Amy Canonico, editor, art and architecture; Mary Mayer, art book design and production manager; Kate Zanzucchi, managing editor, art and architecture; and Raychel Rapazza, editorial and production assistant at Yale. Jason Best shaped and conceptually clarified the book's texts with remarkable grace and skill, and Michelle Lee Nix of McCall Associates created an original and elegant book design and was, as always, a delight to work with.

The complex nature of this project required the expertise of virtually every department in the Museum. I am especially grateful to Anna Martin, exhibition designer and production coordinator, whose inventive and dynamic installation design was crucial to the exhibition's success. I also want to recognize Zoe Tippl, exhibition coordinator, and Brenna Cothran, assistant registrar, for their dedication and attention to detail, which were essential to the realization of this exhibition's ambitious scope. The interactive and experiential aspects of the exhibition were deftly managed by Reid Farrington, audio-visual manager, who oversaw all aspects of the projections, films, and touchscreens. Carol Mancusi-Ungaro, Melva Bucksbaum Associate Director for Conservation and Research, and Matthew Skopek, associate conservator, played a key role in securing the loans of fragile objects.

Paco Link, Ben Wolf, and the Topiary Productions team overcame the challenge of translating the experience of viewing site-specific murals made by U.S. artists in Mexico City's Abelardo L. Rodríguez market with their immersive film, which, along with the photo-panorama of Diego Rivera's *Detroit Industry* produced by David Mariotti, was a centerpiece of the exhibition.

No project of this scale would be possible without the fundraising acumen of the Museum's advancement department under the leadership of Pamela Besnard, chief advancement officer. I particularly want to acknowledge the efforts of Stephanie Adams, director of individual and planned giving; Morgan Arenson, director of foundations and government relations; Kim Craig, major gifts officer; Eunice Lee, director of corporate partnerships; and Jocelyn Tarbox, manager of corporate sponsorships. My gratitude goes to them as well as to those who helped guide the interpretive materials and public programming for this exhibition: Kathryn Potts, associate director, Helena Rubinstein Chair of Education; Anne Byrd, director of interpretation and research; and Megan Heuer, director of public programs and public engagement. I am additionally beholden to Brianna O'Brien Lowndes, chief marketing officer; Lindsay Pollock, chief communications and content officer; Stephen Soba, director of communications; Danielle Bias, senior communications officer; Zoe Jackson, director of marketing; Benjamin Lipnick, tourism sales and marketing manager; Jackie Foster, senior digital content manager; Aliza Sena, digital producer; Hilary Greenbaum, director of graphic design; and the rest of the marketing, communications, digital, and graphic design team. Finally, no exhibition of any size at the Whitney happens without the management skills and diplomacy of Emily Russell, director of curatorial affairs; Christy Putnam, associate director for exhibitions and collections management; I. D. Aruede, co-chief operating officer and chief financial officer; Amy Roth, co-chief operating officer; and Nicholas S. Holmes, general counsel. And for their roles in ensuring that visiting the Whitney is always a special and rewarding experience, I thank Adrian Hardwicke, chief visitor experience officer; Wendy Barbee, senior manager of visitor services; Meryl Schwartz, senior manager of visitor experience; Larry DeBlasio, director of security; and Peter Scott, director of facilities, and their staffs.

All exhibitions rely on the generosity of public and private collectors, but the scope and international character of this project made this generosity all the more urgent. I am particularly beholden to collectors Marcos and Vicky Micha Levy for agreeing to share fragile and important frescoes from their collection with the public and to the museum and gallery colleagues whose generosity and assistance was crucial in securing loans: Esther Adler, Virgilio Garza, Lisa Gentry, Dakin Hart, Ilona Katzew, Mary-Ann Martin, Norberto Rivera, Andy Schoelkopf, Jessica Todd Smith, Elsa Smithgall, Louis Stern, Ann Temkin, Randy White, and Debra Wider. In addition, I am immensely grateful for the support of the Mexican government, in particular Marcelo Ebrand Casaubon, minister of foreign affairs, and the individuals who lead Mexico's cultural institutions: María Álvarez Reyes-Retana, Tatiana Cuevas, Carmen Gaitán, Mariana Munguía Matute, Stefanie Belinda Schwarz, and Hilda Trujillo Soto. Their commitment as well as that of Jorge Islas López, Consul General of Mexico, and Denise Simon, chairman of the board, Miguel José Gleason, director, and María Fernanda Burela Maldonato, program coordinator, of the Mexican Cultural Institute in New York to helping the Whitney Museum showcase Mexico's seminal role in the development of art in the United States is deeply appreciated.

—Barbara Haskell

LENDERS TO THE EXHIBITION

AS OF AUGUST 26, 2019

Archives of American Art, Washington, DC

Art Institute of Chicago

Butler Institute of American Art, Youngstown, Ohio

Center for Creative Photography, University of Arizona, Tucson

Childs Gallery, Boston

Columbus Museum of Art, Ohio

Eduardo Costantini

Crystal Bridges Museum of American Art, Bentonville, Arkansas

Dallas Museum of Art

David Dechman and Michel Mercure

Detroit Institute of Arts

Bram and Sandra Dijkstra

Fine Arts Museums of San Francisco

Frances Lehman Loeb Art Center, Vassar College, Poughkeepsie, New York

Bernard Friedman

The Harmon and Harriet Kelley Foundation for the Arts, San Antonio

Hirshhorn Museum and Sculpture Garden, Smithsonian Institution, Washington, DC

Hood Museum of Art, Dartmouth College, Hanover, New Hampshire

Howard University Gallery of Art, Washington, DC

Indianapolis Museum of Art at Newfields

The Isamu Noguchi Foundation and Garden Museum, New York

Kaluz Collection, Mexico City

Marcos and Vicky Micha Levy

Library of Congress, Washington, DC

Los Angeles County Museum of Art

Lucas Museum of Narrative Art, Los Angeles

McNay Art Museum, San Antonio

Memorial Art Gallery of the University of Rochester, New York

The Metropolitan Museum of Art, New York

Mizoe Art Gallery, Fukuoka/Tokyo, Japan

Museo Anahuacalli, Mexico City

Museo de Arte Carrillo Gil, INBA, Mexico City

Museo de Arte Moderno, INBA, Mexico City

Museo Dolores Olmedo, Mexico City

Museo Nacional de Arte, INBA, Mexico City

Museum of the City of New York

Museum of Fine Arts, Boston

The Museum of Modern Art, New York

Museum of Modern Art, Wakayama, Japan

National Gallery of Art, Washington, DC

Nelson-Atkins Museum of Art, Kansas City, Missouri

New Haven Museum, Connecticut

Palm Springs Museum of Art, California

Philadelphia Museum of Art

The Phillips Collection, Washington, DC

Phoenix Art Museum

Harvey and Harvey-Ann Ross

San Antonio Museum of Art

San Diego History Center

San Francisco Museum of Modern Art

Sheldon Museum of Art, University of Nebraska–Lincoln

Sindicato Nacional de Trabajadores de la Educación, Mexico

Smithsonian American Art Museum, Washington, DC

Susan Stockton and Chris Walther

Matilda Stream

Tate, London

Thomas Colville Fine Art, New York

Throckmorton Fine Art Inc., New York

Steve Turner; courtesy Hirschl & Adler Galleries, New York

UCI Museum and Institute for California Art, Irvine

University of Kentucky Art Museum, Lexington

Whitney Museum of American Art, New York

Charles K. Williams II

The Wolfsonian–Florida International University, Miami Beach

Yale University Art Gallery, New Haven, Connecticut

And those who wish to remain anonymous

WHITNEY MUSEUM OF AMERICAN ART STAFF

Carlos Noboa
Jaison O'Blenis
Lindsey O'Connor
Kimie O'Neill
Nelson Ortiz
Ahmed Osman
Eloise Owens
Nicky Ozir
Luis Padilla
Jessica Palinski
Jane Panetta
Joseph Parise
Max Parry-McDonell
Christiane Paul
Jessica Pepe
Roberto Perez
Jason Phillips
Laura Phipps
Angelo Pikoulas
Raymond Podulka
Lindsay Pollock
Carla Posner
Kathryn Potts
Eric Preiss
Eliza Proctor
Laura Protzel
Eric Pullett
Vincent Punch
Christy Putnam
Emma Quaytman
Lauren Quesada
Julie Rega
Andrea Gomez Resendiz
Gregory Reynolds
Omari Richards
Yevgeniy Riftin
Felix Rivera
Gabriella Robles
Melissa Robles
Enrique Rocha
Manuel Rodriguez
Gina Rogak
Clara Rojas-Sebesta
Julia Rome
Justin Romeo
Sara Romo
Antonio Rosa
Joshua Rosenblatt
Amy Roth
Scott Rothkopf
Emily Russell
Angelina Salerno
Laura Salomon

Leo Sanchez
Ximena Santiago
Lynn Schatz
Meryl Schwartz
Peter Scott
David Selimoski
Aliza Sena
Jason Senquiz
Dumitru Sersea
Stephen Sewell
Joseph Shepherd
Leslie Sheridan
Elisabeth Sherman
Sadia Shirazi
Adelina Simmonds
Dyeemah Simmons
Matt Skopek
Roxanne Smith
Joel Snyder
Michele Snyder
Stephen Soba
Elizabeth Soland
Barbi Spieler
Carrie Springer
Mark Steigelman
Minerva Stella
Jennifer MacNair Stitt
Betty Stolpen
Emilie Sullivan
Denis Suspitsyn
Elisabeth Sussman
Haley Tanenbaum
Jocelyn Tarbox
Melanie Taylor
Joseph Teliha
Ellen Tepfer
Latasha Thomas
Zoe Tippl
Ana Torres-Hurtado
Ambika Trasi
Stacey Traunfeld
Beth Turk
Lauren Turner
Matthew Vega
Eric Vermilion
Nancy Viglione
Igor Vroublevsky
Farris Wahbeh
Beatrix Walter
Adam D. Weinberg
Clemence White
Ashanti White-Wallace
Olivia Wilcox

Andrew Wojtek
Sasha Wortzel
Lori Wright-Huertas
Ally Xing
Raul Zbengheci
Sefkia Zekiroski
Jessica Zhao
Lily Zhou
Alex Zylka

AS OF JUNE 24, 2019

INDEX

CONTRIBUTORS

Barbara Haskell is a curator at the Whitney Museum of American Art, New York.

Mark A. Castro is Jorge Baldor Curator of Latin American Art at the Dallas Museum of Art.

Dafne Cruz Porchini is a researcher at the Institute of Aesthetic Research at the Universidad Nacional Autónoma de México, Mexico City.

Renato González Mello is a researcher at the Institute of Aesthetic Research at the Universidad Nacional Autónoma de México, Mexico City.

Marcela Guerrero is an assistant curator at the Whitney Museum of American Art, New York.

Andrew Hemingway is professor emeritus of art history at University College London.

Anna Indych-López is professor of Latin American and Latinx art history at the Graduate Center of the City University of New York.

Michael K. Schuessler is professor of the humanities at the Universidad Autónoma Metropolitana, Cuajimalpa, Mexico City.

Gwendolyn DuBois Shaw is associate professor of history of art at the University of Pennsylvania, Philadelphia.

ShiPu Wang is professor and Coats Family Endowed Chair in the Arts at the University of California, Merced.

James Wechsler is an independent scholar based in New York.

PHOTOGRAPHIC CREDITS

In reproducing the images contained in this publication, the publisher obtained the permission of rights holders whenever necessary and possible. Reasonable efforts have been made to credit the copyright holders, photographers, and sources; if there are any errors or omissions, please contact the Whitney Museum of American Art so that corrections can be made in any subsequent edition.

Boldface numerals refer to page numbers

Abbreviations
ARS: Artists Rights Society (ARS), New York
INBAL: Reproduction authorized by the National Institute of Fine Arts and Literature (INBAL), 2019
MOMA: Digital image © The Museum of Modern Art/Licensed by SCALA/Art Resource, New York
Banco de México–Rivera–Kahlo: Banco de México Diego Rivera Frida Kahlo Museums Trust, Mexico City
SOMAAP: SOMAAP, Mexico City
VAGA–ARS: Licensed by VAGA at Artists Rights Society (ARS), New York
WMAA: Photograph © Whitney Museum of American Art, New York

Cover: © 2019 Banco de México–Rivera–Kahlo/ARS, photo: Detroit Institute of Arts, USA/Bridgeman Images
Details: **12–13** © The Alfredo Ramos Martínez Research Project, reproduced with permission; photo: Ben Blackwell. **46–47** © 2019 The Pollock-Krasner Foundation/ARS, photo: The Art Institute of Chicago/Art Resource, NY. **170–71** © 2019 The Jacob and Gwendolyn Knight Lawrence Foundation, Seattle/ARS. **238–39** © 2019 Banco de México–Rivera–Kahlo/ARS

Haskell Essay: **17** © The Alfredo Ramos Martínez Research Project (left); © Aperture Foundation Inc., Paul Strand Archive (right). **18–19** © 2019 ARS/SOMAAP, image courtesy The New School, photo: Martin Seck. **19** © 2019 ARS/SOMAAP, image courtesy The New School, photo: Martin Seck. **20** © 2019 Banco de México–Rivera–Kahlo/ARS, image © San Francisco Art Institute. **24–25** © 2019 ARS/SOMAAP, image © Santa Barbara Museum of Art. **27** Detroit Institute of Arts, USA/Bridgeman Images. **28** © 2019 Banco de México–Rivera–Kahlo/ARS, INBAL, image: Anahuacalli Museum, Frida Kahlo and Diego Rivera Archives, photo: Agustin Estrada. **29** © Lucienne Bloch, courtesy Old Stage Studios. **31** © Taiji Municipal Ishigaki Memorial Museum, photo: Uncredited/AP/Shutterstock. **33** © Heirs of Marion Greenwood, image © Bob Schalkwijk (top); © Heirs of Grace Greenwood, image © Bob Schalkwijk (bottom). **34** © The Charles White Archives. **35** © Heirs of Aaron Douglas/VAGA–ARS. **36–37** © 2019 ARS/SOMAAP, image: Philadelphia Museum of Art (photography by Graydon Wood and Timothy Tiebout). **38** © 2019 The Pollock-Krasner Foundation/ARS, image © The Metropolitan

Museum of Art/Art Resource, NY. **40** Image: Fondo Fotográfico CENIDIAP/INBAL, Biblioteca de las Artes. **41** MOMA. **42–43** © 2019 Banco de México–Rivera–Kahlo/ARS

Plates: **49** © 2019 Banco de México–Rivera–Kahlo/ARS, photo: © Museum Associates/LACMA. **50** © Latham Family Educational Trust. **51** © 2019 ARS/SOMAAP, MOMA. **52** © The Alfredo Ramos Martínez Research Project, reproduced with permission; photo: Ben Blackwell. **53** © 2019 ARS/SOMAAP, photo: The Art Institute of Chicago/Art Resource, NY. **54** Image © 2018 The Regents of The University of California. **55** © 2019 ARS/SOMAAP, INBAL. **56** © Rachel and Judith Siporin (top); © Aperture Foundation Inc., Paul Strand Archive (bottom). **57** © 2019 Banco de México–Rivera–Kahlo/ARS, INBAL, photo: © Francisco Kochen. **58** © 2019 Banco de México–Rivera–Kahlo/ARS, photo: Katherine Du Tiel. **59** © The Alfredo Ramos Martínez Research Project, reproduced by permission. **61** © 2019 ARS/SOMAAP, photo: Lee Stalsworth. **62** Image courtesy Throckmorton Fine Art (top). **64** © Maria Elena Rico Covarrubias, image courtesy Pablo Goebel Fine Arts Gallery, Mexico City. **65** © 2019 Banco de México–Rivera–Kahlo/ARS. **66** © 2019 Center for Creative Photography, Arizona Board of Regents/ARS, photo: Don Ross (top); © Aperture Foundation Inc., Paul Strand Archive (bottom). **67** © 2019 Tamayo Heirs/Mexico/VAGA–ARS. **69** © 2019 Banco de México–Rivera–Kahlo/ARS, photo: Albright-Knox Art Gallery/Art Resource, NY. **70** © 2019 ARS/SOMAAP, MOMA (top); © 2019 ARS/SOMAAP, INBAL (bottom). **71** © 2019 ARS/SOMAAP, MOMA. **73** © 2019 ARS/SOMAAP, photograph © 2020 Museum of Fine Arts, Boston. **74** © 2019 The Pollock-Krasner Foundation/ARS, MOMA. **75** © 2019 ARS/SOMAAP, photo: Fredrik Nielsen. **76** © 2019 ARS/SOMAAP, image courtesy the San Antonio Museum of Art, photo: Peggie Tenison. **77** © The Estate of Philip Guston. **78** © 2019 ARS/SOMAAP. **79** © 2019 The Pollock-Krasner Foundation/ARS. **80** © 2019 The Pollock-Krasner Foundation/ARS, photo: © Tate, London 2019. **81** © The Charles White Archives. **82** © Estate of Everett Gee Jackson. **83** © 2019 The Pollock-Krasner Foundation/ARS, photo © Sheldon Museum of Art. **84–85** © 2019 ARS/SOMAAP, MOMA. **88–89** © 2019 T. H. and R. P. Benton Testamentary Trusts/UMB Bank Trustee/VAGA–ARS, photo: Nelson-Atkins Media Services/Jamison Miller. **90–91** © 2019 The Jacob and Gwendolyn Knight Lawrence Foundation, Seattle/ARS. **92** © Rachel and Judith Siporin. **93** © Heirs of Edward Millman. **94–95** © The Charles White Archives, image: Howard University Gallery of Art, Washington, DC, photo: Gregory Staley. **97** Photo: Smithsonian American Art Museum, Washington, DC/Art Resource, NY. **98–99** © 2019 Banco de México–Rivera–Kahlo/ARS, photo: Detroit Institute of Arts, USA/Bridgeman Images. **100–101** © 2019 Banco de México–Rivera–Kahlo/ARS, photo: Detroit Institute of Arts, USA/Bridgeman Images. **102** © The Estate of Philip Guston. **103** © 2019 Estate of Seymour Fogel/VAGA–ARS, photo courtesy Smithsonian American Art Museum, Washington, DC/Art Resource, NY. **104** Courtesy the Estate of Harry Sternberg and the Susan Teller Gallery, New York, WMAA.

The lead sponsor for *Vida Americana: Mexican Muralists Remake American Art, 1925–1945* is the Jerome L. Greene Foundation

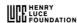 JLGreene

The exhibition is also sponsored by

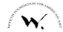 and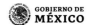

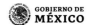 DELTA

Major support is provided by the Barbara Haskell American Fellows Legacy Fund, the Henry Luce Foundation, and the Terra Foundation for American Art.

Generous support is provided by The Mr. and Mrs. Raymond J. Horowitz Foundation for the Arts Inc. and the National Endowment for the Arts.

Significant support is provided by Arthur F. and Alice E. Adams Charitable Foundation.

Additional support is provided by the Garcia Family Foundation and the Robert Lehman Foundation Inc.

Curatorial research and travel were funded by the Steven and Alexandra Cohen Foundation.

HENRY LUCE FOUNDATION TERRA FOUNDATION FOR AMERICAN ART

NATIONAL ENDOWMENT FOR THE ARTS arts.gov

Support for the catalogue is provided by the Wyeth Foundation for American Art.

GOBIERNO DE MÉXICO | CULTURA SECRETARÍA DE CULTURA | INBAL

This publication was produced by the publications department at the Whitney Museum of American Art, New York: Beth A. Huseman, director of publications; Jennifer MacNair Stitt, editor; Beth Turk, editor; and Jacob Horn, editorial coordinator; in association with Yale University Press: Amy Canonico, editor, art and architecture; Mary Mayer, art book design and production manager; and Kate Zanzucchi, managing editor, art and architecture.

Project manager: Beth Turk
Editor: Jason Best
Photo editor: Anne Levine
Designer: McCall Associates
Proofreader: Julia Ridley Smith
Indexer: David Luljak

Set in Hope Sans designed by Charles Nix, Monotype, and Versus designed by Marcelo Moya, Latinotype
Printed on 115gsm Kasadaka White

Cataloging-in-publication data is on file with the Library of Congress
ISBN 978-0-300-24669-8

A catalogue record for this book is available from the British Library.

The paper in this book meets the requirements of ANSI/NISO Z39.48-1992 (Permanence of Paper).

Printed in China through Asia Pacific Offset

10 9 8 7 6 5 4 3 2 1

Cover: Diego Rivera, lower panel of *Detroit Industry, North Wall*, 1932–33 (detail of pl. 53); pages 12–13: Alfredo Ramos Martínez, *Zapatistas*, 1932 (detail of pl. 4); pages 46–47: Diego Rivera, *Open Air School*, 1932 (detail of pl. 18); pages 170–71: Jacob Lawrence, *During World War I there was a great migration north by southern African Americans.*, panel 1 from the *Migration Series*, 1940–41 (detail of pl. 44); pages 238–39: Jackson Pollock, *Untitled*, c. 1938–41 (detail of pl. 109)

Whitney Museum of American Art
99 Gansevoort Street
New York, NY 10014
whitney.org

Yale University Press
302 Temple Street
P.O. Box 209040
New Haven, CT 06520-9040
yalebooks.com/art